WITHDRAWN

THE
ART AND ARCHITECTURE
OF
MESOPOTAMIA

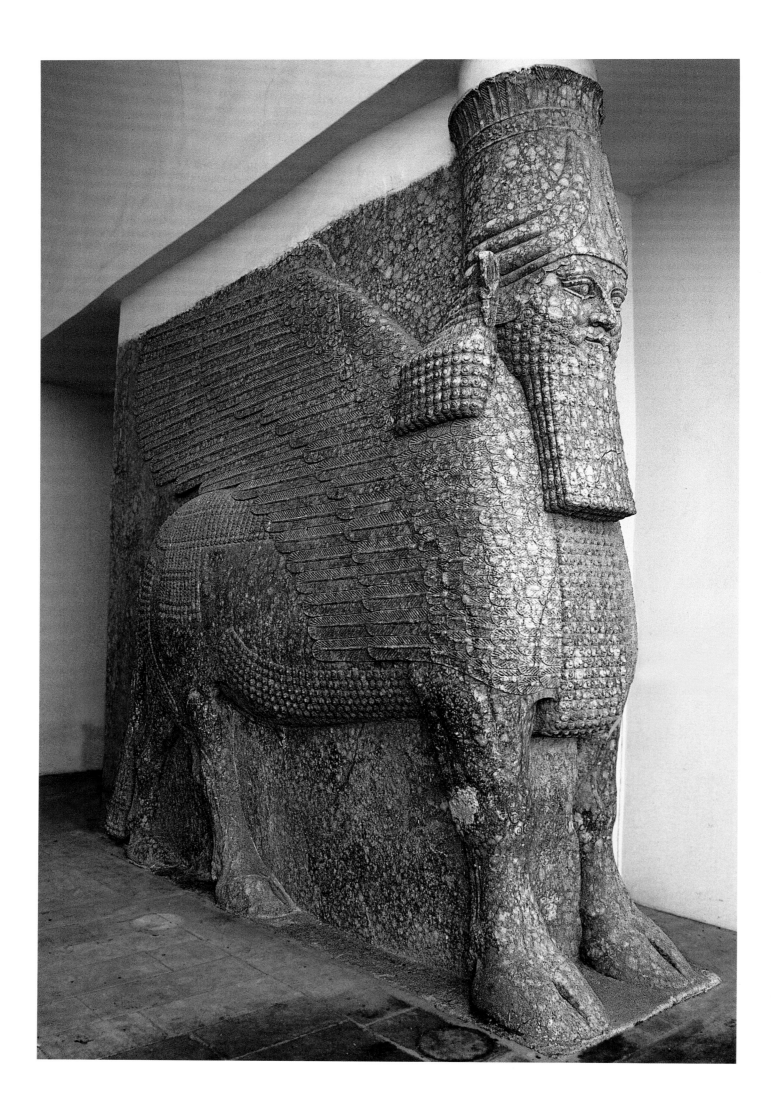

Giovanni Curatola · Jean-Daniel Forest · Nathalie Gallois · Carlo Lippolis · Roberta Venco Ricciardi

THE ART AND ARCHITECTURE OF
MESOPOTAMIA

INTRODUCTION BY DONNY GEORGE
EDITED BY
GIOVANNI CURATOLA

ABBEVILLE PRESS PUBLISHERS

New York London

Batavia Public Library
Batavia, Illinois

Front cover: Statuette of Gudea from Tello (ancient Girsu), c. 2150 BC (see plate 41).
Back cover: Minaret of the Abu Dulaf mosque in Samarra, AD 859/60 (see plate 145).
Page 3: Androcephalous bull from Nineveh, neo-Assyrian period (see plate 65)

FOR THE ENGLISH-LANGUAGE EDITION
Translation: Translate-A-Book, Oxford, England
Editor: David Fabricant
Copy editor: Ashley Benning
Proofreader: Theodore Dawes
Production manager: Louise Kurtz
Composition: Angela Taormina
Jacket design and typography: Misha Beletsky

The publishers wish to thank the Nucleo del Patrimonio Artistico dei Carabinieri
for placing at their disposal certain photographs relating to archaeological sites
in the province of Dhi Qar.

First published in the United States of America in 2007 by Abbeville Press,
137 Varick Street, New York, NY 10013

First published in Italy in 2006 by Editoriale Jaca Book, S.p.A., via Frua 11, 20146 Milano

Copyright © 2006 Editoriale Jaca Book, S.p.A. English translation copyright © 2007 Abbeville Press.
All rights reserved under international copyright conventions. No part of this book may be reproduced
or utilized in any form or by any means, electronic or mechanical, including photocopying, recording,
or by any information retrieval system, without permission in writing from the publisher.
Inquiries should be addressed to Abbeville Press, 137 Varick Street, New York, NY 10013.
The text of this book was set in Monotype Dante. Printed in Italy.

First edition
10 9 8 7 6 5 4 3 2 1

ISBN-13: 978-0-7892-0921-4
ISBN-10: 0-7892-0921-7

Library of Congress Cataloging-in-Publication Data
Iraq, l'arte dai sumerai ai califfi. English.
 The art and architecture of Mesopotamia / Giovanni Curatola... [et al.];
introduction by Donny George ; edited by Giovanni Curatola. — 1st ed.
 p. cm.
 Includes bibliographial references and index.
 ISBN 978-0-7892-0921-4 (alk. paper)
1. Art, Assyro-Babylonian. 2. Art, Ancient—Iraq. 3. Architecture,
Ancient—Iraq. 4. Iraq—Antiquities. I. Curatola, Giovanni. II. Title

N5370.I7313 2007
 709.35—dc22
 2006101543

For bulk and premium sales and for text adoption procedures, write to Customer Service Manager,
Abbeville Press, 137 Varick Street, New York, NY 10013, or call 1-800-ARTBOOK.

Visit Abbeville Press online at www.abbeville.com.

CONTENTS

NOTE ON THE TEXT

Plate numbers in parentheses, for example, "(plate 1),"
refer to the color images that appear alongside the text,
while abbreviated place names with numbers in parentheses,
for example, "(Ctes. 1)," refer to the black-and-white images in the section
"Key Sites of Mesopotamian Art" on pages 209–72.

INTRODUCTION

Donny George
FORMER DIRECTOR GENERAL OF ANTIQUITIES OF IRAQ

Tracing a profile of the art produced by the Mesopotamian civilization, the culture that evolved in the "land between two rivers," the Tigris and the Euphrates, is an undertaking that is at once both arduous and necessary: arduous because an entire library of work has been dedicated to the subject since the first archaeological digs in the 1800s, which revealed to the world what has been defined as the very cradle of civilization, with its governmental, economic, and political organization all having repercussions on the artistic expression of our peoples; necessary because the latest archaeological finds, new discoveries, and growing awareness in the sector require that definitions and explanations be continually updated in order to cast new light on the quickly developing context and render the entire picture more detailed and comprehensible. This is especially true in that the successive cultural strata discovered at Mesopotamian sites are now examined taking into consideration the settlements' continuity over the course of millennia. Therefore the necessary approach is not only multidisciplinary but also open to an analysis of the historical and artistic phenomena characterizing the settlements: it is an attempt to review in a linear fashion, dictated by historical perspectives, events that in reality did not follow a precise pattern. Various competencies are needed in order to incorporate the immense archaeological and artistic patrimony of modern-day Iraq into a single analysis.

All of this is happening at an exceptional time when the nation is extremely fragile (to use a euphemism), at a stage in which its identity (all the identities, plural, that have contributed to defining this ancient civilization) is being challenged by external factors, well known to all. The very image of Iraq today is connected more than ever to its past and not just to the abundance of its oil resources. In the last few dramatic years, the activities of the National Museum of Iraq, a glorious avant-garde institution dedicated to the conservation, study, and presentation of the legacy of the past (made tangible thanks to an immense heritage boasting over half a million finds, many of which are absolute and unique artistic masterpieces), have come to the attention of the world due to the painful events that have inflicted a serious wound on the entire Iraqi population. Both national and international reaction has been consistent with the principle that such a wound and such devastation has not been inflicted merely on a distant people, but that this intolerable affront has affected all humanity in one of its highest expressions. The help and support given to the State Board of Antiquities and Heritage and to the museum—its direct emanation—by various parties and in different

ways, and the growing concern of the successive political authorities in charge of the coun-
try toward these institutions, treating them with sensitivity and care, can only be viewed
with deeply felt sympathy and constitute a stimulus for the rapid deliverance and rehabilita-
tion of the museum as the main custodian of the historical memory of all, not just the Iraqi
population. This work, divided into three main sections, is thus heading in the right direc-
tion, and I feel a personal pleasure in contributing to its creation with these introductory
pages. I mentioned three main sections: that which we can define as the "classical" antiquity
of royal Mesopotamia with its great and celebrated empires, followed by the extraordinary
epoch of Hellenism, the prelude to the Parthian and Sasanian ages, and finishing with the
Islamic period, generally somewhat absent and neglected, but fundamental to the formation
of the Muslim culture and civilization that we know today. Briefly, the depiction of Iraq's sig-
nificance over the millennia as a center of the development and spread of culture is certainly
reinforced here.

Jean-Daniel Forest and Nathalie Gallois were given the not easy task of summarizing in
just a few pages the evolution in all its complexity of the great Mesopotamian age over a
vast period of time. The periodization is spot on, though still complex and relative: the first
chapter begins with its origins and continues to the end of the third millennium BC, while
the second chapter deals with the phase from the beginning of the second millennium BC
until the fall of Babylon. The importance of the geographical surroundings and canal works
are the backdrop against which historical events stand out, starting from the longevity of the
Ubaid culture (fifth millennium BC) with its extraordinary ceramics. Uruk (modern Warka),
with its large built-up areas, was a city-state (with an already well-structured state culture)
led by a monarch, and it underwent three phases of development. The architecture, built of
unbaked bricks, is extremely important, and to this Forest and Gallois dedicate ample space.
However, the buildings are not necessarily connected to a religious function; in some cases
they are multifunctional: palace, temple, living quarters, official building. The applied arts of
this period are opulent. The so-called "Lady of Uruk"—recently restored by conservation
lab technicians, who discovered traces of polychrome—is an artistic masterpiece. The cylin-
der seals engraved with high or low reliefs also make up a sizeable corpus, and "allegorical
realism" is a good definition given to an important iconographical analysis of their themes
of power, strength, and sovereignty. The interpretation of the materials comes in the light of
knowledge about Neolithic production: one illuminates the other. Under discussion are the
most outstanding sites of the Early Dynastic Period revealed so far, such as Eridu, Kish, and
Tell Agrab, but also Mari. It is possible to speak of a Sumero-Akkadian civilization that, also
in iconographic terms, is correctly placed in relation to the Uruk one, of which it could be
considered the heir. A detailed analysis of the role of sovereign is given, and Akkadian power
is traced with clarity even along more general lines. A few lines are dedicated to Lagash and
the sovereign Gudea, an obligatory detour thanks to the excavations carried out in Tello
(ancient Girsu). In particular, the authors concentrate on—and they are right to do so—the
period known as Ur III, probably the height of Sumerian culture. Mention is also made of
the centralized structure of the empire and of the literary epic of Gilgamesh, a vital source
of information.

Fittingly, the second part of this analysis focuses on the North, not forgetting its external
relations, and particularly on the Amorite (Semite) dynasties, the region of the Diyala River,
and the rule of Mari, with pertinent comments on the architecture and principal works of
art. Hammurabi, founder of the First Babylonian Dynasty (at the beginning of the eigh-
teenth century BC) and famous for his "code of laws," had to face foreign potentates such as
the Hittites. The consequences of this are dealt with clearly. The Kassite dynasties (who were

not Sumerians and yet not Semites either, and who dominated the scene between the six-teenth and the twelfth century BC to then be replaced by the Elamites) are seen from a per-spective of continuity/discontinuity with the Babylonian civilization. The ziggurat of Aqar Quf is brilliantly contextualized. The first *kudurru* (such as the one of Meli-Shipak), cippi with administrative texts and symbolic decorations of great interest for the role they play in cultural and iconographic representation much later on, are ascribed to the Kassite period. The Middle Assyrian period and the city of Assur act as the introduction to the more com-plex discussion relating to the neo-Assyrian empire, which around the tenth century BC be-came the predominant power in Mesopotamia. Summarizing a historical period so vast and full of events, and with such important excavations (Assur, Nimrud, Nineveh, Khorsabad, to name but a few) is not easy, but the authors offer us a wide panorama that is excellently doc-umented in images. Finally, relations with the neighboring regional potentates and city-states such as Ebla and Mari are of interest.

"Hellenism in Mesopotamia" is the title of the essay by Carlo Lippolis, who with clarity writes about the role of the Seleucid dynasty, heir to Alexander's great political project. His thoughts on the contacts preceding the advent of the Macedonian (from the eighth century BC onward) are interesting, as is the "easternizing" artistic production, which was much more widespread than is generally thought. He concentrates on the three localities in which archaeological digs have uncovered a Hellenistic phase: Babylon, Seleucia, and Uruk. In Baby-lon, Alexander took over Nebuchadnezzar II's residence in a sign of continuity, also in for-mal terms, with the neo-Babylonians and Achaemenids. Hellenistic construction in Babylon mostly maintained the original Mesopotamian architectural typology, and the urban system remains unchanged. The transfer of the capital to Seleucia (and thus from the Euphrates to the Tigris), to the mouth of the royal canal, at a more geographically central location, meant that the city was a place of almost obligatory transit. The ruins at Seleucia cover a breath-taking area (almost fifteen hundred acres [600 hectares]) and it is estimated that at the time of its greatest prosperity this metropolis was home to as many as six hundred thousand inhabitants. The town planning, with blocks of buildings, bears a Hellenistic stamp, albeit with major concessions to native styles. This theory of a "mixed" approach is confirmed by the archive at Tell Umar with twenty-five thousand *bullae*: the iconography is predominantly Hellenistic, but with Babylonian motifs and Iranian influences. Uruk diverges slightly from the aforementioned sites—for example in the production of terra-cotta figurines—and it is confirmed as a city that had capital importance while maintaining its peculiarities. Other centers that underwent a Seleucid phase, such as Borsippa, Ur, and Nippur, are mentioned, as is the problem of links with other not exactly Mesopotamian centers, such as Dura Euro-pos, which nonetheless interacted with this civilization.

Roberta Venco Ricciardi writes about the Parthian and Sasanian period. It is a highly important time that has often been neglected, but she draws attention to it here with an informative, accurate, and detailed essay. It is divided into two sections, the first relating to Parthian power and the second to Sasanian power. It begins with Seleucia, where we find a continuity of settlement with the subsequent establishment of a Parthian architectural type (an *iwan* court) and the gradual decline of the Greek one with its *in antis* portico. The foun-dation of Vologesias, which has yet to be located, as has the city of Ctesiphon, gives us an idea of just how much work still remains to be done on the ground. Archaeological data about the first period is limited to the city of Nisa (in Central Asia) and is thus somewhat lacking. However, Parthian presences have been discovered at Uruk and Assur. In the first case, we can observe a certain continuity (a conducting and recurring thread throughout the entire volume) until the construction, in a decentralized position, of the temple of Gareus

(III BC), with a unique combination of Babylonian, Hellenistic, and Parthian elements. Between the second and first centuries BC we witness the diffusion of the *iwan*, an architectural feature of possibly Iranian origin, with examples at Nippur, Seleucia, Abu Qubur, and Assur. The latter, already an ancient capital of the Assyrian Empire, is particularly interesting for showing us the Parthians' artistic syncretism. The analysis of architectural features confirms this. However, the greatest space in the first part of this essay is justly reserved for Hatra—where Venco Ricciardi has worked for many years as part of the Italian archaeological team. Although the historic and artistic events of the fortified city of Hatra inevitably have been more or less reconstructed, the essay is particularly acute and allows the reader to understand the role of this settlement—an imposing religious center that was a pilgrimage destination—and its structures, some of which were miraculously intact at the beginning of the last century and excavated by a number of Iraqi teams from the 1950s onward. Here, the splendid architectural decorations and statuary have the spotlight they deserve. The author also underlines the technical and artistic debt owed to the western world, thus emphasizing the originality of Parthian cultural life. The connections with Dura Europos, where important pictorial works have survived, influenced the culture of Hatra, which excelled in sculpture, as can be seen from the superb photographs.

With the Sasanian period we return to a great centralized empire. The new organization led to a gradual abandonment of the previous commercial routes, hastening and determining the decline of centers such as Dura Europos, Assur, and Hatra. Once again, a certain substantial continuity prevails, albeit disguised by the dynasty's proud claim of Iranian origin, with ideological attention given to the Achaemenid Empire. The Sasanian dynasty's role as mediator between on the one hand the West and on the other the East (for this, read India and China) led to it being greatly strengthened, and Mesopotamia returned to being a central crossroads of commercial traffic along the itineraries of the Silk Route. Sasanian glory in Iraq is linked to the name of Ctesiphon, which according to sources stood facing Seleucia on the opposite bank of the Tigris and has only been partially investigated by archaeological campaigns, and the site of the Taq-i Kisra (the *iwan* part of the palace that Khosrow I Anushirvan [r. AD 531–579] ordered), which, at ninety-eight feet high and eighty-four feet wide (30 by 25.65 m), is without doubt one of the architectural wonders of the ancient world. The State Board of Antiquities and Heritage is particularly concerned about the stability of this structure. Venco Ricciardi describes this monument, paying particular attention to the decorative choices and specifically to the major use of stucco, which was not a totally new material, but whose use here in relation to the architecture (and in the actual sculptures) led to its becoming widely employed in the subsequent Islamic age. Particularly timely is the final mention of the minorities (mainly Nestorian and Syriac Christians, but also Jews, Mandaeans, and Manichaeans) whose contribution to Mesopotamian civilization as a whole should never be underestimated.

Our friend Giovanni Curatola, who is also the general editor of this work, has appraised the Islamic phase in the final chapter. His essay contains a brief historical preface, indispensable for understanding the art history of this period. In the architecture of the Umayyad period, he looks at the differences between the Syrian territory—leading towards the Mediterranean—and the Iraqi territory, where we see the development of an autochthonous architecture that obviously recalls the past, but also has the need to invent a present and a future. Here the importance of centers such as Basra and Kufa with its Dar al-Imara is highlighted. An important stage is the foundation of the circular city of Baghdad (August 1, 762) along the banks of the Tigris. Archaeological evidence is scarce, but thanks in part to literary sources we have a fairly realistic idea of what it looked like. From the second half of

the eighth century, the complex of Ukhaydir, on the margins of what is now a desert zone approximately fifty miles (80 km) from Kufa, occupies a significant place in the architecture of the late Umayyad period, many stylistic characteristics of which it maintains, and the discussion relating to its stately structures is absolutely essential. The main and central part of Curatola's essay is dedicated to Samarra, capital of the Abbasid Empire between 836 and 889 (though the latter date is only indicative of when the development process ended, considering that occupation of the city went well beyond that year). Samarra is closely examined, and its fundamental role in the development of an independent artistic Muslim language is powerfully underlined, though without taking anything away from the external contributions or the complexity of every major historical phase of artistic creation. The description of some of Samarra's most important architectural structures (palaces and monumental mosques) is completed with a close examination of the stuccos and ceramics uncovered during excavations. It is an important part of the text as it helps us to understand why experts in the history of Muslim art and archaeology consider Samarra such a crucial place, being the source of inspiration of a totally Islamic artistic language capable of conditioning and influencing numerous subsequent artistic creations, and not just in Mesopotamia. However, although immensely important, Samarra certainly does not exhaust the wealth of Islamic monuments and works in Iraq. Thus the section "Iraqi Monuments of the Eleventh to Fourteenth Centuries" is particularly apt, with plenty of space given to the architecture of Baghdad that Curatola clearly knows very well. Of interest are his thoughts regarding those mausoleums (of Zumurrud Khatun and ʿUmar al-Suhrawardi) with conical domes faceted with *muqarnas* and examples of stylistically correlated architecture that are not limited to Iraq. The concluding paragraphs are dedicated to the so-called "decorative arts," which in the case of the Islamic period is a totally misleading term. Here, wooden works are examined (two cenotaphs and a *minbar* [pulpit] housed in the National Museum of Iraq), and some metal works from some of the most important and longstanding Islamic producers, those of Mosul. Manuscripts and miniatures, abounding with masterpieces, close the book and project us into a world full of colors and powerful symbolic evocations. Multifaceted Islamic art is thus an important stage of an artistic path that has covered several millennia.

In conclusion, this is a book full of impressions, sustained by accurate illustrations, that, faced with the ceaseless unraveling of an extraordinary artistic story—often marked by continuity, as we have already noted—aims to maintain a balance of views that allow the reader to follow the development of one of the most exceptional intellectual and artistic adventures of human civilization.

February 13, 2006

1

MESOPOTAMIAN ART, FROM ITS ORIGINS TO C. 2000 BC

Jean-Daniel Forest and Nathalie Gallois

Mesopotamia, or more precisely the alluvial plain between the Tigris and the Euphrates (the southern part of present-day Iraq), was among the greatest centers of civilization in the world. As such, for 3,000 years it produced exceptional works, both in architecture and the plastic arts. Of course, the hugely prestigious buildings, displaying the grandeur of elites and institutions, attracted the attention of visitors and impressed them with their sumptuousness. But we cannot be sure that the criterion used in their construction was an aesthetic one. When royal builders described their works (particularly religious structures), they stressed the importance of their investments and recorded, for example, the quantities of wood and precious metals that had been imported at enormous cost. Likewise, figurative representations (statues, bas-reliefs, glyptic art, or paintings), especially those in composite scenes, were not primarily designed to please the eye, to judge only by the fact that many works (in temples, for example) were not accessible to the public. They had other purposes, as we shall see, and an aesthetic dimension is better sought in what, today, we call the "applied" or "decorative" arts. If we change our perspective and adopt a modern viewpoint, the ambiguity remains. Since Mesopotamian architecture was built mainly of unbaked mud bricks, often all that remains is the base, and we can only appreciate the full scale of the extraordinary edifices by reconstructing them. The figurative representations, either forming part of the architectural decoration or on movable objects, surprise us, above all, by their antiquity, and by the fact that they belong to a cultural world so very different from our own. Iraq has been closed for more than fifteen years, so, sadly, no recent discovery has been made that might update our knowledge. Among the movable objects there are exceptional pieces, but those are justly famous and have frequently been presented in publications such as this one. Hence, we are more concerned here to set these antique remains back in their context and, above all, to try to determine their significance. In fact, figurative representations are often codified; that is, they make conventional and largely arbitrary use of apparently realistic objects to convey a message. It is, therefore, an extremely difficult task to interpret them, and, in truth, this has never been done in an entirely satisfactory way.

As understood by archaeologists, Mesopotamia comprises all the regions crossed by the Tigris and Euphrates downstream from the mountains of Anatolia: it is a long ribbon running north to southeast about 125–55 miles (200–250 km) wide and 750 miles (1,200 km) long, stretching from northern Syria to the Persian Gulf and between the Zagros Mountains and

4000	Ubaid					Northern Mesopotamia	Southern Mesopotamia	
						Amorite invasion		
	Early Uruk		2000			Kingdom of Upper Mesopotamia	Kingdoms of Isin and Larsa	Nur-Adad (1865–1850) at Larsa; Sin-Kashid (c. 1850) at Uruk
					Zimrilim (1775–1761) at Mari		Old Babylonian Empire	Hammurabi (1792–1750) at Babylon
3500	Middle Uruk		1500			Middle Assyrian Empire	Kassite Kingdom	Kara-Indash Kurigalzu (1332–1308) Meli-Shipak (1186–1172)
	Late Uruk				Adad-nirari I (1307–1275) Tukulti-Ninurta I (1244–1208) Tiglath-pileser I (1114–1076)		Second Dynasty of Isin	
3000			1000			Aramaic invasions		
	Early Dynastic I				Adad-nirari II (911–891) Tukulti-Ninurta II (890–884) Ashurnasirpal (883–859) Shalmaneser III (858–824) Adad-nirari III (810–783) Tiglath-pileser III (744–727) Sargon II (721–705) Sennacherib (704–681) Asarhaddon (680–669) Ashurbanipal (668–630/627)	Neo-Assyrian Empire		
	Early Dynastic II					Neo-Babylonian Empire		Nabopolassar (626–605) Nebuchadnezzar II (604–562) Nabonidus (556–539)
2500	Early Dynastic III	Ur-Nanshe Eannatum at Lagash	500			Achaemenid Empire		Cyrus II (539–530)
	Akkadian Kingdom	Sargon Manishtushu Naram-Sin				Alexander and the Seleucids		
		Ur Ba'u, Gudea, Ur-Ningirsu at Lagash						
2000	Third Dynasty of Ur	Ur-Nammu Shulgi	0			Parthian Empire		

1. A chronology of ancient Mesopotamia.

the Syro-Arabian desert. Thus the region has extremely varied natural features, determined by latitude, elevation, the nature of the soil, and above all by rainfall. In fact, rainfall decreases as you move farther away from the mountains, so that the humid steppe of the foothill region gradually gives way first to dry steppe and then to desert. In northern Mesopotamia, rainfall was the decisive factor before the introduction of water-pumping, because the rivers are sunk too deep in the sedimentary plain to be used for irrigation simply from gravity; the ten-inch (250 mm) isohyet (the line that connects points of equal rainfall) generally separated settled farmers from nomadic shepherds, as this is the minimum annual rainfall necessary to grow grain. On the alluvial plain of southern Iraq, the situation is completely different. Although the annual rainfall is well below ten inches, irrigation is possible because on this flat terrain the Tigris and Euphrates tend to deposit the sediment they carry and thus to raise their beds, instead of drowning them. Today, the region is a vast, melancholy desert, gray and dusty, but in the past it was traversed by canals that made cultivation possible. Its desertification is generally attributed to the rise in the water table, with its accompanying increase in salts, and to overexploitation of the land and, in particular, the lack of drainage, but it is no doubt necessary to take historical factors into account also. The irrigation network, which had developed over the course of time and allowed the land to be fully cultivated, was adapted to the needs of a constantly expanding population. It required regular maintenance, which was done by the state. The abandonment of this maintenance, through

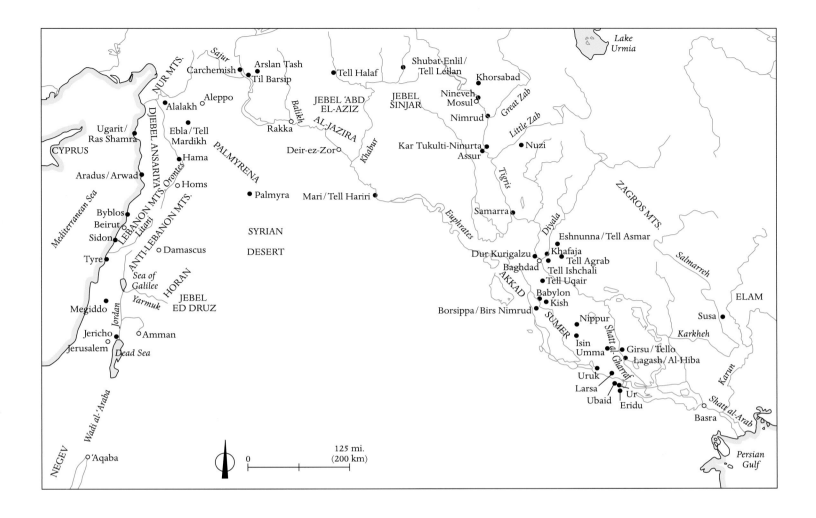

2. A map showing major sites and cities in ancient Mesopotamia and the western regions bordering the Mediterranean; present-day cities are indicated with a white circle, while archaeological sites are indicated with a black one.

wars or a power vacuum, could have irreparable effects, since it was impossible to restore in just a few years a network that had taken millennia to build. Mesopotamia underwent just such periods of disorder, with serious results.

Nevertheless, it was this initially hostile alluvial plain that became the center of Mesopotamian civilization, precisely because its inhabitants had to organize themselves to confront the problems posed by the environment. When a settled way of life, with agriculture and stock farming, took over in the Levant and in the foothill regions of the Taurus and Zagros mountains from around the eighth millennium BC, this new lifestyle gradually spread to the hunter-gatherers of the surrounding regions who lived in less favorable territories, such as southern Mesopotamia. In this region, however, the most ancient sites are buried deep in alluvial mud and are flooded by the water table, so that the earliest remnants of the first inhabitants of the alluvial plain date only to the middle of the seventh millennium BC, with the so-called Ubaid culture (named after a site near Ur). They are immediately recognizable by their light-colored ceramics decorated with nonfigurative motifs, usually geometrical patterns. That culture lasted nearly 2,500 years, evolving ever-greater complexity, until it formed political structures that can be identified as chiefdoms, dating from at least the second half of the fifth millennium BC. In time, the Ubaid communities grew and were obliged to set up political, social, and ideological structures in order to govern the larger human groups; this then led them to develop an ever more sharply defined hierarchy.

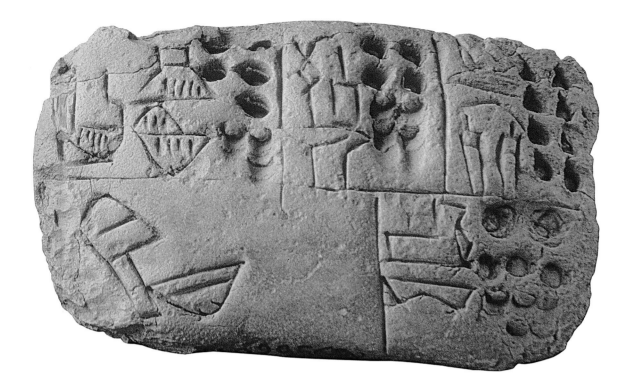

This change greatly accelerated with the culture now called Uruk, which owes its name to the major site that is called Erech in Genesis and is still known today as Warka. The Uruk culture succeeded the Ubaid without loss of continuity, and the new name is given solely because of the disappearance of the painted ceramic work and the progressive adoption of new forms. The Uruk culture covered nearly the whole of the fourth millennium BC, and, because it lasted so long, it has been divided into three phases (early, middle, and late). The population continued to increase and tended to accumulate in a number of great urban centers—such as Ur, Eridu, Uruk, Larsa, Bad-tibira, Lagash, Umma, Zabalam, Shuruppak, Adab, Nippur, and Kish—which divided up the alluvial plain and controlled larger or smaller territories. These city-states, as they are called, were ruled by a powerful elite led by a sort of king. This was the golden age of Mesopotamian civilization: at the latest at the end of the fourth millennium, in the so-called Late Uruk Period, architecture attained great heights, and the visual arts flourished, with the appearance of figurative scenes exalting the power of the king. It was also at that time that writing came to be invented: the resulting release of cultural and intellectual energy can only be imagined. Writing was then used exclusively in the economic sphere, primarily as a memory aid, but it nevertheless enables us to recognize that its inventors spoke Sumerian, an agglutinative language without any known parallel.

The epoch that followed is also conventionally subdivided into three phases (I, II, and III) because it lasted so long, from 2900 until about 2300 BC. It is called the Early Dynastic Period because the use of writing had been extended and for the first time written records provide us with the names of sovereigns. The texts also indicate that the Sumerians bordered on a people who spoke a Semitic language (Akkadian), who had apparently settled in the northern part of the alluvial plain. From the Early Dynastic Period II, the two populations came to share the same material culture, which we call the Sumero-Akkadian. The city-states became a bit more structured, but their dynamism led to opposing interests and developed into a climate of endemic war, until a stalemate led to the search for more radical solutions with hegemonic aims. More than one city-state tried, in its turn, to impose its rule upon the whole alluvial plain. But it was a Semite from the Kish region, Sargon, who succeeded in doing so in about 2300 BC. He thus created the first unified state, upon which he imposed his own language; his dynasty remained important for nearly a century, but the state gradually

ABOVE
3. A tablet with pictographic writing (2 × 3 in. [5.2 × 7.8 cm]). From southern Mesopotamia, end of the fourth millennium BC. Musée du Louvre, Paris.

OPPOSITE
4. A terra-cotta cone (height 14½ in. [37 cm], diameter 6 in. [15 cm]) with inscriptions recording the sovereign Urukagina's provisions for reducing taxes and ending abuses. From Tello (ancient Girsu), Early Dynastic Period III, twenty-fourth century BC. Musée du Louvre, Paris.

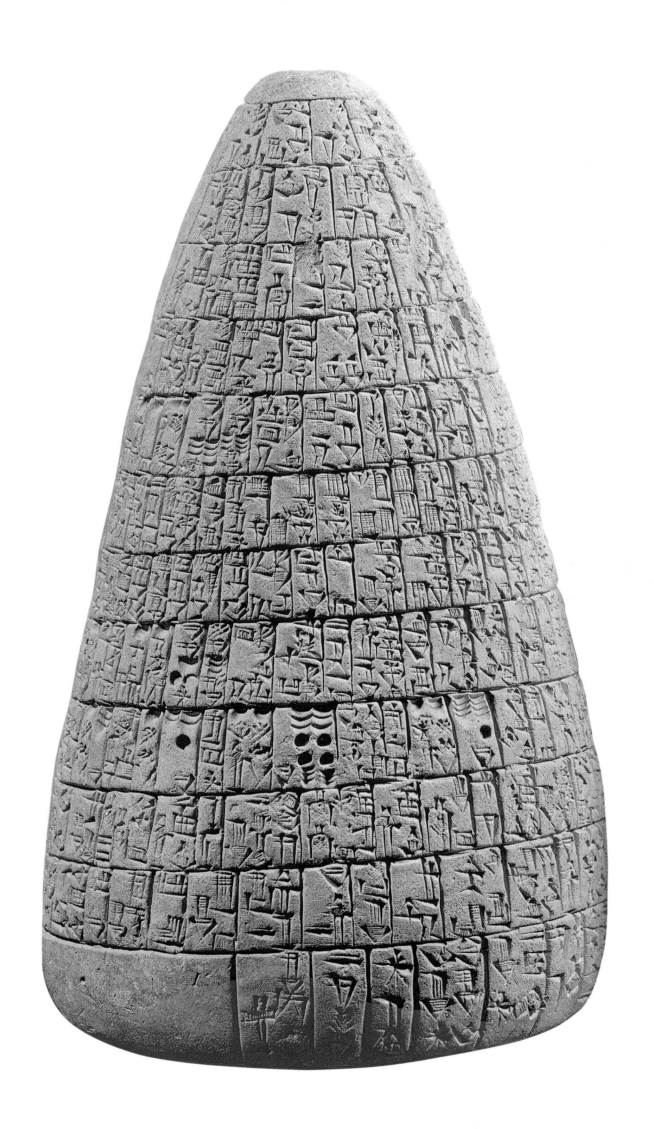

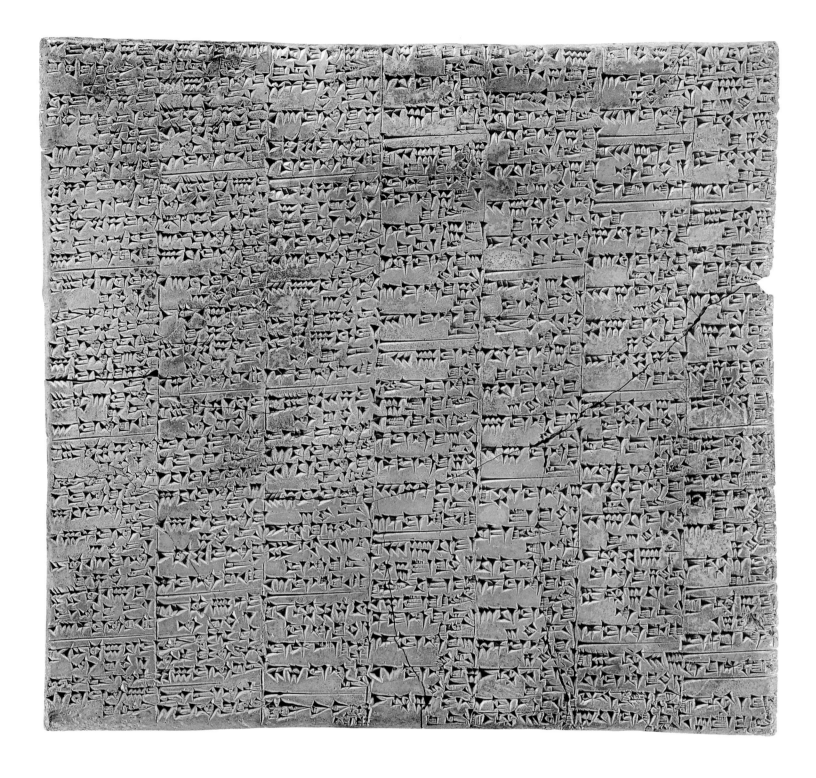

disintegrated and finally disappeared, through the combined effects of internal revolts and foreign interventions.

The city-states gradually regained their independence, so that we can speak of a Sumerian renaissance. The city-state of Lagash, for instance, and its ruler Gudea are particularly well-known, thanks to the excavations at Tello. Yet ideas of hegemony still prevailed. All aspired to reproduce Sargon's unified state for their own ends. This time it was a Sumerian, Ur-Nammu, who succeeded, establishing what came to be known as the Third Dynasty of Ur (or Ur III) for a century (c. 2100–c. 2000 BC); this was a bureaucratic state that recorded everything in writing and was the last political entity to use Sumerian.

The rest of Mesopotamian history, with its series of highs and lows and upheavals, is merely a variation on the same theme, until political formations appeared that extended beyond Mesopotamia alone, although these were too ambitious to last long. Again and again

5. A tablet with inscriptions, Ur III period. Musée du Louvre, Paris.

the unified state fragmented and then was reestablished, because, beyond the ups and downs of history, the ideal of unity remained, even for those who came in from abroad and gained power. In fact, several groups appeared for a certain time on the political scene, beginning with the Amorites, who were Semites coming from the Syrian plains in about 2000 BC. One of these, Hammurabi, founded the First Babylonian Dynasty at the beginning of the eighteenth century BC, but once again the kingdom gradually weakened, until a Hittite raid finished it off at the beginning of the sixteenth century. New foreigners, the Kassites, perhaps from Zagros, whose language was neither Sumerian nor Semitic, arrived in the sixteenth century and remained in power until the middle of the twelfth.

Whatever the origins and language of these new masters, they conserved the values in force before their arrival and totally assimilated Mesopotamian culture. The Kassite dynasty disappeared, in its turn, when it was attacked by the Elamites from Susiana. It was replaced by the "Second Dynasty of Isin" (another southern Mesopotamian city) until the end of the millennium, when a new wave of migrants arrived from Syria, this time the Aramaeans.

As a result of a general crisis, the center of power moved from the alluvial plain for the first time and transferred to the north of the region, to Assyria, forming what came to be called the neo-Assyrian Empire (934–610 BC). In fact, the political hotbed of southern Mesopotamia quickly generated rivals and led to the appearance, on its margins, of secondary states destined, in the course of their development, to become competitors. For example, from the third millennium, city-states (such as Mari and Ebla) on the model of the great cities of southern Mesopotamia were founded in Syria. These, in turn, also tried to dominate the region. Various kinds of kingdoms succeeded in both north and south, but geopolitical interests broadened and involved ever more powerful protagonists. And the conflicts themselves extended to farther-flung regions. They became international, involving Hittite Anatolia, Egypt, and then the Medes of Iran. It is in this broader context that during the fourteenth and thirteenth centuries BC a powerful Middle Assyrian kingdom arose, which led, after the Aramaic interlude, to the neo-Assyrian Empire. After the fall of Nineveh in 612 BC, power passed again to the south, to the neo-Babylonian Empire (609–539 BC), until an even greater power emerged: the Persian Empire, which would find, in its turn, a challenger of comparable strength.

THE URUK PERIOD

For the whole of the fourth millennium BC, society continued to become more hierarchical, which enabled the politico-administrative system to govern a developing society. The hereditary elites who held the reins of power were at the center of a vast, centripetal network that administered the region and fundamentally depended on their statutory capacity to mobilize the community's workforce. This energy reserve, governed by the size of the population, enabled them to undertake public works (irrigation, for example), build sumptuous buildings, organize foreign expeditions, and obtain craft products and agricultural surpluses. This, in turn, enabled them to satisfy their own needs, maintain their dependents, meet their obligations, trade, and in general assume all the burdens of their public and private duties (the two being broadly combined). It was the need to control all these activities that led to the invention of writing during the Late Uruk Period.

In particular, the requirements of the elites had a qualitative influence that resulted in the more spectacular aspects of Uruk culture. In the field of architecture, all professional categories, as we would say today, were mobilized to build prestigious buildings of unparalleled inventiveness. On the eponymous site, a German team had the good luck to discover the

LEFT
6. The ruins of the
"White Temple," built
on the "Anu Ziggurat"
in Uruk at the end of the
fourth millennium BC.

politico-religious heart of the city at the end of the fourth millennium BC (Late Uruk Period) and to locate a whole series of exceptional buildings. Some of these were inherited from the Ubaid period, during which they had appeared from the beginning of the fifth millennium BC onward. This is the case with the "White Temple," built on what is usually called the "Anu Ziggurat" (plate 6; Uruk 8–9). Actually, it is not a ziggurat but a terrace that was progressively extended and raised as the structure it supported was repeatedly rebuilt. The reference to Anu (the most important god of the Mesopotamian pantheon), deduced from texts dating four thousand years later, is also mistaken. Furthermore, the succeeding buildings on top of the terrace are not temples, but council chambers where eminent people met to pronounce judgment on public matters. The plan is tripartite, with a large meeting room in the center and annexes on either side. Numerous openings allow for access and light, a characteristic that is incompatible with the function originally proposed, since it is known that in Mesopotamia, as elsewhere, temples were inaccessible to the public. Here, as in the nearby site of Eridu, the council chamber was rebuilt on the same site over many centuries,

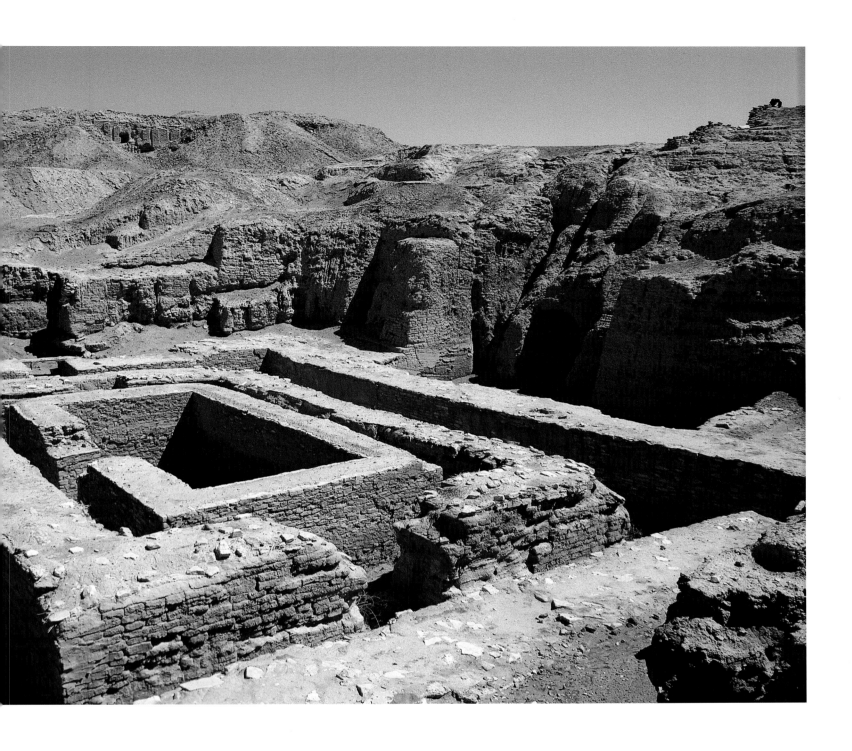

which indicates the permanence of its function. Doubtless, the building was visible from all sides, and its raised position physically expressed its preeminence. With its facades, niches, and recesses—covered with white plaster (hence its name)—it was a symbol of authority and civilization that demonstrated before all eyes the city's power and success. Every urban center of some importance certainly had a building of this kind, and many have been discovered. The slightly more recent one found in Uqair is distinguished by its mural paintings, although these are in a very fragmentary state (Tell Uqair 1–2).

The most spectacular buildings in Uruk, however, are found farther away from the Anu Ziggurat in a sector called, with more reason this time, the Eanna: this means something like "heavenly palace" (Uruk 5). Here, several architectural constructions succeeded one another over time. Tripartite plans are found, but in this case they are considerably enlarged: "Temple C" measures nearly 12,900 square feet (1,200 m²), whereas "Temple D" is nearly 48,400 square feet (4,500 m²); that is, it covers nearly 80 percent of the surface area of Notre Dame in Paris. In each case, the grand central hall spreads out into one of the extremities in

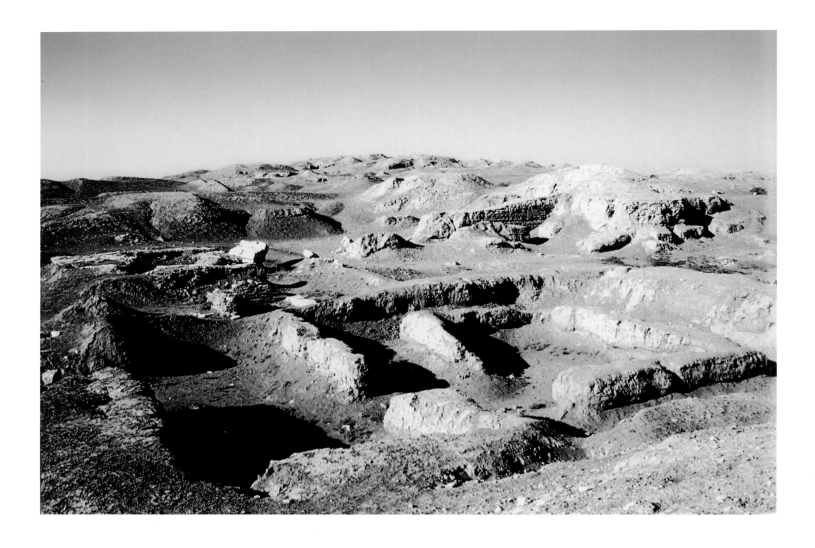

8. The ruins of the *Riemchengebäude* in Uruk, end of the fourth millennium BC.

a sort of transept, and a transverse structure, also tripartite, is sometimes joined to the principal building (as in "Temple C"). At the same time, novelties are introduced, like large rectangular chambers built of independent piles, labyrinthine layouts, and a vast square building comprising four wings around a courtyard. Most of these buildings were constructed of unbaked mud bricks—in particular, small bricks with a square section (called *riemchen*), which were easy to work with. However, previously untried building techniques also were tested: limestone blocks quarried nearby were used as foundations in some cases, while gypsum, also available locally, was transformed into plaster that was either cast between planks (just like concrete nowadays) or molded into bricks or large blocks. Additionally, at least the largest of the buildings required enormous quantities of wood for their roofs, and the width of the roof beams implies the use of imported species (especially cedar). A similar search for new solutions is evident in the facades. Although we still find the ancient arrangement of recesses inherited from the Ubaid culture, the decoration of these niches became much more complicated, and completely new solutions appeared, with the use of either solid cones (Uruk 4, 12–13), the colored heads of which were arranged in geometric patterns, or else hollow cones (Uruk 14), which create a play of light and shade. This decoration could be attached to the main structure by terra-cotta cramps (Uruk 11, 15).

As is indicated by the names given by the archaeologists who discovered them, most of these buildings were taken to be temples. But here, too, their openness to the outside and the often enormous dimensions of their main halls suggest that this identification was mistaken. Rather, together they formed a kind of palace, with religious areas, reception areas, and living areas, but a palace in which the various functional elements were not yet integrated. We should imagine the king surrounded by his whole court, with great festivals and religious

ceremonies being performed. This religious dimension then leads us to look at certain individual structures.

The *Pfeilerhalle*, or Pillar Hall (Uruk 5), is made up of twelve masonry pillars covered in cones with red and black designs on a white background (Uruk 12). This decoration is organized in three independent series, in the outer, the inner, and the access areas. It has been suggested that the inner decoration depicts the annual course of the sun, with equinoxes and solstices. The variable length of days was indicated by the variable use of the colors, with red corresponding to daytime and black to nighttime. Indeed, from one end of the chamber to the other, the red naturally increases as the black decreases, the two long sides correspond, and the two short sides are the opposite of each other. With this play of colors, the building might well be paying homage to the course of the heavens, since this was then conceived as the most obvious expression of the divine will.

Two labyrinthine plans are remarkable: the *Riemchengebäude*, or *riemchen* building (plate 8; Uruk 7), built of small unbaked mud bricks some distance from the Eanna, and the *Steingebäude*, or stone building (plate 7; Uruk 8), built of limestone and large gypsum blocks at the foot of the Anu Ziggurat. They are the buried foundations of buildings that, in this case, were certainly temples. It is ironic that the archaeologists thought of most of the major buildings they unearthed as temples, except these two. Their plans consist, respectively, of two and three inset rectangles. The innermost rectangle supported the actual sanctuary, a single, very narrow chamber; in the next rectangle there were only columns or pillars, which formed a covered gallery. The other walls defined a terrace, either in front of or around the building.

These are surely the oldest known temples in Mesopotamia, and the appearance of this new type of building was not by chance. Indeed, it is difficult to get tens of thousands of people to live together and to justify an order that has become very pyramidal. To reinforce social cohesion, an appeal is made to a higher power with indisputable authority, and the divinity is set in the midst of humanity in a building that manifests its presence. It remains a matter for debate, but we think it is likely that the divinity took concrete form as a statue, given that, as we shall see, there was no hesitation about making representations of it.

We find the same inventiveness in the applied arts (although what has come down to us can surely give us only a faint idea of what the craftsmen of the time were capable of creating) and, above all, in the plastic arts, which began to appear during the Late Uruk Period. For millennia, Ubaid ceramics had been decorated only with geometric patterns. At most we find terra-cotta figurines, either anthropomorphic or theriomorphic, used for some domestic cult, and, apart from these, just a few engraved amulets. Everything changes at the end of the fourth millennium BC, during the Late Uruk Period, when a whole series of objects make their appearance. In these, images with figurative representations are used, often in complex compositions.

One exceptional piece, known as the "Lady of Uruk" (plate 9) could be the remains of a composite divine statue. It is a female mask carved in marble at almost natural size. The carved hair that it originally possessed has disappeared, as have the inlays of the eyebrows and eyes, which were probably of shell and lapis lazuli or black stone. Nevertheless, the face is amazingly realistic, as nothing before it could lead one to expect such a mastery of the material. The rear side is flat and has holes indicating that it was fixed to a support. If it were a statue, as we think it was, the body could have been made of wood and metal-plated bitumen, as some more recent texts suggest.

However, the majority of plastic art objects served to legitimize the royal authority. Most are engraved cylinder seals, but there are also objects decorated in high or bas-relief and some

three-dimensional pieces. Here, the whole royal ideology is condensed and expressed by means of figurative motifs, which are often allegorical despite the realism of the portrayal. The image is often encrypted and presents enormous difficulties in its interpretation, which would be impossible to overcome without first analyzing a much more ancient decorative repertoire. Some time ago at Çatal Hüyük, an Anatolian site dating from the beginning of the seventh millennium BC, wall paintings and reliefs were discovered that were well enough preserved and sufficiently numerous to deduce their significance. The conventions adopted in them seem to have spread throughout the ancient East and to have lasted for millennia, so that the artists of Uruk—and many others after them—continued to work with them.

First, we need to take a preliminary look at the principal elements of this iconographic repertoire, as their meanings are so unexpected. All the horned animals (cattle, goats, or even deer) represent people, or rather, society. With the scorpion, the two more developed front legs are also likened to horns, but this creature is strictly linked to death and symbolizes the society of the past. But in all these cases the horn is the basic symbol, adopted because of its connotations of vitality and power. And this is also the reason why the anthropomorphic gods of Mesopotamia are normally represented with horned crowns as a symbol of their omnipotence. Wild animals (particularly the lion in Mesopotamia) are the incarnation of the divinity's destructive power and, at the same time, the symbol of hostile forces. Nevertheless, these forces can be used purposefully when they have been channeled, and this is what makes the lion a common apotropaic figure, especially as a guardian of gates. The king himself, as the armed strength of the divinity on Earth, can become a lion to his enemies. This is doubtless the reason why the lion progressively prevails as the symbol of kingship. Birds of prey were also originally symbols of death, but this meaning tends to become diffuse, leaving the lion as the dominant figure here. Then birds of prey seem to allude merely to divinity in general, and their devaluation is such that they can be replaced in this role by any other bird. In carvings, birds are frequently represented in the field, thus conferring a divine guarantee upon the action illustrated in the scene in which they appear. However, birds of prey are often replaced in their original function by aquatic birds in the act of swallowing fish, symbolizing both the dead person and the embryo about to be born.

Representations of this kind hold a place of honor, particularly at the beginning of the third millennium BC, on the Scarlet Ware of the Early Dynastic Period I. Moreover, wild animals and birds of prey can be combined to create a composite figure, the lion-headed eagle (Anzu). The myths often stress its ill-omened aspect, but it may also embody, like the lion, the devastating power of the divinity in the service of a good cause. Then, the lion-headed eagle personifies a divine force, but frequently it represents merely the divinity itself. Thus, it often appears on heraldic compositions, associated with two horned animals (or two lions), arranged symmetrically to remind the viewer that divine power is based on the mastery of duality. Its hybrid nature (in contrast to an ordinary bird), often linked to a frontal representation, simply indicates that it has to do with a supernatural being.

Other concepts also derive directly from the Neolithic heritage. One is the Tree of Life, a classic in the history of religions, often represented from the end of the fourth millennium BC onward in Mesopotamian iconography and, therefore, often mentioned in texts. In fact, almost any plant may be an allusion to it, such as all kinds of trees, primarily whole ones, but also branches, flowers, or shoots. We have to wait until the second millennium BC for its representation to acquire the more or less canonical form of a stylized tree in a set style. First of all, the tree alludes to the blood tie that links human generations over time. From this viewpoint, it can be compared with our own genealogical trees, but, whereas the latter describe the relationships of particular individuals, the former is more abstract. It extends to

9. The Lady of Uruk (8½ × 6¼ in. [21.5 × 16 cm]), marble, c. 3000 BC. National Museum, Baghdad.

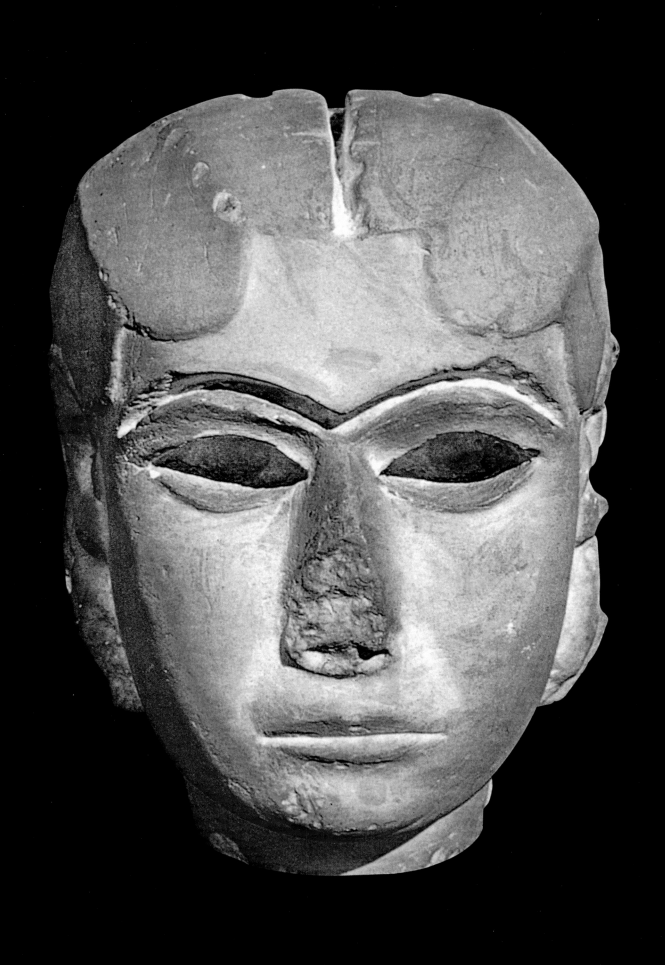

the whole of humanity, past and present, uniting the living with their mythical parents, like a sort of umbilical cord. (The idea that the divinity is the source of society may be expressed by the image of a sheepfold, a symbol of the divine matrix, from which emerge horned animals representing society.) Nevertheless, if we consider the principle of creation to be continually at work in the process of reproduction, with the divinity as the permanent source of life—and not just its origin—we can imagine that the tree's sap is the divine essence that nourishes all life. Its branches, shoots, blossoms, and fruit all bear witness to its creative vitality, and all possess miraculous powers, which can be acquired by removing them from the tree or by eating them. Items cut from the Tree of Life or objects fashioned from its wood are related, in a particular way, to the general notion of power. Indeed, the divinity possesses all powers, and those who can take something belonging to this tree, nourished by the divinity, can partake of those divine powers, as we can deduce from the Gilgamesh story. The royal scepter, the marshal's baton, the bishop's crosier, the shepherd's crook, and the wizard's or magician's wand are all linked to this idea. However, according to the idea that power comes from the conjunction of two elements, the upright, masculine symbol of the tree is normally associated with a circular, feminine symbol: the staff is ringed or prolonged by a circular element, while the club, symbol of Mesopotamia's power, unites the linearity of the handle with the roundness of the mass itself. The other concept is that of the Cosmic Mountain, also familiar to historians of religion and often illustrated and referred to in texts by the term *kur*. It is both the center and the source of the world, everlasting and forever. So that is, of course, where the Tree of Life grows.

When figurative representations occur, we note that the king is often depicted with features that are easy to recognize: he is bearded, his hair is gathered into a bunch fastened by a band that may look like rolled fabric, and he is dressed in a long garment fastened by a belt or a similar piece of material. A limestone statuette, of which only the bust remains, represents him with his elbows close to his body and his hands on his chest, in an attitude that recalls more recent praying figures (plate 10).

But the royal personage who possesses these distinctive attributes is usually found in complex compositions, and the nature of the scenes in which he is present leaves no doubt about his function. Whether or not he corresponds to the En (lord) about whom the texts speak, all are agreed in recognizing him as the king. From the beginning, the characteristics of the royal function are clearly defined, and the whole corresponding ideology is condensed in the iconography into various themes, some of which remain in force for centuries, even millennia. However, this ideology is often expressed through figurative motifs that, despite their familiar aspect, are allegories. They would be almost impossible to understand had the Neolithic repertoire of symbols not set us on the right track.

Much of our documentation is based on cylinder seals, which, when rolled onto fresh clay, left their impression and served as a sort of signature, indicating that a responsible person had supervised an operation. A famous cylinder seal now in Berlin shows the king feeding horned sheep with leafy twigs (plate 12a). Normally, this is interpreted as the priest-king feeding the sacred flock of Inanna, because the scene is associated with curled poles, which are thought to be a symbol of the goddess. In fact, the animals with horns represent society in accordance with the tradition derived from the Neolithic period; it means that the king is feeding his people. As for the leafy twigs, they refer to the concept of the Tree of Life and its sap, which is the receptacle of the divine essence with supremely beneficent powers. So the scene indicates that the king feeds society with the divine essence; according to whether this is regarded as a physical or moral effect, it may mean that it makes the people prosper or that

10. A royal statuette in limestone (height 7 in. [18 cm]) from Uruk, c. 3000 BC. National Museum, Baghdad.

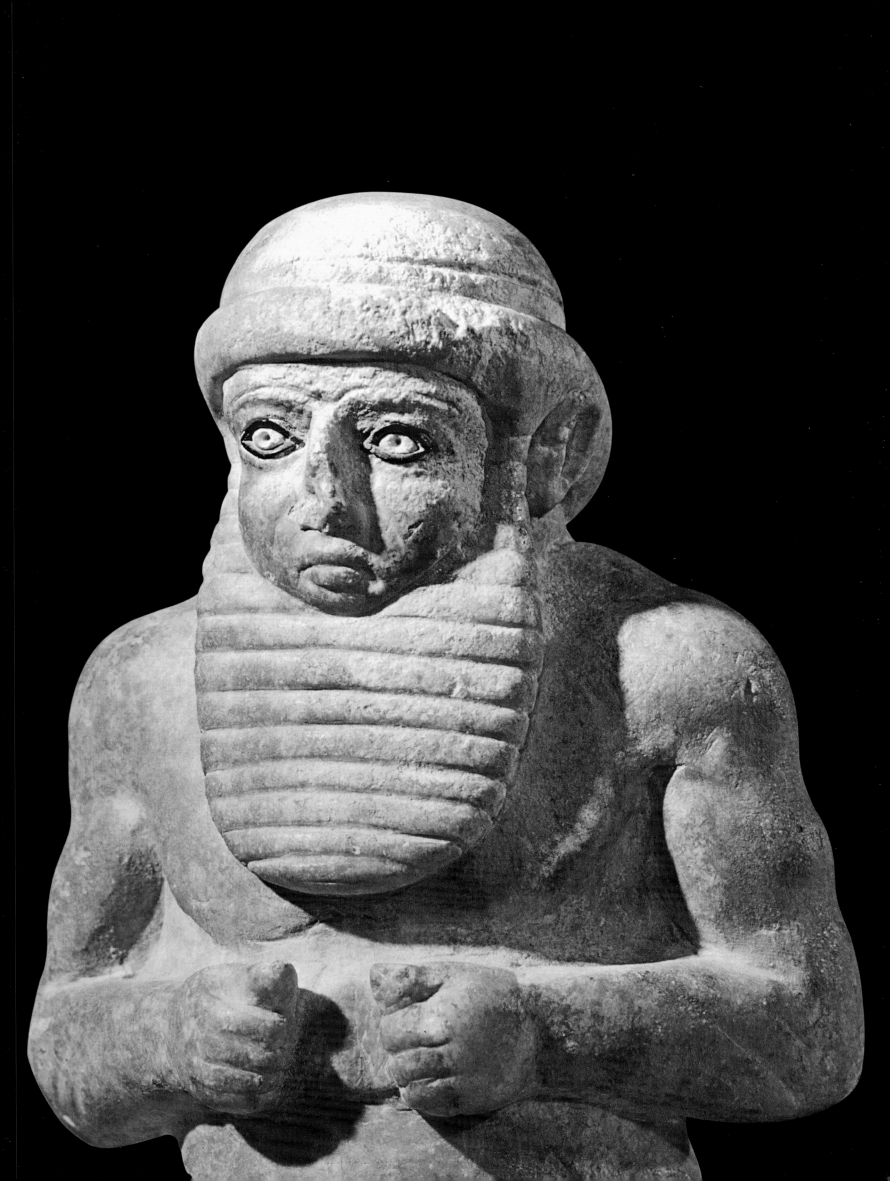

it makes them assimilate the divine laws, which are of themselves a guarantee of prosperity. The raised poles at the temple doors, as well as the vessels belonging to the cult, bear witness to the presence of the divinity and in some way bestow a divine guarantee upon the scene, thus legitimating the royal action. The heraldic form given to the composition helps translate the abstract meaning of the message and suggests that the central personage designates not so much the king himself, but kingship in general. But often the scene is less elaborate, and the Tree of Life is reduced to a flower, stalk, or twig offered to the flock (plate 12b).

This vegetal element may be replaced by a liquid, and the way it is represented (a vase gushing water) is enough to indicate its supernatural character. It is another image of the divine essence as the source of life, which, as it is more abstract, stresses the moral interpretation of the message. Unfortunately, the scene found on a cylinder seal at Kish (plate 12c) is not easy to decipher and seems not to have been rendered as it should have been (the personage, probably the king, appears behind the animals he is leading). Scenes such as these, in which the king feeds or perhaps waters his flock, express the theme of the good shepherd and find figurative expression from the end of the fourth millennium BC onward.

The king's capacity to bring divine benefits to his people (either prosperity or moral precepts) is due to his special relationship with the divinity. A cylinder seal (plate 12d) expresses this idea by juxtaposing two scenes, both reduced to essentials: on the left two sheep, one above the other, are eating some plants that look like ears of corn; on the right the king approaches the temple carrying a lion skin (as a sign that he has conquered some hostile force). He is followed by an attendant, who is carrying an ornamental object (a belt or a necklace). These are gifts offered to the divinity, and because the king honors the divinity, society has access to the Tree of Life. The famous Uruk Vase (which must have been part of the temple furnishings, if we rely on the fact that vases of this sort are often represented in this context) gives us the same message with greater emphasis (plate 11). On the top register, the temple is seen from within, with all its characteristic furnishings, and the divinity is present, wearing the bicorn headgear, to welcome the visiting ruler. The king is accompanied by porters in a line that continues onto the register below. The two bottom registers, one of sheep and one of plants, indicate the consequences of the royal intervention: thanks to the king who has loaded the divinity with gifts, society (horned animals) can benefit from the divine bounty symbolized by the plants.

The king's relationship with the divinity involves gifts, but perhaps it also involves something else. In fact, more recent texts tell us about a ceremony called sacred marriage, in which the king meets the goddess Inanna/Ishtar in an annual ritual that symbolizes an alliance between gods and humans, ensuring prosperity for the coming year. Here, we may ask if the scene is not already implicitly referring to such a ceremony, because we note that the divinity with whom the king is associated (on the Uruk Vase but also on various cylinder seals) is always a goddess, recognizable by her bicorn headgear and her long plait. From this viewpoint, the gifts that he brings to her recall gifts given to a bride, like those, for example, described in the myth of Enlil and Ninlil. In short, the alliance between gods and humans, thought of in Mesopotamia as a marriage, was a major ingredient in the royal ideology, at least since Ur III. As it had become so important, it is probable that the idea of this marriage dates from the Uruk Period, especially if we consider that the royal ideology purveyed through the emerging iconography testifies to deep reflection.

A number of representations show the king in the temple (plates 12e–g) standing before a goddess and holding an ear of grain. The current interpretation is that this was a fertility rite or the offering of the first fruits of the harvest to the divinity. However, the theme of the king

OPPOSITE
11. The Uruk Vase (height 41 in. [105 cm]), limestone, from Uruk, c. 3000 BC. National Museum, Baghdad. Its decoration is "rolled out" in the drawing below.

OVERLEAF
12. Cylinder seals of the Uruk period, c. 3000 BC: a. A marble cylinder seal surmounted by a copper ram (height 2¼ in. [5.4 cm], diameter 1¾ in. [4.5 cm]) and its impression. Vorderasiatisches Museum, Berlin. b. A marble cylinder seal (height 2½ in. [6.3 cm], diameter 1½ in. [3.7 cm]) and its impression. Babylonian Collection, Yale University, New Haven. c. A drawing of the impression of a cylinder seal from Kish. d. A marble cylinder seal (height 1¼ in. [3.5 cm], diameter 1 in. [2.9 cm]) and its impression. Babylonian Collection, Yale University, New Haven. e–g. Drawings of the impressions of seals from Uruk. h–j. Drawings of the impressions of seals from Uruk and Susa.

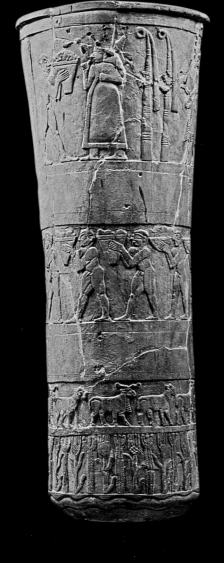
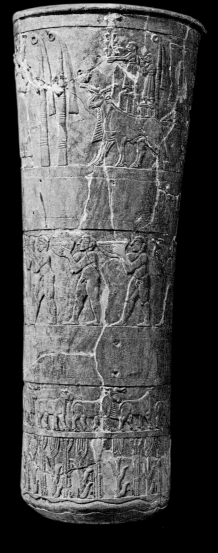
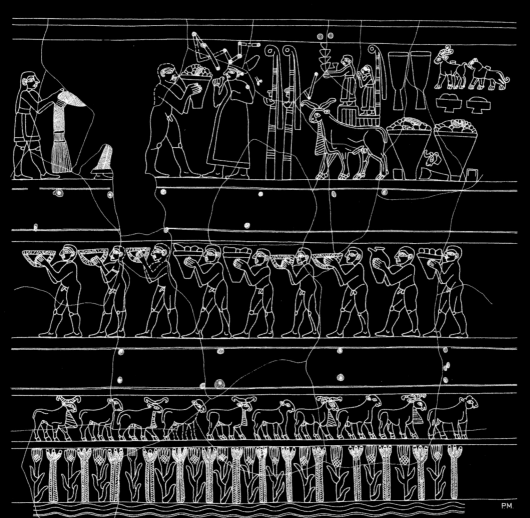

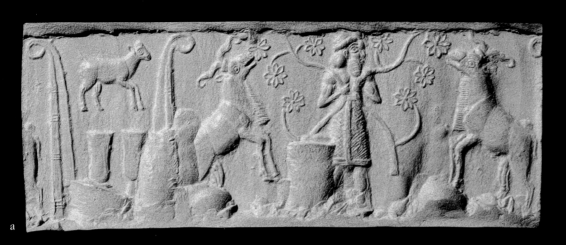

a

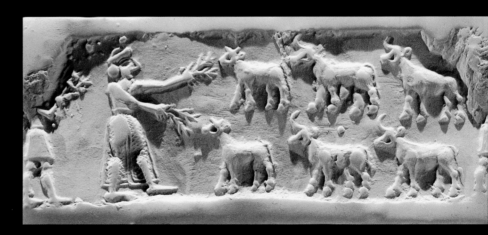

b

c

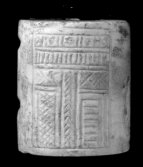

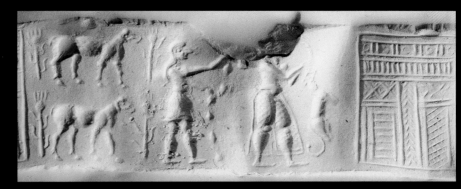

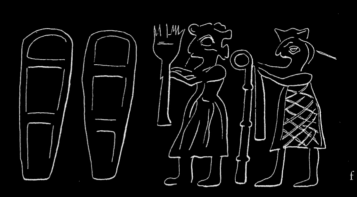

d

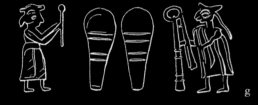

e

f

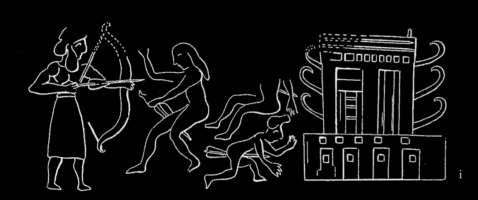

g

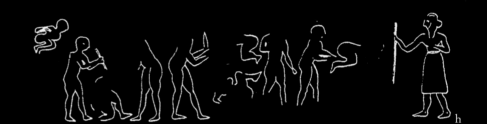

h

i

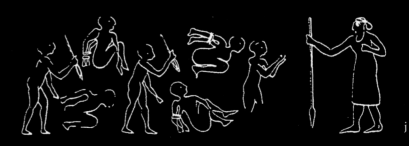

j

feeding his people indicates, without any doubt, that the ear of grain, a further image of the Tree of Life, is what the king has received from the divinity and is preparing to give to his people for their prosperity. Thanks to its sap, the Tree of Life is also the source of all power, so it seems clear that the king's ability to draw the benefits of heaven down to humans is power conferred upon him by the divinity.

Some scenes show the king condemning naked people to death or slaying his enemies (plates 12h–j). If we recall the way in which Mesopotamian iconography evolved, we see that here we have the prototype of the victory scenes that will flourish in the future. In these, the king appears as the guardian of order, the one who makes humans respect the will of the gods. These scenes are relatively realistic and can be deciphered at first glance, but according to the Mesopotamian habit of evoking general notions by means of particular cases, they should be seen as "kingship triumphing over adversity." The same idea can be evoked in a more abstract way, as in the famous Lion Hunt Stele from Uruk, in which the king takes part in the hunt (plate 14). In fact, he is hurling himself against noxious forces, against the forces of chaos symbolized by the animals. As the lion is an allegory expressing an idea, it is easier here to understand that the figure of the king in fact represents kingship in general. And this explains the duplicating of his figure with different weapons: all means are good in order to combat the forces of evil. Oddly enough, the same personage, represented as lord of the wild beasts, appears at the same time in Egypt, on the handle of the Gebel el-Arak knife, showing that the two civilizations were in contact in that period. In fact, the Egyptians traveled up the Levantine coast, probably by ship, while the people of Uruk settled in northern Syria, both wanting to procure the raw materials they lacked: Lebanon cedar, obsidian, and the metals of Anatolia. There is no doubt that contact was made between the Egyptians and the Mesopotamians in the northern Levant, although we do not know precisely in what way, or to what extent.

ABOVE
13. A sculpted limestone vase (height 5 in. [12.7 cm]) of unknown provenance, c. 3000 BC. British Museum, London.

RIGHT
14. Relief from the basalt Lion Hunt Stele (height 31½ in. [80 cm], width 22½ in. [57 cm]) from the Eanna in Uruk, end of the fourth millennium BC. National Museum, Baghdad.

OPPOSITE ABOVE
15. A sculpted limestone vase (height 6 in. [15 cm]) from Tell Agrab, c. 3000 BC. Oriental Institute, Chicago.

Even if, until now, the king has been characterized precisely (beard, bunched hair, turban, long garment), the same discourse may instead be completely coded and make its appeal only with allegories. This is the case, for example, with a scene in which a naked hero controls the lions attacking some bulls (plate 17). The association of the wild beast and the horned animal suggests the forces of evil that threaten society and, as the Lion Hunt Stele shows the forces of evil being combated by the king, we can deduce that the personage depicted frontally here symbolizes kingship. In fact, the use of frontal figures is one way of indicating that the image relates to an idea. So the scene is saying, "Kingship protects society from the forces of evil." This is the same idea as that depicted on the Lion Hunt Stele, but this time it is made clear that it is society that benefits from the royal intervention. The struggle against evil can be understood as both physical and moral, and in the latter case it may mean that the king leads his subjects on the right road, the road willed by the gods. The same idea may appear partially on vases of sculpted stone (plates 13, 15): according to whether the naked hero is associated with lions or with bulls, he either dominates the forces of evil or protects his people (if necessary with the guarantee of divinity present in the form of a bird).

Since he honors the divinity (possibly in all the meanings of the term), the king obtains power from it and consequently can achieve the order willed by the gods on Earth. By making prosperity, fecundity, fertility, and justice reign on Earth, kingship appears providential. Synthetic and concise, the images portray the principal social protagonists, the divinity, the king, and society, to stress in a particular way the nature and origin of the royal function. So the iconography supports the ideology of the moment and translates the higher ideas that it is thought necessary to recall and defend. However, it is not precisely publicity or propaganda, because the images address only a very restricted public. Instead, it is a manifesto: it reproduces things, reinforcing their relative reality or, rather, embodies in matter and renders permanent concepts that may always be at work but that are not, strictly speaking, visible.

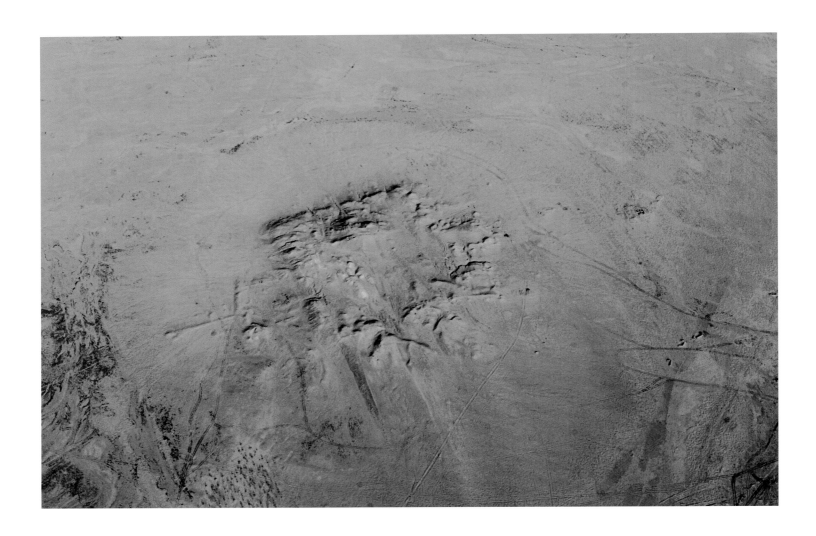

THE EARLY DYNASTIC PERIOD

From a technical viewpoint, the architecture of this period presents some special features. On the one hand, the use of stone becomes very rare, and the use of plaster (cast or molded) tends to disappear in favor of baked bricks. Given the scarcity of fuel, the latter were reserved for the more exposed architectural elements, bases, and floors (especially in the open air). On the other hand, the bricks often become plano-convex and are laid in opposing oblique rows (called, therefore, a fishbone pattern) between piles built in the ordinary way. This particular technique, designed to save time, recalls the way in which we build walls with perpends within a concrete framework.

Early Dynastic palaces have been excavated at Eridu, Kish, and Tell Agrab, but also at Mari on the central course of the Euphrates, where the influence of Sumero-Akkadian civilization was present. By this era, we find integrated buildings that unite all the necessary functional aspects. We cannot be sure that they were royal residences, because no texts have been found in them. These vast structures, with numerous chambers set around inner courtyards and an upper story that is difficult to reconstruct, are all somewhat different and have yielded very few objects. For all these reasons and also because most of them have not yet been fully excavated, it is very difficult to analyze them.

The most complete one is that of Eridu (E. 2). What immediately surprises us is that two practically identical buildings are juxtaposed, for unknown reasons. We know that in some African kingdoms, the king and queen, or the queen mother, each had their own palace. Perhaps we have something similar here. At least it is certain that the entrance complex is in the east, and the reception area, containing two large rooms, is behind this and set around a large courtyard. A long peripheral corridor is designed not so much to be a passageway as to allow for openings in the internal wall to let light into the adjacent rooms.

Palace A at Kish (Kish 3), to the southeast of Baghdad, is too fragmentary to rate a long

ABOVE

16. An aerial view of Eridu. The ziggurat, dating from the end of the third millennium BC, is still visible, but the site is especially famous for the excavations of more ancient levels, from as far back as the sixth and fifth millennia BC.

BELOW
17. A fragment from a carved vase (?). From Tell Agrab, c. 3000 BC. National Museum, Baghdad.

ABOVE
18. Kish, one of the great cities of the Early Dynastic Period, was occupied early in its existence by a largely Semitic population.

commentary. In the southern section of the building, apparently the oldest part, we note, in particular, a vast portico preceded by a colonnade—something exceptional in Mesopotamia. In the northern section of the building, of which we probably know only about half, we find a monumental entrance, preceded by a fine staircase and, as at Eridu, a long peripheral corridor. Certainly, neither the living rooms nor the reception rooms are visible. These must have been in the unexplored areas of the palace or on an upper floor. The labyrinthine character of the communicating passage shows that here we have spaces designed only for marginal functions, particularly storerooms.

Another exceptional building, Palace P, has also been partially excavated on the same site (Kish 2). The entrance, with two successive halls, opens onto an internal courtyard that serves the different areas of the building. We can recognize the kitchen to the east, apparently with its appropriate storerooms. To the southwest, a block with two large, perpendicular rooms immediately recalls the living rooms of the period. All these elements constitute only a secondary area of the palace. The essential part must have been farther to the northwest, where there are two more blocks isolated by long corridors. To the southwest, one more room stands out, but it would be good to know what was around it.

On the Tell Agrab site, in the region of the Diyala to the northeast of Baghdad, another important building has been excavated. This is normally seen as a temple dedicated to Shara, but it might also be a palace. Not much remains, but to the west of a large internal courtyard, we find an immense hall, which looks very like a throne room. At the back there is a dais upon which someone very important must have sat, because it was seen fit to place barriers around it to limit access. If this dais was for a divine statue, the barriers would have been unnecessary, because the public would not have had access to the sanctuary. Another remarkable room, partially preserved, is set perpendicular to the southeast, an arrangement that recalls Eridu. In the southern corner of the building, a set of rooms grouped around a

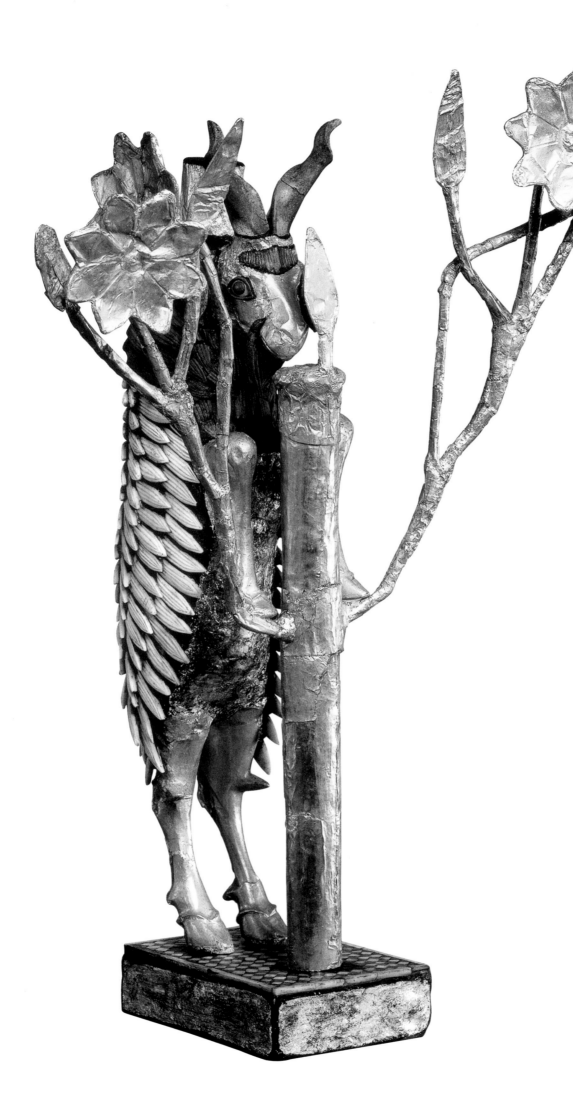

LEFT
19. A ram standing
rampant behind the
Tree of Life; composed
of gold, silver, copper,
shell, red limestone, and
bitumen (height 16¾ in.
[42.6 cm]). From the
royal cemetery at
Ur (PG1237), Early
Dynastic Period III,
c. 2600–2300 BC. Univer-
sity of Pennsylvania
Museum, Philadelphia.

OPPOSITE TOP
20. A copper panel
representing Anzu with
two stags (42 × 102 in.
[107 × 259 cm]) from
Tell Ubaid, Early
Dynastic Period III,
c. 2600–2300 BC. British
Museum, London.

OPPOSITE BOTTOM
21–22. Two columns
from the temple of
Ninhursag at Tell Ubaid
(heights 45¼ and 68¼ in.
[115 and 173 cm]), inlaid
with shell, red limestone,
black schist, and
bitumen. Early Dynastic
Period III, c. 2600–2300
BC. British Museum,
London, and University
of Pennsylvania
Museum, Philadelphia.

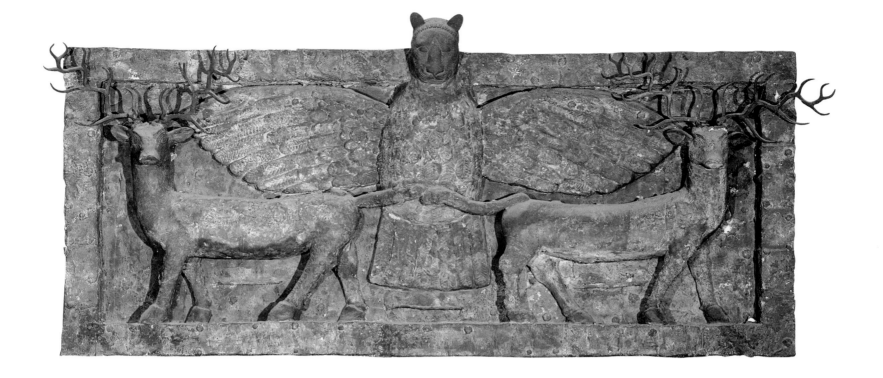

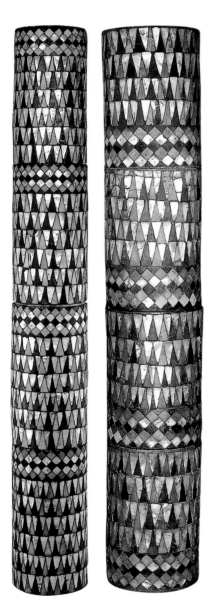

courtyard makes us think of living rooms. In the western corner are rooms with benches that suggest they may have been used for administration.

From this period we also know of some large temples, at Khafaja on the Diyala (Khaf. 2–4) and farther south at El-Hibba (Lagash) and Tell Ubaid. The first remains anonymous, but the one at El-Hibba is described as the Ibgal of Inanna, and the one at Tell Ubaid, as "Ninhursag's house." (Inanna and Ninhursag were important goddesses.) In both cases the identification is due to foundation deposits, that is, finds whose association with the construction of the buildings is certain.

These buildings of considerable size were all constructed on the same radically original model, with a strong, oval wall around an internal courtyard; there were some peripheral chambers and a high terrace in the center, upon which stood a building that in no case has been preserved. Nevertheless, a series of successive buildings excavated at the end of the nineteenth century at Tello (ancient Girsu) correspond to the temple of the god of the city, Ningirsu, and can give us an idea of what used to be on the other terraces (Tello 2). The sanctuary itself is a modest building, with two chambers (about 650 square feet [60 m²] in all) adjoining a peripheral gallery, based at least in part on a colonnade. A reconstruction of a building of this type found upon the raised terrace of Tell Ubaid (T. Ubaid 2) is particularly interesting because it allows us to restore a decorative whole. Indeed, on this site, the upper sanctuary had at one point been demolished, with a view to a later reconstruction. On that occasion, everything that could be recovered (beams, columns, decorative elements) was carefully dismantled and deposited at the foot of the terrace and, for some unknown reason, has come down to us. Columns decorated with shells and colored stones (plates 21–22) supported the peripheral gallery. The separate entrances to each of the two rooms were guarded by three-dimensional lions, made of copper leaf upon a base of wood and bitumen. On the facade, some three-dimensional bulls, created using the same technique, browsed in a field of artificial flowers according to a well-known iconographic scheme. Above the entrance, a panel in high relief (plate 20) represented a lion-headed eagle between two deer. Various animal heads made of metal or stone that have been recorded here and there may have likewise adorned, according to their size, exceptional buildings or movable objects.

As it was heir to the Uruk culture, it is not surprising to find in the Sumerian (or rather, Sumero-Akkadian) culture of the first dynasties a largely similar iconographic program. The image of the king giving food does not have a direct descendant, but the horned animals

browsing from the Tree of Life continue to be present, for example, with the rams of Ur, preserved in the University of Pennsylvania and the British Museums (plate 19). The king, however, reappears watering his flock. As early as the Early Dynastic Period I, certain scenes show a personage watering a horned animal that is partially inside a building: despite the lack of distinctive characteristics, it can only be the king letting his people partake of the divine essence. The building is the image of the matrix and recalls that society was created by the divinity; moreover the scene is guaranteed by the divine presence, signified by either a normal bird or an eagle with two spread wings. From the Early Dynastic Period I, the image of the good shepherd is in competition with another metaphor, the image of the "gardener." The theme is often illustrated on the commemorative slabs so characteristic of the period; they are perforated, which shows that they must have been fixed to the walls of buildings, probably temples. One of these (plate 24) shows a seated female divinity with her head and

ABOVE
23. Fragment of a carved basalt vase (9¾ × 7¼ in. [25.1 × 18.6 cm]) of unknown provenance, Early Dynastic Period III, c. 2600–2300 BC. Vorderasiatisches Museum, Berlin.

OPPOSITE
24. A perforated limestone plaque (6¾ × 6¼ in. [17.4 × 16 cm]) from Tello (ancient Girsu), Early Dynastic Period III, c. 2600–2300 BC. Musée du Louvre, Paris.

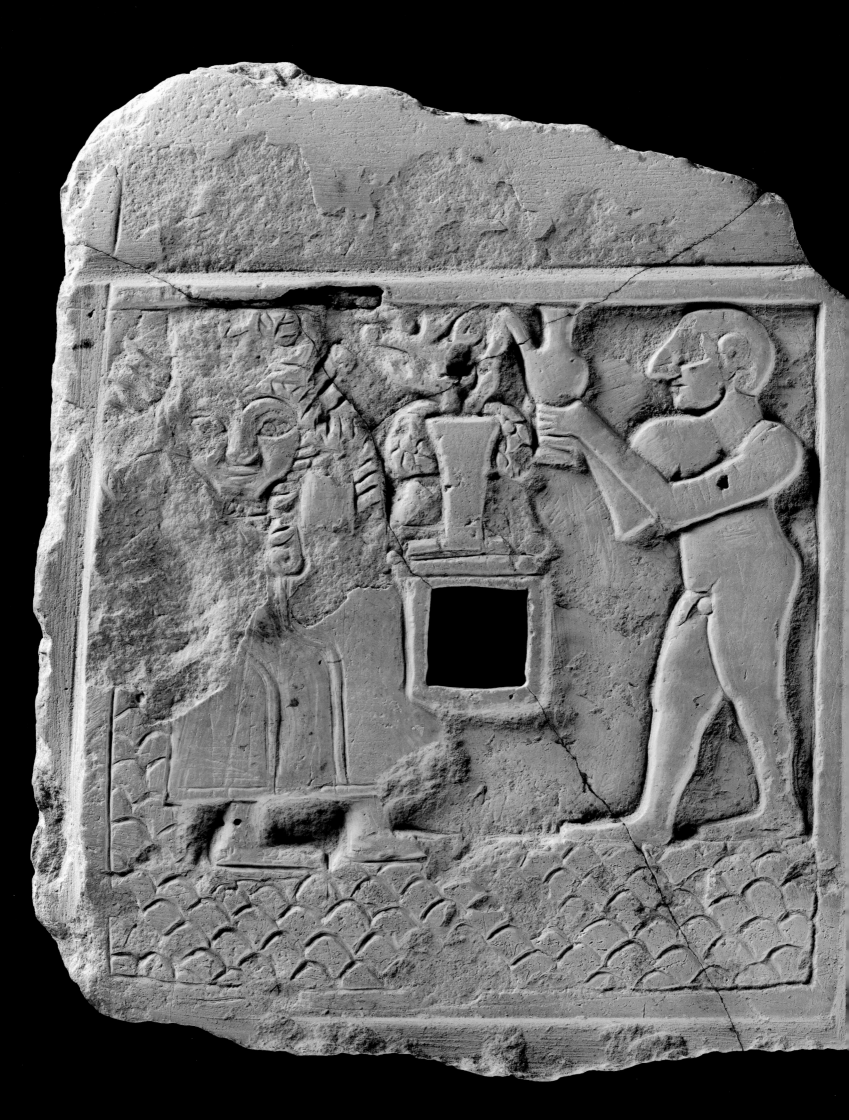

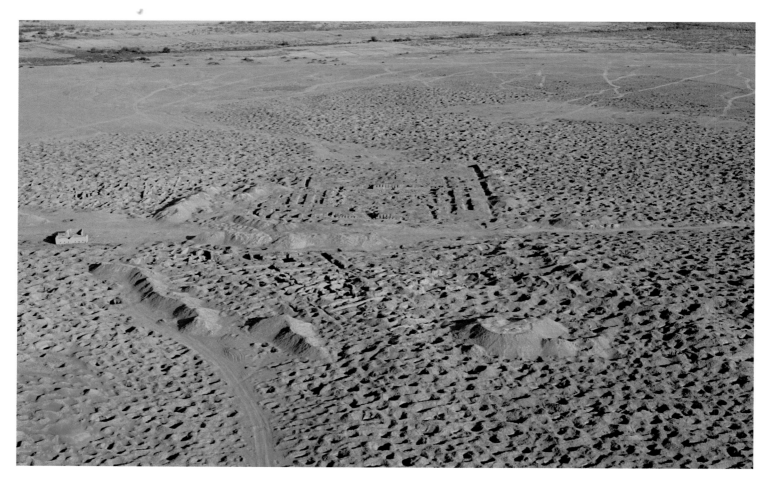

ABOVE
25. Umma, one of the great cities of the Early Dynastic Period and a rival of Lagash in terms of importance.

OPPOSITE ABOVE
26. Umm el-Aqarib, where various remains from the Early Dynastic Period have been excavated.

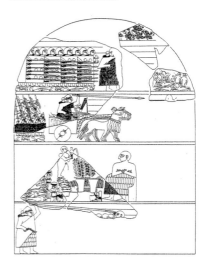

bust in full frontal view and legs in profile, according to the conventions that are also found on a fragmentary stone vase (plate 23). Before the divinity, a naked male personage waters the Tree of Life. It can only be the king, both because only he can stand so close to the divinity, and because other, more recent scenes are more explicit. Overlapping scales allude to the Cosmic Mountain, that is, the world of the gods, and thus situate the scene in a temple. It seems to mean that the king makes his people prosper according to the norms laid down by the gods. Another perforated slab, from Ur, takes up the same theme twice: first in front of a seated divinity and second in front of the door of a temple; in the lower section, a feminine personage stands in a full-frontal representation, which is normally reserved for the divinity, though she could be a great priestess.

The most noteworthy, and also most enduring, theme remains that of the king guaranteeing order, often depicted in a concrete way when war has became the activity of the day. The Stele of the Vultures (at the Louvre; plate 27), apparently preserved in the temple of Ningirsu that has already been mentioned, was commissioned by Eannatum to commemorate the victory of the city-state of Lagash over its neighbor Umma. The so-called historical side shows the royal figure wearing the tufted wool garment characteristic of the period (the *kaunakes*); he is immediately recognizable by his greater height. Despite this convention, the absence of perspective, and the arrangement of stacked sections, the scene does not lack realism, for example, in the representation of warriors and chariots. However, the enemy

BELOW
27. Drawings reconstructing the limestone reliefs on the two sides of the Stele of the Vultures (70 × 50 in. [180 × 130 cm]) from Tello (ancient Girsu), Early Dynastic Period III, 2600–2300 BC. Musée du Louvre, Paris.

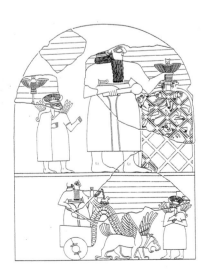

soldiers appear only stereotypically, as stripped bodies trampled on by the royal army and piled up or abandoned to birds of prey. In fact, these are victory scenes concerned, above all, with exalting the role of the king, who is represented several times. By assuming the function of warlord and guaranteeing his people's safety, the king is merely restoring a momentarily threatened order, which is, furthermore, an order held to be in conformity with the divine will. When, under the infallible leadership of its own king, the city-state triumphs over its adversary, and over adversity, war assumes the function of ritual regeneration. The image of the victorious king is used here as an allegory of the king who guarantees the order of the world, demonstrating the sacred character of royal power. On the other side of the stele, the great god of Lagash, Ningirsu, has caught in his net the pathetic human beings who have dared to attack his city and slays them with his club. In his hand he holds the lion-headed eagle, the image of his omnipotence, the symbol of his force. It means that victory is first and foremost brought about by the divinity and the king is only his armed instrument.

We can say the same thing about the famous Standard of Ur (which comes from one of the "royal" tombs at Ur; plates 28–29), a kind of wooden chest decorated with shell-encrusted panels, a very widespread technique of the period that can be found as far afield as northern Syria. On the one hand, we have a victory scene, very similar to that of the Stele of the Vultures, where the hieratic king dominates a line of conquered enemies by his tall stature, while the war chariots travel along, crushing the naked bodies of the dead enemies. On the

28–29. The two long sides of the Standard of Ur (8 × 18½ in. [20.3 × 47 cm]), composed of shell, lapis lazuli, red limestone, and bitumen. From the royal cemetery at Ur (PG 779), Early Dynastic Period III, 2600–2300 BC. British Museum, London.

30. A perforated limestone plaque of Ur-Nanshe (15¾ × 18½ in. [40 × 47 cm]) from Tello (ancient Girsu), Early Dynastic Period III, 2600–2300 BC. Musée du Louvre, Paris.

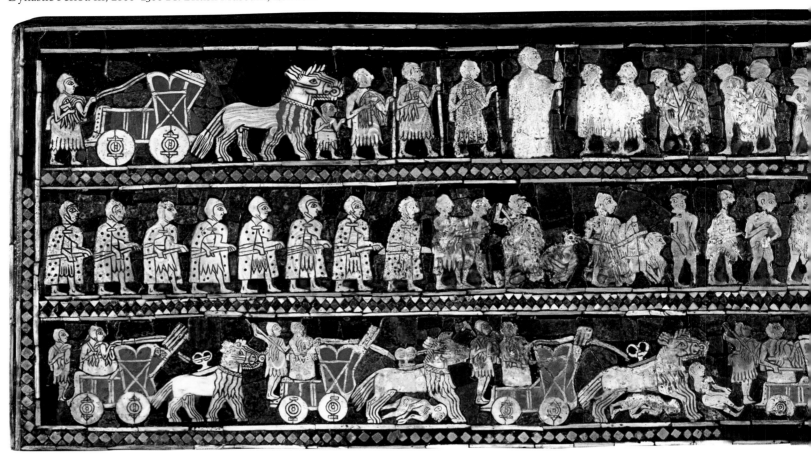

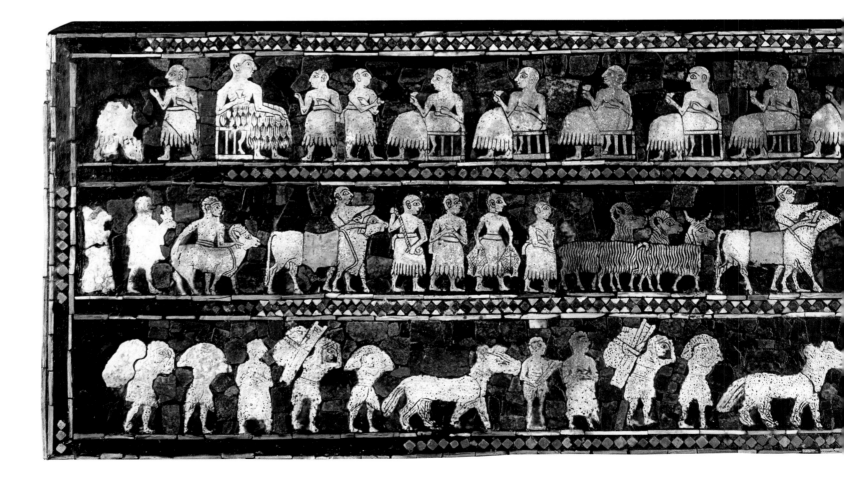

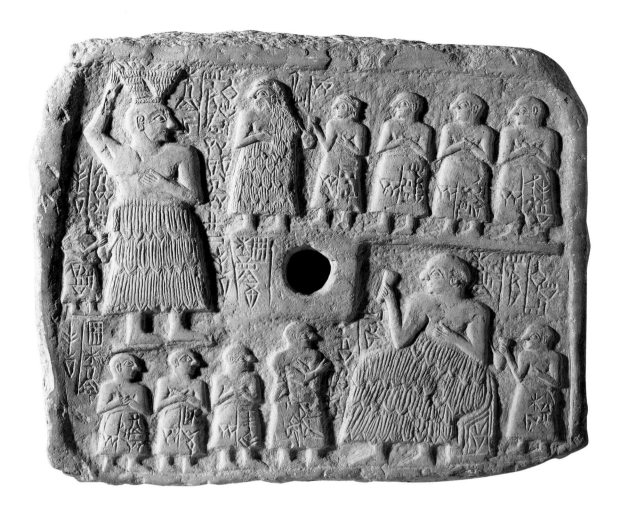

other hand, a banquet scene surely corresponds to the ceremony celebrating the return of peace, which then comes to be considered as a sort of golden age. The king is seated and drinks a toast with his noblemen. There is musical accompaniment, while a line of porters bring him the spoils of war.

The same theme recurs, in abbreviated form, on the perforated slabs we have already mentioned. Here the much more limited space is often subdivided into three sections, respectively representing a banquet, a line of porters bringing offerings, and a chariot, the only remaining element that evokes the war.

As on the stele from Uruk, the theme of the king as guarantor of universal order continues to be expressed for nearly two thousand years by scenes of lion-fighting of an allegorical character. From the beginning of the third millennium BC, during the Early Dynastic Period I, this becomes a more commonplace aspect of the cylinder seals. In their iconography, the image becomes stereotyped and less explicit. But, at the beginning of the Early Dynastic Period I, some scenes (plates 31b–h) still show royalty protecting society from evil, even though the personage depicted does not have a distinctive character. Often a bird, which represents the divinity, adds its guarantee to the scene, meaning that the king is acting in conformity with the divine will or fulfills the mission with which he has been entrusted. The same scenes were thereafter, in the Early Dynastic Periods II and III, very successful, but the personage is usually more individualized, with an exuberant hairstyle, a sign of his vitality and strength, and often (as on the Ishma-ilum cylinder in the Louvre; plate 31a) with his face represented

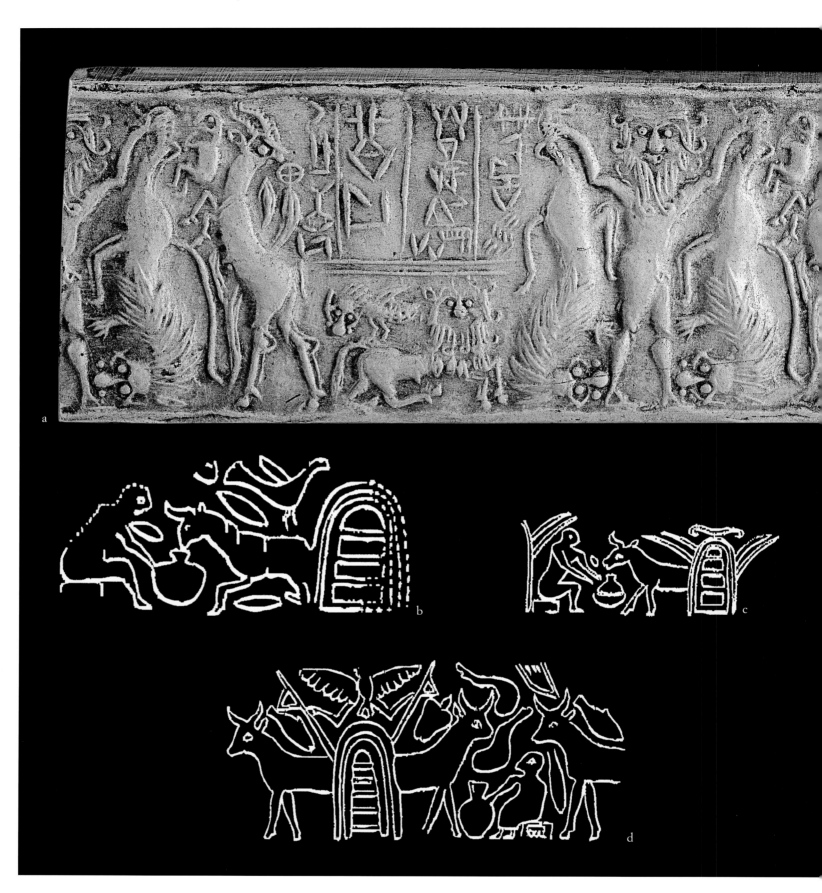

ABOVE

31. Cylinder seals of the Early Dynastic Period:
a. A lapiz-lazuli cylinder seal of Ishma-ilum, Early Dynastic Period III, 2600–2300 BC, and its impression. Musée du Louvre, Paris.
b–h. Drawings of the impressions of cylinder seals from Ur, Early Dynastic Period I, beginning of the third millennium BC.

PAGE 46

32–33. Two statuettes from Mari, Early Dynastic Period III, 2600–3000 BC: Left, Ebih-il (height 20¾ in. [52.5 cm]; alabaster, with shell and lapis-lazuli eyes), from the temple of Ishtar. Musée du Louvre, Paris. Right, a female statuette (height 14¼ in. [36 cm]; gypseous alabaster), from the Temple of Ninni-zaza. National Museum, Damascus.

PAGE 47

34–35. Two statuettes from the "temple of Abu" at Tell Asmar (Eshnunna), Early Dynastic Period II, c. 2700 BC: one male (height 28¼ in. [72 cm]; gypseous alabaster) and one female (height 23¼ in. [59 cm]; gypsum). National Museum, Baghdad.

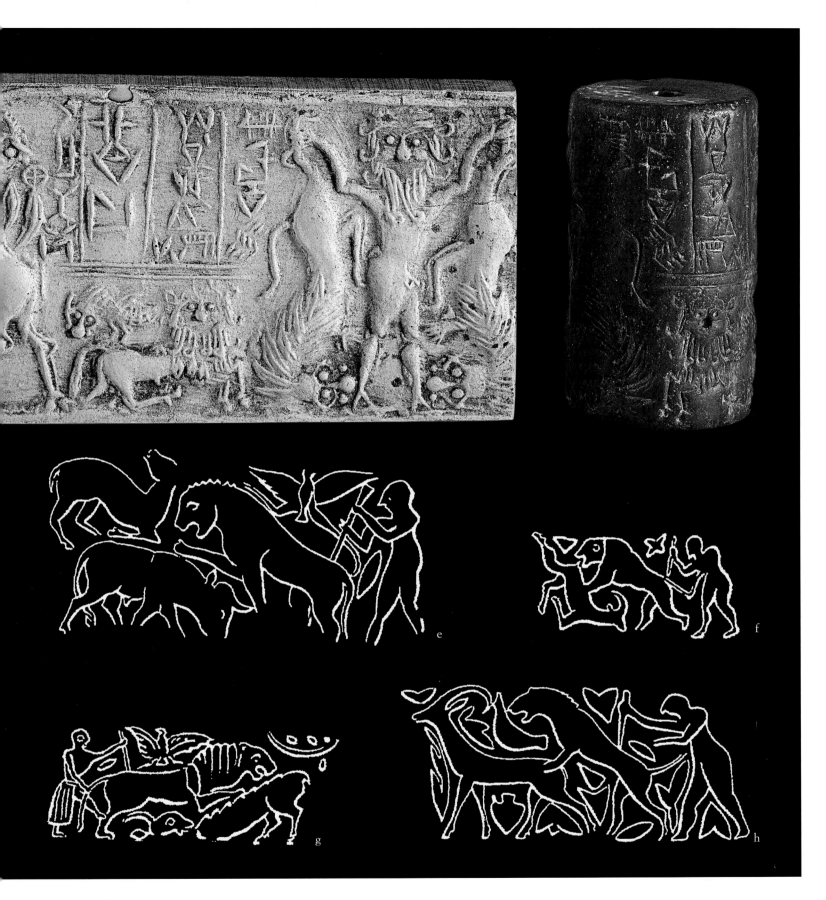

PAGES 48–49

36. A variety of objects from the royal cemetery at Ur, Early Dynastic Period III, 2600–2300 BC, University of Pennsylvania Museum, Philadelphia:

a. The headgear of Queen Puabi, comprising a comb (height 14¼ in. [36 cm]) of gold, lapis lazuli, and carnelian; gold rings (diameter 1 in. [2.7 cm]); a crown of gold, lapis lazuli, and carnelian; a gold ribbon; and gold earrings (diameter 4¼ in. [11 cm]), PG 800.

b. Gold earrings (diameter 3 in. [7.5 cm]), PG 800.

c. A gold necklace (length 15¾ in. [40 cm]) with lapis lazuli and carnelian, PG 800.

d. A bull's head (height 14 in. [35.6 cm]) and the front panel of the "great lyre"; gold, silver, lapis lazuli, shell, bitumen, and wood, PG 789.

e. A lion's head (height 4¼ in. [11 cm]) of silver, lapis lazuli, and shell, PG 800.

f. A beaker (height 6 in. [15.2 cm]) in electrum, PG 800.

g. A vase in the form of an ostrich egg (height 5¾ in. [14.6 cm]); gold, lapis lazuli, red limestone, shell, and bitumen, PG 779.

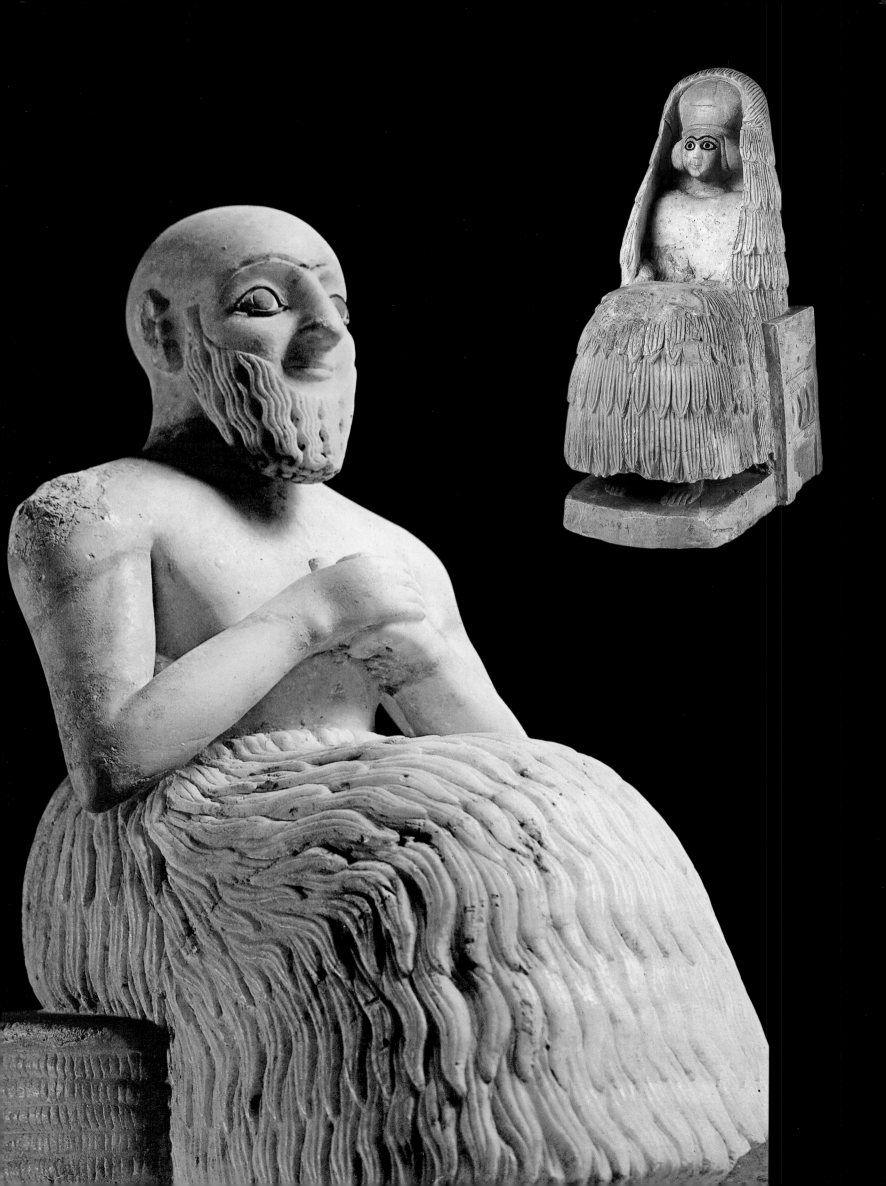

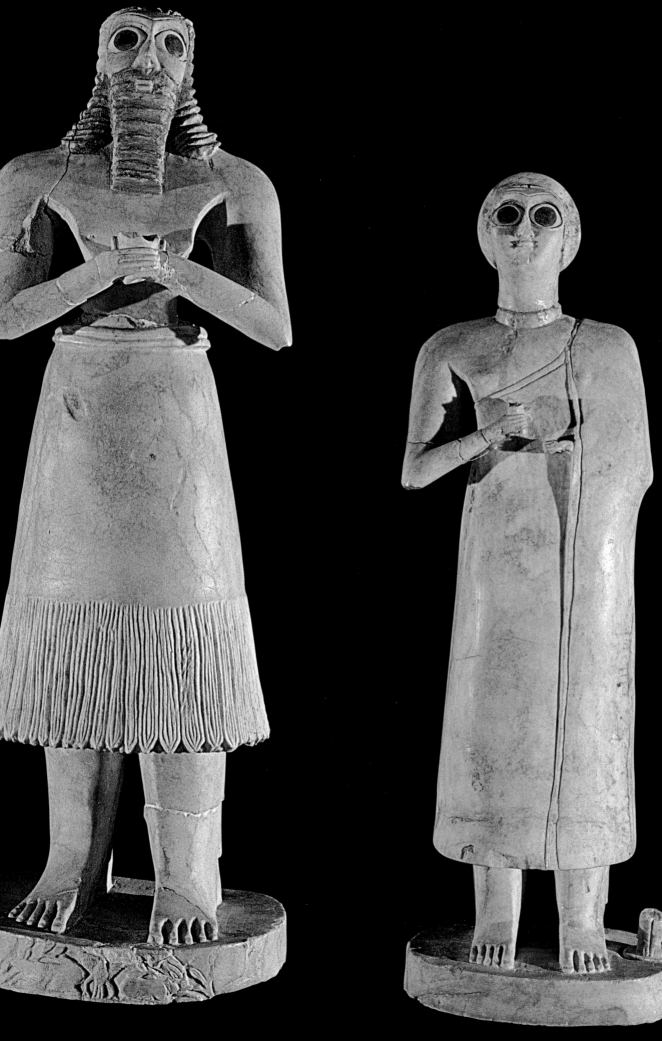

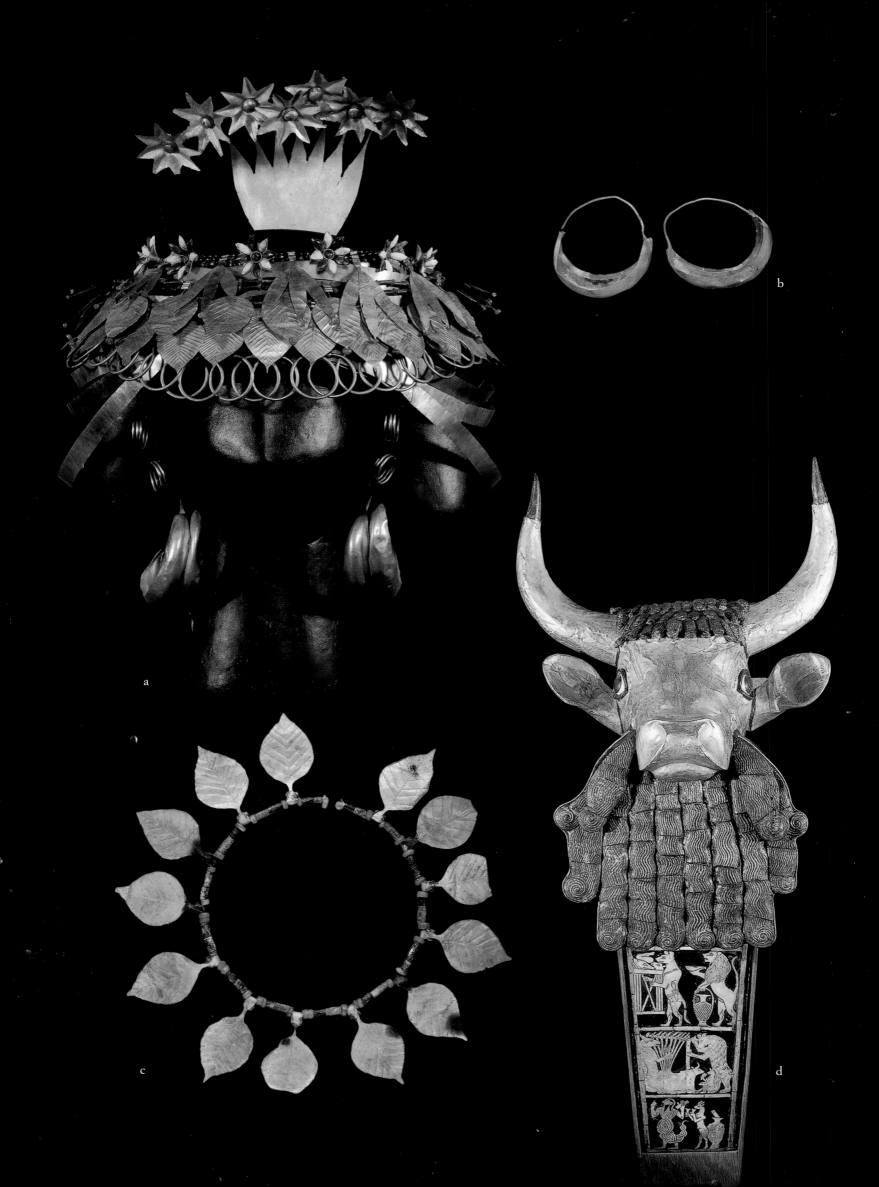

a

b

c

d

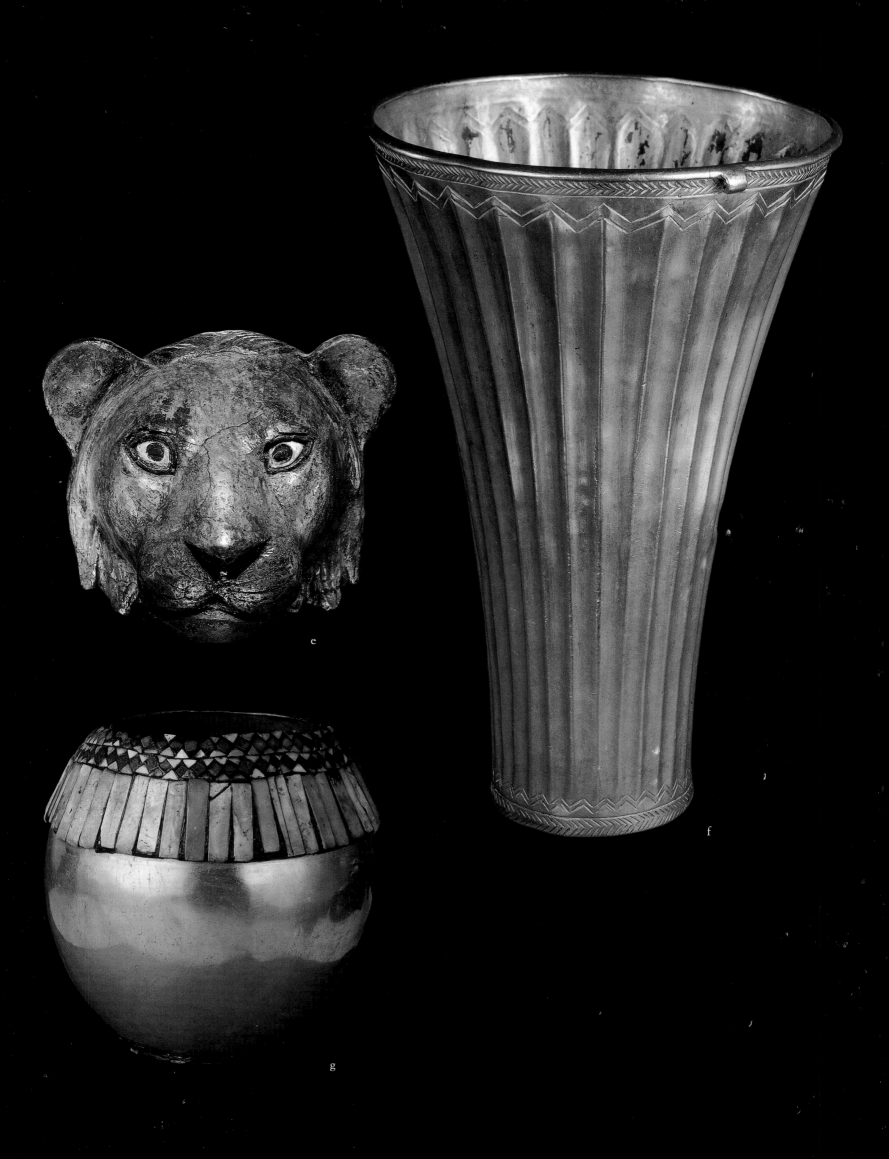

e

f

g

frontally, indicating an allegory. This naked hero, or Gilgamesh as he is called, represents kingship. These very frequent depictions have a prophylactic value and show that the royal ideology is perfectly assimilated. Often the horned beast is omitted, as on the Lion Hunt Stele, and the scene only shows royalty combating or overcoming the forces of evil.

On the margin of these more widespread representations, there also appears, from the Early Dynastic Period onward, the theme of the builder-king, with the image of the basket that served to carry building materials. These are religious foundations, testifying to the king's piety and to his privileged relationship with the divinity. This theme lasted a long time and was illustrated on commemorative perforated slabs, like that of Ur-Nanshe from Tello, now at the Louvre (plate 30).

The Early Dynastic Period also saw the development of small-scale statuary (the objects are seldom larger than twenty inches [50 cm]) with no relation to the royal ideology. These represent men and women, usually dressed in *kaunakes*. In the Early Dynastic Period II, most of these works, carved in soft stone, are very schematic: the modeling of the face is fairly rudimentary, and the shoulders and elbows are angular, with a rigid garment in the form of a cone. Some of these are noteworthy for their huge eyes, which give the face an ecstatic expression (plates 34–35). Later, the carving becomes softer and more realistic, and the pieces have more varied poses. Perhaps the most beautiful examples are those discovered at Mari, on the middle Euphrates (plates 32–33). In general, it is agreed that these statuettes were placed in temples to pray uninterruptedly and thus attract the favor of the gods, but this idea must be qualified. Several hundred statuettes of this sort were discovered in the northern part of the alluvial plain, near the Diyala (in particular, at Khafaja and Tell Asmar). A great deal of these come from buildings that were thought to be temples, but were more likely audience chambers where eminent personages such as lineage leaders, among other tasks, resolved the disputes that arose among the population. Some of the plaintiffs, perhaps because they had obtained the desired result, left an object that in some way or another rep-resented them: a statuette with their effigy or, failing that, their war club. This object, which was both a symbol of power and an actual defensive weapon (still used by the Arabs of southern Iraq), in this case represented metaphorically the personality of its owner. Even if the buildings were not temples, probably the decisions made in them still referred to intan-gible values, so that the judgments enjoyed the assent and sanction of the gods. Hence, satisfied visitors might also have dedicated an object, expressing their gratitude to these higher powers.

The Early Dynastic Period left many spectacular objects besides figurative representa-tions. In particular, the tombs of the "royal cemetery" at Ur contained extremely valuable furnishings, in which gold, silver, copper, lapis lazuli, carnelian, and agate were used exten-sively (plate 36).

THE AKKADIAN KINGDOM

Although we have no knowledge of major Akkadian architecture, as the state's capital has not been identified, we do have a series of great artworks, mostly from Susa, where they were brought as spoils of war by the Elamite Shutruk-Nahhunte in the twelfth century BC. These steles and statues, testifying to an art in the service of power, were distributed throughout the principal cities of the kingdom to remind people of the sovereign's greatness.

Various Akkadian victory steles, many of diorite imported from the country of Magan (the present-day Sultanate of Oman), resume the stereotypical narrative of the preceding period, with the same clichés (the crushed naked enemy, devoured by vultures or caught in

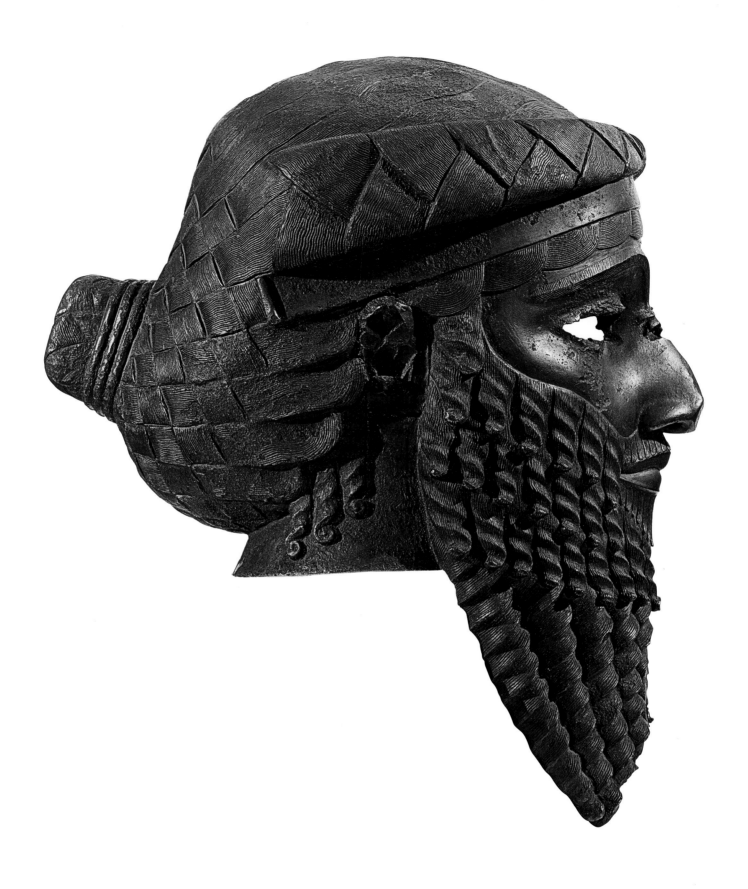

37. A bronze head
attributed to Naram-Sin
(height 14½ in. [36.6 cm]),
from Nineveh, Akkadian
period, c. 2250 BC.
National Museum,
Baghdad.

some divinity's net; plate 38). Lines of conquered enemies are the most common and recall that war expeditions (especially those conducted beyond the alluvial plain) were intended to bring back not only spoils, but also slaves. A stele made of sandy limestone, attributed to Naram-Sin, is much more original (plate 39). Whereas the Stele of the Vultures is quite static, the Stele of Naram-Sin strikes us by its dynamism. Trampling dismembered enemies, the king leads his men in assaulting a mountain, with tremendous force. In scaling the mountain, Naram-Sin imitates on his stele the pose assumed by the triumphant sun god on many seals of the era. Firstly, therefore, the scene is a sort of epiphany, modeled on that of the god, and this parallel indicates that the royal victory has a metaphysical dimension. In

LEFT
38. Fragment of a victory stele (height 13½ in. [34 cm]) in white limestone, from Tello (ancient Girsu), Akkadian period, c. 2300–2250 BC. Musée du Louvre, Paris.

OPPOSITE
39. The Stele of Naram-Sin (79 in. [2 m]) in sandy limestone, from Susa, Akkadian Period, c. 2250 BC. Musée du Louvre, Paris.

PAGES 54–55
40. Cylinder seals of the Akkadian period:
a. A serpentine cylinder seal of Ibnisharri, c. 2200 BC, and its impression. Musée du Louvre, Paris.
b. A red jasper cylinder seal (height 1 in. [2.8 cm], diameter ¾ in. [1.6 cm]), c. 2200 BC. Metropolitan Museum of Art, New York.
c. A cylinder seal in black-green serpentine, c. 2200 BC, and its impression. Pierpont Morgan Library, New York.
d. A chalcedony cylinder seal (height 1½ in. [3.6 cm], diameter 1 in. [2.3 cm]), c. 2200 BC, and its impression. British Museum, London.
e. A drawing of the impression of a cylinder seal (height 1½ in. [3.9 cm]). Musée du Louvre, Paris.
f. A drawing of the impression of a cylinder seal, representing the king Gudea (height 1 in. [2.7 cm]), from Tello (ancient Girsu), "Second Dynasty of Lagash," c. 2150 BC. Musée du Louvre, Paris.
g. A nephrite cylinder seal of Hashamer (height 2 in. [5.3 cm], diameter 1¼ in. [3 cm]), Ur III, reign of Ur-Nammu, and its impression. British Museum, London.

fact, the mountain represents a reworking of the theme of the Cosmic Mountain. Placing the king at its summit, and thus at the center of the world, the image expresses here more forcefully than ever the decisive role of the king in the process of regeneration. This development in the iconographic tradition should doubtless be set beside a change of title that made the sovereign the "King of the Four Regions" (that is, of the whole world) and associated his name with the divine determinative (the *dingir* sign, which previously had characterized the gods).

According to previous usage, some scenes represent royalty combating and overcoming the forces of evil, as is the case on a magnificently carved cylinder seal in the British Museum. On this, a nude, curly-headed hero, down on one knee, grasps a lion with his arms (plate 40d). In New York is found a similar seal, on which a naked hero protects a horned animal, and a man-headed bull confronts a lion (plate 40c). The theme of the king watering his flock also reappears, as on the famous seal of Ibnisharri in the Louvre (plate 40a), with a vase overflowing with water, very similar to the Late Uruk one, this time held by a nude, curly-headed hero representing kingship. The same nude hero sometimes appears on foot or

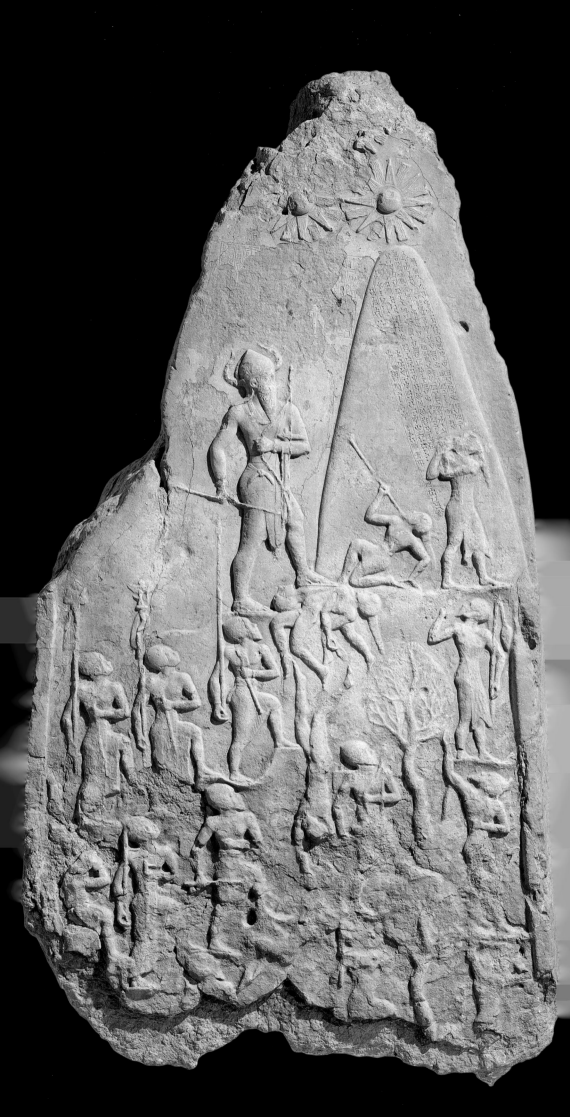

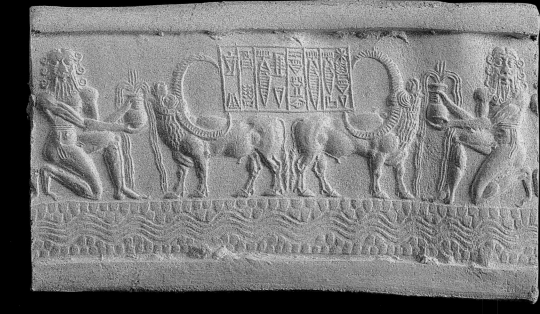
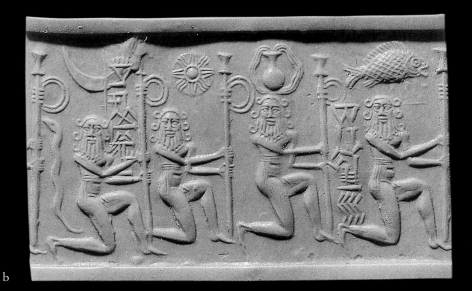
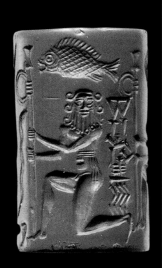

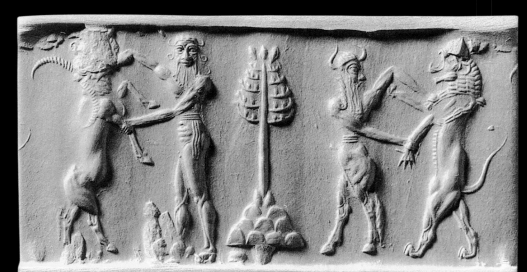

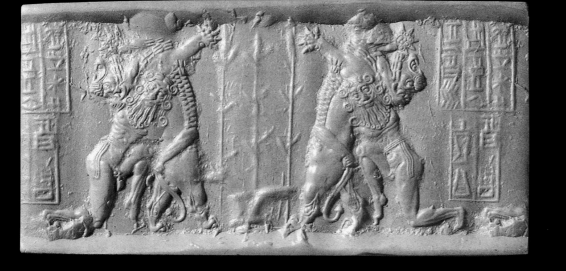

d

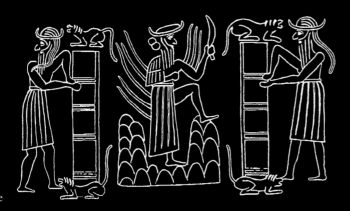
e

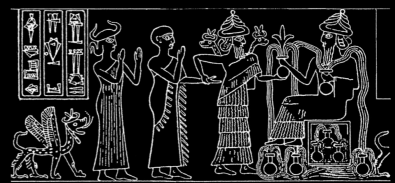
f

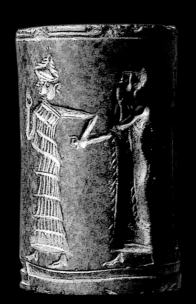

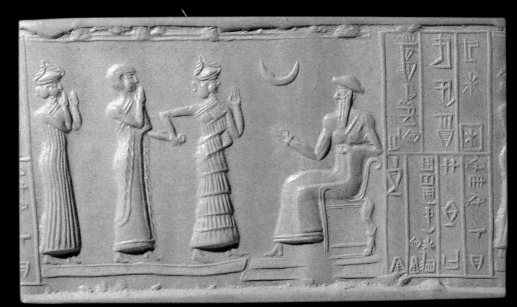
g

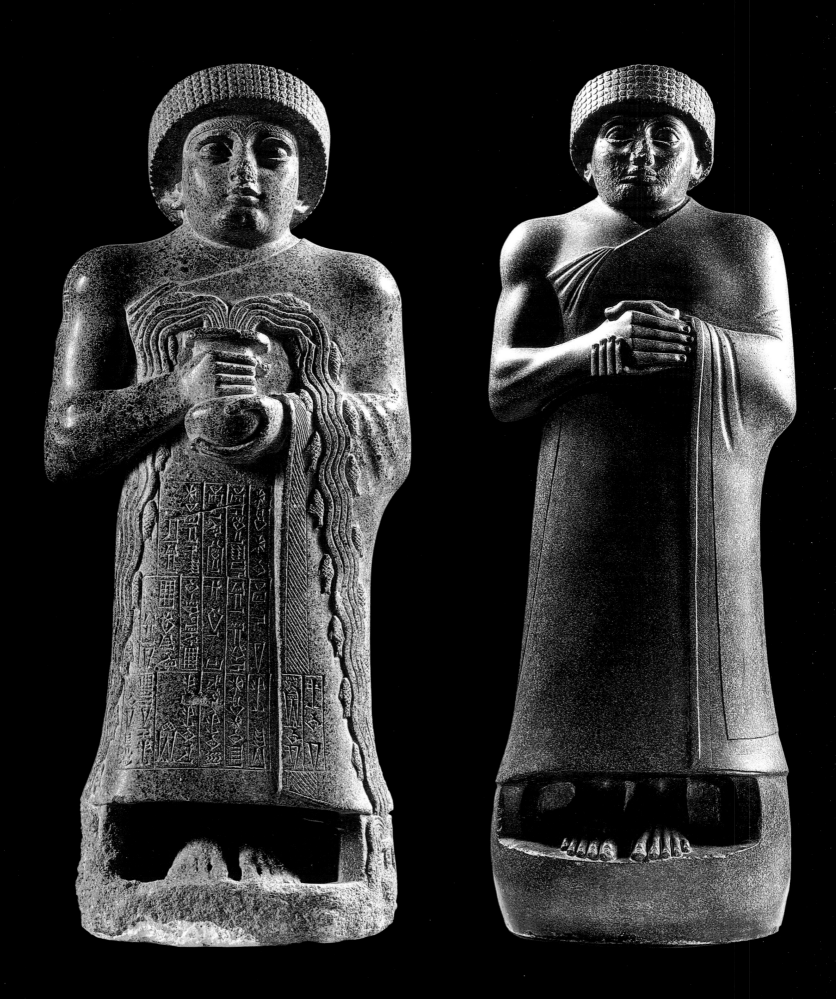

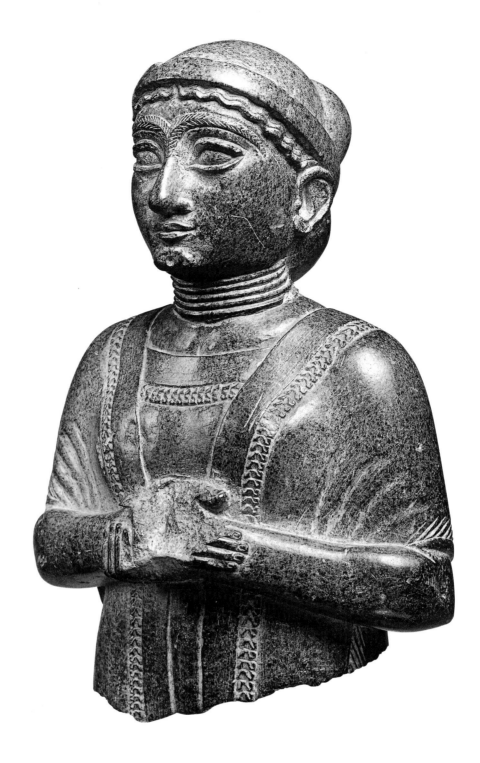

OPPOSITE
41–42. Two statuettes of
Gudea, from Tello (ancient
Girsu), "Second Dynasty
of Lagash," c. 2150 BC. The
calcite statuette on the left
shows the king holding a
vase that is overflowing
with water and is 24½ in.
(62 cm) high. The diorite
statue on the right is 42 in.
(107 cm) high. Musée du
Louvre, Paris.

ABOVE
43. A female statuette
(height 6¾ in. [17 cm])
in steatite, from Tello
(ancient Girsu), "Second
Dynasty of Lagash,"
c. 2150 BC. Musée du
Louvre, Paris.

kneeling on one knee, holding one of the ringed poles that were placed on either side of temple doors (plate 40b). This could possibly be interpreted as the king, the intermediary between the two worlds, opening the way to divine benefits for human beings.

For the first time, court art also includes standing or seated statues, more or less of natural size, but most of these are now fragmentary. The traditional *kaunakes* give way to long fringed garments, and the anatomical model is much more realistic. Like the steles, these statues were made in series and sent out to different parts of the kingdom as royal propaganda. An extremely fine copper head, called the "Nineveh Head" because of its provenance, perhaps also belonged to a royal statue, possibly of Naram-Sin (plate 37).

The glyptic art of the period is distinguished by both the quality of its workmanship and its mythological subjects. As the Akkadian unification was accompanied by a synthesis of local pantheons, which partly coincided, it was in this period that each divinity began to be allotted distinctive attributes and poses. Ea (the Akkadian equivalent of Enki) is associated with streams full of fish. Shamash (the sun god, Utu in Sumerian; plate 40e), whose rays

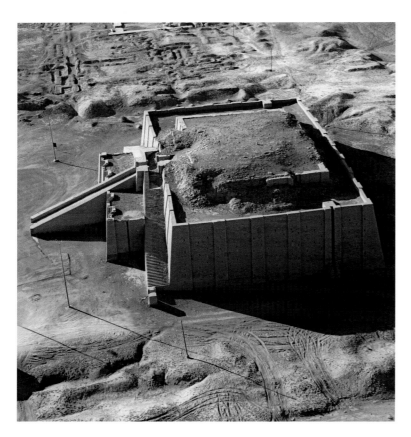

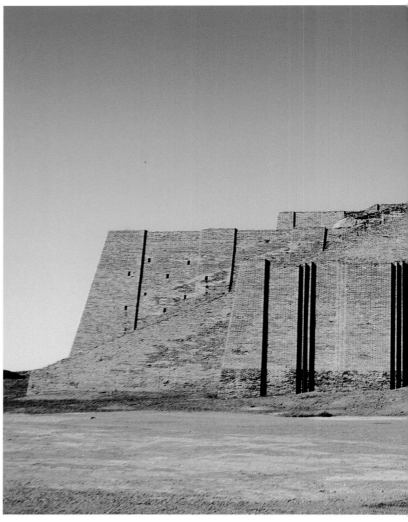

form a luminous aura, holds in his hand the key that enables him to burst triumphantly out of the Cosmic Mountain (represented by overlapping scales). Ishtar (Inanna in Sumerian), represented frontally, occasionally winged, raises one knee as a sign of victory to recall her warlike aspect, while her shoulders are laden with weapons.

44–45. An aerial view, and, above, the northeast facade of the ziggurat of Ur, Ur III period, twenty-first century BC.

THE STATE OF LAGASH

When the Akkadian kingdom disappeared, the city-states once again recovered their independence. The French excavations carried out at Tello (ancient Girsu, one of the three cities of the state of Lagash) from the end of the nineteenth century did not succeed in discovering any substantial architectural remains, but they uncovered a whole series of statues, mostly of diorite, accurately modeled as in the Akkadian epoch. They represent important personages of the period, of whom some are women (plate 43), but most men, especially the principal kings that came to power, Ur-Ba'u, Gudea, and Ur-Ningirsu. Gudea alone has about twenty surviving statues representing him, sitting or standing, with his hands together (plate 42). These were dispersed to the principal temples of the city as evidence of his piety and to attract divine favor. The sovereign's piety, doubtless intended to show a return to true native values after the Akkadian hegemony, was also attested by numerous religious foundations, as is recalled in one of the statues of him, called "the architect with plan": the plan of the temple of Ningirsu is reproduced on his knees. The theme of the builder-king reappears in a more commonplace form, that of foundation figurines in bronze buried under buildings at strategic points, particularly corners and doors. Like Ur-Nanshe, Gudea is represented with

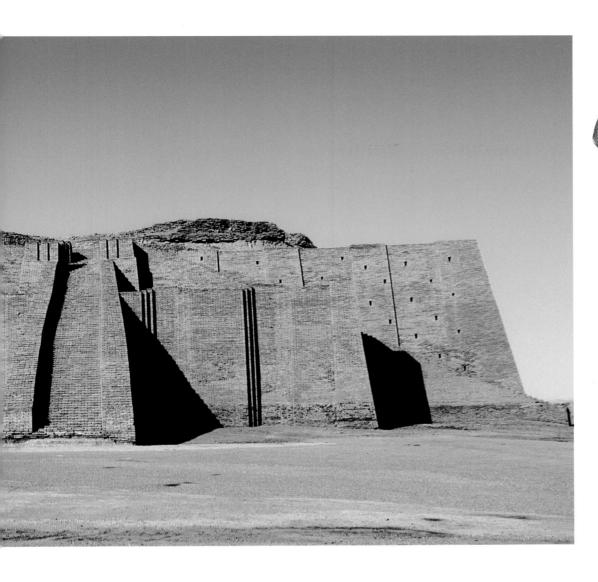

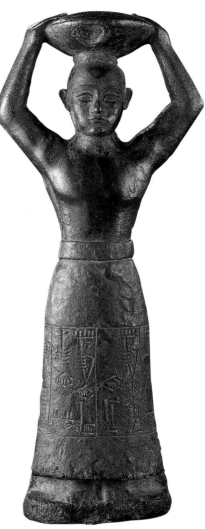

ABOVE RIGHT
46. A bronze foundation figurine of Ur-Nammu (height 13¼ in. [33.5 cm]), Ur III period, twenty-first century BC. Pierpont Morgan Library, New York.

OVERLEAF
47. The ziggurat of Uruk, Ur III period, end of the third millennium BC.

a basket. Another statue shows the sovereign with a vase overflowing with water, intended to illustrate the already familiar theme of the king bringing abundance (plate 41). The supernatural liquid, teeming with fish that symbolize the embryos of life, refers to the concept of *apsu*, the primordial Ocean whose lord is the great god Enki/Ea. This privileged relationship with the great creator god is also represented on the sovereign's seal (plate 40f), where his own personal god presents him to the lord of the primordial waters, while a goddess called Lama intercedes in his favor. This is one of the most ancient examples of the presentation scenes that would thereafter become an essential part of the repertoire. The great seated god (whether it is Enki/Ea or the city god Ningirsu adopting Enki/Ea's attributes here, as has been suggested) is surrounded by vases overflowing with water, from one of which the Tree of Life emerges. If we remember that in one of his statues it is Gudea himself who holds the vase, we may understand that here the god is entrusting it to him, and hence we have a sort of enthronement scene. This same scene has a precise, albeit very fragmentary, parallel on a great limestone stele in Berlin.

THE THIRD DYNASTY OF UR

At the end of the millennium, a unified state was restored, but whereas the Akkadian state was founded upon the threat of war, Ur III was based on intrusive administration. Resuming the idea of a centralized state, the sovereigns of this dynasty sought legitimacy for their hegemonic enterprise in an unprecedented literary effort. It is now, for instance, that the first Gilgamesh poems make their appearance; he is a mythical king, chosen to represent royalty.

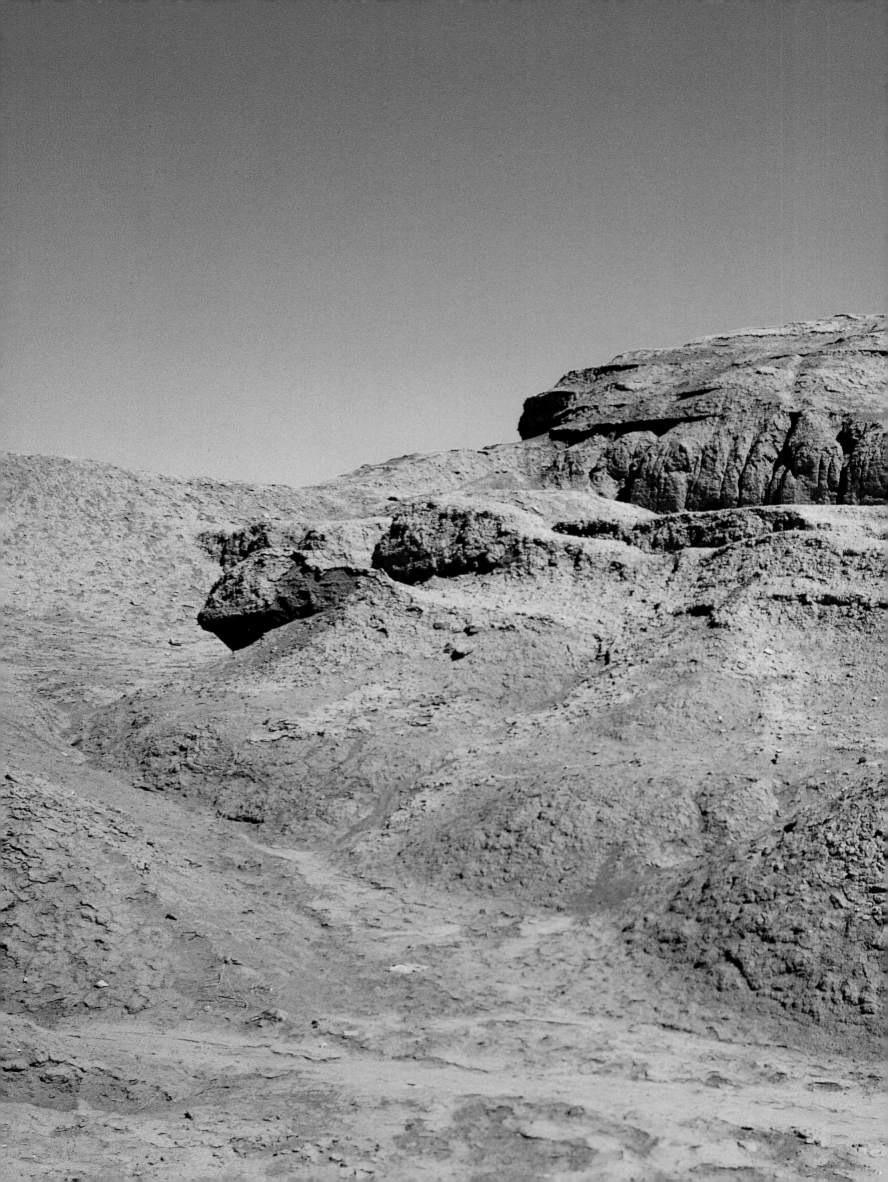

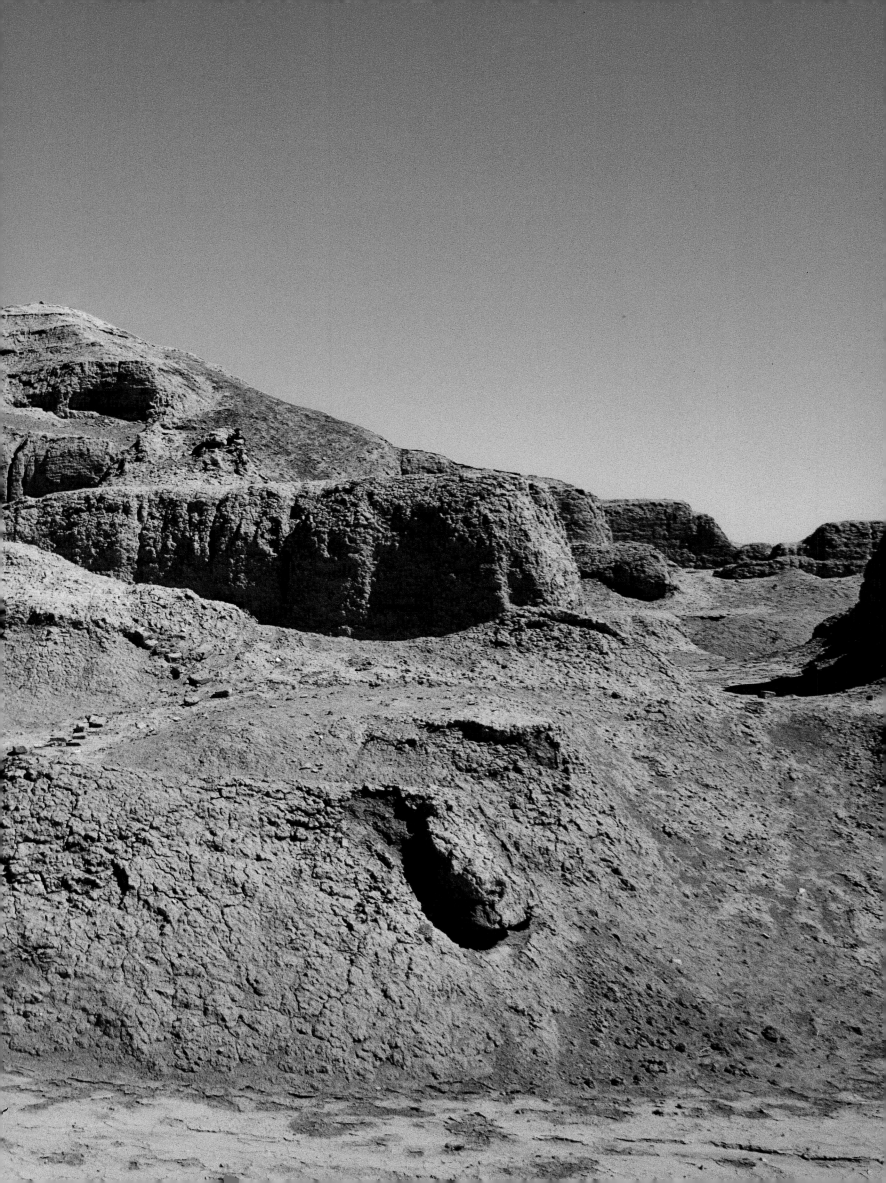

Furthermore, they created new architectural forms and introduced a court art of a standard high enough to meet their ambitions.

Indeed, the kings of Ur are distinguished by their very intense architectural activity. It is to them, and especially Ur Nammu, that we owe the first ziggurats. These enormous, multistory masses of brick still dominate many Mesopotamian sites. The one at Ur (plates 44–45; Ur 3–6), consecrated to the moon god Nanna, is the best preserved, and the best known, thanks to Sir Leonard Woolley's excavations, and is partially restored. It is a great mass of unbaked mud bricks with a covering of baked bricks. Its base is 205 by 141 feet (62.5 by 43 m). On top of its lower story, which, slightly inclined, reaches a height of thirty-six feet (11 m), there were one or two narrower stories, on top of which there was probably a temple. A staircase perpendicular to the facade and two more staircases on either side converge halfway up the second story on a landing, from which further diverging stairways may have led up to the top. The ziggurat is the image of the Cosmic Mountain where all things begin and end, like the Egyptian pyramids, but whereas the latter are linked to death (although the pharaohs buried in them were destined for a kind of resurrection), the Mesopotamian buildings are linked to the source of life. In every case the ziggurat formed part of a vast cultic complex (Ur 2). At Ur this was associated with a raised courtyard, with direct access from outside through a monumental door (Edublalmah). This courtyard was also used as a tribunal and a storeroom for records, and it communicated to the northeast with another, smaller one (called "Nanna's Courtyard"), which, with a much more majestic entrance, must have formed part of the principal walkway. The two courtyards, each surrounded by a series of chambers, were both in the same L-shaped enclosure. The space to the south of the smaller courtyard was occupied by a building (Enunmah) whose plan suggests storerooms, although it might have had another floor with different functions. To the south of the ziggurat, an independent building (the Giparu), measuring 259 by 251 feet (79 by 76.5 m), housed both the sanctuary of Ningal, Nanna's partner, and the residence of her priestess. The temple proper is worthy of attention because here we see, for the first time, a solution that would be used continually thereafter. It consisted of associating an internal courtyard with two parallel, oblong chambers, the first being the antecella and the second, with an axial niche, the cella. A very similar solution is found in the palaces of the period, and this is not by chance. If the temple is thought of as the dwelling place of the divinity, then it is reasonable to conclude that the divinity has comparable needs to the great ones of this earth, and the building in which it not only dwells, but also is clothed, decorated, and fed, must pay homage to its prestigious guest.

A building (the Ehursag) even farther to the south (and doubtless outside the sacred enclosure despite the reconstruction offered by the archaeologist), a 590 square foot (55 m²) structure attributable to Ur-Nammu, is likely to be a palace, even though some of the inscribed bricks make us think rather of a temple (as HUR.SAG alludes to the Cosmic Mountain). It is interesting because it is the first example of a palace reception complex that, like the temple mentioned above, associates a more or less square courtyard with two parallel oblong chambers, which in this profane context become antechamber and throne room.

The architectural activity of the kings of Ur is also attested to by the numerous copper foundation figurines found at Ur, Nippur, Tello, Uruk, and Susa that show Ur-Nammu and his successor Shulgi bearing baskets (plate 46). We also have the example of the Stele of Ur-Nammu, whose scattered fragments were collected near the ziggurat of Ur (plate 48). On one of the five registers of the most legible side, the king, standing behind a seated god, carries building tools on his back: an axe, a basket, and a dismantled plow (to dig the earth to be used for bricks). For his part, the god seems to be supervising the construction of a building

TOP
48. A reconstruction of the Stele of Ur-Nammu and a fragment of the limestone stele itself (41¼ × 28¼ in. [105 × 71.8 cm]), from Ur, Ur III period, twenty-first century BC. University of Pennsylvania Museum, Philadelphia.

BOTTOM
49. The limestone Stele of Shamash (26½ × 24½ in. [67 × 62 cm]), from Susa, Ur III period, twenty-first century BC. Musée du Louvre, Paris.

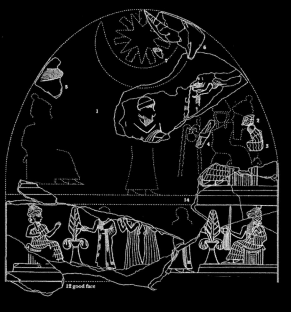

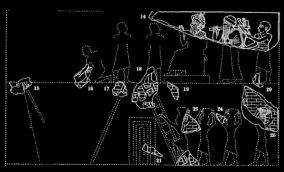

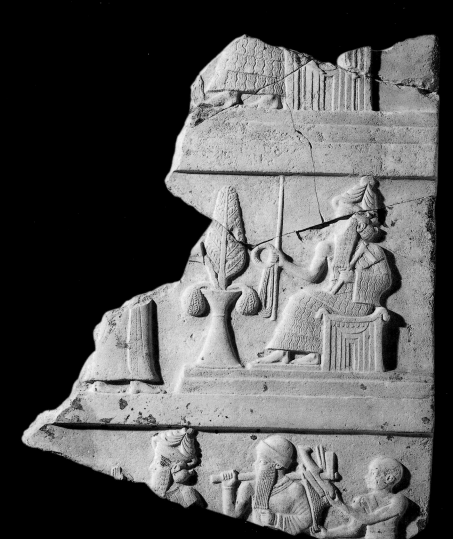

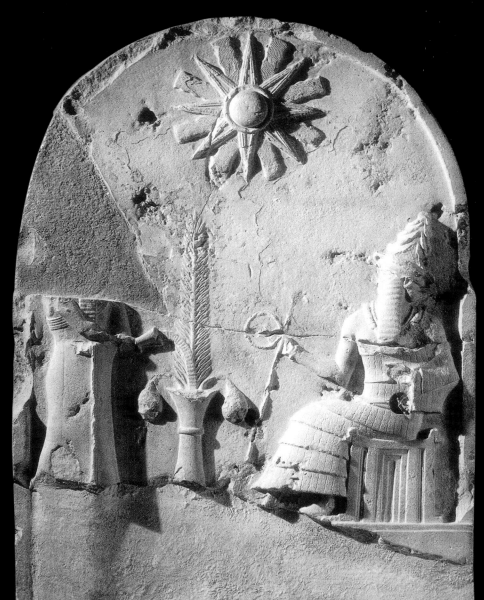

in front of and beneath him. Workmen with baskets can be recognized, and some of them are climbing ladders that lean against the brickwork. In another section, the king waters the Tree of Life, in two rigorously symmetrical scenes in front of two divinities, who could be the lords of the place, Nanna and his partner. The god bears the symbols of power, but the circle, normally associated with the staff, is replaced here by a rolled-up cord. This anomaly could be explained by the fact that the stele is linked to a religious foundation: the circle and staff would then assume the form of a land surveyor's cord and a measuring rod, as if the god himself had designed the plan of his temple. From the Ur III period on, the insignia of divine power often take the form of a circle and a staff (feminine and masculine, respectively), as can be seen, for example, on the Stele of Shamash, which is certainly contemporary (plate 49).

The finely wrought glyptic art of the period mainly shows presentation scenes similar to those on Gudea's cylinder seal (plate 40g).

2
MESOPOTAMIAN ART, FROM C. 2000 TO 330 BC

Jean-Daniel Forest and Nathalie Gallois

THE AMORITE KINGDOMS

Although the fall of the empire of Ur III brought with it the end of Sumerian dominance, the Amorites, who had already established themselves in Mesopotamia, assumed their legacy. The kingdom of Isin controlled the alluvial plain for a time before being overthrown by the kingdom of Larsa. At the same time, other powers developed in the region of the Diyala River (Eshnunna) and in northern Mesopotamia (like Mari in the middle Euphrates or Ekallâtum in the middle Tigris) until Hammurabi (r. 1792–1750) reestablished, to his advantage, territorial unity around a city that was then emerging from the shadows, Babylon. From then on, its name could be used to indicate the entire region between the rivers.

The Amorite sovereigns, like the kings of Ur, were great builders. Although Hammurabi's Babylon is completely unknown to us because it has sunk into the groundwater under the neo-Babylonian city, several Amorite buildings have been excavated at other sites. At some of their palaces, like that of Nur-Adad (r. 1865–1850) at Larsa (L. 1) or that of Sin-Kashid (c. 1850) at Uruk (U. 6), one finds the reception complex that first appeared in the preceding era, with the difference that now the antechamber is separated from the throne room by a series of smaller rooms. By backing these onto the throne room, the need for a broad middle wall was avoided. But the best-known palace is that of Mari, thanks to the abundance of material gathered there and, above all, to the nearly twenty thousand tablets discovered at the site. Built at the end of the third millennium and enlarged and restored over time, the building that has come down to us is the palace of Zimrilim (r. 1775–1761 BC; Mari 1–2). Preserved at some points to a height of sixteen feet (5 m), it extended over nearly six acres (2.5 hectares) and comprised more than three hundred rooms, corridors, and courtyards on the ground floor alone. The entrance was to the north, through a well-guarded small courtyard, joined on the east side to the lodgings of the officer who controlled access. Beyond it, a great courtyard (131) allowed people to circulate in every direction. To the south of this, opposite the entrance, we are struck by the great chamber that looks like an *iwan* (open to the courtyard all along one side). It is usually interpreted as a chapel consecrated to Ishtar, but it was more likely to have been used as the king's audience chamber, to judge from, among other things, the fragmentary pictures that have been recovered there (one of which is a scene of the king watering the Tree of Life). To the southeast of the courtyard was a special walkway that led to another, independent area, apparently housing the palace sanctuary. To the west of the

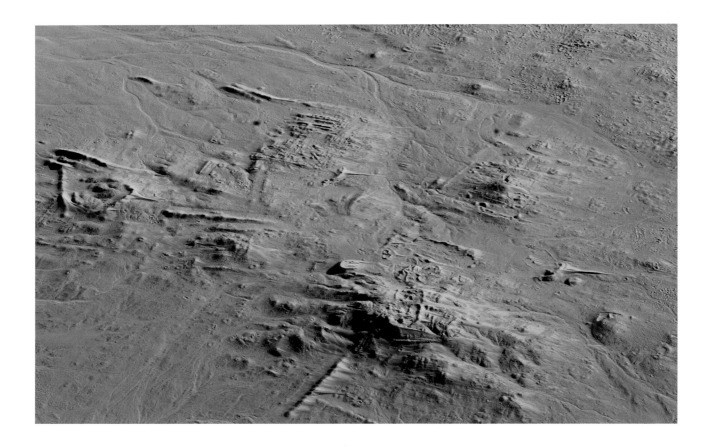

courtyard, an elbowed corridor led to a second courtyard (106), called the "palm courtyard" because an artificial tree was installed there. This courtyard, in turn, gave access, to the south, to two enormous, parallel long rooms, based on a plan inherited from the kings of Ur. The first was an antechamber, in the middle of which stood a statue of a female divinity bearing an overflowing vase, which served as a fountain. The second was the throne room, thirty-seven feet wide and eighty-two feet long (11.25 by 25 m). The king sat on the west side, on a podium surmounted by a canopy, opposite some form of platform on which stood the effigies of his ancestors. It was here that the great receptions were held, as is indicated by the close proximity, to the west, of kitchens, where ovens and numerous pudding molds were found. The rest of the ground floor housed the lodgings of the staff, the administrative offices, archives, and a large number of storerooms. In particular, to the south, the whole of an area of storerooms was directly accessible from the outside via secondary entrances designed to guarantee supplies for the palace. The royal apartments were confined to the second floor: the king's were above the storerooms to the east of the throne room; the queen's were in the northwest of the palace. Bathrooms, complete with bathtubs and toilets connected to pipes and water tanks, provided these apartments with all the necessary conveniences.

The palace was also decorated with numerous murals in mineral colors, applied in tempera to the white plaster. Most are now very fragmentary, especially those that fell from the second floor (the royal apartments were particularly lavishly decorated), but a painted panel eight feet long and six feet high (2.5 by 1.75 m) was found in place on the southern wall of

50. An aerial view of Larsa, a great city of the second millennium BC. The palace of Nur-Adad, the ziggurat, and the E-Babbar, the temple of Shamash, can be recognized.

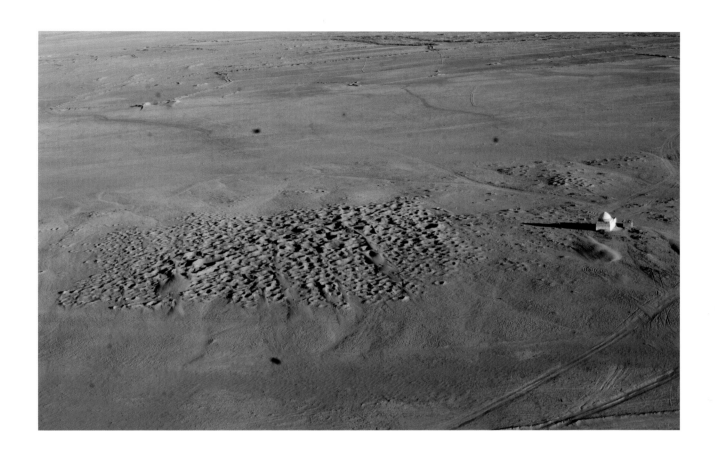

51. An aerial view of Abbas el-Kurdi, a small site near Larsa, which gives an idea of the landscape as it is today.

courtyard 106, just to the right of the passage leading to the throne room (Mari 3). Within a rectangular frame, where two protecting goddesses (the Lama goddesses inherited from Ur III) seem to greet visitors, two kinds of trees, arranged symmetrically in pairs, allude to the Tree of Life and suggest the idea of a marvelous garden. The outer pair are palm trees, each with two small human figures climbing up them as if they are about to gather dates. This is the image of humanity itself, striving so hard to gain divine benefits—it almost restates the famous, if clichéd, modern metaphor of the "greasy pole." A bird, the symbol of divinity, takes flight from the tree's branches. The inner pair of trees are covered with marvelous flowers. In the middle of the garden, guarded by three pairs of hybrid monsters, stands the sanctuary, represented schematically as two stacked rectangles. In the antecella, below, there are two goddesses with overflowing vases, a sign of abundance. In the upper cella, the king is introduced to the warrior Ishtar by two Lama goddesses, in the presence of a secondary god. In accordance with a common scheme, the goddess is standing, armed, and wearing a long, open garment that allows her to move freely, and she has one foot on a lion. She holds out to the king the circle and the staff, clearly inviting him to touch the insignia of her omnipotence. It is this scene that has given the decorative panel the name the Investiture Painting. Indeed, even though many earlier representations had already shown very clearly that the king had a divine mandate, here it is absolutely obvious that royalty is a divine gift. This theme was also well established in literary form from the time of Ur III: in the poem called *Gilgamesh, Enkidu, and the Underworld*, for example, the goddess Inanna (the

Sumerian equivalent of Ishtar) gives the hero pieces of the Tree of Life, from which he can carve two objects, respectively linear and circular, symbolizing his full powers. Above this panel, a long painted frieze is present only in fragments, the most important of which is known by the name of Orderer of the Sacrifice (plate 52). Here an outsize personage, probably the king, guides a procession extending over two registers and comprising dignitaries and sacrificial bulls.

As during the Ur III period, religious architecture may take up themes similar to those of palace architecture, as we see in a vast complex dedicated to cult worship (measuring c. 328 by 220 feet [100 by 67 m]), built by a prince of Eshnunna in about 1850 BC at Neribtum (Tell Ishchali), a city on the banks of the Diyala (Neribtum 1–2). In the western part that houses the sanctuary of Ishtar Kititum, a monumental entrance gives access to a large rectangular courtyard, at the end of which two successive oblong chambers constitute the antecella and the cella, as in the earlier Giparu of Ur.

But Larsa's E-Babbar (L. 4), the great temple dedicated to Shamash the sun god, is completely different: it is a huge complex, probably built in the eighteenth century by Hammurabi. It extends to more than 980 feet (300 m) in length, and it has two centers: to the northeast is a small ziggurat, associated with a rectangular courtyard, while the actual sanctuary is to the southwest. Between the two were two successive great courtyards, surrounded by

ABOVE
52. The Orderer of the Sacrifice, a painting in the palace of Zimrilim at Mari, eighteenth century BC. Musée du Louvre, Paris.

OPPOSITE
53–54. The Code of Hammurabi (height 89 in. [225 cm]), black basalt, eighteenth century BC. It seems that this stele, though discovered at Susa, was erected at Sippar. Musée du Louvre, Paris.

OVERLEAF

55. The Worshipper of
Larsa (7¾ × 5¾ in. [19.5 ×
14.8 cm]), bronze, gold,
and silver, from Larsa,
beginning of the second
millennium BC. Musée du
Louvre, Paris.

PAGE 71

56. A royal head (height
6 in. [15 cm]) in diorite,
nineteenth or eighteenth
century BC, found at Susa
but originally from
Mesopotamia. Musée
du Louvre, Paris.

rooms whose functions are uncertain (perhaps they housed the scribes and other professionals necessary to the running of the temple), which were probably associated laterally with secondary courtyards. An axial walkway through three monumental gates enabled people to pass from the ziggurat to the sanctuary, traversing a sharp slope by means of a majestic staircase. It has not been possible to recover the eighteenth-century sanctuary (the one that has been excavated dates only from the neo-Babylonian era), but we do know that it was very high up, perhaps built on the ruins of the ancient Ur III ziggurat. In the second courtyard, the facades were decorated with double niches and with panels of twisted semi-columns (the tori were carved into the unbaked mud brick or, more often, the plaster; L. 2–3), in accordance with a style also found at Ur and in northern Mesopotamia, at Tell al-Rimah (ancient Karana) and Tell Leilan (ancient Shubat Enlil; Sh.-E. 1).

Among the objects, it is perhaps the Code of Hammurabi that is the most important from this period (plates 53–54). This stele in polished black basalt was transported to Susa by the Elamite king Shutruk-Nahhunte in the twelfth century. There were various copies, spread throughout the great cities of the kingdom, but this is the only one that has come down to us intact. Properly speaking, rather than a code, the text of 3,500 lines is a collection of penalties to be taken as a model. At the top of the stele, a relief illustrates that the king's decisions were just because they were inspired by Shamash himself, who was the god of justice since

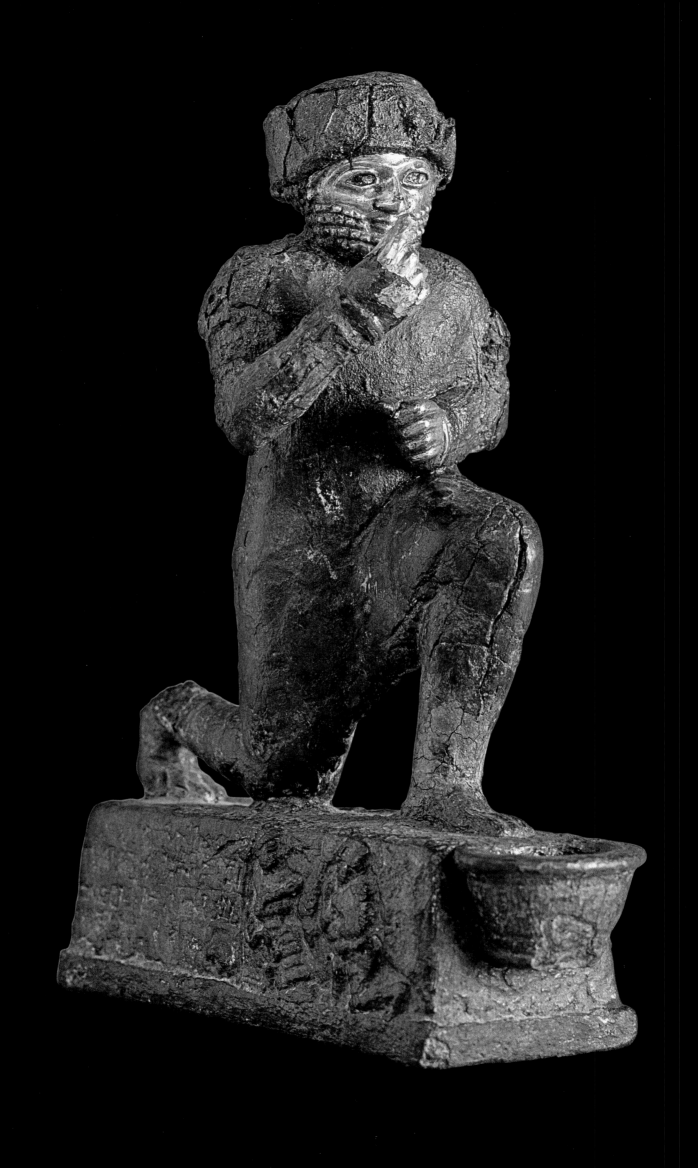

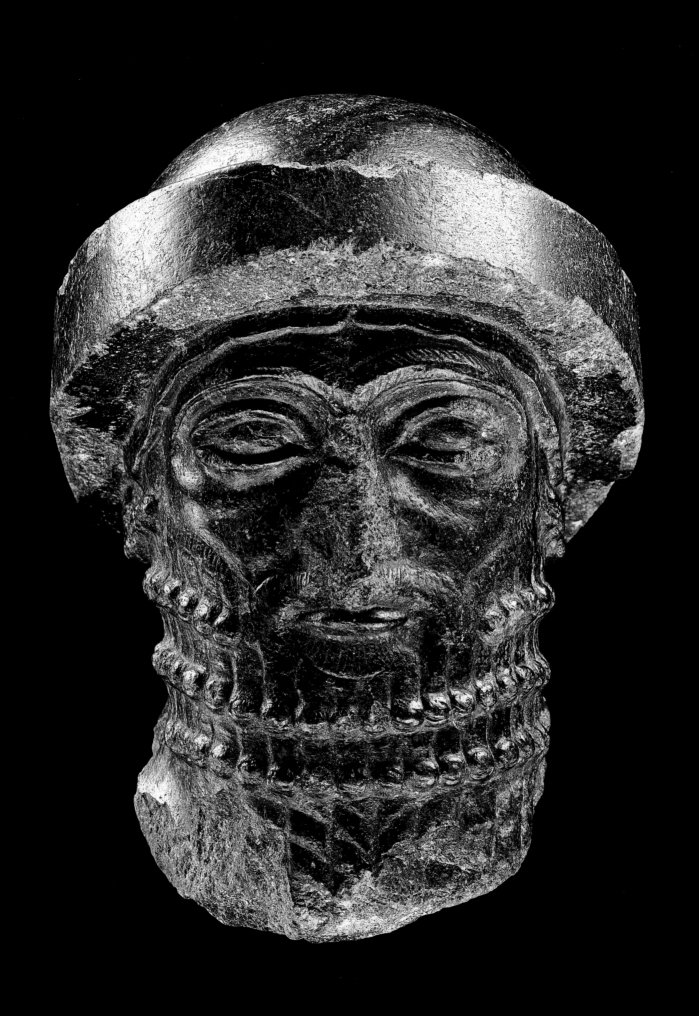

nothing escaped his attention. Hammurabi, wearing a long garment and a thick-brimmed cap on his head (following a tradition that goes back to Gudea), stands with one hand raised in greeting or respect before the divinity on a throne above the Cosmic Mountain (with scales), who is identified by the rays coming out of his back. The god holds the insignia of his omnipotence, the circle and the stick, which the king must be about to touch (as in the Mari painting) in order to fulfill his role as unfailing, supreme judge.

A small diorite head, long attributed to the same sovereign, although without any corroboration, is distinguished by its realistic style (plate 56). Wearing a thick-brimmed cap, the bearded personage seems to be quite old, and his somewhat disillusioned expression is very different from the serenity represented by Gudea.

Several Amorite sovereigns, like a prince of Eshnunna or Puzur-Ishtar of Mari (plate 57) have left diorite statues, some of natural size, in the tradition of the statues of Gudea. The king is standing or seated in a hieratic posture, with joined hands.

A bronze statue represents a kneeling personage with one arm at his chest and the other raised in front of him (plate 55). On the plinth, which has a small basin at the front, there is a bas-relief of a ram lying down and a figure kneeling in front of a seated divinity. The figurine, with face and hands covered in gold leaf, is an ex-voto, as is indicated by some lines of text, dedicated by an inhabitant of Larsa to the god Amurru in gratitude for the life of his sovereign, Hammurabi.

The glyptic art of this period is characterized by its marked preference for a gray stone with a metallic look, called hematite. The carving is very fine, but the iconography, inherited from the neo-Sumerian epoch, of presentation scenes with a petitioner (often identified by an inscription) led by a Lama goddess into the presence of a divinity is quite repetitive.

THE KASSITE DYNASTY

When the invading Hittite king Mursilis I conquered Babylon in 1595, thus putting an end to Hammurabi's dynasty, Babylon came to be ruled by the Kassites. These people (perhaps from the Zagros Mountains), whose society was organized on a tribal model, were already present in the area, and they had occasionally served the previous rulers as mercenaries and farmers. As the occasion arose, they would invade Babylon, but they adopted the Akkadian language, and they very deliberately perpetuated Babylonian culture and civilization in the political, religious, and intellectual fields. The first centuries of their domination are particularly obscure, but it seems that unity was not restored before the fifteenth century: like the Amorites, at first they created a mosaic of small kingdoms.

The Kassites continued the policy of building and maintaining sanctuaries. At Uruk, a temple dedicated to Ishtar appears to be the work of a Kassite king called Kara-Indash at the end of the fifteenth century. Its facade was decorated in a very original way, with baked, molded bricks that form, in alternating niches, goddesses and bearded gods carrying overflowing vases (plate 59). One sees decoration of this kind at Susa in the twelfth century, on the facade of a temple of the Elamite dynasty, with the difference that here the molded bricks are glazed (green or yellow).

During the fourteenth century, another Kassite king, Kurigalzu I, founded a new capital to which he gave his own name: Dur Kurigalzu (today known as Aqar Quf, about twenty miles [30 km] west of Baghdad). Here, he built a ziggurat in unbaked mud bricks covered with baked bricks (plate 58). The building that remains today, currently with a height of 187 feet (57 m), was perhaps once 230 feet (70 m) high and was associated with three temples dedicated to Enlil, Ninlil, and Ninurta. About 2,300 feet (700 m) away, an enormous palace

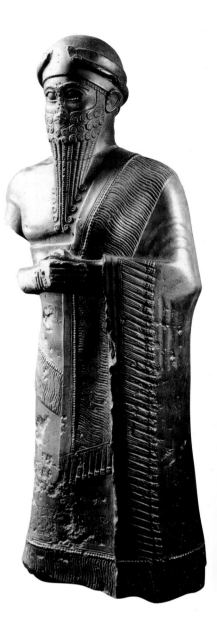

57. A diorite statue of Puzur-Ishtar of Mari (height 69 in. [175 cm]), from Babylon, beginning of the second millennium BC. The head is in the Vorderasiatisiches Museum, Berlin; the body, in the Istanbul Archaeological Museum.

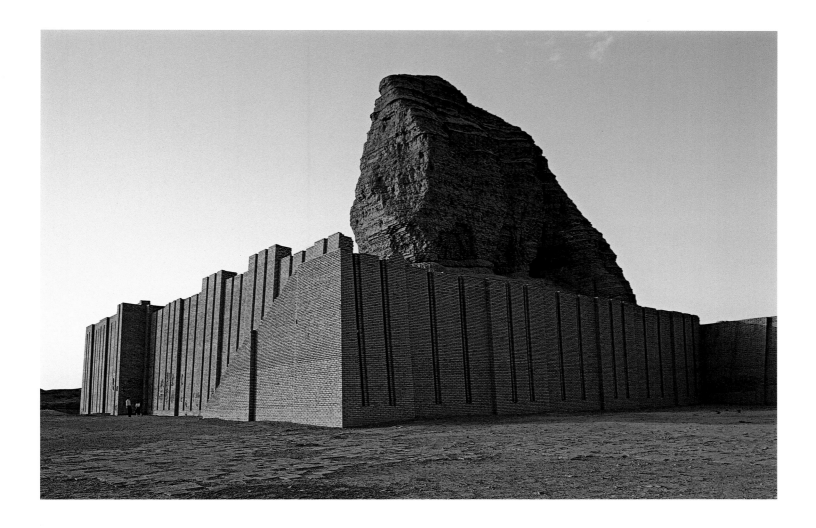

58. The restored remains of the fifteenth-century BC ziggurat at Aqar Quf (Dur Kurigalzu).

OVERLEAF
59. The facade, in baked, molded bricks, of a temple dedicated to Ishtar by Kara-Indash in Uruk in the fifteenth century BC. This reconstruction is in the Vorderasiatisches Museum, Berlin.

(covering at least twenty-two acres [9 hectares]) has been partially excavated (Aqar Quf 2). The rooms were arranged around multiple courtyards, in accordance with the current style, but we know of no parallel to the very distinctive way in which they were disposed. The builders also seem to have made great use of the arch, and some mural paintings have been uncovered by archaeologists.

The Kassite epoch also produced a new type of piece: the *kudurru*. In Akkadian, the term refers to the concept of a border, or a boundary stone; in fact, they are boundary stones with round tops, whose inscriptions, where they exist, indicate land grants and sometimes tax exemptions. But instead of marking the lands in question, they are set in temples to commemorate the transaction and thus avoid quarrels about deals. Most of these *kudurru* are decorated in bas-relief and reference an entire series of gods in symbols (many of which had not been known before), perhaps to make maximum use of the space available. The lists of gods vary, and it is certainly valid to wonder whether each may refer to the gods present in the sky (in the form of constellations) at the moment of the transaction. The Meli-Shipak *kudurru* (beginning of the twelfth century; plate 60) presents, for example, the three astral symbols Sin (the Moon), Shamash (the Sun), and Ishtar (Venus), then the three most important

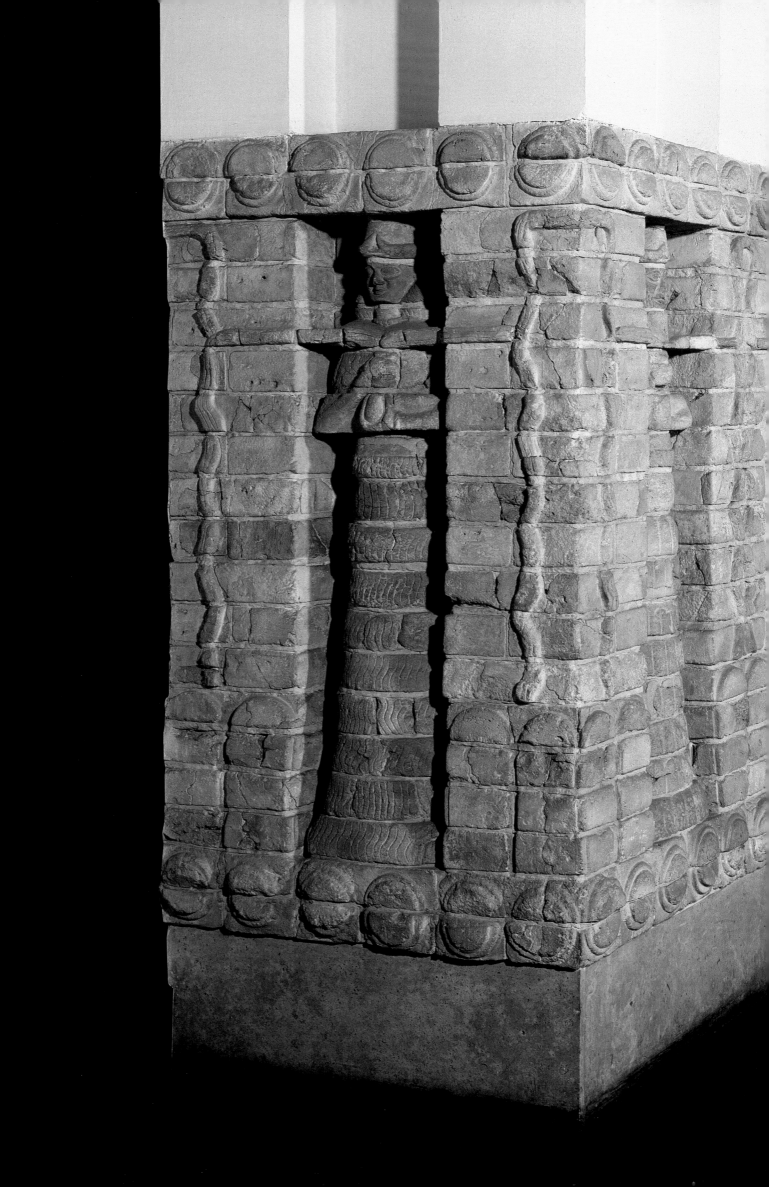

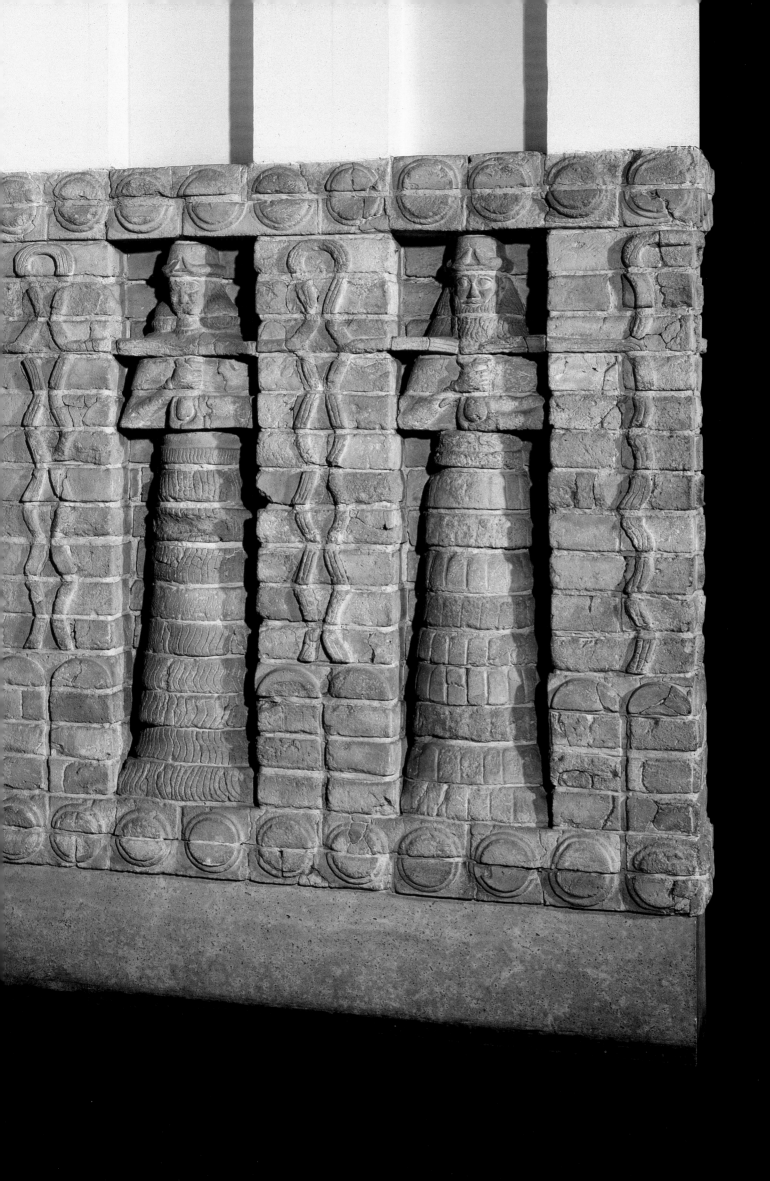

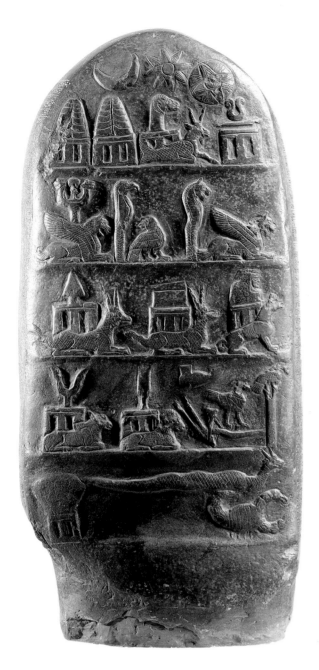

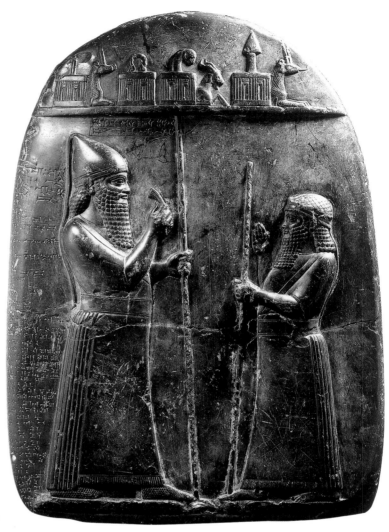

divinities of the pantheon, with the two tiaras of Anu and Enlil and a ram's head over a goat that represents Ea, while the symbol shaped like an inverted omega, farther to the right, could allude to either Ninhursag or Nintu. In the lower section, there are depictions of Ninurta (the triple-pronged weapon on a winged lion), Zababa (a pole with a bird of prey's head), Harba (a bird), Nergal (a pole with a lion's head), and another, unidentified divinity. The practice of creating this type of object survived the Kassites, from the Second Dynasty of Isin (1154–1027) until the seventh century (plate 61).

THE MIDDLE ASSYRIAN KINGDOM

The Kassite dynasty came to an end in 1155, when the Elamite Shutruk-Nahhunte conquered Babylon and pillaged the region. At the end of the millennium, however, it was succeeded by a Second Dynasty of Isin, which included Nebuchadnezzar I. But, from the fourteenth century, a new power had been rising in the middle Tigris: the Middle Assyrian kingdom, which grew around the city of Assur (eponymous with the local god). Adad-nirari I (r. 1307–1275) built a palace there, which has been only partially excavated. A temple dedicated to Ishtar (Assur 2) dates back to Tukulti-Ninurta I (r. 1244–1208 BC). Its long vestibule leads to

ABOVE LEFT
60. A *kudurru* of the Kassite sovereign Meli-Shipak (height 25½ in. [65 cm]), black limestone, beginning of the twelfth century BC; found at Susa but originally from Mesopotamia. Musée du Louvre, Paris.

ABOVE RIGHT
61. A *kudurru*, in black marble, of Marduk-apla-iddina II (r. 721–710 BC), a Chaldean king who ascended the throne of Babylon (height 17¾ in. [45 cm]). Provenance unknown. Vorderasiatisches Museum, Berlin.

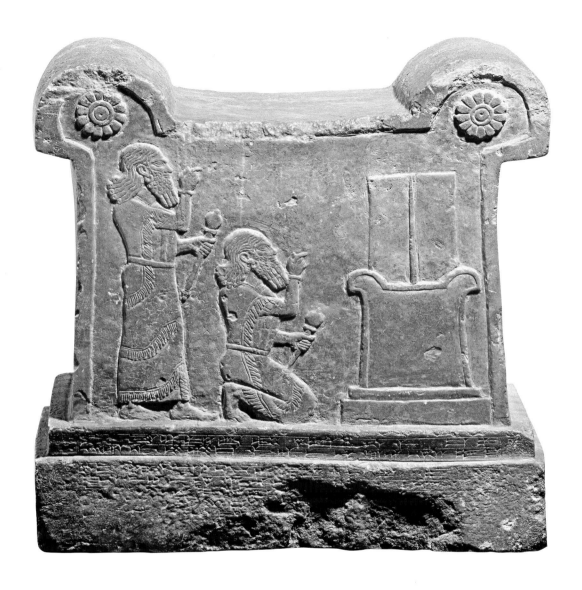

62. A cubic alabaster altar (height 23½ in. [60 cm], length 22½ in. [57 cm]) of Tukulti-Ninurta I (r. 1244–1208 BC), from Assur. Vorderasiatisches Museum, Berlin.

an even larger, parallel room, at the back of which there is a raised cella accessible by a broad, axial staircase. In one of the temple annexes, a cubic alabaster altar has been found, a kind of throne with lateral arms, upon which a divine emblem must at one time have been placed (plate 62). On the front side of the plinth there is a bas-relief of an identical altar, but this time it is associated with an emblem that is like Nabû's tablet and stylus. The inscription beneath, however, mentions another god, Nusku, charged with interceding on behalf of Tukulti-Ninurta with the other, greater gods Assur and Enlil. Before this altar the king is represented in two successive positions, standing and then kneeling, as in a comic strip. In both positions he is wearing the same fringed garment. In his left hand he carries the club symbolizing his power, and he raises his right hand and points his index finger, which could mean he is snapping his fingers to attract the divinity's attention.

A double temple, dedicated to Anu and Adad, dates back to Tiglath-pileser I (r. 1115–1077); here one finds a vast, enclosed courtyard that gives access to two twin sanctuaries, each associated with a small lateral ziggurat. In both, the vestibule is perpendicular to a large room, at the end of which is found the narrower cella.

A very beautiful cylinder seal from the thirteenth century resorts to an old royal theme, with a kneeling hero clasping a lion in his arms.

THE NEO-ASSYRIAN EMPIRE

From the eleventh century, the Aramaic threat became more pressing, and the whole of Mesopotamia soon fell into chaos. Although during the first half of the ninth century Babylon gradually reorganized itself, it was Assyria, from the tenth century on, that became the dominant power for the first time: over a few hundred years, this newly developed polity built a vast empire. Its expansion began at the end of the tenth century with Adad-nirari II and continued in the ninth century with Tukulti-Ninurta II, Ashurnasirpal II, and Shalmaneser III, at the expense of the Aramaic principalities that had set themselves up in Upper Mesopotamia. After a setback, caused by various internal disturbances, it was Tiglath-pileser III (r. 745–727), who founded the real Assyrian Empire, extending from the plain of Iran to the Mediterranean and intermittently controlling Babylon. Shalmaneser V, Sargon II, Sennacherib, Esarhaddon, and Ashurbanipal were its successive leaders. The power of Assyria was overcome only at the end of the seventh century, with the fall of Assur in 614 and of Nineveh in 612, under the combined attacks of the neo-Babylonians and the Medes.

Like those of preceding eras, the neo-Assyrian palaces were built around internal courtyards, but they also had their own special features. They had two principal areas: one was the *babânu*, whose name refers to the door, and thus to the public area; the other was the *bîtanu*, whose name refers to the house, and thus to the more private area. The throne room, situated at the junction of these two areas, is a vast oblong chamber (that of Ashurnasirpal II at Nimrud was 154 by 33 feet [47 by 10 m]) with three side entrances opening directly onto the great courtyard adjacent to the *babânu*, the main one being axial, and the other two on the right and left. The throne stood at one end of the room, usually to the left of the entrance, on a stone podium. In front of it, there was usually a paved area with two tracks, along which moved a brazier on wheels. At the opposite end of the chamber was normally a staircase that led to the upper floor, where the royal apartments were. The same arrangement of space can be found in the great private residences, but the plan of these palaces is immeasurably greater and enriched with numerous annexes.

Several of the royal palaces have been excavated, though to a varying extent. Every king felt the need, for the sake of his own glory, to build a palace that was larger and more sumptuous than that of his predecessors (the palace of Sargon II at Dur Sharrukin and that of Sennacherib at Nineveh were described as "matchless"). If the occasion arose, there was no hesitation about changing the capital: Ashurnasirpal II had already abandoned Assur for Kalhu (Nimrud), a small settlement at that time situated on the banks of the Tigris between Nineveh and Assur, and founded by Tukulti-Ninurta I in the thirteenth century to accommodate deported Babylonians. Sargon II managed to build a new capital bearing his name (Dur Sharrukin, modern Khorsabad) out of nothing, about nine miles (15 km) north of Nineveh, just as, in the past, Tukulti-Ninurta I had built a new city bearing his name (Kar Tukulti-Ninurta) near Assur. In both cases, the cities were abandoned at the (violent) deaths of their founders. Finally, when Sennacherib settled at Nineveh, it remained the capital of the empire until its fall.

Among the better-explored palaces is that of Sargon II at Dur Sharrukin (Khors. 2, 4): it has been excavated since 1842 and is clearly a new settlement, built in barely ten years by prisoners of war and deported populations. The city walls are almost square (c. 5,600 feet [1,700 m] each side) and are breached by seven monumental gates. Two buildings sit astride the wall: an arsenal to the south and Sargon's palace to the northwest. Within the palace area, an almost rectangular inner wall (980 by 2,130 feet [300 by 650 m]) defines what is known as the citadel. Here we find the residences of four high dignitaries, including the king's brother, and a temple dedicated to Nabû (Khors. 3), built on an independent terrace.

63. A view of the archaeological site of Assur with the ziggurat in the background.

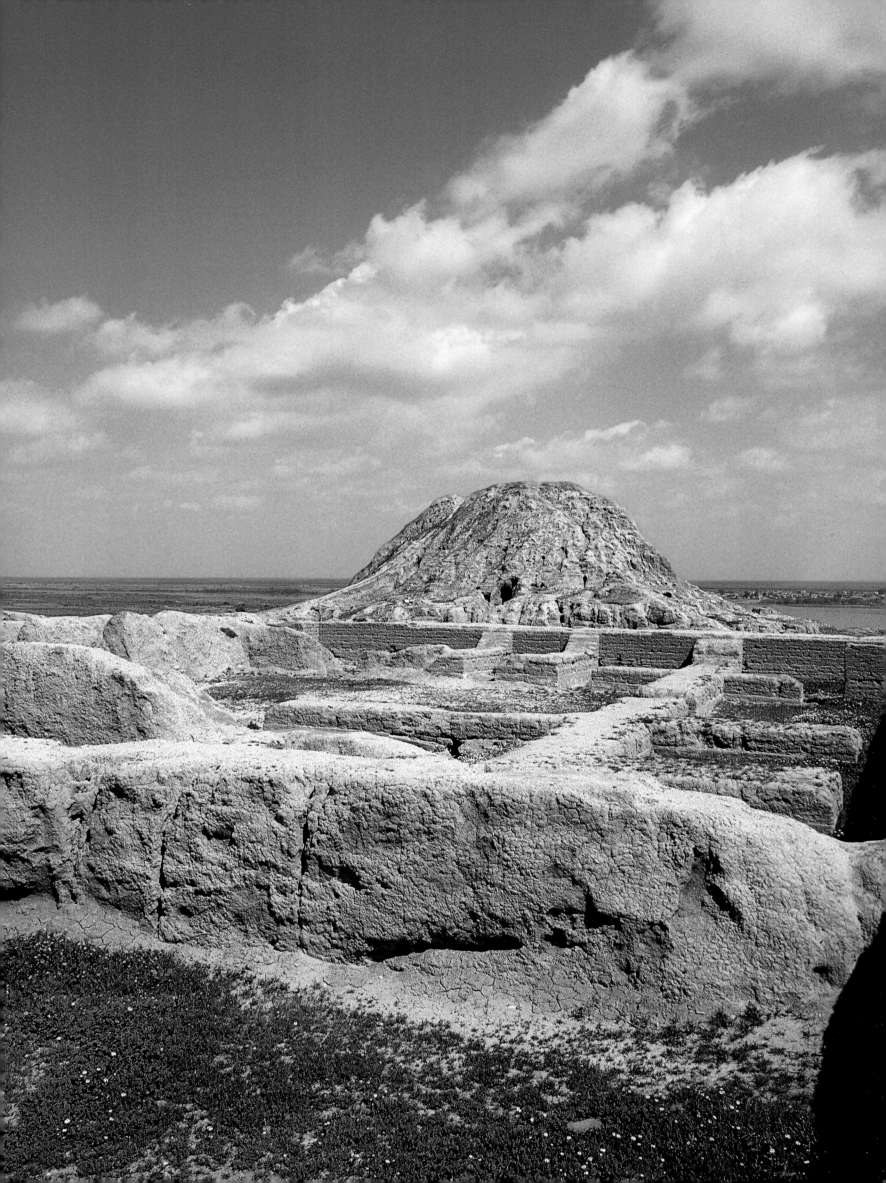

On a fortified terrace at the summit of the citadel, the palace of Sargon II dominates the city from a height of thirty-nine feet (12 m), with a surface area of about twenty-five acres (10 hectares). A monumental triple entrance, preceded by a wide, sloping ramp, leads directly to an immense forecourt (covering almost two and one-half acres [1 hectare]; XV on the plan), which was most likely where the chariots were parked. To the southeast, annexes built around internal courtyards housed kitchens, larders, and vast storerooms. To the southwest lay the cultic area, attached to the temple of Nabû by a stone bridge. Here stood three temples (consecrated to Sin, Shamash, and Ningal). Their plan, like that of the temple of Nabû, was a legacy from the Middle Assyrian period, and it is also found at various other sites such as Assur and Nimrud (Assur 3, Nimrud 4). They are dominated by a small, square ziggurat (141 feet [43 m] on a side), four stories of which still remained even at the time of the first excavations (plate 63).

The palace, properly speaking, lies more to the north, the *babânu* to the northeast and the *bîtanu* to the northwest. In the northern corner of the forecourt a monumental door leads to the court of honor (eighth century), a vast, rectangular level area of almost seventy-five thousand square feet (7,000 m²; VIII on the plan). The throne room (147 by 33 feet [45 by 10 m]) is at the center of its southwest side, with the required three doors. Behind it, a parallel room of equal length, but narrower, leads to the *bîtanu*, an almost square courtyard (more than 10,760 square feet [1,000 m²]), onto three sides of which open similarly long, parallel rooms, which must have been the apartments of state. The rest of the *bîtanu*, between this area and the great forecourt, houses three residences, of which even the smallest is nearly seventy-five hundred square feet (700 m²). But the main living spaces must have been above, on one or perhaps two floors. The rest of the area, to the northwest, has two spaces of unequal size open to the country, probably for gardens. They are separated from each other by a group of long rooms, three parallel and two transverse, doubtless further staterooms. One of these, to the northeast, is very like a small throne room, except that the principal podium is associated with a second one. To the west, an isolated building, closed off by a portico with columns of Syrian type, might have been a garden pavilion.

Such gigantism can surely be explained by the sovereign's unlimited ambition, but also by the fact that the palace had to lodge a large number of people performing quite varied functions. The king, whose least movement was managed as a spectacle, was surrounded by a true court, organized, like that of Louis XIV, with punctilious etiquette. Around him moved the nobles, the dignitaries and generals of the empire, and the high palace officials. Among these, many were eunuchs, not only to avoid the temptations offered by the vast female contingent, but also because, having no children, they could not establish powerful families of their own. On the feminine side, there was the queen mother, the royal wives, and the concubines, who would have been surrendered to seal a treaty or captured from the conquered, and their retinue. There were also children, including those who were given up as hostages by foreign princes and who, being raised in the Assyrian tradition, could one day become useful. Then there was a whole series of scribes and people capable of translating all the languages of the empire, as well as astrologers, haruspices (diviners), exorcists, and doctors who looked after the king's health and determined auspicious days for all of his actions. Additionally there were the bodyguards, musicians, singers, and all the members of the service staff (domestics, cooks, craftsmen, and others). For his palace at Nineveh, Ashurbanipal says he had thirteen thousand servants. Along with the rooms necessary for the more important functions (religious practices, reception, lodgings), the palace also accumulated products from the whole empire and therefore needed all kinds of space: administrative offices,

64. A modern reconstruction of the city walls of Nineveh.

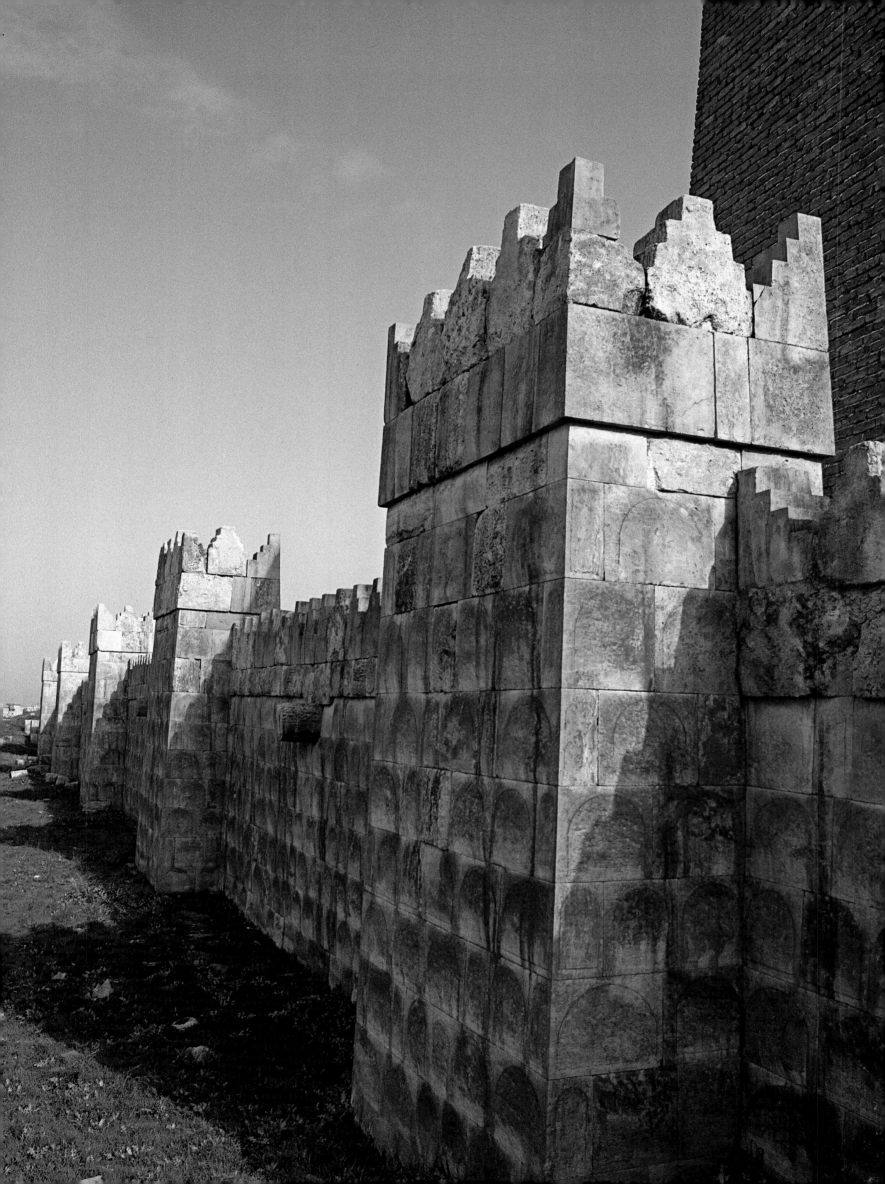

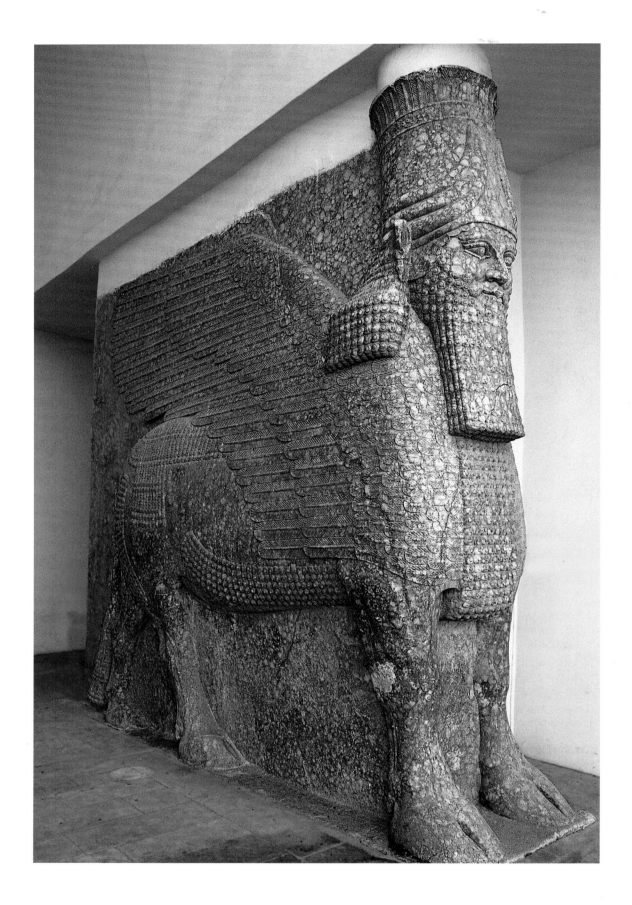

rooms in which to keep the records and libraries, functional rooms such as kitchens and larders, studios for the craftsmen, stables, and so on.

To match this architectural excess there was a corresponding orgy of decoration. The walls of these palaces were covered with sculptures, paintings, glazed-brick panels, and sometimes also metal paneling or plates, as well as, no doubt, curtains and carpets. Of course, it is mainly the sculptures in the gypseous alabaster called "Mosul marble" that have come down to us. Some have a magical character; others exalt the sovereign's greatness. In the first category we find the enormous winged, androcephalous bulls that were set in pairs at the sides

ABOVE
65. One of the andro-cephalous bulls from Nineveh.

OPPOSITE
66. A view of a partially reconstructed gateway to the palace of Ashur-nasirpal II at Nimrud, ninth century BC.

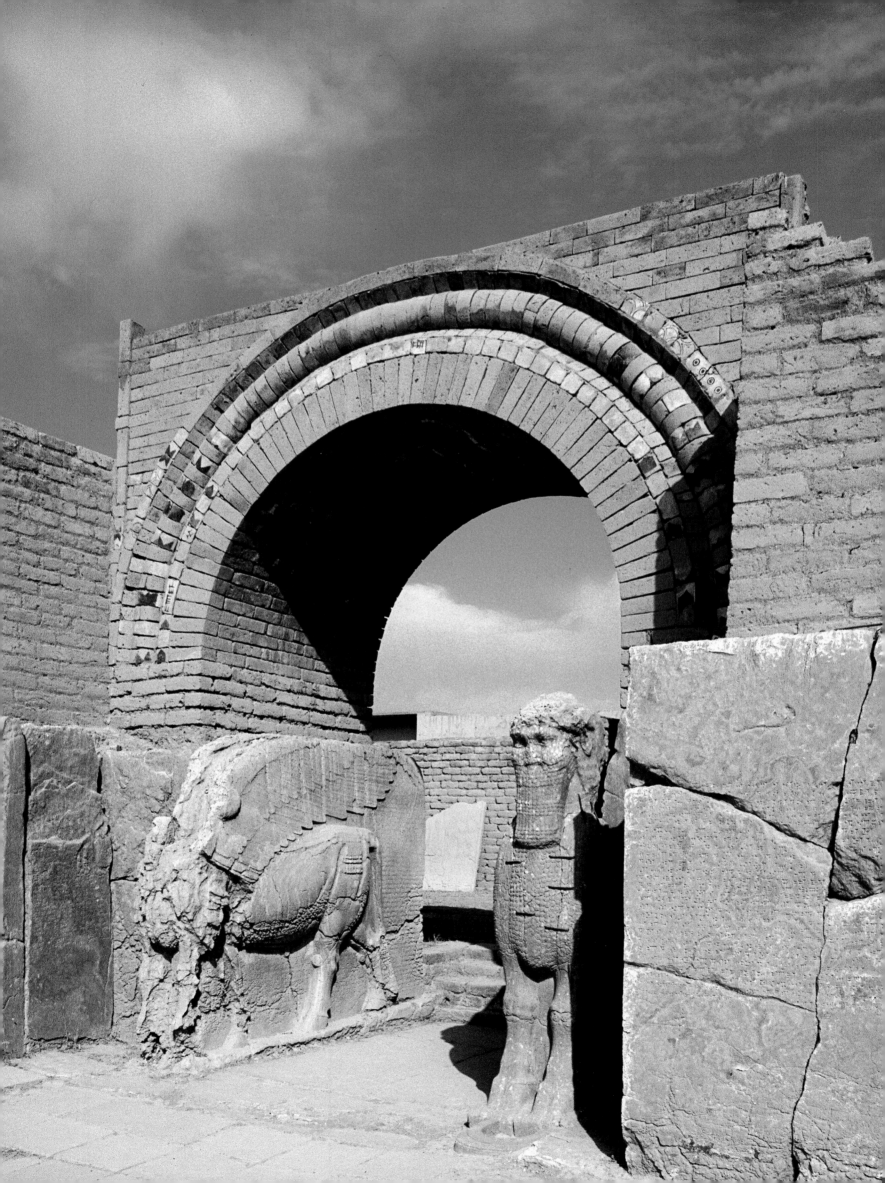

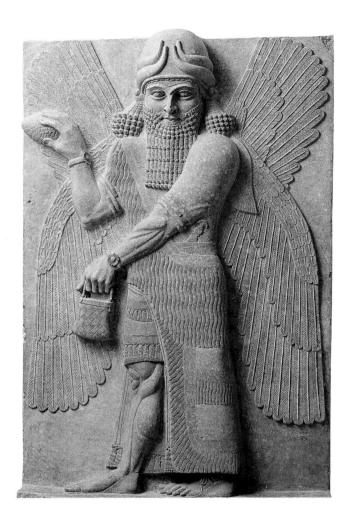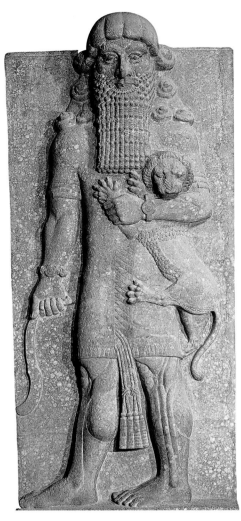

67–68. Two reliefs in gypsum from the palace of Sargon II at Khorsabad, end of the eighth century BC: a winged genie (height 10 ft. [3.05 m]) and a hero grasping a lion (height 15½ ft. [4.70 m]). Musée du Louvre, Paris.

of the main passages and charged with driving away malignant forces (plates 65–66; Khors. 5–6). The bodies are sculpted in high relief, but the heads are three-dimensional. Some have five legs, following a convention already used by the Hittites, so that they seem complete both from the front and in profile. The blocks, quarried in the upper Tigris region and roughly shaped on-site, were carried to the river on wooden sleds, loaded onto rafts, and transported to the palace for finishing. Their creation was regarded as exceptional enough to merit illustration (in the southwest palace of Sennacherib at Nineveh). Many are monoliths; some of the biggest (up to twenty feet [6 m]) are made up of several joined blocks. They began to appear in the ninth century at Nimrud in Ashurnasirpal II's palace and continued to be used until the sixth century. About thirty of these figures have been counted at Dur Shar-rukin alone, at the gates of the city and the palace of Sargon II. At the strategic accesses, they were associated on the facade with two smaller pairs of winged, androcephalous bulls, represented with their bodies in profile and their heads to the front. These secondary bulls were back to back, and in some cases (at the entrance to the palace or at the central entrance to the throne room), they were separated by a hero of similar size (nearly sixteen feet [5 m]), who grasps a small lion with his arm in a hypertrophied variant of a theme that goes back to a distant past (plate 68).

Along with these monstrous beasts appear winged genies (dipterous or tetrapterous; plate 67) with human heads or sometimes the heads of birds of prey, whose task was to attract positive forces. Indeed, they hold in one hand a situla and in the other an object like a pinecone, with which they seem to sprinkle anyone who comes near them (in the passages, for example). But, as on the panels behind Ashurnasirpal II's throne at Nimrud, these figures also appear in composite scenes: twice behind the king, who is also depicted twice, once on

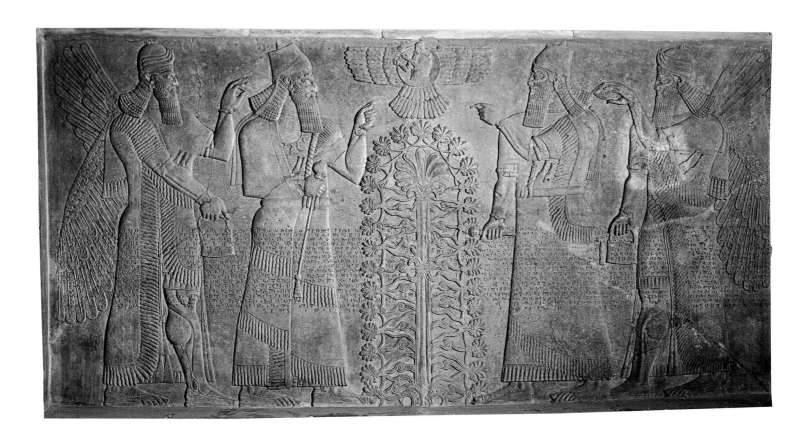

69. A relief panel in
gypsum (height 70 in.
[178 cm]), found at the
back of the throne
room in the palace of
Ashurnasirpal II at
Nimrud, ninth century
BC. British Museum,
London.

each side of the Tree of Life, which itself is surmounted by a winged disc representing the great god Assur or the sun god Shamash (plate 69). Here we have an ancient theme, with the difference that the king makes the characteristic sign of respect, while it is the winged genies who sprinkle the tree. At Nimrud, whole rooms are decorated in this way.

With the exception of some podia that bear figurative representations, the decoration of neo-Assyrian palaces consists essentially of orthostats. These are broad stone slabs placed next to each other at the base of a wall and covered in bas-reliefs, which must once have been painted, or at least enlivened with color. This type of decoration, inherited from a long Syrian and Hittite tradition, was adopted in ninth-century Assyria by Ashurnasirpal II for his palace at Nimrud. There the scenes appear to be associated with a stereotyped text, so that the image supplies particulars that are not present in the writing. But, later on, the text comes closer to the image, until it becomes a caption. The scenes that were chosen, which are often developed over sections, one above another, to a considerable height (up to twelve feet [3.7 m] in the throne room at Nimrud), are essentially dedicated to the glory of the king. Therefore, they appear in the most visible positions: courtyards, throne rooms, and reception rooms. Some recall the sovereign's religious dimension (his privileged relationship with the gods, his respect for the Tree of Life—certainly conceived in this case as a composite expression of the divinity). Others recall his building activities (the construction of the enormous androcephalous bulls, the transportation of great masses of stone or wood). But most of them show him as the absolute lord of both humans and of nature in the wild.

People are represented by long rows of dignitaries: A relief at Khorsabad shows the king, recognizable by his tiara in the form of a truncated cone, and by his sumptuous garment,

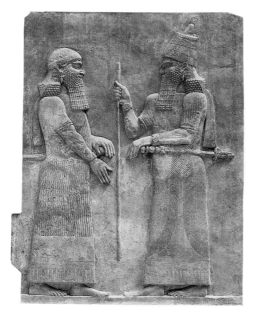

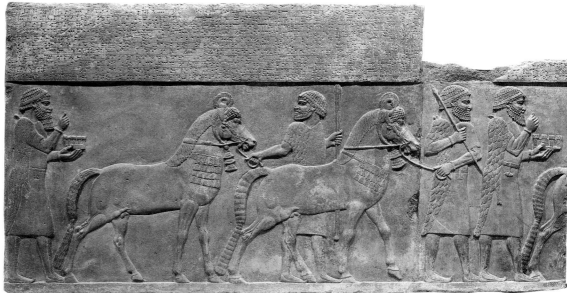

ornamented with rosettes (plate 70). Welcoming a high dignitary, he holds a long staff in one hand, and his other hand is placed on his sword hilt. There are rows of servants and tribute bearers (some carrying a crenellated model symbolizing their city; plate 71), who are moving in procession toward the sovereign. All these people are at the king's command, or belong to a subjugated group. The others are enemies crushed by the Assyrian armies or shackled prisoners. The message is clear: a choice has to be made between order and chaos, to submit or to perish.

Images of the natural world include hunting scenes with all kinds of animals (birds, gazelles, bulls, horses, hares) but, above all, lions. The lion hunt was the king's prerogative and a ritualized activity, designed to show that the sovereign was able to control the forces of evil, as his office required. Here again we find the great themes dating from the beginning of Mesopotamian iconography, but enormously developed.

The Standard of Ur (plates 28–29) or the great victory steles of the third millennium already went beyond the symbolic and might refer to a particular victory (for example, the victory of Lagash over Umma). But the huge surface offered by the orthostats (estimated to be about one and one-quarter miles [2 km] in Sargon II's palace at Khorsabad) allowed for operations to be narrated in great detail, just as history was recorded in writing in the annals that were developing at the time. To be seen are Assyrian soldiers attacking and taking cities (for example, the city of Lakish in Judea) with the help of ladders and war machines or crossing rivers on inflated goatskins, or the sovereign present at the arrival of deported prisoners. (Deportation was the fate inflicted on those who had dared to challenge the imperial authority.) At Nimrud, a composition shows a campaign conducted by Ashurnasirpal II on the Euphrates and the siege of the city of Anat on an island. Some Assyrian archers are shooting from the riverbank at clothed swimmers who are trying to escape or get back to the fortress in the background. In the palace that Sennacherib restored at Nineveh, Ashurbanipal

70–71. Panels in a gypseous alabaster, called "Mosul marble," from the palace of Sargon II at Khorsabad, end of the eighth century BC. On the left, the king receives a dignitary (height 130 in. [330 cm]); on the right, there is a procession of Medean tributaries (height 60 in. [152 cm]). Musée du Louvre, Paris.

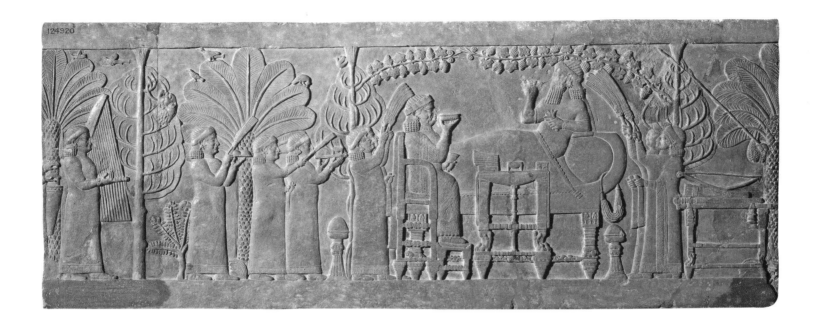

72. A bas-relief of a banquet under a pergola (height 23 in. [58.5 cm]) in the gypseous alabaster known as "Mosul marble," from the "North Palace" of Ashurbanipal at Nineveh, c. 650 BC. British Museum, London.

described his Elam campaign. After having gained the victory, as is shown by the enemy corpses being carried away by the Ulai River, an Assyrian general forces the Elamites to prostrate themselves before their new king, whom he takes by the hand. The campaigns described are real, and the victories are attributable to a particular king; this helps to explain why an Assyrian sovereign did not like to install himself in a place that had been occupied by his predecessors.

Given that war is men's business, women are excluded, and in general they have no place in an art designed to glorify the power of the sovereign and instill the fear of his wrath. However, there is a notable exception in one of Ashurbanipal's bas-reliefs at Nineveh (plate 72). In a park of pine and palm trees, the king and queen are under a pergola, the king on a couch, the queen on a throne, and each is holding a cup. They are drinking and listening to music, and servants are fanning them. Because the king has left his bow, quiver, and sword on a nearby table, we can deduce that he is relaxing after an exhausting hunt. However, the bucolic atmosphere is disturbed by a severed head hung from a branch. It is the head of a lesser Elamite king, whose defeat is illustrated in another Nineveh palace. So, in reality, we are seeing a feast to celebrate a victory, comparable to those of the third millennium, but less stereotyped.

We find this same exuberance in the hunting narratives with animals, especially lions, which are impressively realistic. Up until this time hunting scenes were limited to presenting the confrontation between man and animal. At most, on some Akkadian cylinder seals a landscape might be sketched. Now, however, the hunting scene is boundlessly spread out, and, for example, in Ashurbanipal's (north) palace a whole room is devoted to it. All the stages are minutely illustrated. It begins with the preparations, with servants gathering and checking the materials, while others see to the harnessing of the chariot, which the king has already mounted. Farther off, a tree-covered hill is occupied by people wanting to see the

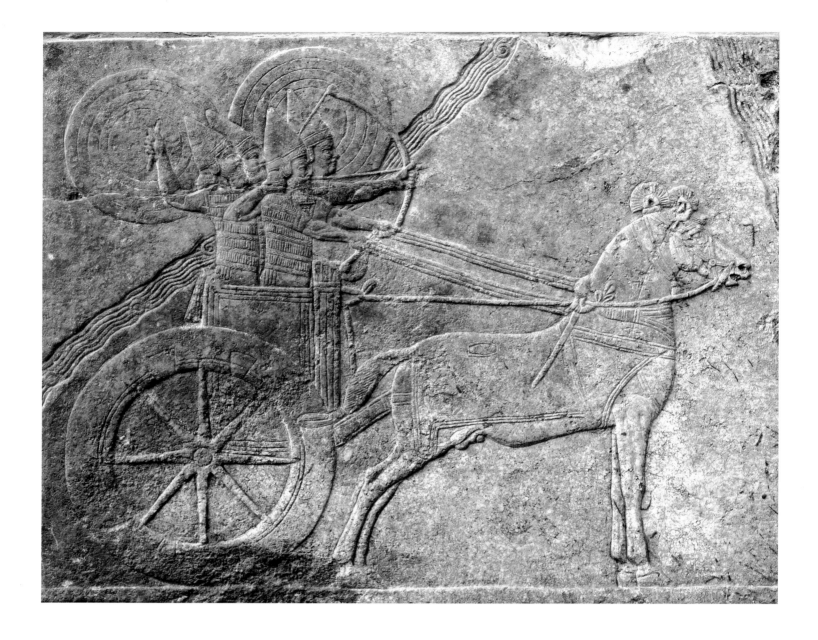

spectacle. They are separated from the hunting field by two lines of men armed with bows and pikes, who form a hedge of shields and whose task it is to create a barrier to the animals. Hunting takes place not deep in the country but in a cleared area prepared for the royal chariot. The king, who may also be on foot or on horseback, armed with a pike or sword, is seen here hunting from his chariot with his bow. Around him, horsemen and other people accompanied by hounds are ready to intervene, even though the risks are minimal. Indeed, the viewer is shown that the lions have been let out of cages, and we may ask whether they have not been well fed to diminish their aggression or even if they are semi-tame. In the wake of the royal chariot, the animals are represented as wounded, dying, or dead in all positions (plates 74–75). Farther off servants are attending to their carcasses in groups. The ceremony concludes with a libation on the piled-up bodies. If we consider that the king hunts animals as he fights his enemies, that he catches young animals as he brings back young foreign princes, that he surrounds himself with tame lions as he receives his subjugated vassals, it becomes clear that hunting and war are merely two interchangeable aspects of a single ideology, that of universal domination.

All these reliefs swarm with minutely sculpted details and represent a mine of information on the customs, hairstyles, ornaments, handicrafts (ivory veneers, like those discovered at Nimrud and elsewhere, are described with exact precision), and luxury objects that surrounded the king, as well as the weapons of the soldiers, the components of the chariots, and the horses' harnesses (plate 73).

73. An alabaster bas-relief of an Assyrian war chariot (13¾ × 18¼ in. [35 × 46 cm]), from Nineveh, second half of the eighth century BC. Vorderasiatisches Museum, Berlin.

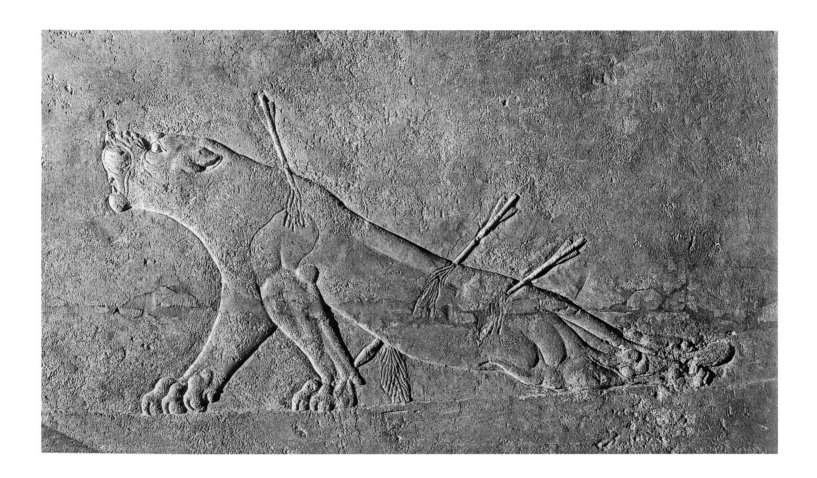

74. A gypsum bas-relief of a wounded lioness (63 × 47 in. [160 × 120 cm]), from the palace of Ashurbanipal at Nineveh, c. 650 BC. British Museum, London.

The neo-Assyrians also decorated their ceilings and walls, either above the orthostats or in place of them, with paintings. At Khorsabad, for example, Palace K (under the palace of Sargon II) was decorated in this way, and it has been possible to restore one of the paintings, which was nearly thirty-three feet (10 m) high (Khors. 7). Above three stacked friezes (bulls and kneeling winged genies), the king and a high dignitary stand before a great god who is holding the circle and the staff. A provincial palace (Til Barsip, in northern Syria) was also decorated exclusively with paintings (blue, red, and black on a white background), which date back to the eighth and seventh centuries. They comprised decorative friezes (very like those in Palace K in Khorsabad), hunting scenes, and scenes of royal audiences with rows of figures, and also winged bulls and genies charged with guarding the entrances. On one of the panels, some scribes are compiling a list of spoils brought back from a victory before the king, who is seated with a lion at his feet.

Traces of panels of enameled bricks have also been preserved. From the arsenal of Shalmaneser ("Fort Shalmaneser") at Kalhu (Nimrud) comes a composition more than thirteen feet (4 m) high, showing two facing bulls on either side of a Tree of Life (Nimrud 2). At Khorsabad, too, the temples adjoining Sargon's palace were decorated with enameled bricks. On the embrasure of the doorway the king was represented, while on either side, on the facade, there were, in succession, a lion, a bull, an eagle, a fig tree, and a plow; nearby there were artificial palm trees, whose metal coating has been partly preserved, and statues of gods with overflowing vases.

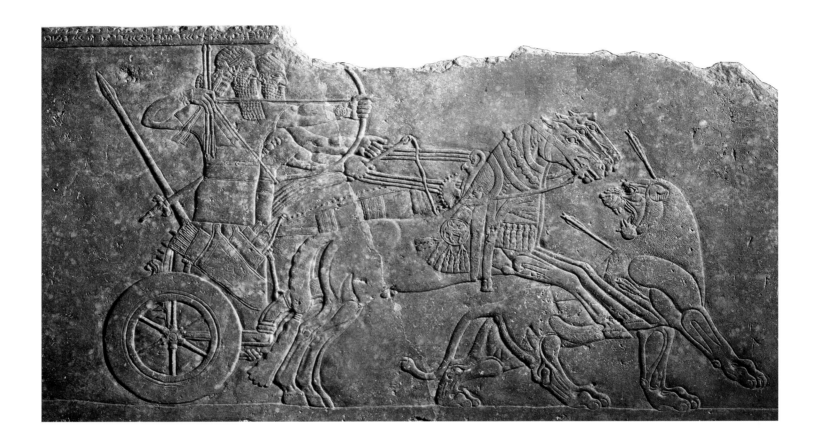

Some rooms in the palaces could also have wood paneling (some woods were especially sought after for their color or their scent) or metal paneling, which could even be of gold or silver, according to some sovereigns' accounts of their building activities. Metal could also be used as sheathing for beams, columns, and doors, some remains of which have come down to us. The most famous are those from a temple built at Balawat (not far from Nimrud; plate 77) by Shalmaneser III. The two cedar panels (four and one-half feet wide by twenty-three feet high [1.40 by 7 m]) were covered with eight horizontal bronze bands, eleven inches (27 cm) high, decorated in repoussé with a sequence of scenes representing military campaigns.

The Assyrian sovereigns left many other documents of their rule. Shalmaneser's black obelisk shows, in a series of sections one above the other, various exotic animals sent by a pharaoh to the Assyrian king (plate 76). It is famous above all for its representation of a king of Israel, Jehu, prostrate at the sovereign's feet. Some steles, which doubtless were placed in temples, represent the king standing, with one hand raised and the index finger pointing. Another shows Esarhaddon holding conquered princes on a leash that is attached to rings passing through their lips. Various steles of Ashurbanipal take up the theme of the builder-king carrying a basket.

Some Assyrian sovereigns (Ashurnasirpal II, Shalmaneser III) have left us statues (smaller than natural size) with their effigies, which show them as rigid and austere: one of these, sculpted in a very rare type of stone, magnesite, has been found at Nimrud, in the temple of Ishtar.

ABOVE
75. An alabaster bas-relief of Ashurnasirpal II from Nimrud, showing a hunting scene (height 38 in. [0.97 m]), first half of the ninth century BC. Vorderasiatisches Museum, Berlin.

OPPOSITE LEFT
76. A black alabaster obelisk of Shalmaneser III (height 6½ ft. [2 m]), 829 BC. British Museum, London.

OPPOSITE RIGHT
77. Details of two bronze bands (each 10½ × 55¼ in. [27 × 140 cm]) from the door of the palace of Shalmaneser III at Balawat, ninth century BC. British Museum, London.

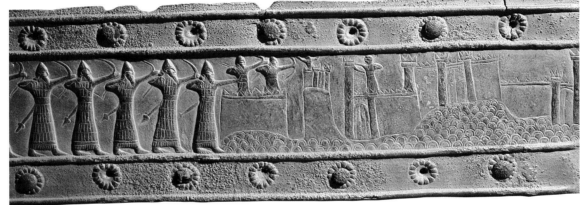

THE NEO-BABYLONIANS

Nabopolassar, the founder of a new dynasty, ascended the throne of Babylon in 629. He quickly managed to shake off Assyrian control and recover a large part of the empire. His son Nebuchadnezzar II continued this work, and it was he who conquered and sacked Jerusalem (in 597 and then again in 587), thus gaining power over the Mediterranean coast. After a period of dynastic scuffling, Nabonidus came to power in his turn, but in the end he had to yield to Cyrus II, king of the Persians, who conquered Babylon in 539. At that point Mesopotamia became part of the Achaemenid Empire and definitively lost its independence.

Nevertheless, while it lasted, their empire provided the neo-Babylonian sovereigns with almost unlimited manpower. Thus, they were able, in little less than a century, to undertake immense architectural works: everywhere, they restored traditional sanctuaries, and, first and foremost, they rebuilt Babylon (destroyed in 689 by Sennacherib, then in 648 by Ashurbanipal). They made it the splendid city described by the Bible, Herodotus and Ctesias, and then Diodorus Siculus and Strabo (Bab. 1–2).

The city proper consisted of a vast rectangle of about 1,112 acres (450 hectares) straddling the Euphrates, which was crossed by a 404 foot (123 m) long bridge. On the left bank (to the east), a triple surrounding wall, which was altogether 98 feet (30 m) wide and was bordered by a broad moat, formed a wide triangle with the river, bringing the surface area of the city up to 2,471 acres (1,000 hectares). However, we do not know to what extent this zone was

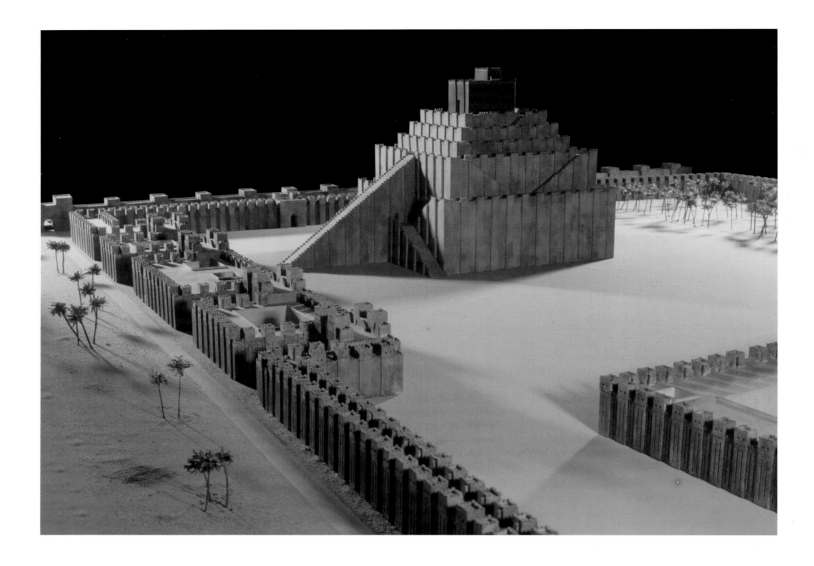

built up. The heart of the city was protected by a second surrounding wall. On the left bank, which has been better explored, this inner wall was double and again flanked by a wide moat. It had eight gates, each bearing the name of a divinity. The best preserved is the Ishtar Gate to the north, a structure that is 92 feet (28 m) wide and 174 feet (48 m) deep (Bab. 7, 10). It comprises two successive elements (corresponding to the two adjacent walls), each with two higher towers. In its final phase, today reconstructed in Berlin (plate 81), the facade was covered with blue enameled bricks on which there are reliefs of horned dragons and white and yellow bulls surrounded by friezes of rosettes (plates 79, 80). These are symbols of Marduk (the titular god of the city, who had been promoted to first place in Hammurabi's pantheon) and Adad (the storm god). Through the gate, a great street ran from north to south, called the processional way because the statues of Marduk and his divine court were carried along it to a temple outside the walls for the grand ceremonies of the New Year (Bab. 8–9). Just outside the gate, the processional way was flanked by high walls (including those of the North Palace to the west) covered with glazed bricks: these have yellow and white lions (symbol of Ishtar) in relief on a blue background.

Inside the city, the processional way passed first the South Palace, which was built of baked bricks by Nabopolassar and enlarged by his successors (Bab. 14, 15, 17). Extending along the city wall in the direction of the river, its plan formed a giant trapezium, 1050 by 620 feet (320 by 190 m) in its largest dimensions. Within this complex, various buildings, with many functions, were organized in five bands on either side of as many courtyards. Opening through three doors onto the central courtyard (the largest one, measuring about 35,500

78. Reconstruction of the Etemenanki, the ziggurat of Babylon, or the biblical Tower of Babel, c. 600 BC. This model is in Vorderasiatisches Museum, Berlin.

PAGES 94–95
79–81. Right, a reconstruction of the Ishtar Gate at Babylon (beginning of the sixth century BC), decorated with enameled brick reliefs. Left, two of the reliefs, of a lion and a mythical animal. Reconstruction: Vorderasiatisches Museum, Berlin; reliefs: Istanbul Archaeological Museum and National Museum, Baghdad.

square feet [3300 m²]), was the throne room. This chamber was immense, 171 feet (52 m) long and 56 feet (17 m) wide, making an area of almost 9,700 square feet (900 m²). The facade on the courtyard side is decorated with enameled bricks, showing prowling lions, Trees of Life, and friezes with palmettes and rosettes (Bab. 16). In the northeast corner of the palace, an imposing building had long rooms on either side of a central corridor. For a long time this is where researchers situated the famous Hanging Gardens (Bab. 18). To their disappointment, however, it seems that they were simply storerooms, as is shown by the amphoras and administrative records that have been found there. Today, we wonder whether the ancient writers might have confused Babylon and Nineveh, where we do know of the existence of gardens from Sennacherib's texts and Ashurbanipal's bas-reliefs.

The processional way then reached a series of temples. Coming out of the Ishtar Gate, opposite the South Palace, one would see the temple of Ninmah, built by Ashurbanipal on the Babylonian model (Bab. 7, 8, 13). It is a building with the appearance of a fortress, measuring about 174 by 115 feet (53 by 35 m) and built around a central courtyard, which leads to two parallel, oblong rooms, the antecella and the cella. Farther to the south, other temples have been found: the temple of Ishtar of Akkad (Bab. 11–12) and the temple of Nabu sha hare and then those of Gula and Ninurta. But before reaching these last two, at a distance of about 2,950 feet (900 m) from the Ishtar Gate, the processional way forked to the west, in the direction of the bridge over the Euphrates, to cross the sacred *temenos* (Bab. 3). To the south stood the temple of Marduk, the Esagila ("the house with the raised top"; Bab. 6); to the north, the ziggurat, the Etemenanki ("the house of the foundation of sky and earth"; plate 78, Bab. 4–5). This temple has been only partially excavated, because of the enormous mass of earthworks (more than sixty-six feet [20 m] high). Archaeologists have drilled a great sounding in the center, and, from it, they have excavated several galleries. The structure was built using baked bricks, and is a further thirty-three feet (10 m) in height. Its almost square plan (c. 280 by 260 feet [85 by 79 m]), open on all sides, was organized, in the usual way, around a central courtyard that gave access to the antecella and then the cella. Other parts of the building so far remain to be revealed.

The famous Tower of Babel was on the other side of the processional way, to the north, inside a surrounding wall thirteen hundred feet (400 m) on a side. Today, very sadly, all that remains is its footprint on the ground. It was built of unbaked mud bricks in the eighteenth century and then enlarged several times. Its rebuilding by Nebuchadnezzar II can be reconstructed thanks to a tablet called "Of the Esagila" that describes it. It was covered in baked bricks, had a square footprint 295 feet (90 m) on a side, and it stood seven levels high, including the temple at the top. The first level, of 108 feet (33 m), was accessible by two symmetrical staircases set against the southern facade. A transverse staircase led directly to the second floor, between fifty-six and fifty-nine feet (17 and 18 m) high. The next three floors were less high and led to a temple on the top floor; texts suggest that this building, at its summit, was covered in blue enameled bricks.

While many architectural remains have been discovered, very few figural monuments have come down to us: we know of hardly any besides a few steles of Nabonidus, which show him standing, holding a long staff in his hand.

After the conquest of the city by Cyrus II, Babylon became a Persian satrapy, governed by Serse. The Persians built a palace in Babylon, decorated in enameled bricks, with a great hall constructed with columns in the Iranian tradition.

Alexander triumphed definitively over Darius III at the battle of Gaugamela in 331 and made his victorious entry into Babylon in 330, where he died seven years later, before he

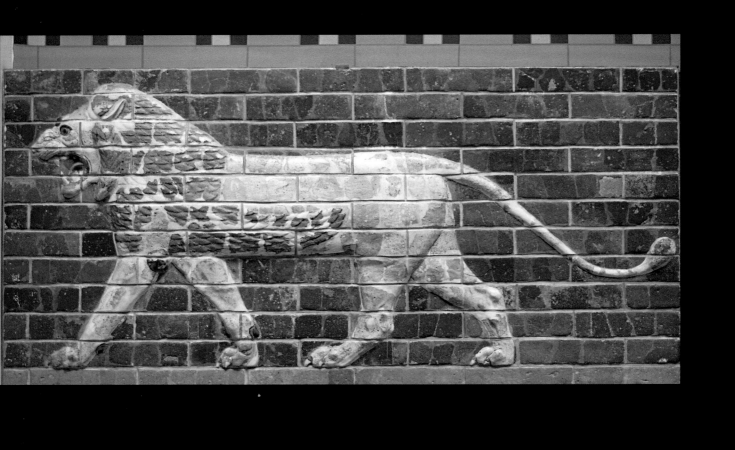
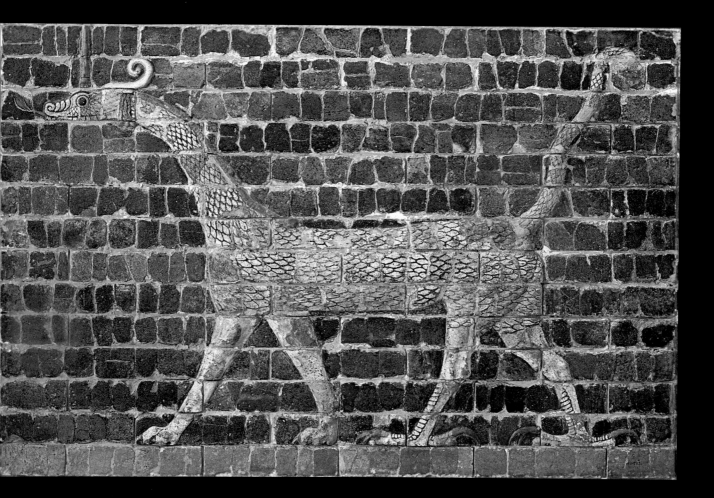

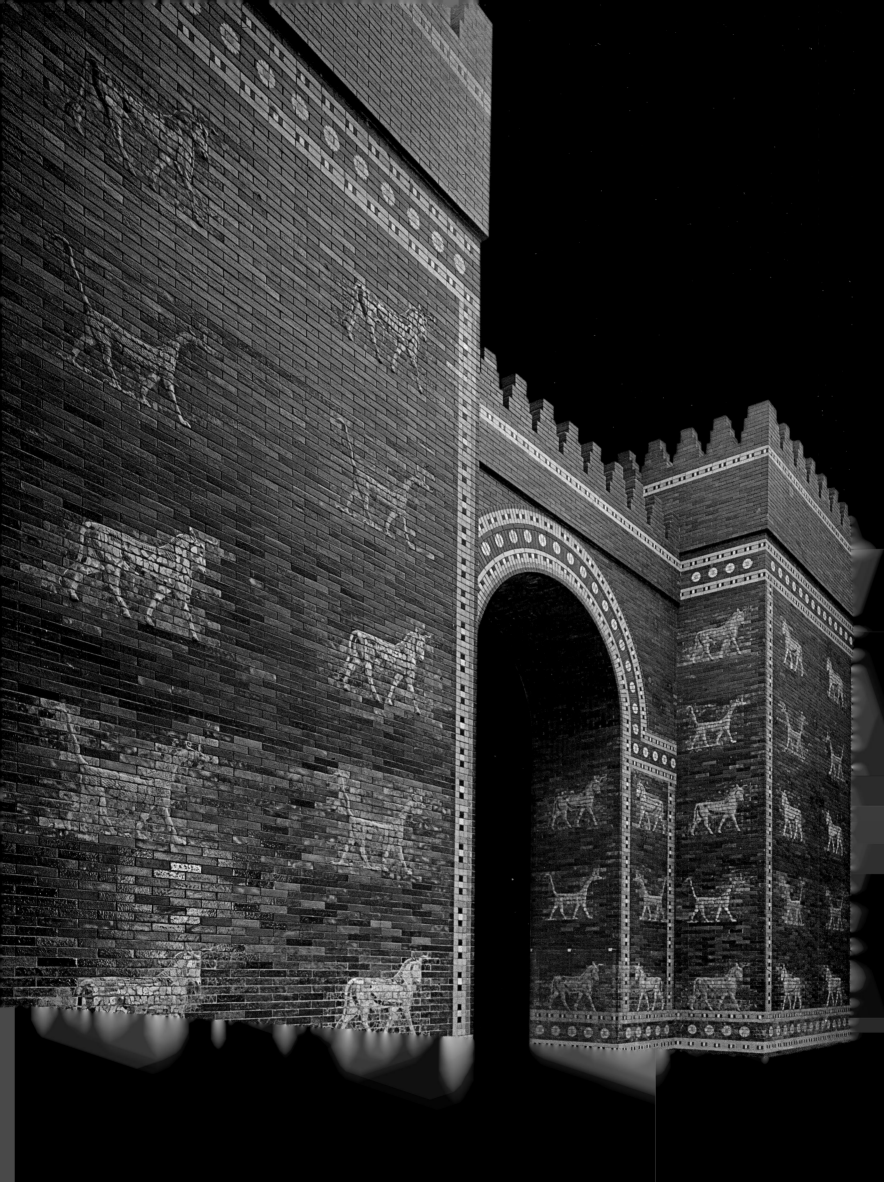

could even manage to rebuild the ziggurat in the way he wished. It seems that his body was laid out in Nebuchadnezzar's throne room. The subsequent penetration of Hellenism, which began in the Persian era, increased under the rule of the Seleucids, Alexander's successors. Ideas, techniques, and new fashions flooded in from the West, and, ultimately, Greek became the official language. It finally brought to an end the cuneiform culture, a culture that had lasted several millennia, and had, in its day, expressed what may have been the greatest flowering of the human intellect in action up to that point in history.

3
HELLENISM IN MESOPOTAMIA

Carlo Lippolis

THE DREAM OF ALEXANDER THE GREAT

"And now I am not far from the end of the world, and passing beyond this, I have resolved to open to myself a new realm of Nature, a new world . . . I at least shall not be found wanting, and wherever I shall fight, I shall believe that I am in the theater of the whole world. I will give fame to unknown places. I will open to all nations lands which Nature had moved to a distance." Thus Alexander the Great addressed his soldiers during the Indian campaign.[1]

The deeds of Alexander the Great, which between 336 and 323 BC led to the formation of a huge albeit transitory empire extending from Greece to India, left an indelible mark on the history and culture of both eastern and western peoples. Alexander's entry into the East opened the way to complex processes of cultural interaction, reinforced through his active policy of "colonization and urbanization" of the conquered regions. Recent research in the fields of history, archaeology, and epigraphy has created a strong awareness of the prior existence of complex ancient cultures in the areas conquered by Macedonia, highlighting the rich and variegated picture resulting from the encounter between the western and eastern worlds. For some time, therefore, attention has been focused on the complex intercultural processes stemming from contact between the different civilizations, highlighting just how inexact it is to speak in absolute terms of the civilizing work of Greek culture.

One of the points that has received most attention in the historiography is the marked dichotomy underpinning Alexander's attitude toward eastern cultures. This ambiguity derives, on the one hand, from his interest in indigenous cultures and his dream of an ecumenical empire engendered by the fusion of peoples: "He tried to bring [Persian customs] into closer agreement with Macedonian customs, thinking that by a mixture and community of practice which produced good will, rather than by force, his authority would be kept secure . . ."[2] On the other hand, the imprint of his Greek upbringing (it should be remembered that Aristotle was his tutor) led him to identify non-Greeks with the "barbarians": "Alexander's new subjects would not have been civilized, had they not been vanquished."[3] But, beyond cultural motives, it is clear that from the outset Alexander was politically aware of the impossibility of governing such a huge, heterogeneous empire without taking into account its oriental component. The foundation or "Hellenization" of cities, the installation of garrisons and Greco-Macedonian craftsmen within the territories, the use of typically Greek institutions and forms of government even in the most remote regions, mixed marriages,[4] respect for

indigenous traditions in the eastern territories—all these are aspects of a multi-focal vision of a new political and universal order. It is not this chapter's concern to explore Alexander's ecumenical dream; however, while the brevity of the Macedonian's career and the aversion of some of his successors to political openness toward the easterners allow one to admit only cautiously, at a historical and political level, to a real interest in the fusion of peoples, it is nevertheless necessary to recognize the existence of a perhaps more tangible "cultural ecumenism" capable of bringing the most distant provinces of the known world near to those of the Mediterranean basin. It is in such cultural and artistic terms that archaeologists today recognize an eastern Hellenism that was well adapted to the indigenous local traditions and had entirely different characteristics from the Mediterranean version.

THE GREEK PRESENCE IN MESOPOTAMIA

In the spread and affirmation of this heterogeneous cultural process (which was to reverberate in both the East and West right up to the medieval period), a determining role was played by the Seleucids, the Macedonian-Iranian mixed-blood dynasty that inherited the eastern provinces conquered by Alexander. Among the countries of an immense empire extending from the Mediterranean to the lower slopes of the Hindu Kush, it is Mesopotamia that assumed the primary role as the center of the new, ecumenical unity of eastern Hellenism, since it was a country of ancient traditions and the original core of the Seleucid Empire. For thousands of years, the Land of Two Rivers had been the seat of prosperous and powerful urban centers until becoming, in the neo-Assyrian and neo-Babylonian periods, a central region with broadening international horizons in the cultural, political, and economic spheres.

The earliest mentions of the Greeks in Mesopotamian sources go back to the eighth century BC: some texts, edited by the chancery of the neo-Assyrian kings, record military contacts with the Greeks of Ionia and Cyprus at the outset, subsequently furnishing information about Greek tributes and individuals who became established in Mesopotamia. Neo-Babylonian sources cite them in foreign trading exchanges. It is well known, however, that the interaction between Greek and eastern cultures goes back even further. After the initial stirrings of the Minoan and Mycenaean periods, the formation of an independent and coherent Greek art began with the geometric period, in which the influence of eastern iconographic motifs and themes in art and architecture was clear. These were to become decisive in the "orientalizing" production of the eighth to seventh centuries, contributing to the artistic and conceptual reworking of the Daedalic period and emerging in the production of Proto-Corinthian and Corinthian ceramics, which clearly evince close cultural contact between the Mediterranean and Near East. However, from the sixth century BC onward, this diffusion of great artistic themes from Mesopotamia to the Mediterranean basin reversed course: henceforth eastern regents and aristocracy were in close contact with Greek culture and devised a new courtly style. The Greek colonies of Asia Minor—and the larger Greek presence in Mesopotamia and Iran—began to change the direction of cultural flow, resulting in a stronger influence from Greek culture and craft techniques on the eastern tradition.

The Achaemenid period represents a crucial moment in the circulation of Greek cultural influences in the eastern regions. It was the Achaemenids, albeit historically enemies of the Greeks after the Persian wars, who played a key role in the promotion of exchanges and contacts between craftsmen and workshops. Darius I ordered stone from Ionia and Lydia for his

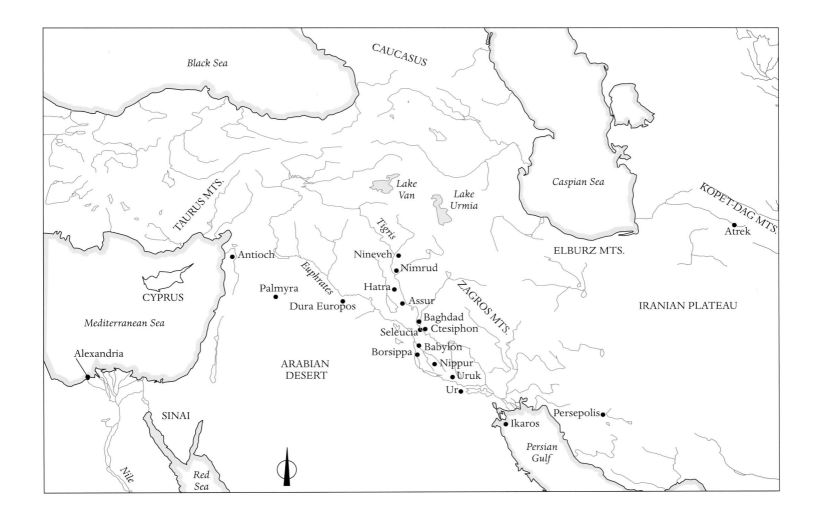

82. Mesopotamia in the Hellenistic, Parthian, and Sasanian periods.

palaces at Susa and Persepolis, while Ionic carpentry techniques were introduced into Babylon, chosen by the new masters of Mesopotamia as one of their royal residences. Clearly Greek influence went beyond technical progress or the handling of construction materials to pervade the minor arts, as is superbly exemplified in both glyptic art and coins.[5]

It was as the setting of the meeting between East and West that Mesopotamia maintained its pivotal economic, historic, and cultural position even after the downfall of the eastern empires. The southern part of the country, an inexhaustible granary within the Achaemenid borders, became the junction of the major trade routes linking the Mediterranean to the Persian Gulf and, by extension, the Indian subcontinent. This was a legacy that, after Alexander, was passed on to the Seleucids, rulers of an immense, politically unified kingdom that was also characterized by heterogeneity and independent drives.

The archaeological landscape of the Mesopotamian region is highly meaningful, although it should be remembered that the data we possess on this period is scanty. There are a number of reasons for this—both the physical and geographic context of Mesopotamia (which led to the use of perishable building materials such as unbaked brick) and the widespread thought that the Hellenistic Mesopotamian world was a peripheral area have at times posed limits to archaeological research. And yet, systematic excavations of the Seleucid levels of important city centers have been carried out in Babylon, Seleucia, and Uruk. Even if such data may refer only to a portion of a wider cultural and geographic context (the southern part of the entire Mesopotamian region), it may still provide us with a reasonably detailed picture of the Greek presence in the Land of Two Rivers.

THREE CITY CENTERS
Babylon

Following his magnificent victory over the Persians at Gaugamela (331 BC), which opened the doors of Mesopotamia, Alexander marched triumphantly into Babylon, offering himself as its new and victorious king, legitimate heir to the Babylonian tradition. He subsequently spent just one month in that city before setting out again for Bactria and India, but only after having stationed Greek civil servants and a garrison in Mesopotamia. The Macedonian was to return to Babylon in 323 shortly before abandoning his dream of further conquests: ultimately, it would be his untimely death before the age of thirty-three that would bring an end to this extraordinary career. The last of Alexander's residences, Babylon would be the first of his general and successor: with Seleucus I (358–281 BC), southern Mesopotamia reclaimed its central position in the economic and cultural fields, through both its own historic prestige and the support that the Babylonian community guaranteed Seleucus's cause in his fight against his rival Antigonus.

It is well known that Alexander did not found a new capital in Mesopotamia. He chose to reside in Babylon, whose grand layout (the result of neo-Babylonian city planning), befitting an imperial capital (Bab. 2), perhaps exerted a fascination for him. In this city were applied the principles of zone division and the organization of the urban fabric that Ionic science

83. Terra-cotta from Babylon depicting the rape of Europa, possibly imported, made with a double mold (7½ × 6¼ in. [19 × 16 cm]). British Museum, London.

84. Fragment of a decorative frieze in stucco from the stage of the Greek theater at Babylon, excavated in the first half of the twentieth century (by F. Wetzel et al., t.22a).

had already absorbed and reworked with Hippodamus of Miletus, and that, in the Hellenistic period, were also applied by Dinocrates to the foundation of Alexandria in Egypt. According to classical sources, Alexander paved the way for reconstruction works after the razing and abandoning of various major complexes of the Achaemenid period.[6] Although some of the information gleaned from the classical authors has been confirmed in the field, what has been handed down does not always tally with objective data from excavations. The building activity attested in the sources for the years 327–325 (while Alexander marched to India) within the Esagila, for example, seems to have comprised only routine maintenance. On the other hand, enormous works were begun by Alexander within the ziggurat enclosure wall, concerning the removal of the debris of the ancient buildings already in ruins. The material was transported to the northeastern part of the city to create an artificial mound (Homera), where the *cavea* of the Greek theater was to be set up.

Sources also indicate that Alexander chose as his own residence the famous palace of Nebuchadnezzar II, the main seat of the neo-Babylonian rulers and subsequently the Achaemenid rulers as well. His decision was clearly informed by political propaganda, intending as he did to affirm and legitimize his own power by perpetuating ancient Eastern traditions. Inside the palace, excavations have revealed a Hellenistic level composed of typically Greek elements: fragments of antefixes and terra-cotta tiles demonstrate that, in at least one of the

palace's inner courtyards, a peristyle had been incorporated, and the remains of the pictorial decoration—consisting of geometric patterns on the courtyard facades—are also eloquently western in conception. The dating of these renovations is problematic, but judging from the excavation results, it would seem likely that the buildings go back not to Alexander but to his successors. Indeed, archaeological evidence sets a series of large-scale building works in the Seleucid period, a chronology corroborated by cuneiform sources. The respect the new rulers had for the traditional temples of Babylon is clearly in keeping with a precise political strategy of consolidating links between the interests of the dynasty and those of the local aristocracy. Likely datable to the years subsequent to the war between Antigonus and Seleucus I (after 312/11) is the renewal of substantial building in the two complexes of the city's main sanctuary of Marduk: the "low temple" of the Esagila and the enclosure of the ziggurat (Etemenanki), which had been, for hundreds of years, the core of Babylonian religious life. The overall plan of the complexes remained unchanged, and all new building activity was a calculated attempt to perpetuate the traditional forms of Babylonian architecture. This tendency can be seen in the external facades of the buildings, where the typical alternation of projections and recesses, a traditional characteristic of Mesopotamian architecture, is preserved.

However, alongside the maintenance and continuation of religious, administrative, and cultural traditions, and despite the almost total absence of archaeological evidence for Greek cults, other, purely Hellenistic institutions did exist in the city. A Greco-Macedonian presence in Babylon is felt in the appearance of innovative and purely western architectural types within the urban context. In particular, the theater (Bab. 19–20) confirms the existence of typically Greek cultural institutions within the society. Thus there was a central institution for a Greek community whose use was not limited merely to the Seleucid period, but extended to the city's last years.[7] The theater and *cavea* were erected on the artificial hill created from the debris hauled away from the ruined buildings in the main complexes of the city. The construction was in unbaked mud brick, which had always been used in this area poor in raw materials such as wood and stone. However, the columns, stylobates, bases, and elements comprising the architectural decoration, which all follow Greek models, are of stone with a plaster coating. The front of the theater stage was decorated with stucco friezes with meanders, vine rinceaux, and wave motifs after the Hellenistic tradition (plate 84). Along the edges of the orchestra stood statues on brick bases. Directly to the south, the theater gave way to a spacious peristyle court, the use of which, as either a gymnasium or an agora, is still disputed today.

As far as urban planning is concerned, Babylon maintained its original layout: there is no new foundation, and therefore the interventions during the Seleucid era belong to urban spaces already defined. Also in the case of Merkes—the quarter of the town with private housing—even if the Seleucid levels are characterized by a revival of building activity, there is no evidence of new planning of the built-up area. The units of housing continued to be set up following Babylonian tradition and in accordance with the typical characteristics of the residential districts of ancient eastern cities. The main features of the plan of each house remain unchanged, being organized around a central courtyard and with their external sides arranged in a succession of indentations. The only new contribution from the western tradition that perceptibly changes the plan is the addition of a peristyle in the central courtyard.

Seleucia on the Tigris

However, the preeminence of Babylon was destined to decline within the Mesopotamian heartland, giving way to a new capital. At the end of the fourth century BC, Seleucus I

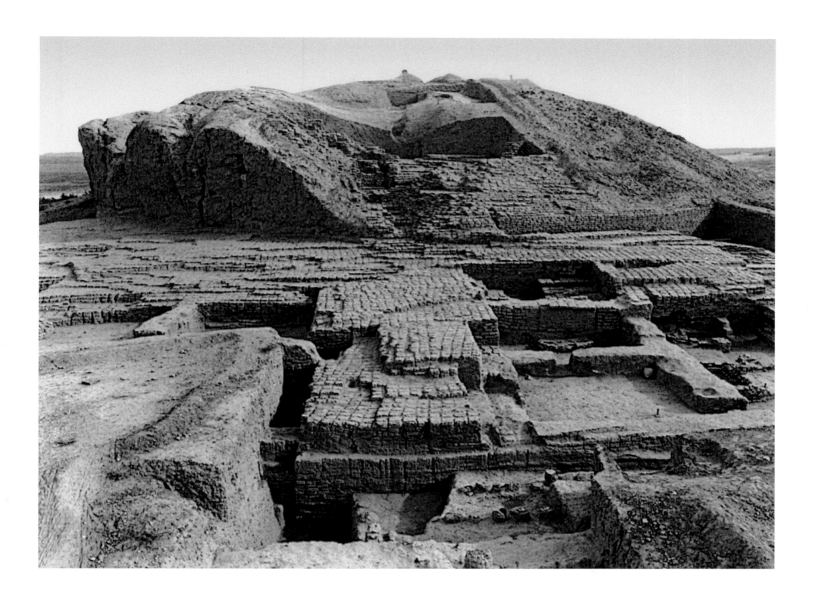

85. A view of the Italian excavations at Tell Umar, Seleucia on the Tigris.

transferred the capital of his new kingdom to the north. This meant that the capital lay no longer on the course of the Euphrates, but on the Tigris, in a region more central with respect to the principal paths of communication of the international network of exchange. Seleucia on the Tigris (Sel. 1–2) became not only the crossroads of the major trade routes, but also the true metropolis of "Hellenized" Asia.[8] The new capital, which, in the sources, is referred to as "the royal city,"[9] is an example of the politics of colonization and interaction pursued by Alexander's successors, who carried on the Mesopotamian tradition of the king as builder. Moreover, as Seleucia was a new city, planning principles that had been applied for the first time in Alexandria in Egypt were put into practice here, even if they were adapted to a more eastern context. The importance of the new foundation is mirrored in the choice of site: the city was founded at the source of the "royal canal," which had, for centuries, linked the Euphrates with the Tigris, a strategic point where the ancient Opis rose. According to Pliny, the form of the city suggested the shape of an eagle; the population, in his time, had reached six hundred thousand, making Seleucia one of the largest metropolises in the classical world. The historian's figure is probable, considering the huge expanse of the ruins (over 1,360 acres [550 hectares]). Furthermore, the city's exact limits are not known, given that the external boundary walls are no longer recognizable on the ground.

The new development retains nothing of the ancient city of Opis: the regular division of urban space into blocks (of 240 by 476 feet [73 by 145 m], the largest in the Hellenistic world) with streets at right angles is a typically Hellenistic feature. However, the functional Greek urban planning scheme, commonly known as Hippodamian, is juxtaposed with the peculiarities dictated by the physical and cultural environment in which Seleucia was located: the

86–88. Seals from the archives in Seleucia; the glyptic art of this center on the Tigris exhibits a wide variety of themes and styles of execution. The portraits stand out as examples of a high level of technical accomplishment. National Museum, Baghdad, and Museo Civico d'Arte Antica, Palazzo Madama, Turin (top right).

scale of the new metropolis had to reflect that of the massive Mesopotamian monuments. Likewise, the presence of a longitudinal axis-crossing comprising a canal of water with passable quays, harks back to an antique eastern tradition used in the larger centers of historic Mesopotamia (for example, Babylon itself). The functional subdivision of the city places to the north of the canal the official buildings and districts and centers of public life, while in the southern area of the city the housing and the commercial areas are delimited by an extensive road network. Large areas of the city have been investigated by American and Italian archaeological missions, which have enabled the town planning and the architectural and artistic culture of the metropolis to be defined even though the areas that have been investigated so far[10] comprise a tiny percentage of the whole.

The religious architecture of the center is, unfortunately, little known. The only complex that really might be thought to merit a sacred function is a small building on the northern boundary of the city, where the Seleucid levels have only been partially investigated: the discovery of an inscription in Greek naming the priests serving the city rulers might identify the building as a *heroon*, or a temple dedicated to the Seleucid cult of the deified rulers.[11]

The emphasis of recent research has shifted to the two opposite limits of the city: along the southern street, and in the area of Tell Umar, on the northern border (plate 85). On the southern street in the Seleucid period, residential buildings appeared with continuous frontages finished in fired brick as well as inner courtyards, sometimes embellished with a portico with columns between pillars. The use of the portico in domestic architecture is clearly a Greek loan that goes back to the Hellenistic period and is thereafter inherited by the Parthian

LEFT
89. A draped female figure in limestone, marble, and stucco, from Seleucia, first or second century AD (22 × 8 in. [56 × 20 cm]). National Museum, Baghdad.

RIGHT
90. A mask with *kalathos*, or wicker basket, an attribute of abundance to be found on the heads of deities and ministers of the cult that later became a widespread ornamental motif. Terracotta from Seleucia, made with a single mold (12 × 4¾ in. [30.5 × 12 cm]). National Museum, Baghdad.

period but progressively replaced with a vaulted *iwan*.[12] The southern area of the city is known primarily in its Parthian phases, since Seleucid levels have been reached only rarely. However, the construction and alterations of the later period seem to have respected the original layout, while introducing perceptible changes to the buildings and the urban spaces of the Seleucid phases: the series of open marketplaces uncovered by excavations along the south street were not themselves part of the original plan, and the whole district changed its purpose, assuming a commercial function in the Parthian period.

In the northern complex of Tell Umar (Sel. 3), however, remains of the ancient theater of Seleucia can be seen: the walls of the *cavea* and the substructures of the complex underwent a number of building phases, until it was definitively incorporated in a fortified construction of the late Sasanian period, probably a watchtower. Directly to the south there was an agora, delimited on the north-south side by a brick building comprising an aligned suite of small, interconnecting spaces, similar in layout. This building, with walls of unbaked brick and a roof of date-palm wood, was badly damaged by a fire around 129 BC. Excavations of the complex have brought to light about twenty-five thousand clay seals (*bullae*; plates 86–88), preserved because they were baked by the fire that spread through the building. These seals have allowed the identification of the site of the town archives, where, from the last quarter of the third century BC, documents on parchment and papyrus, mostly relating to the salt trade, were sealed and stored. The study of such seal impressions on *bullae* (stamped lumps of clay) has demonstrated the wide variety of the repertoire of glyptic art, and a strong connection between the cultures of Seleucid Mesopotamia. Hellenistic iconography prevails

here, but traditional Babylonian themes also play a significant role, as do, to a lesser extent, Iranian influences. Whereas the seal impressions belong exclusively to the Seleucid period, another form of production continued throughout the history of this center on the Tigris: that of terra-cotta figurines, which were produced in large quantities in local workshops (plates 90, 92, 93). The characteristics of coroplastic art in Seleucia do not differ substantially from those of another important corpus of terra-cotta figurines discovered in Babylon. The types shown are primarily Greek in style, but, inasmuch as they also represent popular religious feeling, they are often expressive of a typically local way of thought. In both Seleucia and Babylon, the style of representation ranges from the naturalistic to the strikingly stylized, and Mediterranean types and techniques of execution occur alongside motifs derived from ancient Mesopotamia. Thus, in both centers there can be distinguished a Mesopotamian group (including especially nude, standing female figures with their arms at their sides or at their breasts, but also figurines of riders and animals), a group with western-type iconography (soldiers, female figures and deities, human masks, *pinaces*, plaques with figures, etc.), and also further examples with more distinctively Iranian features, above all in terms of dress. The terra-cottas, which in chronological terms primarily belong to the Parthian cultural sphere, clearly demonstrate the coexistence of different cultural traditions in a reciprocal partnership.

LEFT
91. This female statuette in alabaster and bitumen is similar to many found in the most recent strata at Babylon, from the Hellenistic through Parthian periods. Provenance uncertain. Vorderasiatisches Museum, Berlin.

CENTER AND RIGHT
92–93. Nude male torso (4¾ × 1¾ in. [12.1 × 4.6 cm]) and recumbent seminude (3½ × 4½ in. [8.6 × 11.4 cm]), terra-cottas from Seleucia. National Museum, Baghdad.

94. Reclining nude sculpted in marble, Parthian period, provenance uncertain. Vorderasiatisches Museum, Berlin.

Uruk

A different cultural situation is reflected in the contemporary terra-cottas of Uruk, the third important center of southern Mesopotamia in the Seleucid period. Although the fundamental components are similar, production in Uruk is characterized by a greater emphasis on the eastern component, and the motifs and techniques of the Mesopotamian tradition recur more frequently than those we might define as typically Mediterranean. This more marked Mesopotamian component is also to be found in other work (statuary, for example) and in architecture in the city, thereby demonstrating that Uruk offered a slightly different cultural mix.

Uruk was the age-old city that gave its name to an entire era (the "proto-urban" one) and was crucial to the history of civilization. At the end of its expansion, it maintained its historic, cultural, and economic importance, as is attested by the range of monumental buildings that have been uncovered. Indeed, the Macedonian conquest ensured that the city became, once more, one of the most important religious centers in Mesopotamia (this is confirmed by Strabo and Pliny, who, in the Seleucid and Parthian periods, placed one of the major Chaldean astronomical schools within this city's walls). This cultural and architectural revival was decidedly conservative: throughout the whole Seleucid period, the religious architecture and cult practices of this center continued to follow Babylonian models, even though

OPPOSITE
95. A bronze statue of Herakles at rest from Seleucia (33½ × 11½ in. [85 × 27 cm]), found fortuitously during excavations and recalling, albeit with variations, the pose of the Lysippan Hercules Farnese, a motif that would also be widely used in the terra-cotta figurines of this center on the Tigris, between the first century BC and the second century AD. National Museum, Baghdad.

ABOVE
96. A crown of golden leaves from one of the Seleucid tumulus burials at Frehat en-Nufeji, just outside the walls of Uruk. National Museum, Baghdad.

innovative elements were introduced. Significantly, it was only later that the widespread use of new, western elements in the layout, decoration, and construction techniques of the buildings was recorded.[13] Among the various centers of southern Mesopotamia, it is perhaps Uruk that most eloquently conveys the clear intention of Alexander's successors to pursue a policy of both continuity of and respect for local traditions.

Besides the grandiose precinct of the Bit Akitu, a building outside the walls that was used for the celebration of the traditional New Year's festival, the Seleucid kings sponsored the reconstruction of the two most important city sanctuaries: the Irigal and the Bit Resh. Taking part in this reconstruction were two notables, both named Anu-uballit, who adopted Greek personal names alongside their original Babylonian names, thus confirming their closeness to the Hellenistic environment. The Irigal sanctuary was rebuilt in accordance with the traditional Babylonian layout, with a central courtyard and surrounding walls. The complex contained the residence of Ishtar, the goddess of war and fertility, who, from the fourth millennium BC, was worshipped in the Eanna, one of the most prestigious sanctuaries of ancient Mesopotamia; that it was still in use is demonstrated by the reconstruction of the enclosure wall and the transformation, it would appear, of the high terrace into a fullfledged stepped ziggurat. In the Seleucid era, cult practices underwent significant changes inside these city sanctuaries. The details are no longer apparent, but it is clear that the cult of Ishtar passed from the ancient Eanna to the Irigal, while the other sacred temple complex, the Bit Resh, replaced the Eanna in importance. It is the Bit Resh that underwent the

most monumental intervention in the city. The complex was entirely rebuilt in unbaked bricks (with extensive use of baked brick in the visible finishings), drawing on the designs preferred by local architectural tradition. This was the house of the divine couple Anu-Antum, with a 689 by 531 foot (210 by 162 m) external wall enclosing the temple proper and a series of structures connected to the cult and its administration. The inner rooms of the complex were organized around a courtyard, a typical scheme in Mesopotamian architecture. Equally traditional is the external decoration of the facades and courtyards with alternating niches and projections. The glazed-brick decoration of the main entrance depicts striding animals and astral motifs, and the layouts of the two temples, each with a courtyard in the front and a wide antecella and cella in succession on the axis, are also traditional.

The cultural tradition of Uruk, both in its practices and architectural forms, appears not to be so strongly influenced by Greek religious beliefs, and indeed, there is no direct evidence of any cult outside the Mesopotamian tradition except for a cuneiform text that records offerings at the table of the kings. This passage might refer to a form of dynastic cult in the Seleucid period. And yet, alongside these traditional characteristics, the Greek strand is still perceptible. Such is the case with the discovery in the Bit Resh of numerous Seleucid texts and a huge number of document seals (*bullae*) indicating the fiscal departments in charge of the salt tax, which probably point to the presence of civic archives here. Thus the administrative situation here is not dissimilar to that of Seleucia. It attests to the existence of a Greek institution (namely the archives) within the most important religious building of the city. It is, however, also through the *bullae* that we can recognize in Uruk a marked insistence on motifs (and even techniques of execution) drawn from the pre-Seleucid period, even though these are the product of the same administrative practices encountered in Seleucia and Babylon. Even in funerary practices, the city does not break with the traditional types of the area and the time (there are pit and sarcophagus burials). However, just outside the walls of Uruk, toward the north, are a group of funerary tumuli, only partially excavated, that are delimited by a circular wall of unbaked brick surrounding the burial chamber. The tumulus represents a funerary type that in no way belongs to Mesopotamian burial practices, though it is commonplace in the Greco-Macedonian tradition. It can be supposed that these tombs belonged to prominent Macedonian individuals, an interpretation substantiated by the rich finds in the burials (including two crowns with golden leaves from the Seleucid period; plate 96).

OTHER SITES OF THE SELEUCID ERA

Apart from the large cities considered above, Seleucid levels have also been uncovered in other important historical centers. Unfortunately, it often happens that our knowledge is limited to what is reported by the sources, and has been only partially confirmed on the ground. In the southern part of the territory, in Borsippa, cuneiform documents refer to Antiochus I's reconstruction of Ezida, the temple of Nabû, while in Ur, maintenance of the sacred complexes is recorded; clay seals of the Seleucid period have also been found in both Ur and Nippur, where archaeological investigations have revealed Hellenistic levels within the so-called "palace." The traditional Mesopotamian layout is preserved, but there is an addition of a peristyle with Doric-order brick columns.

As we have noted, while Babylon and Seleucia stood along the main trade routes of the time, other cities flourished through participation in the commerce between east and west. The Seleucid kings pursued a relentless policy of reinforcing the land, river, and sea trading routes between the Mediterranean and the Persian Gulf (and, accordingly, India, central Asia, and the Far East). Stops along the route that crossed the Euphrates and thus linked the

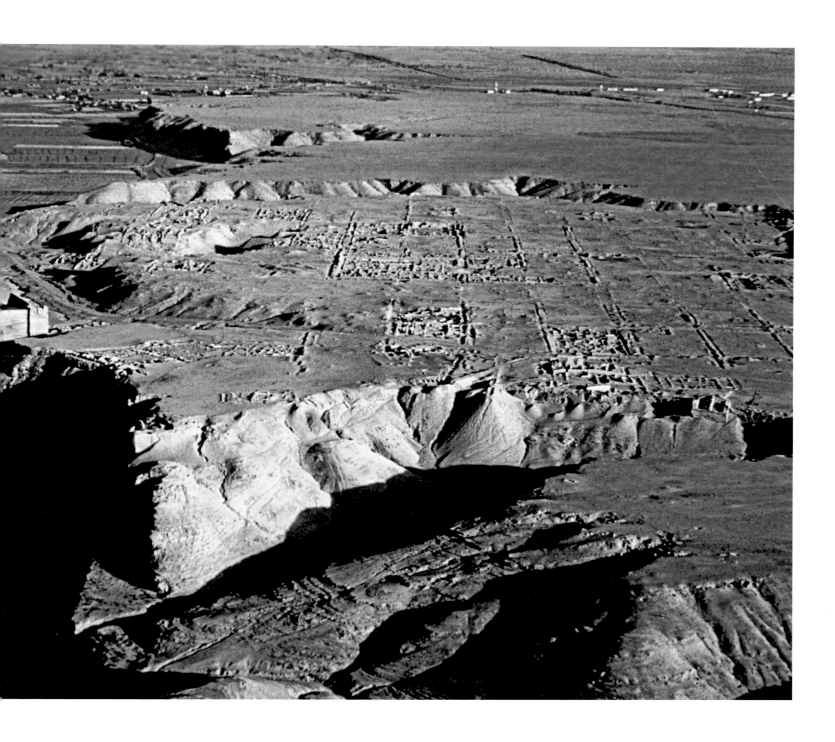

97. An aerial view of Dura Europos from the south.

Mediterranean—and Syria—to the Persian Gulf and, by extension, the Far East, were Dura Europos, Spasinou Charax, and Ikaros. According to classical sources (little archaeological evidence survives), Spasinou Charax must have been one of the major centers on the gulf: its prominence as a trading post increased in the Seleucid and Parthian periods, as it was the terminus of the land route for caravans from Palmyra. The island of Ikaros (modern Failaka) in the gulf was an equally important way station on the route to India, in use from at least the second millennium BC onward. Within the fortified enclosure erected in the Hellenistic period, excavations have brought to light two temples in the Greek style. In particular, the so-called "Temple A" well exemplifies, despite its modest dimensions, the use of an architectural vocabulary that is open to different cultural influences and traditions in terms of both its construction techniques and its decoration: the building, executed in a mixed technique using blocks of limestone and unbaked clay, has a square cella preceded by a portico *in antis* with Ionic columns. The capitals, cornices, and acroteria are particularly Greek in conception, while the high circular bases of the columns, decorated with vegetal motifs, hark back to Achaemenid architecture.

On the other hand, in the case of Dura Europos, which is situated on the present-day course of the Syrian Euphrates (an area the reader may perhaps consider to be peripheral to our current researches), we have to speak of a new Seleucid foundation (c. 300 BC). This city was intended by Seleucus I to be the strategic center imposing control over an economically prominent region along the main trading routes between the Mediterranean, the Persian Gulf, and the Iranian plateau. The layout of this cosmopolitan center and meeting point of the Mediterranean and eastern traditions is typically Hippodamian; this is borne out by aerial views today (plate 97), although the successive reconstructions of the Parthian period have profoundly altered the original appearance of the urban network. The area was divided into regular blocks (of 115 by 230 feet [35 by 70 m]), each containing eight houses. A citadel to the northeast housed the centers of power, while the southern half of the site was reserved for public buildings. For the original layout, in addition to the towered wall and the agora (occupied, in the Parthian period, by workshops and residential buildings), we possess some interesting data concerning the presumed Seleucid levels of the temples of Artemis and Zeus Megistos. The first complex comprises a temple with a *naiskos*, surrounded by a colonnade of the Doric order and preceded by two altars, within a spacious, porticoed enclosure wall with vestibules and auxiliary spaces. The second temple, dedicated to Zeus Megistos, is clearly a result of the interaction between Greek elements and various forms of the Mesopotamian tradition. If the reconstruction proposed by the archaelogists is accurate, the tripartite division of the cella, the roughly square design, the shrine outside the temple, and the outer wall are all non-Greek elements, unlike the form and proportions of the Doric columns of the entrance propylon. The existence of Greco-Macedonian religious forms is also confirmed by a text of the second century AD that mentions the dynastic cult of Seleucus I within the city.

At the time when Xenophon (401 BC) was writing, Tell Nimrud (ancient Kalhu, in northern Mesopotamia) was deserted, but we know that the pitched battle between Alexander the Great and Darius III (331 BC) took place in its vicinity.

Layard's excavations in the nineteenth century brought to light in this famous Assyrian capital Hellenistic burials containing terra-cotta sarcophagi; finds included glass vessels, necklaces in agate, amethyst, and carnelian, and ornaments in copper and silver. From the second half of the twentieth century, the excavations on the acropolis in the Ezida area, and in the so-called "Burnt Palace," revealed the existence of modest residences, often gathered in small groups. These settlement structures of the third and second centuries differ from any other contemporary village in the region: the houses customarily display an irregular plan comprising two to four rooms around a central courtyard where the bread oven was to be found. The material culture from the Hellenistic levels attests to the survival of traditional Mesopotamian features, but now combined with new motifs and with the fashions introduced by the Greeks; finds so far have been comprised predominantly of coins, imported ceramics, and mold-cast terra-cottas. Based on the ceramic types and other datable material, it appears that the village at Nimrud was abandoned after the second half of the second century BC, probably in the aftermath of the Parthian conquest. The importance of the ancient city of Kalhu had diminished after the demise of Assyrian political power; the material culture of the Hellenistic period, albeit in some cases imported, does not necessarily imply a dense network of exchanges throughout the northern Mesopotamian plain.

Nineveh, too, was an Assyrian capital mentioned in the Bible. It presents different evidence insofar as in the Greek era it displays a greater continuity with the preceding periods as a vital center of the region. Here, the Hellenistic levels are better documented, despite still largely incomplete archaeological excavations. After the abandonment of the Assyrian city following its violent destruction by the Medes and Babylonians in 612 BC, a significant

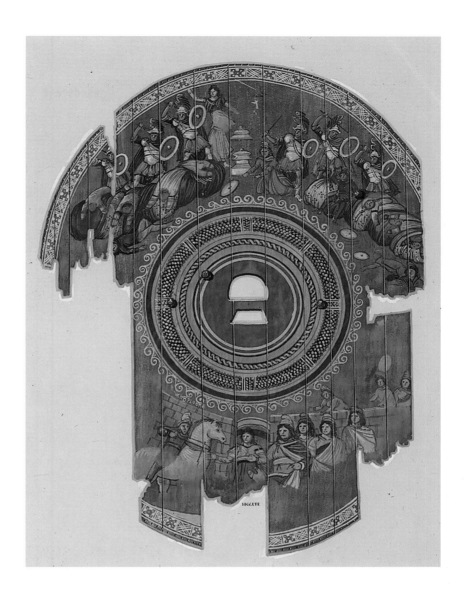

98. A shield from Dura Europos with painted scenes from the *Iliou persis,* a fragmentary poem on the capture of Ilium (Troy). Shown here in a watercolor-on-paper copy by Herbert J. Gute. Yale University Art Gallery.

revival of building activity from the Seleucid period onward is evident. An inscription found in the Temple of Nabû (perhaps restored before the Seleucid era) would appear to be connected to Greek forms of civic organization. Less certain is the presence of a temple, whose plan would be derived from Assyrian prototypes, dedicated to a Greek divinity: the statue of Hermes thought possibly to be from the temple, is in truth a rather provincial work, and perhaps dates to the subsequent Parthian period. The temple, still not pinpointed on the ground, as well as the settlement of the Hellenistic period, probably stood at the foot of the Kuyunjik citadel.

In 1985, a British expedition to the Eski Mosul area excavated a small fort at Tell Deir Situn, finding a good deal of pottery, as well as terra-cottas and a coin of Alexander Balas (r. 150–145 BC). Excavations at Grai Darki revealed a number of grain silos. The Hellenistic occupations at these and other minor sites show that northern Mesopotamia was being exploited at this time.

The symbiosis between different cultural traditions is a fundamental aspect of the multifaceted mosaic of history, peoples, and religions that constituted the Seleucid Empire. The Greco-Macedonian component depended on the extensive involvement of diverse ethnic factors in the fields of administration, politics, and culture, which contributed to the operation of the system of government and to all forms of social life.

The pictures of interrelations and exchanges offered by the various cities of Seleucid Mesopotamia are similar, although they vary according to the individual local context. Archaeological research is still far from having clarified their specific features, and the reconstruction

of the intricate cultural framework is, for now, primarily based on the three main centers of southern Mesopotamia, which reflect different patterns of interaction between the new Greek contribution and the ancient Mesopotamian traditions. Babylon itself, a city linking the Mediterranean world and the East, with its ancient prestige and age-old traditions, constitutes a unique example in which the temples and sanctuaries held their own until well after the Macedonian conquest alongside the enduring Greek presence that is attested by the textual and archaeological evidence. It is no coincidence that "two Babylons" have been spoken of, one Greek and the other Babylonian, two communities in constant symbiosis.

The presence of two distinct cultural worlds in constant dialogue was also a reality in Uruk. Here, a stronger local coloring—less receptive to Greek influence—is unmistakable; the continuation of traditional practices found expression in the reconstruction of whole complexes based on pre-Seleucid canons. However, the reflection of Greek administrative, institutional, and cultural forms is also evident, as in the case of double names, the archives building, the library, and even funerary practices. It is also possible that in Uruk the Greek colony lacked the presence it had in Seleucia (and perhaps in Babylon), where the context is clearer—inasmuch as Seleucia was a new, royal city owing much to Hellenistic influence in its institutions, architecture, statuary, coroplastic art, and numismatics. All products of Seleucia are deeply pervaded by a Greek character, which, however, never rejects the Mesopotamian environment and cultural traditions.

So Babylonia (in the extended sense of the term denoting the whole of central and southern Mesopotamia) played a pivotal role in the complicated historical and cultural events of the Hellenistic East. Recent studies on kingship, administrative practices, and the sociocultural trends of the Seleucid empire increasingly reveal the assimilation of different cultural components (Mesopotamian, Iranian, Greek) and underline an incontrovertible continuity with the preceding neo-Babylonian and Achaemenid eras. What has been defined as a "Babylonization" of the Seleucid rulers' political strategy and cultural attitudes came about because they recognized, as had also their Achaemenid predecessors, the importance of a tradition consolidated through the centuries, like that of Mesopotamia. If local workshop production was characterized by a wider variety of artistic trends, in architecture there is seen primarily the revival of traditional forms; at the same time, the respect for local cults and the promotion of rituals in the name of tradition (with the king as the recipient, officiant, and spectator) found their counterparts in the continuation of administrative forms and practices of the past: even royal titles and the image of the sovereign use the ancient idioms and iconographies. The adoption of these forms, the patronage of the traditional culture, and the close relationships with the local ruling classes all constitute tools with which the Seleucids legitimized and consolidated their own power and prestige.

The considerable variety and, at times, the ambiguity of the evidence, necessarily more complex than we have been able to illustrate in this essay, bear witness to the prevalence of the diffusion of Hellenism in the East. The spread of Hellenistic culture beyond the Land of Two Rivers to pervade central Asia and reach as far as the Indian subcontinent did not follow just one pattern, but adjusted itself to local conditions. Far from being the imposition of the culture of the vanquisher, it was a continuous interaction and adaptation of forms and ideas capable of renewing and restoring the ancient experiences of different cultures.

4
THE PARTHIAN AND SASANIAN PERIODS

Roberta Venco Ricciardi

THE PARTHIAN PERIOD

In the mid-third century BC, Arsaces I, founder of the dynasty that ruled the Parthian Empire for almost five hundred years, seized power in the Seleucid province of Parthia after the rebellion of the local satrap, Andragoras, who sought to take advantage of the weakness of the Seleucid Empire and the erosion of its power in Iran and Central Asia. This event was soon followed by the conquest of the thriving region of Hyrcania, thereby laying the foundations of Arsacid power. Despite repeated attempts by the Seleucid rulers to regain power in Iran and central Asia, the various regions of the Iranian plateau were conquered, in stages, by the Parthians.

In 141 BC, under the leadership of Mithridates I, Mesopotamia, along with Seleucia and Babylon, also fell into Arsacid hands and became part of the domain of Parthia. It was then Mithridates II (r. 124/3–88/7 BC) who consolidated Arsacid power in the region and added further territorial extensions toward Syria. The Seleucid Empire at that point was limited to western Syria, where it would soon face the pressure of Roman expansion.

It was at this time that relations with the Han dynasty of China intensified, giving rise to trade between the Far East and the West via the Silk Route, on which the Parthians, and later the Sasanians, enjoyed the most profitable position, that of the intermediaries. Mesopotamia, which was not only the most fertile region of the Parthian state, but also the natural crossroads of this route, appears to have been particularly prosperous at this time: numerous large settlements were established, even though in the second century AD the area often faced Roman incursions or civil unrest. Given the dearth of written Parthian sources, the value of archaeological and numismatic sources should not be underestimated in gaining insight into all these events.

Seleucia on the Tigris, Ctesiphon, and Vologesias

Seleucia, situated at the very center of Mesopotamia where the Tigris and Euphrates converge and holding a privileged position enjoyed by all the great centers in succession up to the Islamic capital Baghdad, was increasingly important during the Parthian period. Pliny the Elder (first century AD) estimated that the population totaled six hundred thousand inhabitants, thus rivaling the other large capitals of the period, Rome and Alexandria. Under

Parthian rule, Seleucia also boasted a certain administrative autonomy and enjoyed the privilege, granted by the Arsacid sovereigns, of striking bronze and silver coins bearing the symbols of the city. The wealth of examples, including coinage of lower denominations, recovered throughout the Parthian Empire indicates the importance of Seleucia's mint, and its flourishing trade, which was clearly not limited to local traffic. Archaeological excavation, necessarily incomplete given the area of the city (1,500 acres [600 hectares]), suggests that neither the shift of the river's course toward the east between the first and second centuries AD, which led to the abandonment of the port on the Tigris, nor the Roman conquest by Avidius Cassius in 165 AD seems to have had a decisive impact on the city. It was only in the first quarter of the third century that the city was gradually abandoned, to be replaced by a new urban center, Veh-Ardashir, established by Ardashir I, the founder of the Persian dynasty of the Sasanians.

The town still had links with Hellenistic culture in particular, above all with respect to architectural decoration and the figurative arts. For domestic buildings, we can follow the evolution of the house in the Greek tradition, with the portico in front facing onto a courtyard, into a typically Parthian one with the *iwan*. This space, once the columns had disappeared, was opened completely to the area of the courtyard.

Our evidence for domestic building comes primarily from one block (230 by 460 feet [70 by 140 m]) excavated in the thirties by an American group; during this expedition, however, only the Parthian levels, dating from the first century BC to the third century AD, were uncovered, without reaching the Seleucid strata. At the latest level, the block no longer seemed to be a complex of houses of substantially similar dimensions, as two-thirds of its entire area was found to be occupied by a single large complex, the so-called "palace." It is impossible to determine if this change, found in only one block, reflects a social transformation of the town, because research elsewhere at the site is insufficient and offers no comparative data.

According to the classical authors, the Arsacid rulers respected this large, wealthy metropolis, stationing their military camp outside the town, on the opposite riverbank, on the site of a village, Ctesiphon, which was itself later to become capital of the Parthian Empire, in the first century AD. Since the city has not yet been pinpointed, our only reference is the scanty information from written sources. It may be identified with the "old city" referred to by later Arabic authors, in which a "white palace" stood, subsequently razed in the first Islamic period for construction materials for the new capital at Baghdad.

It was probably to oppose the economic preeminence of Seleucia that, in the second half of the first century AD, Vologases I founded a new capital, Vologesias, as a trading center for the nomadic tribes arriving from Palmyra, the city of caravansaries in the Syrian desert, and the western gateway of the considerable international trade between the East and the Mediterranean. As with Ctesiphon, the exact site of Vologesias has not been identified, so we lack material evidence for the Parthian cities, *per se*, in the heart of the Empire. With the exception of Nisa, the first Parthian capital of the second century BC, none of the great centers in Asia (Ecbatana in Iran, Ctesiphon in Mesopotamia) has been investigated. Official Arsacid art is poorly represented, apart from coins, which provide evidence more political than artistic in nature. From these, we can only glean generic clues as to iconography and the transition from a more naturalistic art to a more stylized one with eastern features. Our knowledge of Parthian culture is instead based on the documentation of the peripheral sites, which are particularly rich given the relatively decentralized political organization prevalent in the Parthian Empire. The provinces, maintaining their own characteristics, lent the culture

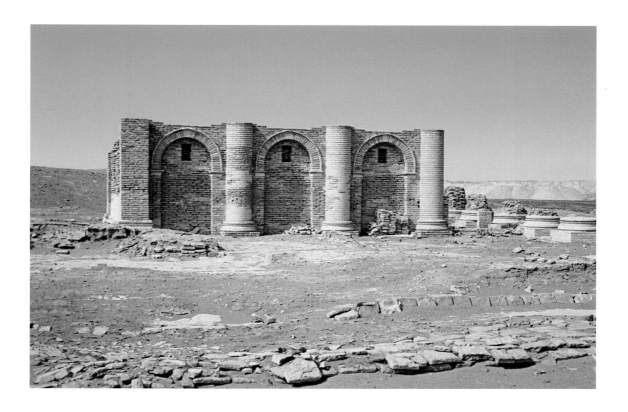

99. The temple of Gareus at Uruk, beginning of the second century AD. View from the southeast.

of the period an eclectic character, even though the general picture is distinguished by an original fusion of strong local traditions and Hellenistic elements.

Architecture in the Parthian Period
SOUTHERN MESOPOTAMIA: URUK AND NIPPUR

The architectural features of western origin in the Parthian period are, in general, more evident in the old Mesopotamian centers. A good example of this is Uruk, the Seleucid-period architecture of which does not show a substantial break with traditional forms, as is shown by the large sanctuaries in the center of the city that appear to have still been in fashion in the early Parthian period, to judge by a cuneiform tablet dated to 108 BC.

Only two hundred years later, the temple of Gareus (plate 99), which is dated by a Greek inscription to AD 111, was built in a peripheral area, most likely by foreign craftsmen. It exhibits a fusion of different elements, which is typical of Parthian culture. The old Babylonian floorplan, with a spacious cella terminating in a cult niche for the holy effigies in line with the entrance, is combined with a western-style arrangement of semicolumns on the exterior, framing arched niches. A frieze with strange beasts on the jambs is in keeping with eastern tradition and is also found at other Parthian sites, notably Seleucia and Hatra in northern Mesopotamia.

Besides this syncretism, fusing traditional and western elements, that is the hallmark of Parthian architecture in Mesopotamia, in the early centuries AD a new architectural type,

possibly of Iranian origin, also appeared: the *iwan*, a rectangular space completely open at one short end that faces onto a courtyard. Widely diffused throughout the Parthian world in religious and civic architecture, the *iwan* was frequently encountered in the architecture of later periods, up to the twentieth century, from Syria and northern Mesopotamia to as far as Iran and beyond.

In larger complexes, the *iwan* is surrounded by a corridor that buttresses the roof and pierces the facade with two smaller openings next to the main one.

In central-southern Mesopotamia, the *iwan* was used both in monumental architecture, such as at Nippur, and in residences of various dimensions, such as at Seleucia and Abu Qubur, which are separated in time by only a relatively few years, between the second half of the first century and the first thirty years of the second century AD.

At Nippur, on the remains of the old ziggurat of Enlil, was constructed a fortification, inside of which, in the last building phase, an imposing structure with four *iwans* was erected. Now in poor condition, these can probably be dated to AD 120. The *iwans*, facing each other in a cruciform design, looked onto a spacious central courtyard, as in the well-preserved palace at Assur in northern Mesopotamia. Nothing remains of the facade decoration, but the depth of the brick foundations seems to indicate that a monumental frontage was envisaged, similar to that of the *iwan* of the palace at Assur.

100. The Parthian palace at Assur. Detail showing the baked-brick molding of a jamb of the *iwan* in the northeast residential quarter.

101. A reconstruction
of the facade of the
west *iwan* of the
Parthian palace at Assur.
Vorderasiatisches
Museum, Berlin.

NORTHERN MESOPOTAMIA: ASSUR AND HATRA

Assur, the ancient Assyrian capital, which was set high on the banks of the Tigris, enjoyed a period of revitalization in the Parthian era after a long span for which the archaeological record is very slim. At this point we find a diffuse occupation over a large area of the old city and the construction of a palace in its southern sector (plate 100) and temples in its northern sector. In these buildings, the architectural and cultural syncretism is particularly striking, and the admixture of traditional western and Iranian traits leads to a wide variety of architectural solutions.

Two temples show this mingling and synthesis of diverse elements, even if the ritual they pertain to and their real significance in the context of worship remain obscure. In Temple A—whose layout, with a spacious cella closely following a Babylonian plan, evinces a strong survival of the Mesopotamian cultural substratum—Heracles, or a local interpretation of him, was probably worshipped. In contrast, the temple built in the Parthian period on the site of the old temple of the god Assur (which, as inscriptions testify, probably maintained the traditional cult of Assur and Scherua) is a new construction and altogether original in conception. In its last phase, it consisted of a complex of three *iwans* of similar dimensions and a single facade punctuated by half-columns, not dissimilar from the temples of Hatra which housed cults of a completely different origin.

However, the temple that best illustrates the architectural syncretism of the period is the so-called "Peripteral Temple," in which the cella and antecella are broad spaces in the

Babylonian tradition, while in front the spacious entrance assumes the form of an *iwan*; a peristyle, clearly of Hellenistic origin, spreads over the other three sides of the building. The tripartite facade—a large arch flanked by two smaller openings, which correspond to the columned ambulatory—is constructed in tiers in a similar fashion to the facade preserved in the palace.

The temples seem to have been concentrated in the northern part of the city, next to the old ziggurat, whereas the palace was erected in the southern part of the city, in an urban area, which, judging from the evidence unearthed to date, must have been intended for private housing.

The palace is a monument of particular importance, not only because its plan, like that of the Peripteral Temple, displays the diverse traditions and the innovations of Parthian architecture, but also because it is the only civic building of the Parthian period for which it is possible to reconstruct the decoration of the facade of an *iwan* (plate 101; Assur 4). This building was developed, in accordance with the typical eastern tradition, around a quadrangular courtyard across which four large *iwans* faced each other in a cruciform plan used to this day. The pattern is remarkably irregular, both in the form of the courtyard and in the dimensions of the *iwans* and the connecting spaces. There is a corridor, however, surrounding the *iwans*—a solution adopted, in all likelihood, for reasons of symmetry that seems to have become a fairly common feature.

The addition of a large peristyle gave a monumentality to the palace entrance on the east side; it is clearly of western derivation in its overall layout, but its function has been completely changed: in Greek houses the porticoed courtyard was the center from which other spaces radiated, whereas here the courtyard functions as a passage between the inside and outside of the building. The liberal borrowing from western types, the composite character, and the continuous and creative blend of elements drawn from different cultural environments that are typical of Parthian architecture are also clearly demonstrated by the stucco decoration of the facade of the western *iwan*, which has been carefully rebuilt from the fallen ruins in the courtyard.

The facade of the *iwan* was lavishly covered with decorative stucco, arranged in three registers of tall, slender half-columns and niches of various dimensions. The registers were divided by high trabeations embellished with vibrantly colored geometric or stylized vegetal motifs. Details such as the capitals display a jumble of elements of diverse origin, freely interpreted in a decorative spirit, but it is the overall conception of this facade that so strongly evinces the character of Parthian culture. It is a blind facade, purely ornamental, inasmuch as the different registers at the sides of the arch of the *iwan* do not correspond with the inner structure of the upper floors of the building, a feature also found in the large temples of Hatra. The articulation into various registers harks back to western architecture, but the close arrangement of the slim columns, and their irregular proportions, bring to mind the light-articulated walls of ancient Mesopotamian buildings, with their pilasters and niches. The pattern of light and shade on the facade is obtained through elements from the Hellenistic tradition, which balance the prevailing shadow of the arch of the *iwan*, thereby accentuating the two-dimensionality of the ensemble.

The importance of the facade is abundantly illustrated in the wealthy city of Hatra, the main center of the Jazira, which was a buffer state between the Parthian Empire and the Roman Empire and therefore of crucial strategic importance. Hatra is situated about thirty miles (50 km) to the northwest of Assur, with which it was in contact, as is demonstrated by

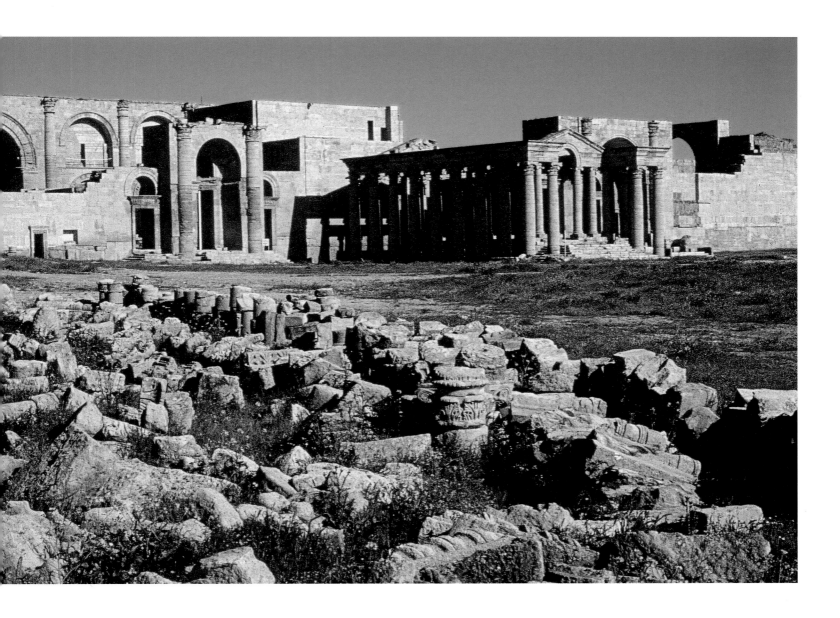

ABOVE
102. A view of the
western part of the
temenos of Hatra,
with the north-south
dividing wall.

OVERLEAF
103. The facade of the
temple of Maran in the
central *temenos* of Hatra.
There are no inscriptions
that date the construc-
tion, but it is considered
the oldest temple of the
temenos on the basis of its
western forms and some
features of its masonry.

numismatic finds. The classical sources report that it withstood both the siege of Emperor
Trajan in 116 and that of Septimius Severus in 198; according to Andrae's hypothesis, they
conquered instead the less powerful city of Assur. Hatra was taken only by the great king
Shapur I of Persia in 240/1 and thereafter was largely abandoned. Assur probably came to an
end in the same period, with the Sasanian victory over northern Mesopotamia in the first
half of the third century.

Hatra was surrounded by a semi-desertic steppe that supported vegetation only in the
spring, a condition not propitious for prolonged sieges. It was defended not only by its natu-
ral position, but above all by massive mud-brick walls on stone foundations, strengthened
with numerous towers. The exceptional state of preservation of the whole city has allowed
a clear overall vision of its fortifications, the phases of which seem to reflect the historical
events referred to in the classics.

An older surrounding wall of a probably quadrangular city has been attributed to the
period prior to Trajan's siege, when the city was described by Dio Cassius as "small and
wretched." In all likelihood, it was following this experience, and as an extension of a build-
ing campaign already majestically begun with the construction of the large temples in the
central *temenos* and the smaller ones in the built-up area, that a formidable and much more
substantial new wall was erected shortly before the second century AD using the same tech-
nique as the older one. The new defensive wall, circular in form and measuring about one
and one-half miles (2 km) in diameter, included, in the areas not yet built up, springs and

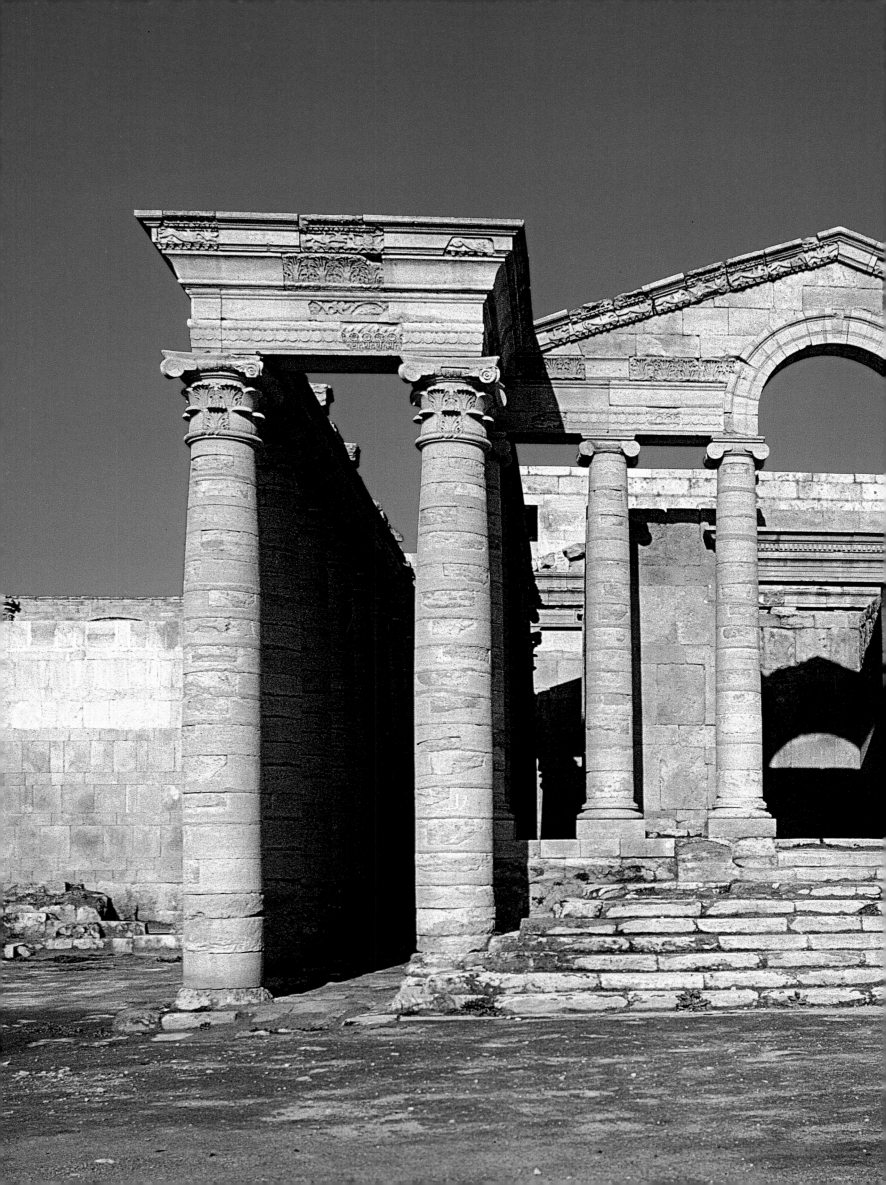

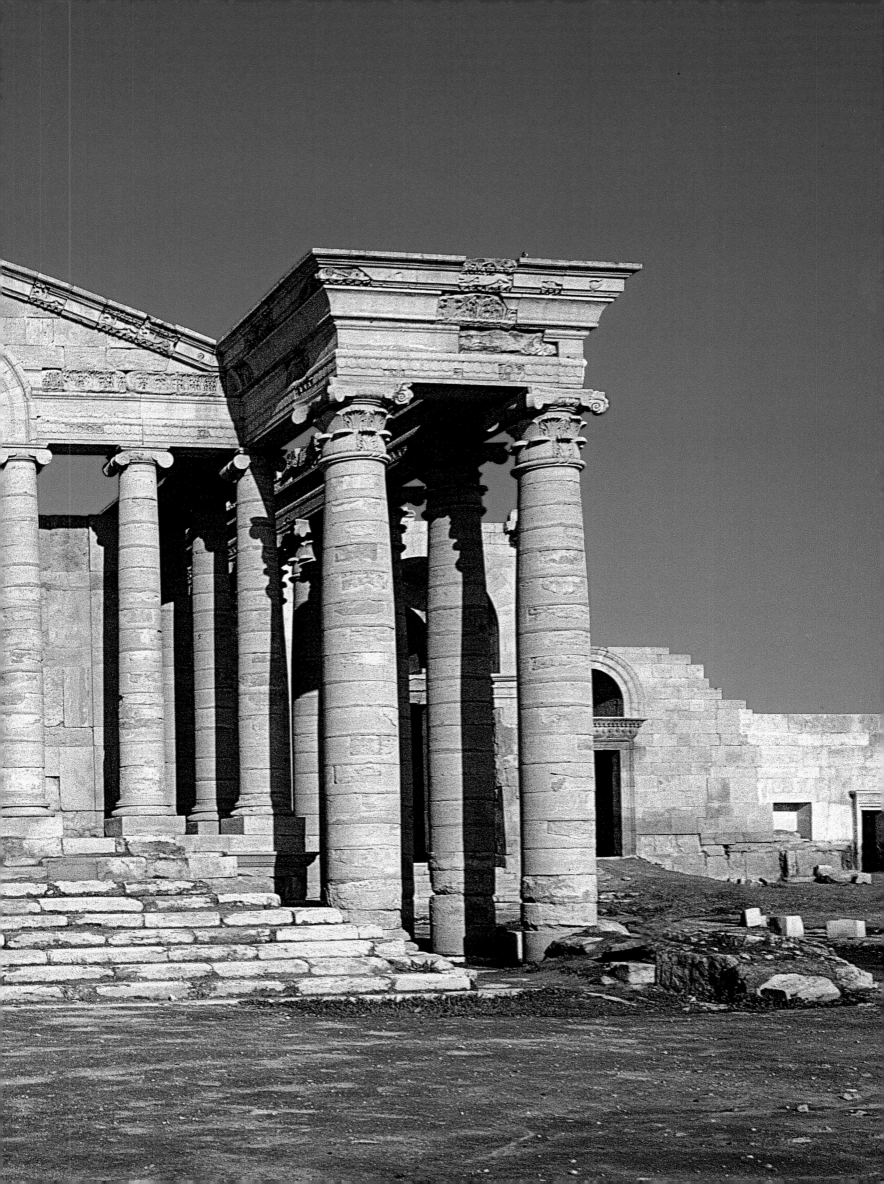

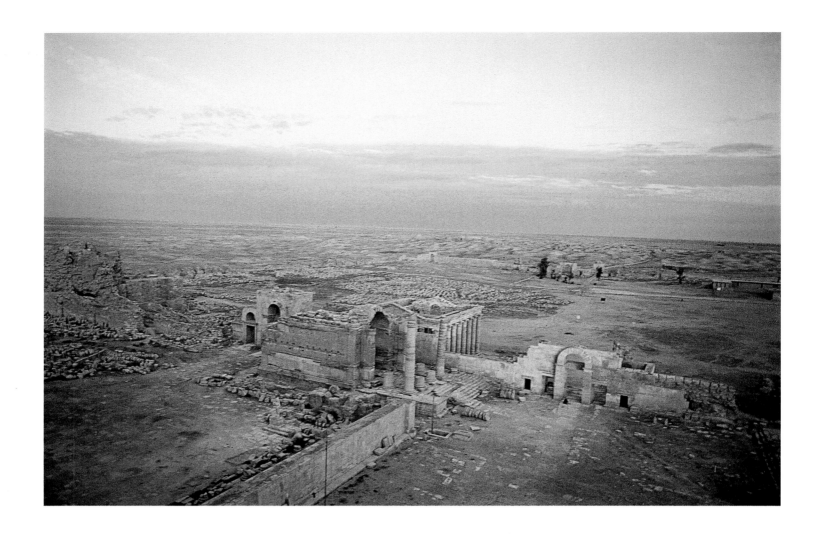

funerary buildings in stone that had formerly stood outside the defined urban area. The square towers of the wall were hollow and equipped with loopholes. The fortification was completed by a wide, deep ditch outside the wall, which was surmounted by small protected bridges corresponding to the four city gates. Following the damage suffered from the sieges of Septimius Severus, the walls were reinforced by ramparts and massive stone towers. Flights of steps on the city side allowed for access and the positioning of engines of war, like the ballast found at the north gate, at the tops of the towers.

Of the urban area of the site only a small part has been investigated, and today it looks like an endless sequence of hills and valleys, which hide buildings, streets, and squares not yet excavated, though they are apparent from the ground and in aerial photographs (Hatra 2). Such propitious conditions allowed the great archaeologist Walter Andrae, at the time director of the German archaeological expedition to nearby Assur, to study and publish his notes on the site at the beginning of the twentieth century, even in the absence of an excavation campaign.

In particular, the great stone sanctuary in the city center was preserved exceptionally well and was the subject of admiring descriptions by nineteenth-century travelers and archaeologists (Hatra 3–4). The main religious center of Hatra, it represented the essence of the city and the reason for its name, as the Aramaic inscriptions on coins testify (*Hatra di Shamash*, the Precinct of the Sun). Dio Cassius identifies the protection of the great solar divinity as one of the main reasons for the city's strength and the failure of Trajan's attack.

This large metropolitan sanctuary may well have been the pilgrimage destination of the Arab peoples before Islam. It contained the large temples, already identified by Andrae along

104. The central *temenos* of Hatra, as seen from the west from the top of the Great Iwans Complex. In the center stands the temple of Shahiru with a colonnaded *pronaos*. Behind the north-south dividing wall, the temple of Maran can be seen, while in the distance is the monumental entrance to the *temenos* and the city itself.

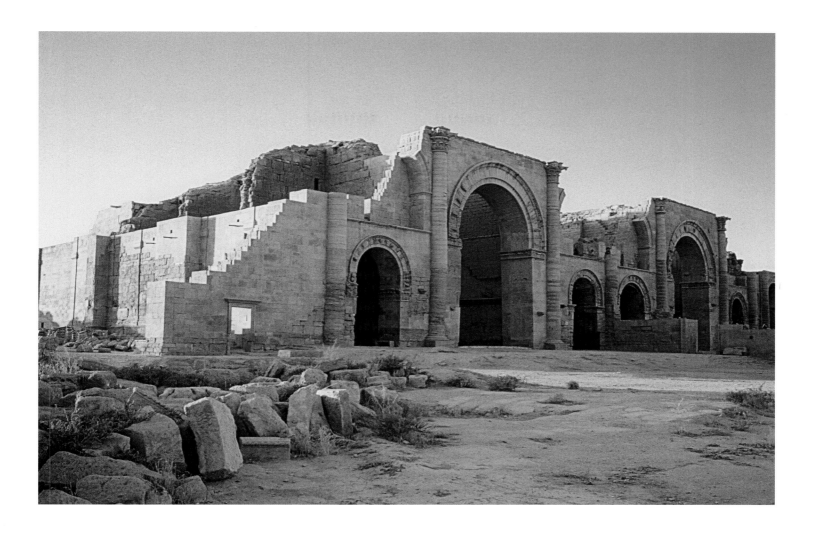

105. A view from the southeast of the Great Iwans Complex (beginning of the second century AD), which stands in the western section of the central *temenos* of Hatra. Clearly visible is the exceptionally well-preserved second story, above the smaller *iwans*.

with the palace, and completely excavated and restored by the Iraq Department of Antiquities in the fifties.

In an earlier period, the center of the site around which the settlement probably developed must have been made up of a consecrated area that only in the first thirty years of the second century AD attained its present-day aspect and dimensions of 1,427 by 1,050 feet (435 by 320 m; Hatra 5). Judging from epigraphic evidence, archaeological research, and direct observations of the structures, the current complex must be the result of numerous building campaigns carried out over a little more than one hundred years, above all in the second century AD, and the present sanctuary must have replaced older structures that were obliterated.

In the second century, Hatra, in a sort of political alliance with the Arsacid emperor, and culturally part of a Syro-Mesopotamian Parthian *koine*, enjoyed a period of great wealth that manifested itself particularly in the first half of the century, in a lavish program of monumental building that is well attested by numerous inscriptions. The head of the city at this time was a lord (in Aramaic *Marya*) who in the second half of the century assumed the title of king, or, more precisely, king of the Arabs. It is probable that, in the city's heyday, the mint of Hatra began to strike coins with symbols derived from western mints. The classical sources confirm this picture: in the description by Dio Cassius of the sieges of Septimius Severus at the end of the century, the sanctuary of the Sun is considered a complex of extraordinary wealth.

The three large gates of its main entrance faced east, as was the case for the majority of the city's holy buildings, and they opened onto a vast, almost empty space, probably intended to receive the numerous pilgrims who thronged the complex. The perimeter was furnished with spaces that faced onto the interior of the *temenos* and were sheltered by noncontinuous

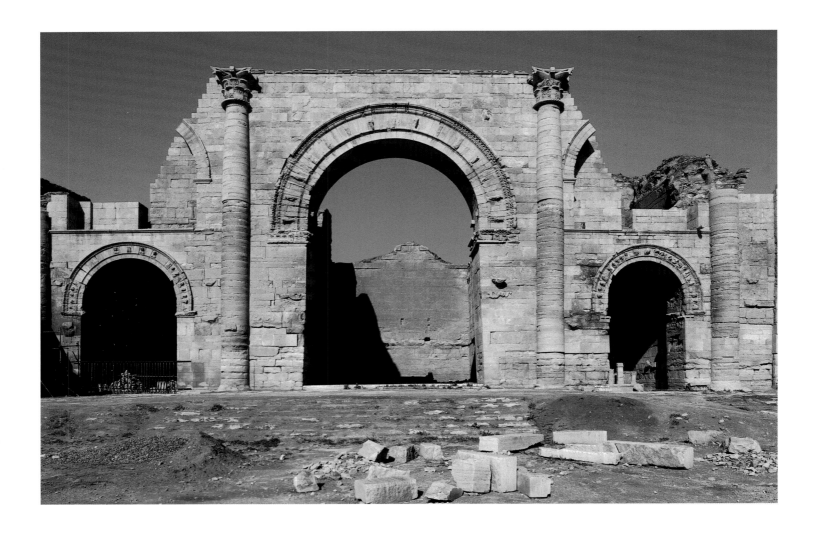

stretches of porticoes. At the end of this area stood the temple dedicated to Maran (our lord of Hatra), its architectural forms typically western in conception (plate 103). In the final phase, it had a double peristyle and a high architrave, with freely assembled western molding ending in a cornice with griffins and other fantastic creatures, scorpions, and devil's eyes, apotropaic motifs that were popular as far west as the Mediterranean. The strong chiaroscuro of the outer peristyle was enhanced by the chromaticism of the inner peristasis, conferred by its colored stuccos, mosaics, blond marble statues imported from the West, and slabs of marble with colored, often figural, inlay on the ceiling.

On the two sides of this temple, which was perhaps the oldest of the complex, monumental gateways with flights of steps led to the western side of the *temenos*. This area was six and one-half feet (2 m) higher than the eastern court, probably as a result of the overall regularization of the area to obliterate preexisting structures. Here there stood an extraordinary group of temples, all characterized primarily by a triple *iwan* format: one larger *iwan* flanked by two smaller ones opening onto a facade with decorative arches of various dimensions. The height of the vaults of the larger *iwans* was offset by the construction of a second floor, generally well preserved, over the smaller *iwans*.

The most majestic composition is the Great Iwans Complex, built at the beginning of the second century AD and facing east; it displays a facade measuring 377 feet (115 m) in length, pierced by large entrances through the arches of eight *iwans* of varying dimensions (plates 105–6). The rhythm of the large shadows of the arches was interrupted by a coeval transverse wall, probably having a cult function. Like the other temples of the *temenos*, the Great Iwans Complex was raised above pavement level, and a large flight of steps emphasized the

106. A partial view, from the east, of the facade of the Great Iwans Complex of Hatra: the large northern *iwan* is flanked by two smaller *iwans*; this part of the facade is to the far right in plate 105.

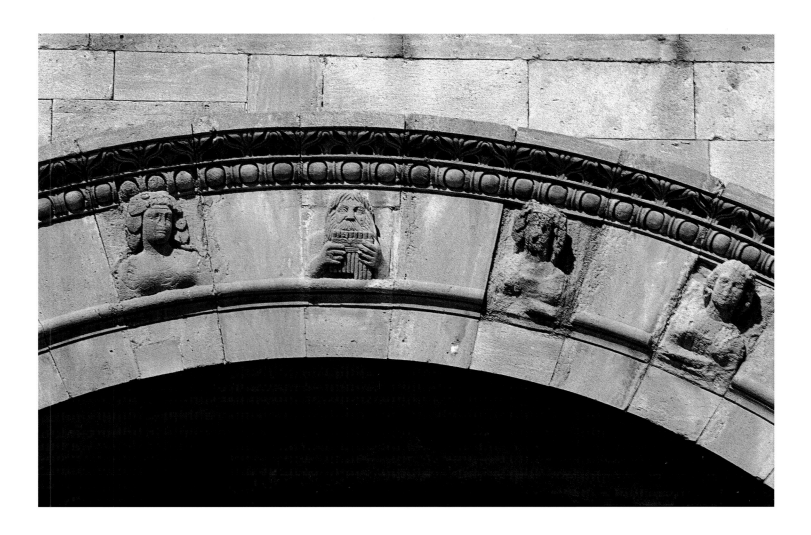

107. A detail of the decoration of the entrance arch of the smaller *iwan* on the south side of the large central *iwan* of plate 106.

importance of the sumptuously decorated facade, while the rear and lateral walls were defined by pilaster strips and bulky corner pillars. Tall engaged half-columns framed the *iwan* entrances, which boasted archivolts densely decorated with high reliefs of full-length figures, human busts, and elements of cultic significance. Brackets at varying heights, often carved with human heads, must have carried statues of the nobles of the city. Reliefs of fantastic beings were sculpted on the piers of the arches, in front of which further statues may well have stood.

The temple of Allat, which conformed to the same layout and decorative scheme, albeit with less huge dimensions, marked the close of the santuaries' great epoch of construction at the end of the second century. This temple broke the division between the two sides of the *temenos* by protruding two-thirds into the eastern area and compensated for the difference in elevation by a higher and more imposing flight of steps. Up to now only partially rebuilt, at ground level it still preserves most of the facade decoration. Judging by the remaining elements, the decoration, organized in at least three registers, must have been based on the interplay of columns of various sizes, arches, and niches covered by semidomes, with a shell decoration. The front, which most likely reached a height of one hundred feet (30 m), was, as was usual, pierced by the opening of the central *iwan* as far as the top, and by smaller lateral *iwans*, with upper rooms, whose function it was to buttress the large central vault. As in the case of the Great Iwans Complex, deities and sovereigns were represented on the keystones of the archivolts. Reliefs of camels, an attribute of the Arab goddess Allat (plate 111), and completely fantastic animals decorated the facade, on which statues of the upper class were also placed. Particularly lively was the interior decoration of the southern *iwan*, probably

once placed on the vault impost, with busts of musicians and singers welcoming the arrival of the goddess Allat, who is portrayed on a camel in a large relief at the center of the procession.

Unlike the cult buildings and public edifices of Assur or the housing and the walls of Hatra, which were primarily constructed in unbaked mud brick on stone socles, the large sanctuary of Hatra was built entirely in freestone, with a core of crushed stone and gypsum mortar. Such a technique, not indigenous to the Mesopotamian environment and clearly born of western influence, is in harmony with the Aramaic names, characteristic of upper Mesopotamia, of the sculptor-architects mentioned in inscriptions and also in keeping with the possible Syrian origin of the craftsmen, which seems to be indicated by the stonecutters' marks.

In the earlier period (perhaps in the first century AD), the architectural forms appeared to be clearly related to the western style, as shown in two of the temples considered to be older: the temple of Maran with a peristyle and the prostyle *in antis* temple of Shahiru (plate 104), both raised on a podium of Hellenistic-Roman type. From the beginning of the second century, the time of the construction of the Great Iwans Complex, the most typical architectural element of Parthian culture, the *iwan* inside a tripartite front, became predominant in the central sanctuary. Western characteristics from a Romanizing influence, however, still made themselves felt in the temples graced with *iwans*. These appear not only in

108. A bust of a youth and a horse's head. Detail of the decoration of the entrance arch of the smaller *iwan* on the north side of the large central *iwan* of plate 106.

109. A bust of a male figure wearing a crown. Detail of the decoration of the entrance arch of the smaller *iwan* to the north of the large central *iwan* of figure 106.

the model of the Roman triumphal arch, underlined by the presence of two winged Victories, and in the use of the composite capital, but, above all, in the use of the classical orders. The molding, western in form, is, however, taken out of its logical sequence in Greek architecture and used as single elements, reassembled in accordance with a purely decorative and entirely original taste, which is typically Parthian. Similarly, with the preeminence of the facade in which the *iwan* opens, the frontal vision dominates—another typically Parthian feature, and one that is more clearly expressed through the figurative arts. The western elements—engaged half-columns, capitals, and molding—constitute only superficial decoration and, although an integral part of Parthian architecture, have no profound connection to its essence. It would seem, however, that the buildings of Hatra within the great sanctuary are more western in style than those at other sites, like Assur, that formed part of the same Syro-Mesopotamian *koine*.

The temple area was not limited to the large central sanctuary; inside the inhabited precinct, numerous smaller temples were erected in the same period: fourteen of these temples, exceptionally rich in finds, have been uncovered to date. While in the buildings of the large sanctuary the new Parthian structure, with *iwans*, was used almost exclusively, the architectural plan of these other buildings is Mesopotamian, with admixtures from the Babylonian and Assyrian traditions. Indeed, the space for worship at these sites consisted of a large

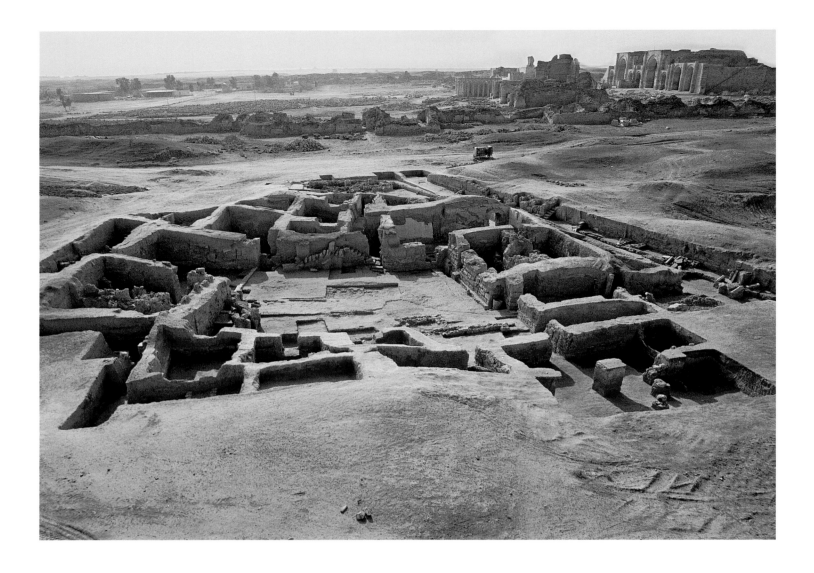

area that terminated on an axis, and at a higher point, with a broad cult niche or, more often, a deep cella intended to house the altar and divine effigy. Judging by the inscriptions, the temples, built between habitations (only sometimes isolated within their own *temenos*), lay within the competence of the Arab tribes who peopled the city. In keeping with their architectural character, it was the old divinities like Nabû, Nergal, Nanai, and Atargatis who were venerated. These were not revered in the large central sanctuary, consecrated in the main to the divine Triad: Our Lord (identified with Shamash, the Sun King), Our Lady, and the Son of Our Lord and Our Lady. However, in the smaller temples the divinities of the large central sanctuary were also venerated.

Unlike Assur, Hatra is famous primarily for its places of worship: public buildings, with the exception of the fortifications, have received far less attention. One palace of large dimensions built near the northern gate of the city, in the district incorporated in the city area after the expansion of AD 140, has been partially excavated (plate 110; Hatra 9–10). It is currently impossible to ascertain its original purpose, but it is likely that at least in the last years of the city's life it was occupied by the Roman garrison whose presence is attested by dedicatory inscriptions in the lesser city temples. The development of the palace, as was the case with all residential architecture, not only in Hatra but throughout Parthian Mesopotamia, falls in with the older eastern tradition, namely the palace developed around a quadrangular courtyard onto which opened at least one *iwan* (a novelty introduced by Parthian architecture), generally intended as the reception hall or, broadly speaking, living room.

110. A view, from the north, of Palace A at Hatra, a large, luxurious residence accessed from the north-south street visible on the right. The main *iwan* of the house (on the left) opened on to the central courtyard. On the right, in the foreground, is the area for domestic activities with a forecourt that has been only partially excavated. In the distance is the *temenos* with the large temples.

City Planning: Seleucia, Dura Europos, Hatra

Little is known about Parthian city planning. In general, the cities maintained their earlier plans without introducing substantial changes.

In Seleucia, as far as can be judged from ground and aerial photography, the Hippodamian grid layout of streets was maintained right up to the end, in accordance with the Hellenistic character of its culture, which remained more apparent there than elsewhere in the Parthian period as well. Given the dimensions of the city, research has been too scanty to allow a coherent evaluation of changes in form and function, except in limited areas, and conclusions cannot be extended to the entire city.

Likewise in Dura Europos, the town built in a strategic position on the right bank of the Euphrates in the Seleucid period but grandly developed during the Parthian period and occupation, the regular urban scheme, in the Hippodamian grid tradition, was maintained. The orientalization of the city took place, primarily, at the end of the second century BC, when the political power of the city passed into Parthian hands and the Hellenistic agora in the city center became an oriental type of "bazaar." At that time, the area lost its ordered layout, becoming thickly covered by a multiplicity of buildings with different functions, as well as streets and colonnades of various dimensions. The eastern contribution to religious architecture is plainly visible in the revival and development of the old plan of the Babylonian temple within an enclosure wall with a wealth of niches, while the Parthian novelty of the *iwan* is not evident; it is as if the Euphrates was the boundary between two different architectural areas.

On the other hand, at Hatra, a city that was founded and developed probably in keeping with the demands of the local Arab tribes, the urban network had neither the Hippodamian grid nor a radial theme. The main streets, wide and well-defined, were rarely straight. The only one that has been at least partially investigated archaeologically leads from the central sanctuary to the north gate of the city. It conveys a typically eastern flavor, inasmuch as there are multiple functions, like a present-day Arab suq, with buildings on two floors and steep flights of steps leading up to platforms on which shops and religious and domestic buildings of varying importance and dimensions are to be found, sometimes enlivened with painted facades.

Figurative Art in the Parthian Period

As in other fields of Parthian culture, but even more clearly in the figurative and coroplastic arts of central Mesopotamia in particular, the Hellenistic elements carried over from the Seleucid period remained lively and vital in the following one, albeit permeated with an eastern flavor. Besides numerous strictly Hellenistic types, both religious and secular, Mesopotamian types and, to a lesser extent, Iranian ones were produced to meet the needs of the various components of the population. The output from the different sites varies greatly, in terms of both iconography and quality: the figurines of Seleucia show a variety of types and an artistic quality unparalleled in the other Mesopotamian workshops, which are characterized by decidedly coarser worksmanship more connected to ancient local production.

The most representative figurative art in the Parthian period is not so much that of the figurines in terra-cotta (and, more rarely, in stone) of central-southern Mesopotamia in which the Hellenistic element is predominant, but rather that of the cities of the western regions, in particular Hatra and Dura Europos. The most substantial corpus of stone sculpture in the Parthian period originates in Hatra, whereas in Dura Europos is preserved, by chance and

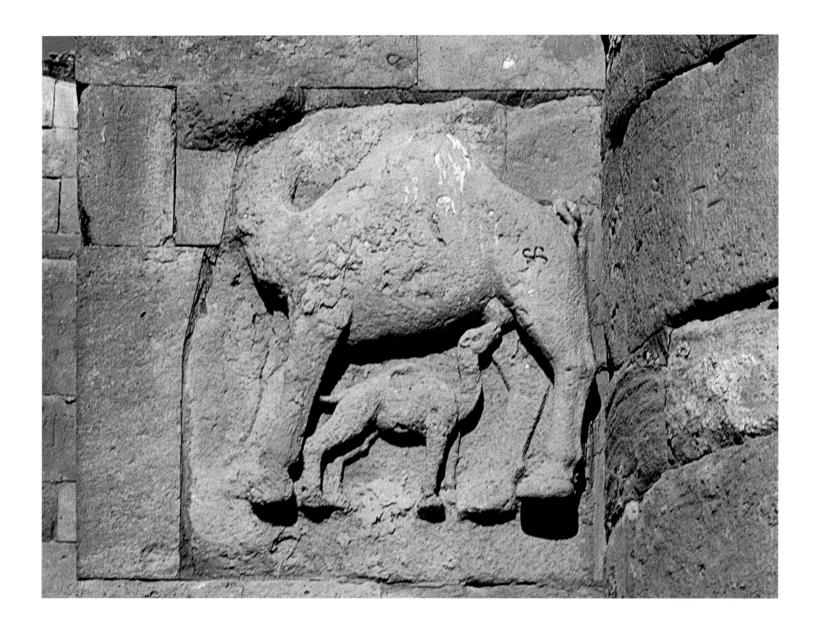

predominantly in religious buildings, an extraordinary record of large-scale mural painting. The documentation of these sites, each characterized by a similar stylistic approach, offers an ample and variegated testimony of the figurative arts in the first centuries AD. Their style probably depended on local interpretations of an art, now lost, that was produced at the court of Ctesiphon (according to Schlumberger) and reflected, with characteristics substantially similar to those of the western sites, elsewhere in the empire, particularly in the Elymaen rock reliefs of western Iran. It is possible that the essentially antinaturalistic representation that characterizes these provincial productions is connected to the progressive decline in importance of the Hellenizing strain and the phenomenon of "neo-Iranism" (Wolski), of which a symptomatic element is the appearance from the first century AD onward of Aramaic script on coins, while Greek writing becomes almost incomprehensible to the general population.

III. A camel suckling. Detail of the decoration on the jamb of the entrance arch of the south *iwan* of the temple of Allat in the central *temenos* of Hatra. The camel was the animal attribute of the Arab goddess Allat.

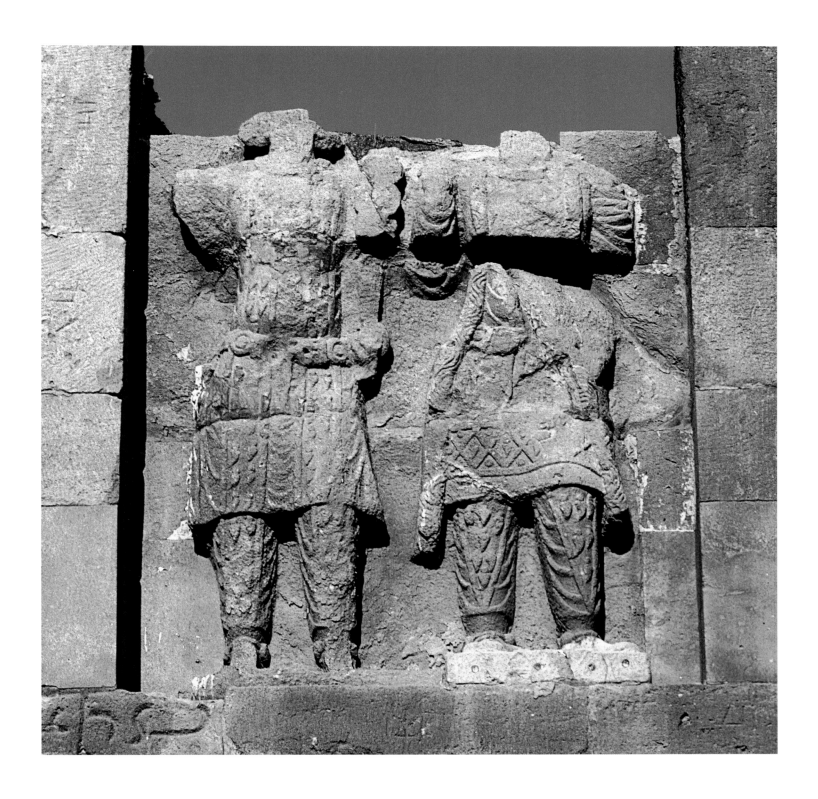

112. A bas-relief found high on the back wall of the south *iwan* of the temple of Allat. It shows two male figures, probably King Sanatruq I, builder of the temple, and his son Abadsamia, heir to the throne. Second half of the second century AD.

THE SCULPTURE OF HATRA

Unlike in the coroplastic art of central Mesopotamia, the western component is marginal in the sculpture of Hatra, which like its architecture seems mostly to belong to the late Parthian period (second to third century AD; Hatra 11–15).

Reliefs showing the effigies of divine figures along with groups of statues, often against a wall, depicting deities and worshippers—sovereigns, priests, horsemen, and nobles of the city, frequently life-size—were to be found in the *temene* and temples. Many specimens are of mediocre workmanship and appear to be stereotyped productions, almost verging on the mass-produced.

These works are characterized by common stylistic features, fundamentally antinaturalistic, which Rostovtzev identified in his analysis of the figurative production of Dura Europos and singled out as being distinctive of "Parthian culture." The figures are hieratic, customarily

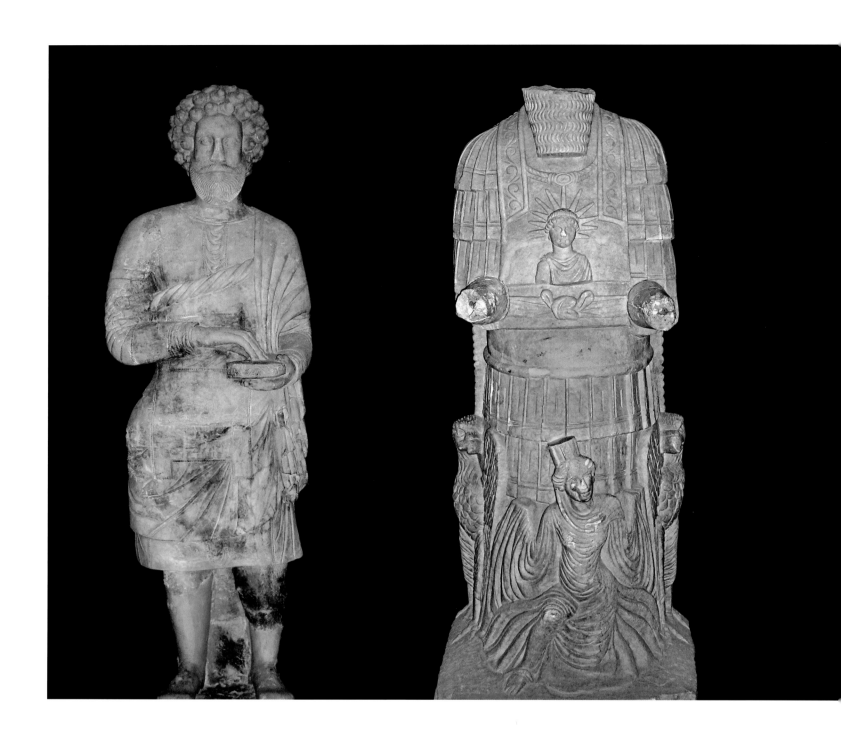

ABOVE LEFT
113. A statue of a priest holding a container of incense. From Hatra. National Museum, Baghdad.

ABOVE RIGHT
114. A headless statue of a divinity with an Assyrian-style beard, wearing a Hellenistic-Roman military uniform (Assurbel or Apollo of Hierapolis?). At his feet are Tyche, the tutelary god of the city, and two eagles. From Hatra. National Museum, Baghdad.

OPPOSITE LEFT
115. A bearded head perhaps belonging to a statue of a priest; the intense expression is an unusual feature in Hatrene sculpture. National Museum, Baghdad.

OPPOSITE RIGHT
116. A statue of Sanatruq I or II from Hatra, second half of the second century or first half of the third century AD. The diadem surmounted by an eagle with spread wings is a royal headdress. National Museum, Baghdad.

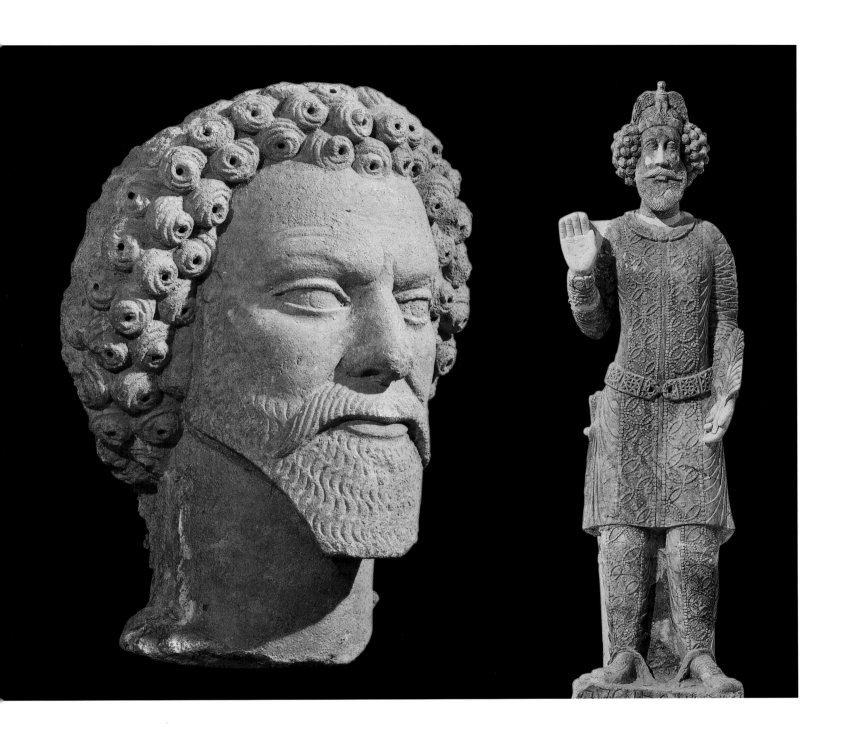

shown in a frontal pose and treated in a linear style. Rather than the composition of the scene being created within an objective space, according to the canon of Hellenistic art, the figures are ranged on a single plane, without any depth. Such statues in frontal groupings evince no connection with each other, but rather turn their gaze to the viewer, who is invited to reassemble the elements of the scene in order to interpret it.

The scenes are typically eastern, characterized in this case by frontal representation, which suggests a link with the magic or religious quality of the figures. The representations are grounded in permanence, not transitory reality. Far from portrayals of individuals with distinctive features, the characters are types whose social status can be readily identified by the details of their headdresses and clothing, which are observed in close detail and emphasized by color and gold leaf.

In the sculpture of Hatra, as in that of Palmyra, the realistic portrayal of detail is not exempt from a certain satisfaction in ever-richer ornamental invention, and in the skill required to carry it out. It is frequently in such minutiae of depiction that the sculptor's best qualities are expressed, even if at times the work sinks to a cold, decorative formalism.

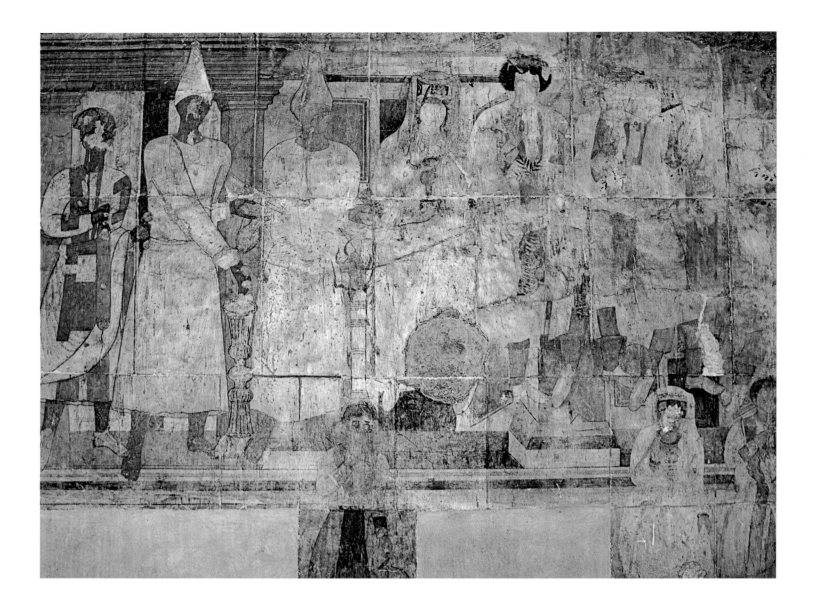

Not only does the depiction of jewelry of opulent beauty, of which a few examples in gold and stone are extant, contribute to the impression of luxury and richness, but so also does the portrayal of the male Parthian costume of tunic, wide pants, and high belt (plate 116), often decorated with discs (perhaps in metal appliqué), which seem to resemble golden leaves, even though they are a different shape. A rich tomb from Nineveh dated to the second century AD presents a classic example of this form.

These artistic concepts are well represented in the sculpture of Palmyra, the Arab caravansary city in the Syrian desert, which although part of the Roman cultural and political sphere testifies to the Syro-Mesopotamian *koine* that extended well beyond Parthian political boundaries.

THE MURALS OF DURA EUROPOS

The figurative art of Dura Europos, like that of Hatra and Palmyra, represents a significant part of this current of Parthian culture that was characteristic of the northern Mesopotamian area and which can clearly be seen even in works executed during the city's long period under Roman rule, like the paintings of the synagogue and the Mithraeum.

It is likely that in Dura wall painting was highly esteemed, but the extraordinary extant examples, which are mostly of the Roman period but typically Parthian in culture, owe their conservation to a specific circumstance, inextricably linked to historical events in the city. In anticipation of the danger of a Sasanian conquest by Shapur I (which in fact occurred), a

117. A mural painting of a sacrifice of incense from the temple of the Palmyrenes at Dura Europos; it depicts, on either side of the priests, Conon and his family (first or second century AD). National Museum, Damascus.

formidable and massive rampart was erected around the city in several phases. It encased not only the western city walls, but also the buildings constructed close to them, or along the street where the walls were erected. The wall paintings of the temple of the Palmyrene gods (plate 117), the Mithraeum, the room in a house converted into a Christian baptistery, and the synagogue are extant because of this protection and accordingly provide spectacular and exceptional evidence not only of pictorial art, which is frequently not so well preserved, but also of the diversified society of a city on the border of so many different worlds and influences in the third century AD.

Painting seems to have been no less widespread in Hatra, although little has survived. The most significant examples are a few large-scale depictions of the hunting on horseback of boars, gazelles, or deer, most often shown in outline in a felicitous, lively style, which decorated a large residential environment. The horsemen, dressed simply in the Parthian costume of wide pants and short tunics, are shown, as was customary, with their heads and torsos in a rigid frontal view and their legs in profile. It is probable that the two figures of boars placed opposite a horseman armed with a spear represent in reality the same animal, struck dead by the horseman's spear, in keeping with a convention characteristic of Sasanian hunting scenes, in which the cause and effect of the action are telescoped into one view.

The motif of hunting, generally on horseback, was favored throughout the Middle Eastern world, from central Asia to the Mediterranean, in later periods as well: in the mid-fourth century, the Roman historian Ammianus Marcellinus extolled a castle in the "Roman style" adorned with hunting scenes in the center of Mesopotamia. The subject can be seen in a royal context in an extensive stucco frieze, sadly quite defaced, which once covered the exterior wall surfaces of the large building to the south of the Taq-i Kisra.

THE SASANIAN PERIOD (AD 224–636)

The Parthians, demoralized by serious problems and ongoing strife with the Romans (who in the second century under Trajan, Avidius Cassius, and Severus repeatedly defeated Mesopotamia and the capital of Ctesiphon), were definitively conquered and replaced within their immense territory by the Iranian dynasty of the Sasanians.

Ardashir I, the first Sasanian ruler, after having overthrown King Artabanus IV in AD 224, soon seized the whole Parthian territory. Shapur I, his son and immediate successor, continued the incursions into Syria initiated by his father and not only conquered the wealthy Seleucid capital of Antioch, deporting its inhabitants, but in the space of fifteen years also defeated three Roman emperors. These events caused a considerable stir and were accordingly perpetuated in a long trilingual inscription on the Ka'ba-i Zardusht and in the symbolic representations in the rock reliefs commissioned by the king in Persis (Fars), the native land of the dynasty.

At the end of the Sasanian period, Khosrow II (r. 591–628) brought the empire to its greatest extent and wealth by conquering Damascus, Jerusalem, and Alexandria and reaching the gates of Constantinople, thereby expanding the frontiers of the Sasanian Empire almost as far as the former limits of the great Achaemenid Empire.

State Organization and Politico-cultural Position

Unlike in the Parthian period, a strong centralization of power, of both state and religion, was the defining precept under the Sasanians. Seals clearly indicate that the new administrative bureaucracy of the region appeared with Ardashir I's foundation of the empire. From

the second half of the third century, Mazdaism became the state religion, and a progressive increase in power on the part of the Zoroastrian clergy can be followed in the rock inscriptions and seals of this time. The fourth century saw the reinforcement of the bureaucratic organization, further refined and strengthened in the sixth century by Kavadh I (r. 499–531) and Khosrow I with the reform of the army and the land tax system.

On the other hand, in this progressive centralization many of the traditional cultural centers and independent cities disappeared. The government of the individual provinces reverted to the court, or was kept under its strict control, with power being delegated mostly to members of the royal family.

Both the efficient bureaucracy that underpinned all Sasanian power and the subdivision of the territory can be reconstructed, at least in part, from the evidence of the seals and *bullae* employed for official documents.

The trade from Mesopotamia to the West probably changed both its itineraries and its organization: the former routes were discarded, and cities like Dura Europos, Assur, and Hatra had no more reason to exist as stopping places on the way west.

The province of Nisibis in upper Mesopotamia acquired importance as an official center of communication and commercial exchange, and the nomadic Arabs on the border were more strictly controlled, in accordance with a state agreement between the Byzantine Empire and the Sasanians.

Despite indisputable and substantial changes in the centralized organization of the state, and also in the arts, which now acted essentially in the service of the ruler, the Sasanian period appears, in many respects, to be a continuation and development of the Parthian era, although the changes in politics and ideology were accentuated by the Sasanians themselves through very negative propaganda about the Arsacids. They confirmed their direct descent from the great Achaemenid Empire by a return to the representation of the king and his court in profile, as in the official art of that time, and this is particularly expressed in the large rock reliefs of Persis (Fars).

The Parthian period, now represented as an interlude distinct from the glorious Iranian tradition, was officially overlooked. In reality, the Sasanians, even in their new state organization, were the heirs politically and culturally of their immediate predecessors. The new dynasty found itself essentially in the same political position, with regard to both the western world (facing first the Roman Empire, then the Byzantine Empire) and the eastern one. Its role as intermediary on the great international trade routes between the West and India and China was further reinforced.

The Archaeological Data

Mesopotamia remained the economic and political heartland of the empire, and its farming practices were greatly enhanced through the intensive construction of canals. Archaeological surface surveys indicate that sites increased in number significantly, while generally adhering to the same territorial organization as before.

The central area, traditionally wealthy in terms of agriculture, with orchards and grapevines that gave rise to a particularly famous wine, also maintained a role of crucial importance in international trading along the Silk Route, namely as a fundamental junction at which goods arrived through various itineraries from the Far East before before they continued onward to the West.

The Parthian capital Ctesiphon remained the royal headquarters, but Seleucia was abandoned. New settlements were founded in the area, consistently covering the territory, as is

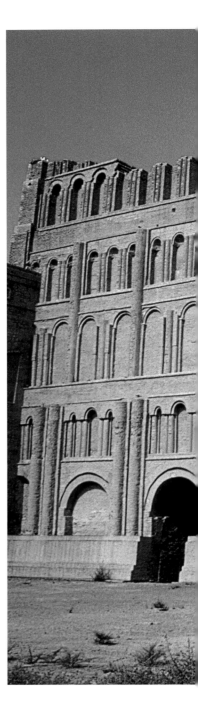

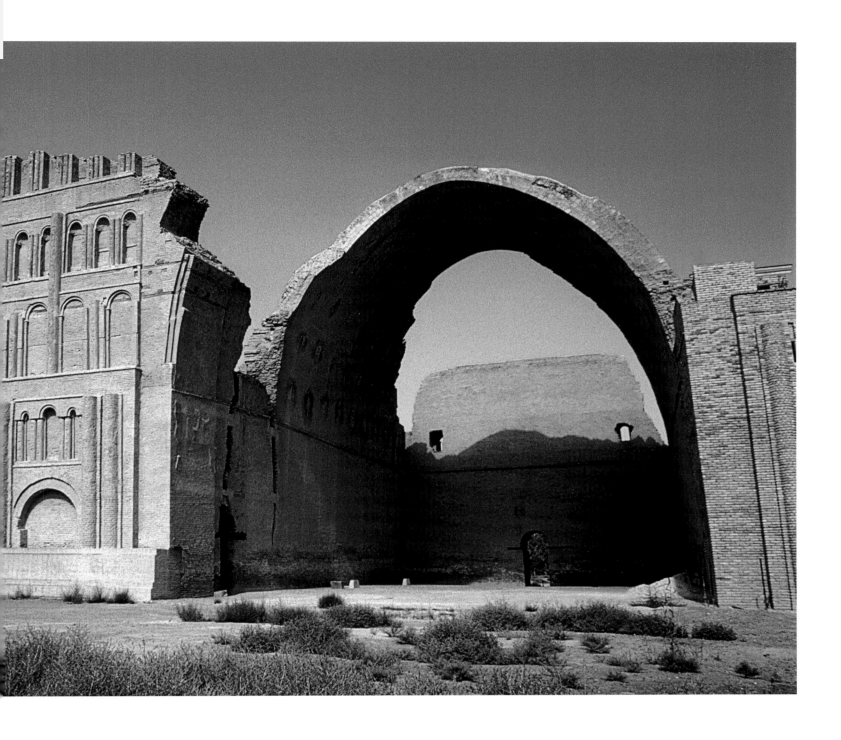

118. The Taq-i Kisra, the imposing *iwan* of the palace attributed to the Sasanian sovereign Khosrow I (r. AD 531–579), near Ctesiphon.

amply evidenced by archaeological surface surveys, though in-depth archaeological investigation has been limited. The location of single sites is based almost exclusively on an interpretation of classical, Syrian, Jewish, and Arab sources, though such accounts are often contradictory in this respect. Complicating matters, after the Arab conquest (636), sources refer to the whole area as *al-Madain* (the cities), lumping together the settlements on both sides of the Tigris.

Two cities, on opposite banks of the Tigris and joined by bridges, stand out as being important. According to the description by Gregory Nazianzenus (fourth century AD), these cities appeared to be a single agglomeration: on the eastern bank, Sasanian Ctesiphon, today no longer visible on the ground, where Ardashir I (r. 224–241) and his successors continued to be crowned, and on the opposite side of the river, Veh-Ardashir, the city founded by Ardashir I, near what had once been the great metropolis of Seleucia, which was almost abandoned. According to Roman writers, both cities were equipped with massive fortifications up to the end of the Sasanian period, so that it was first in Ctesiphon and then in Veh-Ardashir that Khosrow II Parwiz (r. 591–628) sought refuge in 628 when escaping the

Byzantine emperor Heraclius, who had already conquered the royal palace of Dastagerd with its extraordinary wealth.

The great royal foundation, Veh-Ardashir, enclosed by formidable circular unbaked-brick walls and towers in a horseshoe pattern, was at the head of an extensive district that stretched as far as the Euphrates. Already identified with Ctesiphon by a German expedition in 1928–29, it has been only minimally investigated. In a peripheral area of its interior, near the southern wall, a small portion of the original settlement that existed in this area until at least the mid-fifth century was revealed. Two sizeable, irregular blocks, delimited by streets and lanes of varying sizes, fulfilled multiple functions: artisanal, commercial, and domestic. A row of workshops were grouped together close to the houses, many of which were of the traditional type, with a central courtyard, while others were more typically Partho-Sasanian, with an *iwan* preceded by a courtyard. The city was occupied up to the late Sasanian period and, according to the sources, was an important headquarters of Jewish, Christian, and Zoroastrian communities and institutions.

Along the eastern bank of the Tigris, near Ctesiphon, there still stands a famous architectural monument, the Taq-i Kisra, the "Arch of Khosrow" (plate 118), the only extant part of the palace of Khosrow I Anushirvan (r. 531–579). It consists of a huge *iwan*, with an audience hall in baked brick (98 feet high, 84 feet wide, 160 feet long [30 by 25.65 by 48.8 m]) covered with a parabolic vault and flanked by a high facade.

The rest of the palace, of large dimensions but only partially excavated, can be reconstructed only through floorplans, because it was divested of baked brick in the first Islamic period: only the corridor placed parallel to the south facade retains part of its vaulting. The northern part of the facade, today partly reconstructed, collapsed in 1888 when the Tigris burst its banks, but complete records of the facade are still intact, since it had been photographed and described by Dieulafoy a few years earlier (Ctes. 2).

That this structure originally faced, beyond a large open space, another *iwan* (only partially brought to light) testifies, through the architectural type of confronted *iwans*, to the continuity with the preceding era. Similar schemes, also widely employed in large residences of the same period (sixth century) and area, were to be maintained and developed further in the Islamic period.

A few fragments of marble slabs and mosaics are all that remain of the decoration of the interior of the Taq-i Kisra, but Arab sources indicate that the large hall, now completely stripped, once boasted sumptuous ornaments of drapery, wall hangings, and large figurative mosaics, probably the work of Byzantine artists: the subjects included the siege of Antioch, which was represented with the Sasanian king Khosrow on horseback. A silk carpet that was called the Spring of Khosrow adorned the stone floor, representing a garden with abundant water, plants, and flowers; it was embroidered with gold and silver threads and sewn with precious stones.

The frontage, originally probably covered with stucco, consisted of blind niches and half-columns of various dimensions subdivided by large trabeations, western elements used, as in the Parthian period, not for structural reasons but for their effects of light and decorative charge (plate 119). The archivolt, now collapsed, was highlighted by a twisted ribbon motif, which was perhaps originally intended to be completed by low molding in stucco. The structure, freestanding, was tapered, without any opening at the upper levels.

In general, the facade superficially resembles Parthian facades, as exemplified in the palace of Assur, though the two smaller entrances do not correspond to the ends of corridors perpendicular to the facade and flanking the *iwan*, as was the case in the preceding period (at

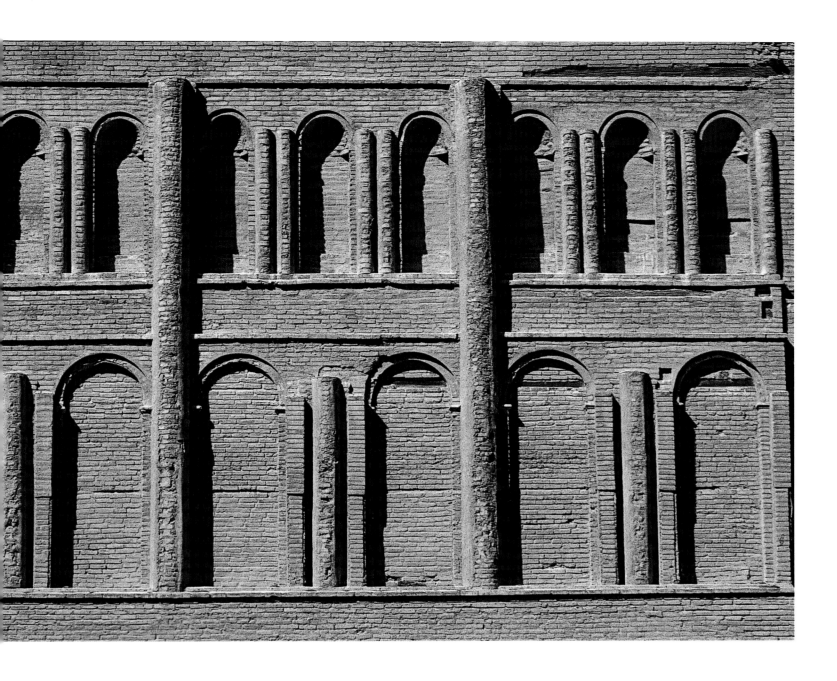

119. A detail of the baked-brick facade of the Taq-i Kisra.

Hatra, Assur, Abu Qubur, and Nippur); they are only passages communicating with a corridor parallel to the facade (Ctes. 4). This type of frontage, which derives typologically from Parthian architecture, appears to be the complement of the new royal Sasanian frontality. This is exemplified in the description in the Arab sources of the annual day of audience: when the heavy drapery was raised, the sovereign would appear in majesty before courtiers and subjects, enthroned in wonderful sumptuousness at the end of the great hall. The ostentatious appearance of the king, who should inspire respect and fear, remained a manifestation of royalty par excellence in the Islamic tradition. Tabari (ninth to tenth century) describes the king in majesty seated under a crown so heavy and elaborate that it was necessary to suspend it from the ceiling. He was luxuriously clad in silk, and the magnificence of his attire can still be seen in the great grotto at Taq-i in Iran, where the materials donned by the king and his retinue in the royal Sasanian court are depicted in detail. The different motifs that appear on the clothing of the various figures were probably linked to the court ceremony.

Sasanian textiles were very well known and their production had a significant influence in both the East and the West, where they were widely disseminated. It is possible that such precious and beautiful materials, with close links to the sovereign and the pomp of his court, were privileged vehicles for the transmission of the symbols connected to Sasanian royalty

that were also applied to subsequent religious or royal iconography. Most of the fragments of silk and wool testifying to the wealth and variety of Sasanian textile production are preserved in western cathedral treasuries.

Wall Decoration in Stucco

The superb wall decoration in stucco, as found in the buildings of Ctesiphon (sixth century; plates 121–26; Ctes. 5) and Kish, near Babylon (end of the sixth and seventh centuries; plate 120), seems to constitute a parallel manifestation, in a minor key, of that taste for wall covering that is evinced in descriptions of the great hall of Taq-i Kisra, and which came to be an integral part of architectural expression. In its iconographic motifs and use, the stuccowork appears to be substantially homogenous: in addition to decorating with symbolic motifs a few architectural elements, like the archivolt, it was extended to vaults and walls through molded panels of various shapes, often juxtaposed, with representations of humans and animals as well as vegetal and symbolic depictions.

Nearly all Sasanian stuccowork appears to be inextricably linked to architectural decoration, and in this sense, as well as for some motifs originally of Greco-Roman inspiration, it seems to be indebted to work of the Parthian period. In reality, however, the stucco decoration of the preceding period differs from the Sasanian variety not only in most of its iconographical repertoire, and in the earlier period's lack of real sculpture, but above all in its relationship to architecture. The stuccowork of the Parthian period highlighted structural elements, while the stuccowork of the Sasanian period instead tended to embellish, not underline, the architectural forms with a sumptuous and symbolic decoration, having much

ABOVE LEFT
120. A stucco plaque with a protoma of a ram wearing a ribbon collar between two wings, from "Palace No. 1" at Kish. Field Museum of Natural History, Chicago.

ABOVE RIGHT
121. A stucco plaque with a monogram in Pahlavi script above two wings, enclosed within a wreath of pearls. The interpretation of the monogram is disputed; perhaps it represents a formula of good omen. From the area of Ctesiphon, sixth century. Museum für Islamische Kunst, Berlin.

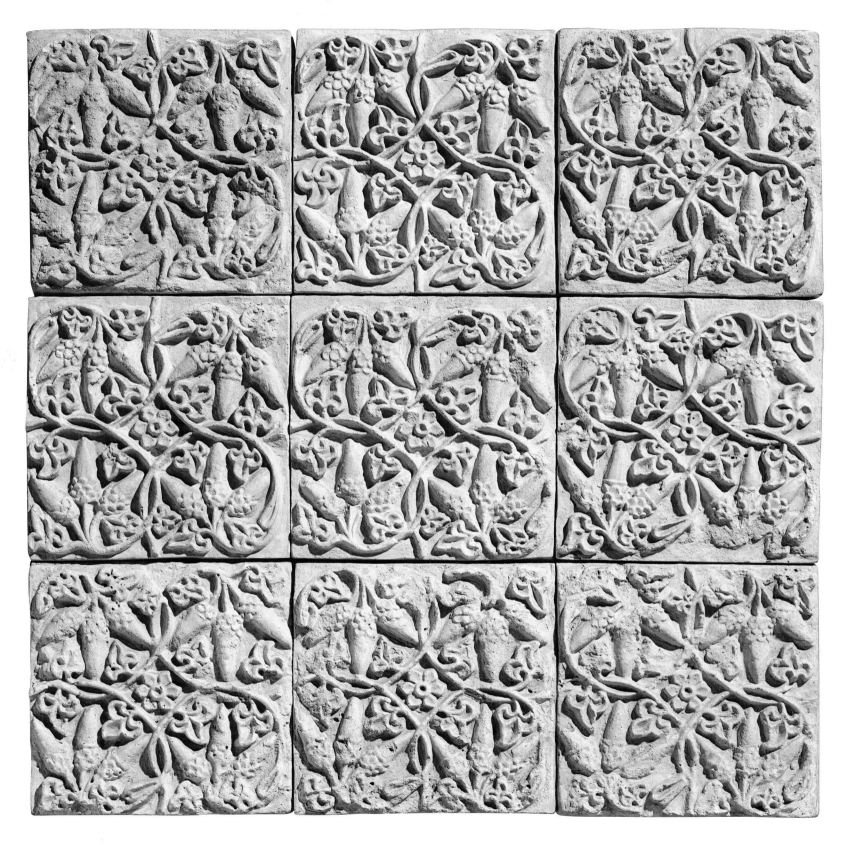

122. Nine stucco plaques from a wall decoration. The basic motif consists of
groups of three acorns linked by undulating, interlaced shoots. The group of
plaques shows the movement of the decoration, which is repeated indefinitely.
From the area of Ctesiphon, sixth century. Museum für Islamische Kunst, Berlin.

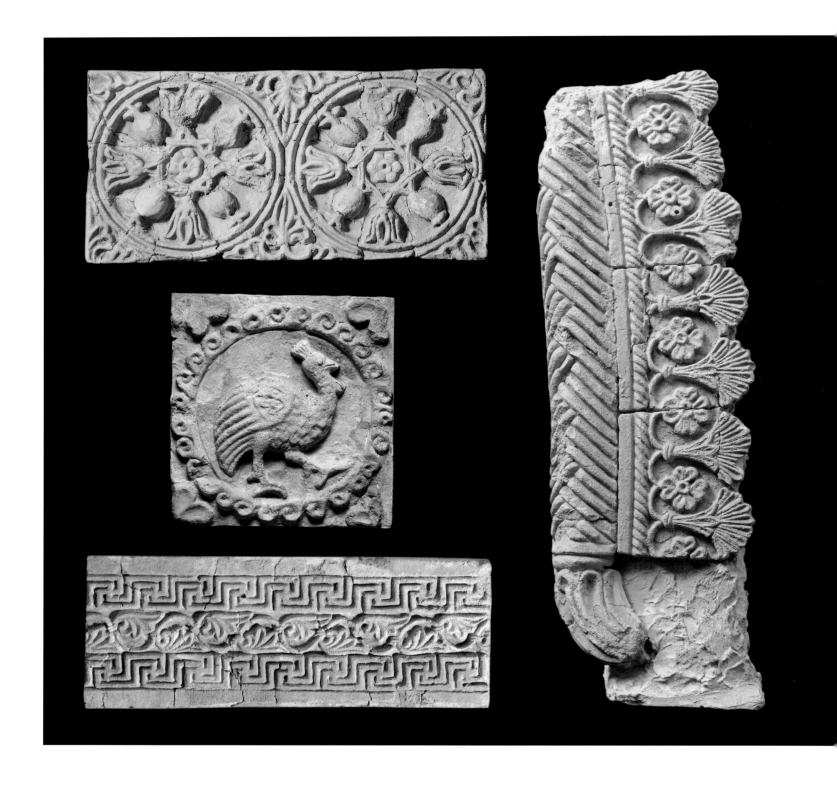

123–26. Various decorative motifs in stucco from the area of Ctesiphon, sixth century. Clockwise from top left: two plaques with rosettes of pomegranates, a fragment of the decoration of the entrance arch of an *iwan*, a frieze with vegetal and geometric decorations, and a plaque depicting a guinea fowl. Museum für Islamische Kunst, Berlin, and Metropolitan Museum of Art, New York (guinea fowl).

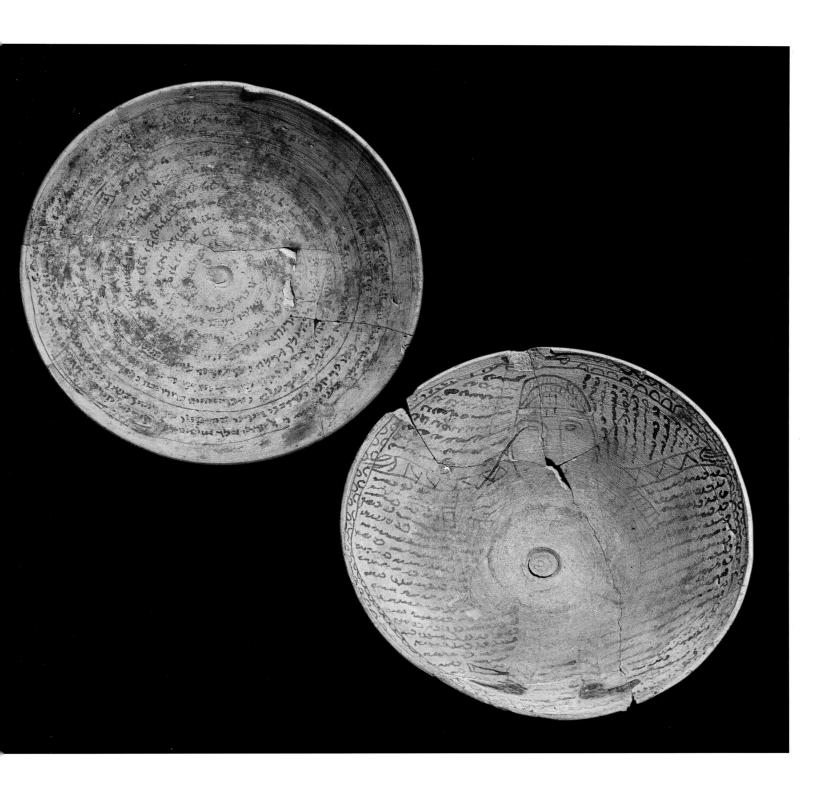

127–28. Two "magic bowls" found
under the threshold of a house at
Baruda (Veh-Ardashir), end of the
sixth or beginning of the seventh
century. The inscriptions, usually in
Judeo-Babylonian Aramaic, spiraling
out from the center toward the edge of
the bowl, had an apotropaic function,
warding off evil spirits and any possible
threat to the well-being of the client.
The right-hand cup shows a demon
with open arms surrounded by wavy
lines simulating writing. National
Museum, Baghdad.

in common with textile design and anticipating the character of the stuccowork of the Islamic period.

Besides its ornamental purpose, which is clear in the placement of the stuccowork within the architecture (on archivolts and, as a divider and covering, on walls and vaults) and in the repetition and intermingling of the motifs, the decorative repertoire must have had a symbolic value. The motifs represented belong to a vocabulary that has a general apotropaic significance, a religious charge, and, at times, a regal quality, but is in reality difficult to interpret fully. The color that completed the stuccos, as far as it is preserved, seems to be abstract rather than naturalistic and based on contrasts of flat tones.

Stuccowork of figures in high relief—bordering on real sculpture—is on the contrary often preserved only in fragmentary fashion in Mesopotamia: a representation of a grand hunting scene with the hunter on horseback, of which a few fragments are extant, embellished the "Southern Building" on that side of the Taq-i Kisra. Busts of sovereigns and female figures were placed in the courtyards of the large villas at Kish, which probably comprised a single palatial complex. The type of the male bust in stucco, which is on the one hand not present in the buildings in the vicinity of Ctesiphon in the sixth century, is on the other hand well represented across the Iranian plateau in the third to fourth century (Qaleh-i Yezdegerd, Hajiabad).

As is customarily the case in Sasanian art, most of these motifs seem to be of symbolic, religious, and courtly relevance, but it is hard to reconstruct the overall significance of the figurative apparatus. At times it seems that the subjects were linked to the function of the building. In particular, at Kish, the predilection for female representations in stucco in the "Palace No. 1" (SP 1) leads us to believe that the building was a women's apartment.

In fact, archaeological exploration at Kish has brought to light a complex, perhaps a palace, in unbaked brick, which included at least three buildings: apart from a construction with a sort of bathing pool (SP 3) and the above-mentioned "Palace No. 1," there is another large complex, "Palace No. 2," characterized by a tripartite hall with columns and a courtyard with half-columns and niches (SP 2), which can be interpreted as the official area for the king or lord due to the presence of royal busts in stucco in the courtyard.

Christians in Mesopotamia

As we have seen, Sasanian architecture in Mesopotamia not only is less abundant and shows less variety than that of the previous period, but also consists almost exclusively of civic buildings. Here the temple, a fundamental "pillar" of earlier architecture, has not left significant traces, except for early Christian churches, while in Iran numerous fire temples were preserved, thereby inducing curiosity about the dissemination of the Zoroastrian religion in the Mesopotamian territory. The situation was probably different in the capital and the major centers, where a considerable Iranian population was present: sources mention, in particular, the existence of a very wealthy fire temple at Veh-Ardashir.

At this time Mesopotamia was characterized by heterogeneous populations and religious minorities, as attested not only in Hebrew and Christian Syriac sources but also by the discovery of Christian cultural buildings, archaeological finds like "magic bowls," and the iconography of seals. In the last century of Sasanian power, in particular, it seems that the Christian population generally increased, a development fostered also by political interventions (expulsions, deportations) by both the Sasanian and the Byzantine empires.

The "magic bowls" (plates 127–28), ordinary ceramic bowls whose interiors are densely painted with spiral inscriptions concerning magic-apotropaic subjects, are of especial interest,

insofar as they enable us to understand the religious inclinations of this period; they indirectly provide information about religious communities present in Mesopotamia. They convey the sense of the immanence of the evil spirits and the resulting magical practices from the Babylonian substratum that permeated at the popular level all the religious communities, Jews, Mandaeans, Christians, and Manichaeans. Widespread in the central-southern area, these bowls, occasionally also found in the northern sector, are generally dated to the last Sasanian period.

Christian architecture, churches and monasteries that also belong mostly to the late Sasanian period, is concentrated in particular in northern Mesopotamia and in the south, where the Christian communities survived even after the fall of the Sasanian dynasty, at least until the end of the proto-Islamic period.

In the central area, in the city of Veh-Ardashir, which according to the sources included a substantial Jewish community as well as one of Nestorian Christians, only one church of small dimensions, Qasr bint al-Qadi, has been identified (Ctes. 6a, 6b), even though, according to sources, it was here that the seat of the Catholics of Seleucia, a huge number of smaller churches, synagogues, and the Talmudic school were located. The church in question, attributed to the sixth century, is a small rectangular building in baked brick, with a single nave covered with a vault and square pillars slightly offset from the walls and joined to them by narrow arches. Three rectangular spaces on the east end comprised the main area dedicated to worship. The entrances are situated on the long sides.

In the Arab city of al-Hirah, in southern Mesopotamia, two more churches attributed to the late Sasanian period offer very similar features, which can be compared to the well-documented church architecture of northern Mesopotamia in the following centuries: a rectangular hall with pillars, a rectangular, tripartite presbytery, and entrances along the elongated sides (Ctes. 7). Likewise, the few houses excavated at al-Hirah, actually belonging to the first Islamic period, bear ample witness to the Christian population who resided there.

The city, situated on a "lake" formed from the Euphrates, was, according to sources, at the center of a very fertile area, and it was a river port of prime importance. It was here that wares from the Far East arrived, transported in ships along the Persian Gulf and up the Euphrates. This area too, like the Mesopotamian center, is particularly rich in the settlements, unfortunately incompletely researched, that seem to be prevalent throughout the territory; two of the large and wealthy cemeteries present in the area seem to have been only very partially Christian and witness activity between the Parthian period and the proto-Islamic period.

Under the Arab dynasty of the Lakhmids, al-Hirah, which had been a buffer state between the Sasanian Empire and the Arab world of the great Hijaz desert from the third century onward, was of fundamental political importance, protecting the southern frontiers of the Sasanian Empire toward the desert and controlling the area to guarantee the passage of caravans from Arabia and Yemen.

The loss of independence of al-Hirah, incorporated in the Sasanian Empire at the beginning of the seventh century, exposed the empire to direct attack by the Bedouins of Arabia and accounted partially for the dramatically rapid fall of the Sasanian Empire brought about by the Arabs of the Hijaz. In a short time, after the battle of al-Qadisiyyah near al-Hirah (636) and the conquest of Ctesiphon, the great Sasanian Empire disintegrated, and the Muslim Arabs proceeded to conquer the whole territory in just a few years.

The new reigning power, while making itself felt from a political and religious viewpoint, in reality not only inherited from its predecessors a bureaucratic organization, coin types,

architectural forms, decorative stuccowork, and the symbolism of royalty, but also assimilated them across the board, in terms of both content and form, adapting them to its own needs. As a result, Sasanian culture passed, in a continuum, with progressive modifications, into the Arabic culture that was to be an extraordinary means of dissemination toward both the West and the East.

The cultural vigor of the conquered and the fame of their sovereigns, who were to survive in Arabian and Persian stories and poems, ensured that forms and iconography characteristic of Sasanian culture and symbolism were used for a long time and were recognizable in very different areas and periods.

5
THE ISLAMIC ERA

Giovanni Curatola

The history of Islamic architecture in Iraq is complicated. We must first consider the environment surrounding these territories, steeped in history, that were conquered by Arab invaders and by their ideology. Then we must consider the dynamics of a radical transformation of the society that had developed within what is known as the "Cradle of Civilization." The Islamic experience did not escape from the characteristic and unique features of Mesopotamian art that have been identified in the previous pages; rather, from the start it presents itself as consistent with them and is, in this respect at least, not exceptional. Fertile and rich territory, Mesopotamia's importance is confirmed from the very beginning of this period. If we consider political Islam, we must on the one hand highlight how events occurred that were crucial to the future of the faith, and on the other hand observe that the conquest occurred as a result of an extremely powerful military effort (in which race was always a factor), lacking a truly cohesive ideology. The construction of such an ideology, which took place only afterward, was not foreign in any way to the nature of the country. The first "mosque" to see Muslims praying to Allah in Iraq was probably the amazing complex in Ctesiphon.[1] And this, of course, is not without significance.

POLITICAL EVENTS IN MESOPOTAMIA DURING THE UMAYYAD ERA

Some explanation of the form of Islam we are describing is useful before we continue with our main discussion. At his death in AD 632, Muhammad did not leave behind a perfectly structured and self-sufficient system. The first Caliphs (*khalifa* in Arabic is "substitute," meaning here "vicar of the messenger of God")—Abu Bakr as-Siddiq (r. 632–634), 'Umar ibn al-Khattab (r. 634–644), 'Uthman ibn 'Affan (r. 644–656), and 'Ali ibn Abi Talib (r. 656–661)— had the task of organizing what would become, after many years of work, the foundations of the Islamic state. Abu Bakr was especially dedicated to putting down a series of rebellions incited by self-proclaimed prophets, who, taking advantage of the understandable disorder following the passing of Muhammad, attempted to obtain autonomy, encouraging the continuous clan rivalry that has always played such a role in Arab history. However, Abu Bakr's time in power was too short. The works of 'Umar, however, were of far greater importance than might have been expected, given the brevity of his reign, and it is no coincidence that

many historians consider him to be the true founder of the Muslim state. He was a decisive man and a capable leader. Beyond having an iron military organization that brought him victory over Byzantium as well as the Persians, he succeeded in obtaining the support of the majority of the most religiously observant Arabs (the so-called "Companions of the Prophet"), maintaining control over tribal chiefs and military leaders, and marginalizing the role of 'Ali. 'Umar conceived and initiated many Islamic institutions that were to be perfected legislatively during later periods. He established regulations for non-Muslim subjects (the institution of the *dhimma* was very significant, especially for Jews, Christians, and Zoroastrians, who had to pay the *jizya*, a capitation, and identify themselves with marks in distinctive colors—yellow, blue, and red, respectively); a census for the military, to determine both army pay and the recipients of important decorations; and the institution of Islamic law and a series of laws concerning civil rights and criminal penalties, as well as regulations for pilgrimages and Ramadan, and penalties for drunkenness and adultery. It was 'Umar who first used the term "caliph," substituting it for the previous "amir al mu'minin" (Commander of the Faithful) in 640. 'Umar founded the city of Basra in 635, the same year as the fall of Damascus. In 638 he took Jerusalem and founded Kufa; two years later he invaded Egypt, taking control of Alexandria and founding Fustat, which later became Cairo. There were repeated conflicts with the Sasanian Persians, and two dates mark significant meetings with the Iranians. In 637, King Yazdgird III was defeated in the area of al-Hirah[2] (already the capital of the Lakhmid dynasty), or of Kufa (southeast of what is now Najaf), thus opening the route to Ctesiphon and Seleucia. With his victory at the battle of Nahavand in 640, 'Umar threw open the way for Arab soldiers to conquer the Persian plateau.

One fact worth highlighting is that during this phase there was still no "officially recognized" written version of the Qur'an. That is, the one text that acted as the foundation for all of the Islamic governmental architecture during the culture's most extraordinary expansion was still not codified! The third "well-guided" Caliph, 'Uthman, is the man usually credited with the authoritative compilation of the Qur'an in 650, a good eighteen years after the passing of the Prophet. This event was traumatic for the young Muslim community, and it incited consistently negative reactions, especially because of the decision that was made to destroy all "provincial" copies of the text that were not canonical (that is to say, that were more or less apocryphal). This was the time when the written version took precedence over the oral prophetic version, and in some ways it marked the end of the heroic era of Muhammad's actual companions.

'Uthman was, in any case, a key figure. Born to the Banu Umayya, he adhered to Islam prior to the Hijra, and he was related to the Prophet, having married two of his daughters: first Ruqayyah and, after her passing, Umm Kulthum. He was chosen as Caliph by six of the oldest and most faithful of the Prophet's supporters who, through combined vetoes, were in essence excluded from the possibility of taking on the role. 'Uthman's government was almost immediately marked by an accentuated tendency toward nepotism when the Caliph nominated members of his family (and his tribal clan) as governors of the provinces of Syria and Egypt. Even the spoils of his frequent bellicosity were not fully divided among the troops; they were assigned to governors and family members in a proto-feudal system. Mounting discontent, especially in the Iraqi province and particularly in Kufa, extended to Egypt and exploded into open rebellion in 655. Very quickly 'Uthman found himself isolated, lacking any support from 'Ali and the other Companions of the Prophet, and also attacked by 'A'ishah, Muhammad's still-powerful widow, and her brother Muhammad ibn Abu Bakr. 'Uthman's brief period as Caliph ended in a violent assassination.

His successor as Caliph was finally 'Ali, and we can say "finally" because a faction had already expressed their favor for him upon the death of the Prophet, and his role of "advisor" had been important to Abu Bakr, though less so to 'Umar. In contrast, there had been open political hostility between 'Ali and his predecessor, 'Uthman. This hostility was sustained by the accusation of making "reformist distortions" (*bid'a*) to the religion; the followers of 'Ali found further foundation for this accusation in the very slight value accorded to their charismatic leader in the Qur'an, with the more or less clear imputation that his opponents had "manipulated the cards." Another reason 'Ali failed to create a viable consensus was that he did not distance himself from the actual assassins of 'Uthman, with the result that the governor of Syria and cousin of the defunct Caliph, Mu'awiyah, refused obedience to him. Even 'A'ishah (probably due to various disagreements in the past, if we believe a certain reading of history that is usually considered gossip) faced off against 'Ali, supported by two of the Companions of the Prophet (Talha ibn 'Ubayd Allah and Zubayr ibn al-'Awwam), although she was defeated in the famous Battle of the Camel (656) near Basra and then exiled to Medina. She is not seen again in Islamic political events until her death (678). None of this was enough for Mu'awiyah, who continued to refuse obedience to 'Ali. The rivalry marked, without a doubt, a hidden dispute between the Syrian and the Iraqi forces, and perhaps even pointed to a Byzantine and Persian influence. This schism between the two powerful players also took on a military aspect and never achieved any form of mediation, as much as they tried, with each one remaining solidly leader over his own territories until 661, when the Khawarij[3] Ibn Muljam killed 'Ali in Kufa. It is here that the Caliph was buried in what would become the holy city of Najaf.

A coda, though a very important one, to these events was the political and human situation of Husayn (626–680), son of 'Ali and Fatimah, and, as such, grandson of the Prophet. Upon the death of Mu'awiyah, who had become the first Caliph of the Umayyad dynasty after the murder of 'Ali, Husayn, in keeping with Shiite sentiment,[4] refused loyalty and obedience to Mu'awiyah's son and successor Yazid I and ended up defeated and killed under dramatic circumstances in the small town of Karbala. Husayn was the third Shiite Imam.[5] His older brother, Hasan (624–669), had been convinced much earlier by Mu'awiyah to refuse the position of Caliph. Husayn's death definitively established the split between the two main Islamic currents and, with it, the split between Syria and Iraq as well.

ARCHITECTURE IN THE UMAYYAD PERIOD

We have mentioned the differences between Syria and Iraq on the political plane. On the artistic plane, what is evident from the historical sources is that while in Syria, along the Mediterranean shores, the new Muslim leaders were adapting to the conquest or acquisition of old centers (Damascus and also Jerusalem), in Iraq there was a frenzy of construction of new centers, like Basra (in 635, but reconstructed thirty years later) and Kufa. This is especially interesting because in some cases—Damascus is the most famous—preexisting buildings were probably renovated into mosques (or, to a lesser degree, mosques were patterned after the cult buildings of different faiths), while in other cases there was a need to "invent" functional buildings that could be used as mosques. We must ask, however, what a mosque is, or, more particularly, what constituted a mosque in the seventh century. The Qur'an does not help at all, other than through shaky indications that cannot be directly correlated to an unambiguous architectural description, and there are few hints from Muhammad himself, who does not deal with this question at all. Iraqi archaeological data is, therefore, quite precious, especially for Basra and Kufa. The primitive outline of a mosque is very simple. There

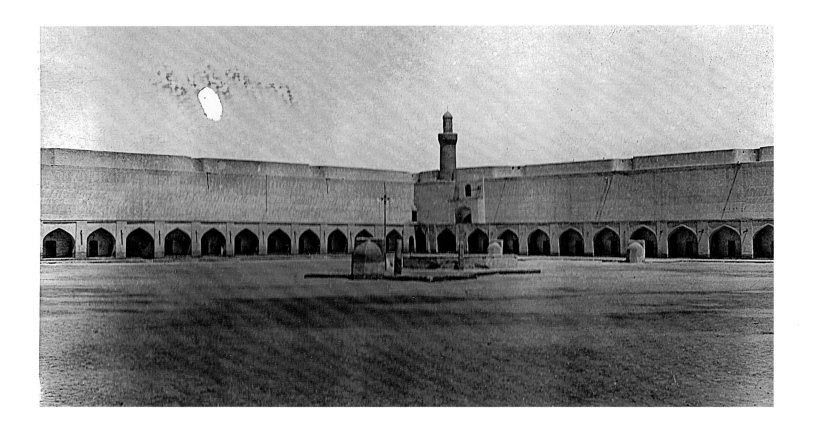

129. Kufa, historical
photograph of the court-
yard of the mosque.
The city is one of the
most important of those
founded by the Arabs in
Iraq. It was loyal to ʿAli
and was the Abbasid
capital until the founding
of Baghdad.

is a square or rectangle (the latter shape perhaps showing the influence of Syria, where Mus-
lims used Christian churches, generally placing the *qibla*[6] on the transverse axis for geo-
graphic reasons) with a covered part that constitutes the main center of the building.

The new Islamic power needed what we call today "visibility," and a large, multifunctional
building based on a very simple plan, a kind of forum, was the most useful type for this pur-
pose. The mosque was a public place, accommodating political as well as communal events. A
building with ample dimensions, it could offer some claim to fame for the city that housed it
and eclipse the tribal particularism (even, clearly, on the structural level) that was always in
the foreground in the restless Iraqi provinces. It was probably with this in mind that Ziyad ibn
Abihi, governor of Iraq in 665, had the mosque in Basra renovated, enlarging it and giving it a
wooden hypostyle ceiling over the prayer room. Creswell,[7] citing al-Baladhuri (ninth century),
argues that Ziyad had the Governor's Palace (Dar al-Imara) built along the northeast side of
the *qibla* to signify the belief that religion had a higher position than political authority.

Obviously, in a region such as Mesopotamia, lacking in both stone and wood (unlike the
areas to the west bordering the Mediterranean, where these materials were comparatively
abundant), the main material was brick (unbaked and baked), and there was considerable
recycling of previously used materials. In Kufa (638), in order to create some shade (in Ara-
bic *zill*, from which we get *zulla*, "roof, portico"), stone from al-Hirah was reused. The roofs,
hypostyle, were situated very high up, and there is no doubt that the architectural model
was Persian—the Apadana type, with smooth or fluted columns with capitals that may have

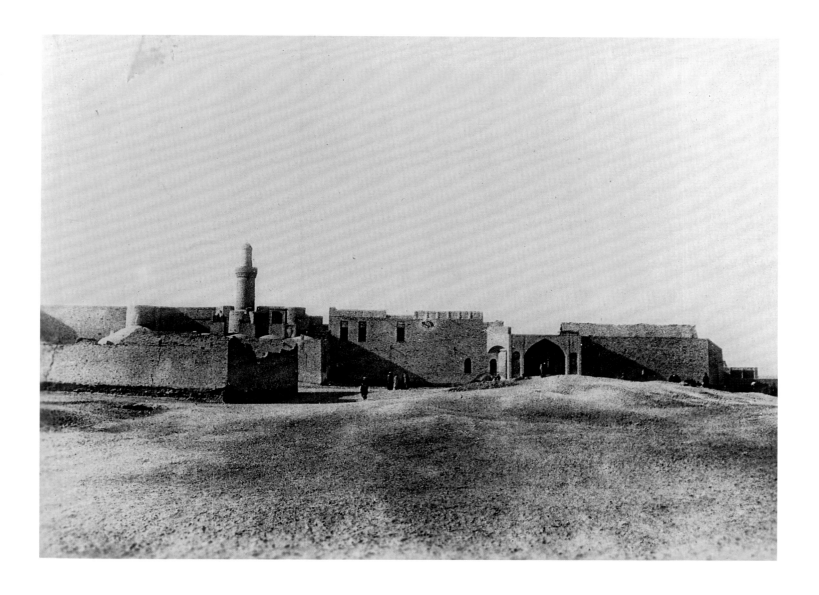

130. Kufa, historical photograph of the exterior of the mosque. 'Ali was killed by a Khawarij rival at its exit. Here, in 749, Abu al-'Abbas, first sovereign of the eponymous dynasty, was solemnly nominated as Caliph.

been animal protomas[8]—even if the plan, with a large courtyard (*sahn*) and a portico (*riwaq*), was adopted right away, becoming the classical model of construction not only in the East[9] but also in the West, such as at the large mosque in Harran, which is attributable to the late Umayyad period.

What is especially interesting is the plan of the Dar al-Imara in Kufa (K. 6), which we know from excavations.[10] This is an important building—among the first constructed by the new Islamic power—with a function that was residential as well as administrative. The ancient center (the building continued to be used, with changes, until the Mongol era in the thirteenth century) was built of unbaked and baked bricks inside a double fortified wall (with classic reinforced semicircular towers) and surrounding a central courtyard. This architectural type was completed with large *iwans* (structures open to a courtyard on one side and generally with barrel vaulting, the most famous example being the *iwan* in Ctesiphon, ingeniously self-supporting; plate 118, Ctes. 2) and *bayt* (a residential unit with small rooms overlooking a small internal courtyard) in an overall structure that is consistent with the western Umayyad palace styles (the two at Qasr al Hayr, but also Mshatta), as well as rooms that functioned as short-term housing and spaces that were more ceremonial. The decoration was mostly stucco, probably polychrome. Even though this material was easily found in the Seleucid, Parthian, and Sasanian periods, with the advent of Islam and the intense construction that typified this first phase of Muslim power, stucco became a characteristic decorative feature that was widely used, especially in Mesopotamia and in bordering Persia.

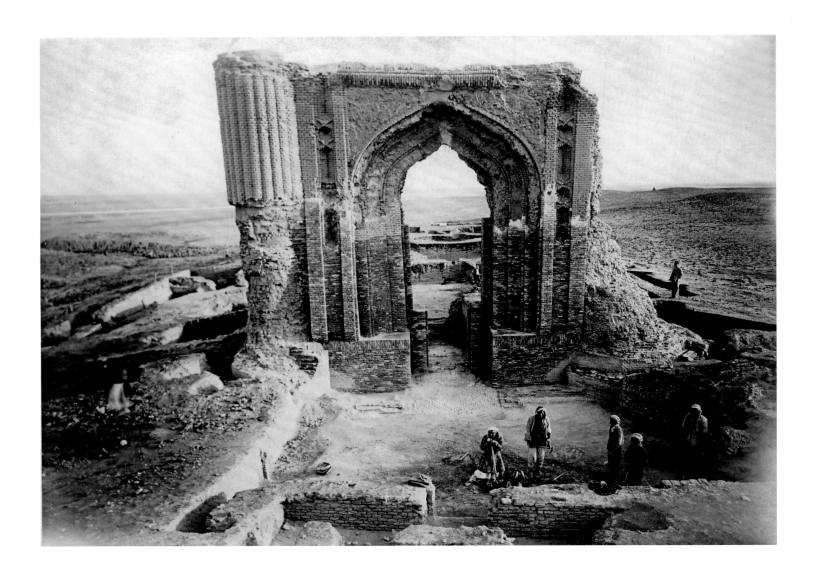

The archaeological excavations in Wasit,[11] in the mosque founded by Hajjaj ibn Yusuf, governor of Iraq in 703/4, confirm the simple plan of ancient mosques, with a central courtyard placed within a square wall measuring about 330 feet (100 m) along each side and a *qibla* facade marked by five rows of eighteen columns. Much more difficult to interpret are the traces of the Dar al-Imara. The construction material is always baked brick, but the columns appear to be remains of monuments from the previous, Sasanian era.

THE TRANSITION TO ABBASID GOVERNMENT AND THE FOUNDING OF BAGHDAD

Historically, the Umayyad dynasty, marked by civil strife and undermined by hopes of independence in the continuously unstable eastern provinces (which considered the regime a Syrian imposition that had turned away from a more "democratic" concept of shared sovereignty in favor of a royal dynasty that was essentially tyrannical in the Greek sense, even if it was, paradoxically, a product of the Bedouin Arab aristocracy), lasted only a short while before the family was destroyed. Marwan II (r. 744–750) was tracked down and killed in Upper Egypt, a victim of the rebellion against the nomination of Ibrahim ibn al-Walid as Caliph after the passing of Yazid III in 744. The only survivor, 'Abd ar-Rahman I (b. 731, r. 756–788), established the Umayyad emirate in Spain with its capital in Cordoba after a daring flight to the West. The Umayyad expansion of Muslim territory in the West with the conquest and conversion of Berber tribes and in the East with the acquisition of Turkish groups would be decisive in affirming the Islamic faith in later times. A fiscal policy that tended to decrease the

ABOVE
131. Wasit was an important military center during the first Islamic period and a regional capital during the entire Umayyad era. This historical photograph of the excavations shows one of the large gates leading into the city.

OPPOSITE
132. A *mihrab* in marble, probably from the first mosque of al-Mansur in Baghdad. National Museum, Baghdad.

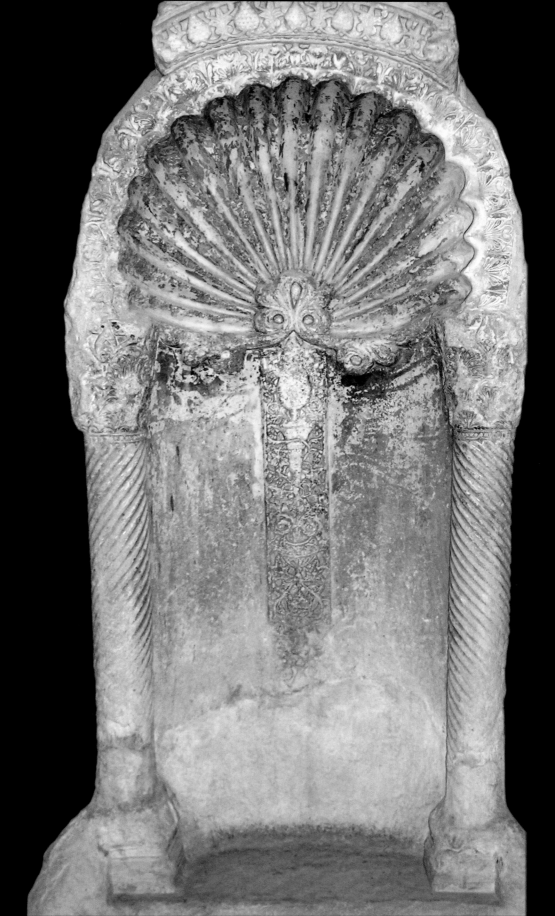

distinction between Arabs and non-Arab "clients" (while maintaining the *dhimma*), though sometimes exacerbating the tax burden that weakened the Islamic East, had largely positive results in the long run, even if at the time it contributed to the undoing of Umayyad rule.

A more detailed analysis of the events occurring before the first half of the eighth century is beyond the scope of this text, but obviously the axis of Muslim political power moved to the East with the nomination of Abu al-'Abbas as-Saffah, the first of the Abbasids, as Caliph in 749 in Kufa. His successor, Abu Ja'far al-Mansur (r. 754–775), was a talented man who transformed the caliphate into a position of power, stability, and centralization. He is credited with founding, on August 1, 762, Baghdad, the city that, more than any other, and especially during the long reign of Harun al-Rashid (786–809), exemplifies the real development of the blooming Muslim civilization as a whole. The selected site, along a bend in the Tigris River, and more or less at the center of the current Iraq, was also symbolic of the *Medinat al-Salam* (City of Peace), that is, the ideal citadel that it was supposed to reflect. In line with this ideological and symbolic function, Baghdad was originally built on a circular plan. Unfortunately, nothing survives of the original layout of the city, and literary descriptions, for the most part quite detailed, are the principal sources of information.[12]

The city was built within a double circular ring wall cut by four gates that faced toward the most important Muslim centers: Bab al-Kufa, Bab al-Sham (Damascus), Bab al-Khorasan, and Bab al-Basra. The residential quarters were arranged radially, forming a great ring, inside of which was a large open space, probably a kind of park area, where the congregational mosque and the Caliph's palace were erected. This center of religious and governmental power (accessible only through the four gates, which could be closed in order to separate and isolate the quarters) was strictly separated from both the residential areas and the commercial and military areas. The construction material was the typical Iraqi unbaked brick, and, according to the descriptions of al-Ya'qubi,[13] the outer wall of the city was thirty-five cubits high, with the reinforced towers reaching up to forty cubits (that is, a height slightly greater than sixty-six feet [20 m]).

Creswell[14] gives a good description of the city and emphasizes its unique construction. The circular plan selected has precedents in the ancient East, from the Achaemenid Ecbatana ("armed with concentric circular walls, in a terrestrial, politico-military imitation of the heavens")[15] to the Sasanian Takht-i Sulayman and Firuzabad, and even to (Parthian) Hatra. Examples—and it is admitted that these are mainly Iranian—are not lacking, which is testimony to an increased eastern influence, to which the conversion to Islam of Turkic tribes from central Asia brought fresh blood (Bagh. 1–4).

Though it is said that the Baghdad of al-Mansur and Harun al-Rashid is attested to only in literary descriptions, nevertheless an ongoing tradition recounts that the incredibly beautiful marble *mihrab* in the National Museum of Iraq in Baghdad, previously in the al-Khashiki[16] mosque, came from the first mosque of al-Mansur. Whether that is true or not, this work is decidedly important and deserves a full description (plate 132). The *mihrab*[17] is a marble monolith (partially restored on the right side) shaped like a niche. Two twisted columns support capitals with stylized acanthus leaves covered by an arch that is decorated with a motif of little arcs (corresponding to the shell fluting of the lunette) with a delicate floral design. Over this cornice is a fragment of a continuous stylized pinecone decoration along with motifs of palmettes connected by vines. Inside the niche, on the upper part, is the lunette with its shell design, and lower down is a strip decorated with vines coming together to form a vase with a floral bouquet and a sort of cornucopia topped by a stylized cypress. Above this strip is a "bow" marking the focal point of the lunette. Obviously, this is a *mihrab*, yet, stylistically, it is still fully Umayyad (the first instance we know of this niche-shaped

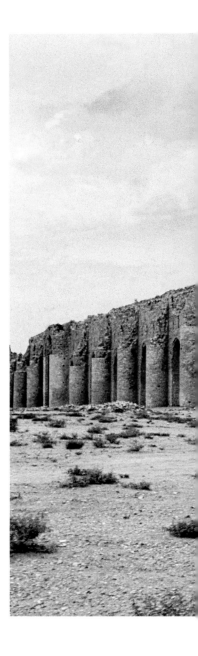

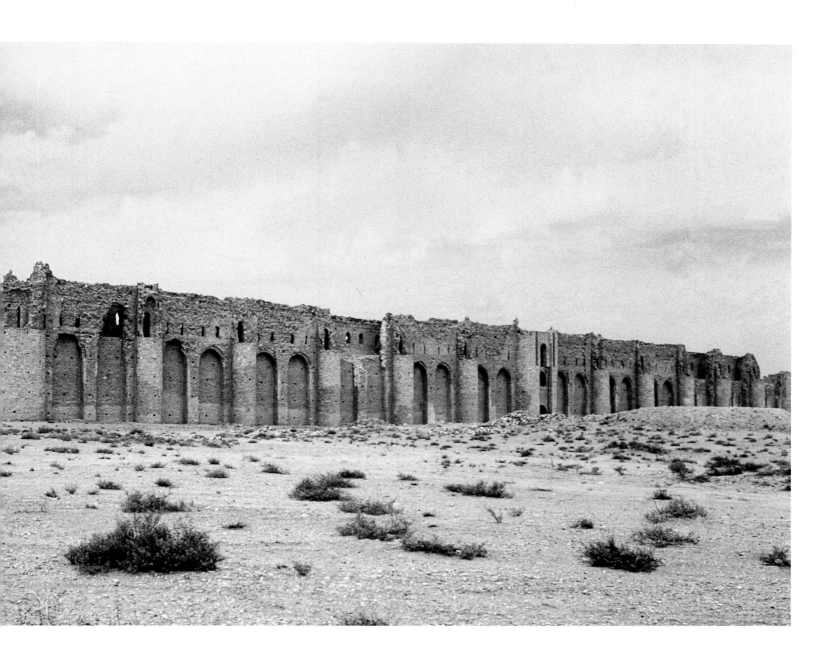

ABOVE
133. The imposing
external fortifications of
the palace of Ukhaydir.

OVERLEAF
134. The interior of the
palace of Ukhaydir, seen
from the outer wall;
a second wall, also
fortified, encloses the
buildings.

structure is from al-Walid I's restoration of the mosque in Medina in 707–9). In fact, if it is compared to the decoration of Mshatta[18]—today found in Berlin—one finds that it is more than just stylistically similar. It is still a late-antique, classical style that permeates the artistic feeling, more Syrian than Iraqi—so much so as to suggest that the *mihrab* found today in Baghdad may have been imported.

THE PALACE OF UKHAYDIR

The palace of Ukhaydir,[19] built approximately fifty miles (80 km) from Kufa, probably dates back, according to Creswell's reasoning,[20] to 778, therefore well after the Umayyad era. This is an isolated site, still extraordinarily imposing today. There is a fortified double wall measuring about 560 feet (170 m) on a side (plate 133). Inside, there is a smaller enclosure (381 by 269 feet [116 by 82 m]); it too has fortified walls (plate 134). The external wall, in stone like the internal one, is especially impressive because it rises, as they say, from nothing in the desert, though further excavations may offer some surprises. At the corners of the wall there are four tall, three-quarter-round circular towers, and the same plan is replicated in the gates located at the center of each side. At the gates, however, the circular curtain wall is interrupted in the middle, opening up a notch of space for an arch, which is, in turn, topped

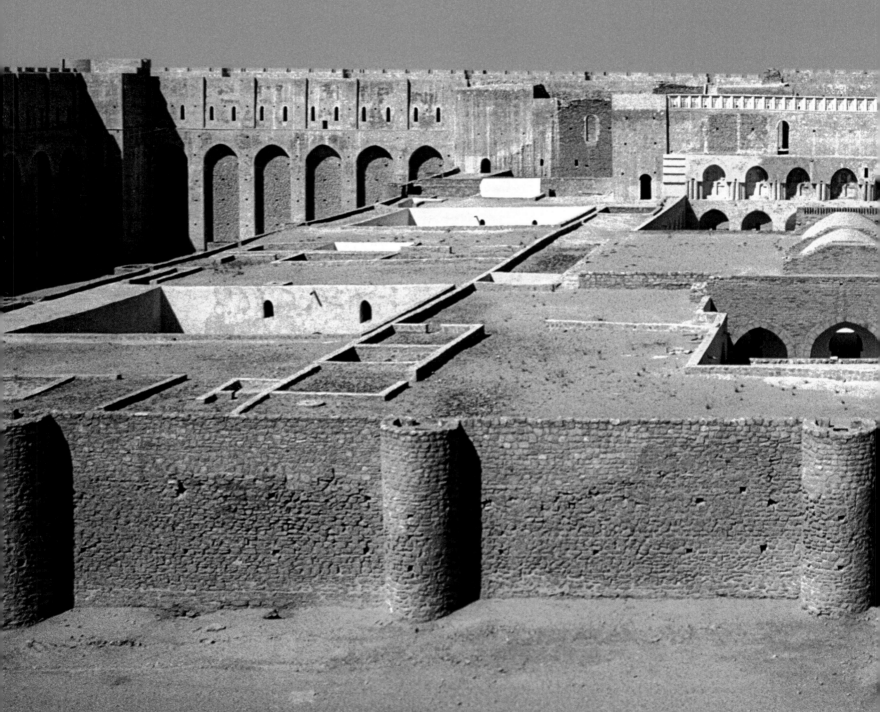

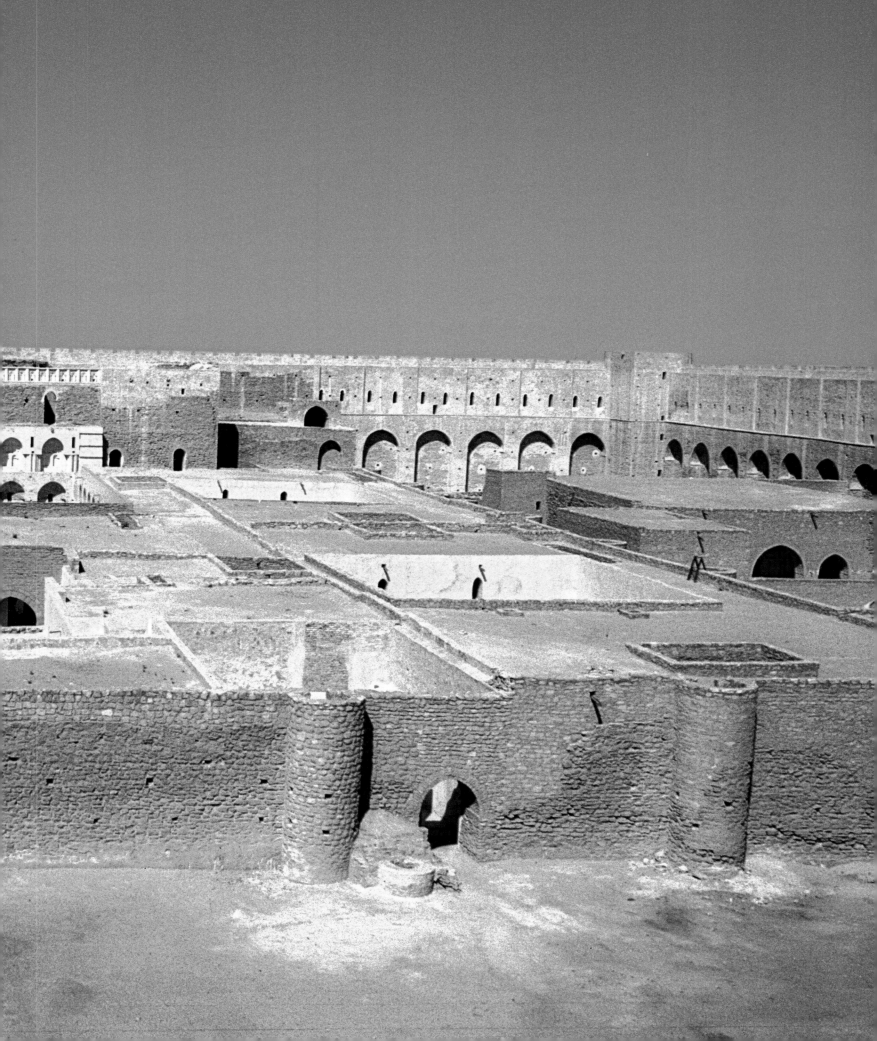

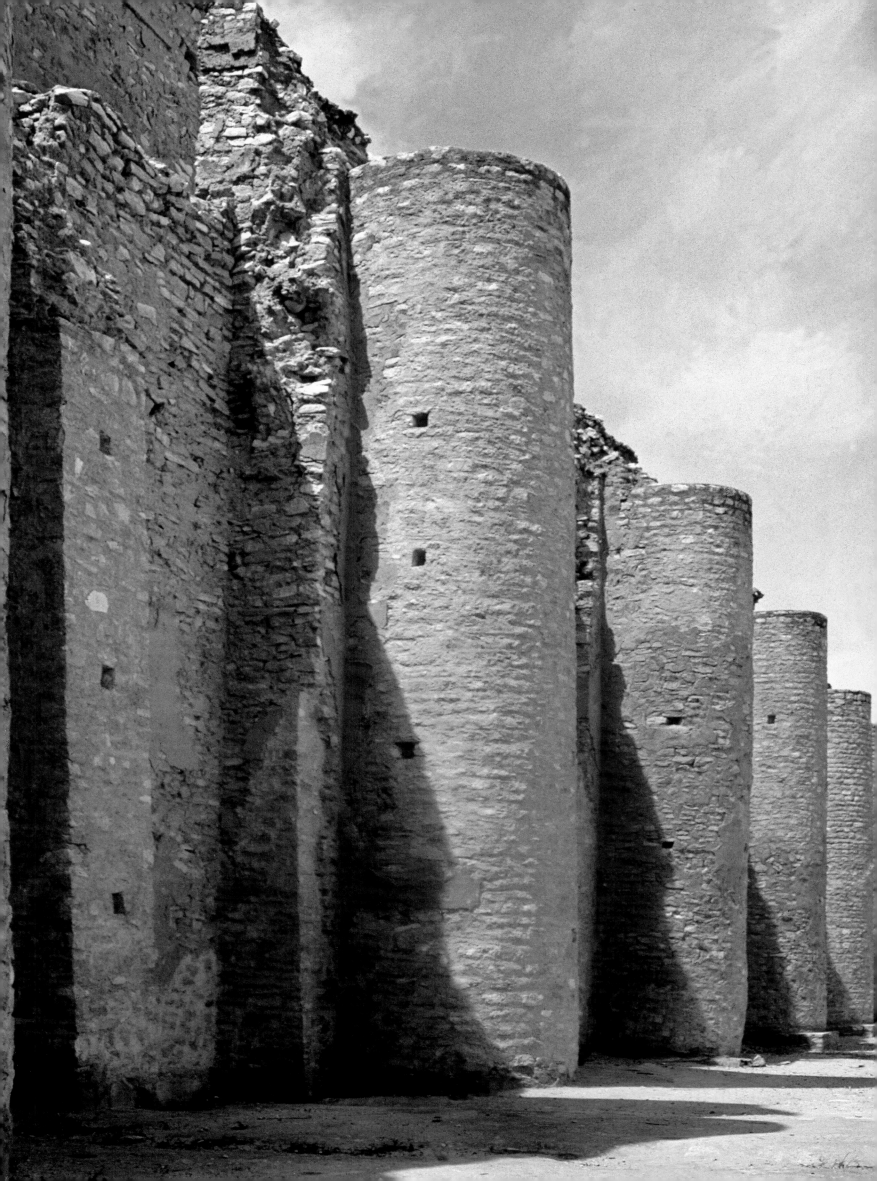

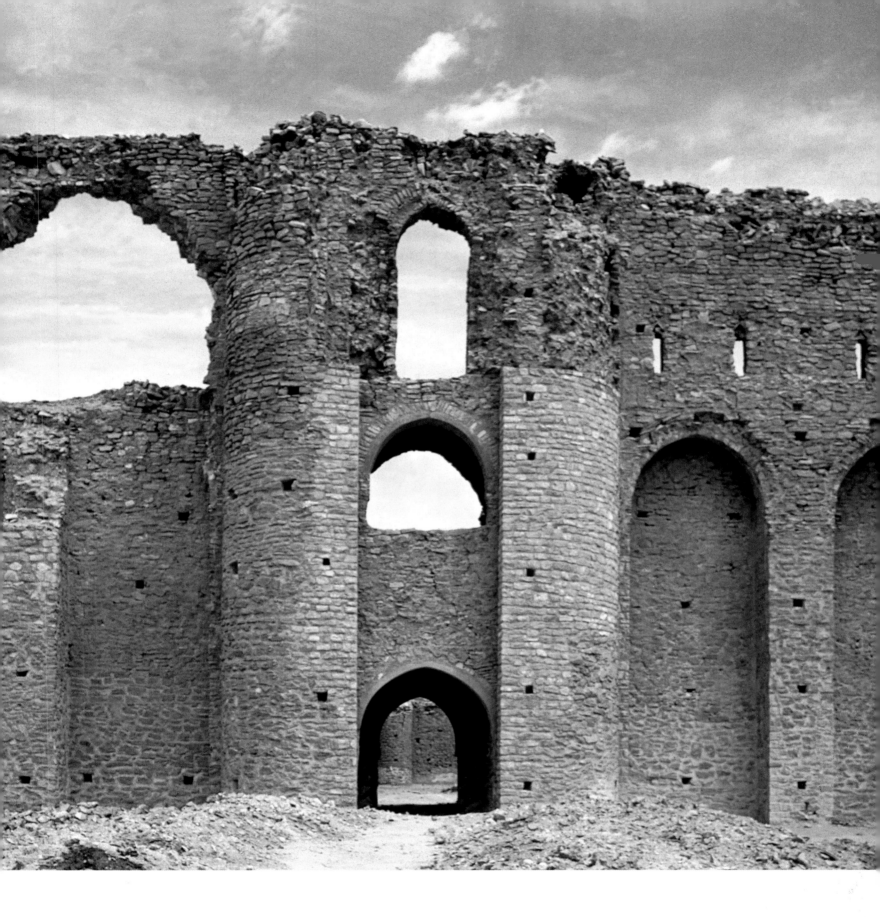

OPPOSITE
135. A detail of the fortified wall of the palace of Ukhaydir.

ABOVE
136. The elegant entrance to the inner enclosure of the palace of Ukhaydir.

by a recessed arched window and yet another, higher window, also arched (plate 136). This is a structure with genuine elegance. Each gate is flanked by semicircular buttresses that alternate with recessed blind double arches. The smaller enclosure, used as a palace, also has a very interesting layout (Ukh. 2).

The only entrance to this area brings one to a vestibule with a barrel vault, to the right of which is a room with a courtyard (the mosque, with a single aisle along its *qibla* wall, which has a rectangular *mihrab*), and to the left of which is a residential area, perhaps reserved for a garrison. On crossing the vestibule, one enters a vaulted hallway that surrounds the entire

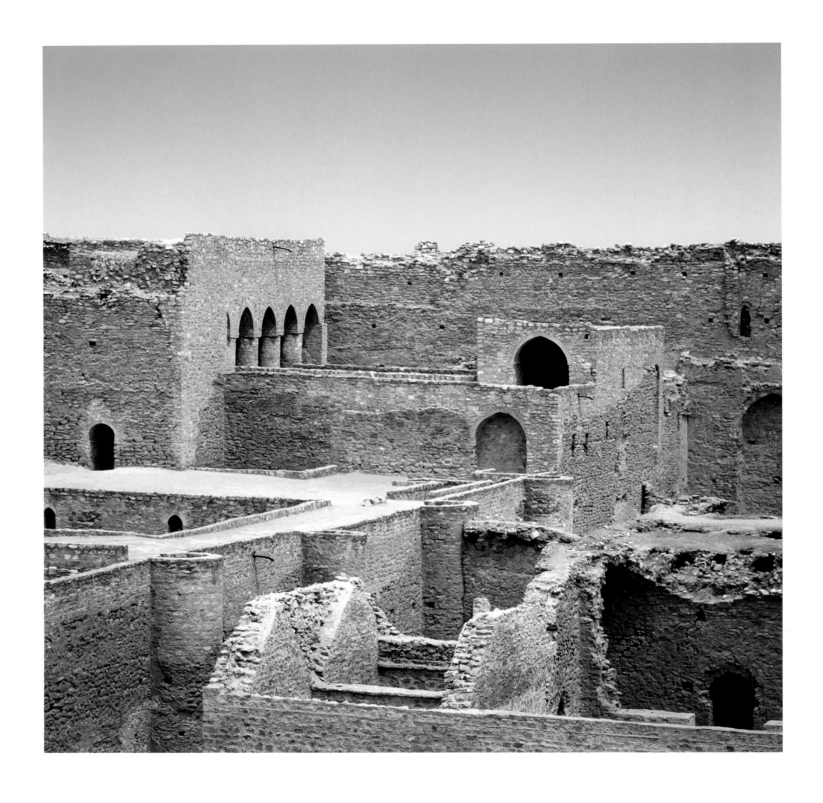

central area and is used to access the residential part. This includes four *bayt* (a term of Semitic origin, meaning literally "tent, room, house, apartment"—could this be the source of the Italian term *baita*, meaning "hut"?), all of which are identical, though not communicating. Each one faces onto a courtyard and then onto another, larger central courtyard (measuring 89 feet wide by 105 feet deep [27 m by 32 m]). This in turn is surrounded by a series of blind archways and leads to an *iwan*, possibly framed by a rectangular structure (a sort of *pishtaq*, or frontispiece, a very popular structure that is often used in later Persian Islamic architecture). The *iwan* leads to a square room that offers access to the ceremonial part of the palace, with various elegant rooms suitable for private as well as public audiences.

Ukhaydir is still connected, through its plan, to late Umayyad architecture, with Mshatta being the most striking example known. Important similarities are the mosque near the

137. A view of the inside of the palace of Ukhaydir. The architectural solutions used are of outstanding quality.

entryway, the large courtyard in the central area, and the *bayt*. What is different, however, is the treatment of the receiving room (which in the Iraqi building is more articulated and better placed). In both cases it is reached by an *iwan*, but the Iraqi example lacks the triconch apsidal part that is found in the Jordanian one. A strong Persian influence is not evident (the *iwan* is not enough of a signifier given that it had been in common use across a large geographic area for some time), and, in our opinion, this incredible palace represents the logical evolution of an already-classic plan that is amply attested in the architecture of the first Islamic dynasty. Ukhaydir was built on the orders of 'Isa ibn Musa, grandson of the first Abbasid Caliph.

SAMARRA

The circular city of Baghdad under al-Mansur was not particularly functional, especially as regards the possibility of expansion. Furthermore, with the advent of the Abbasids, the importance of the ethnic Turkic element increased enormously, quite rapidly becoming the heart of the military power. An almost immediate result of this, given the concentration of these military groups and their recent conversion to Islam, was the escalation of disputes betwen them and the civilian population. The situation, not easily managed, suggested that the greater part of this military force be transferred elsewhere and a new capital be constructed. Samarra (*surra man ra'a*: "delicious to whosoever shall look upon [her]") was founded in 836, upon orders from Caliph al-Mu'tasim Billah, by the Turkish commander Ashnas, about sixty miles (100 km) north of Baghdad.

Samarra remained the capital of the Abbasid empire until 889, when it was abandoned (even though some traces of occupation can be found dating up to the twelfth or thirteenth century) by Caliph al-Mu'tamid 'Ala Allah, who returned the capital to Baghdad. Samarra was built along the right, or eastern, bank of the Tigris, and just a few years after its construction it boasted a north-south extension of almost nineteen miles (30 km) and an east-west one of one to three miles (2 to 5 km). Today its ruins cover a surface area of almost twenty-three square miles (60 km²). This is an incredible range, possibly the largest "field" of archaeological ruins in the world (Sam. 2).

Monuments

Samarra is fundamental to the history of Islamic art for many reasons. It was built and occupied over an extremely limited span of time, just sixty or, at most, one hundred or so years, in an era of great turmoil and transformation. The city is large, with extensive ruins that have been only partially excavated by archaeologists working in great campaigns that began at the start of the twentieth century.[21] In any case, this city, much more so than Baghdad, can well be defined as pivotal in the development of a decidedly Islamic style that, while maintaining its classical, late-antique roots, emancipates itself from them enough to create the basis of a completely unique language. It was at this moment, in part, that Islamic art was born, the original creation of a culture that was by then established and ready to blossom artistically as well, in an independent style.

Al-Mu'tasim also ordered, in 836, the construction of an immense palace, taking advantage of the capable artisans whom he had brought to the city from the four corners of the Islamic empire. Jawsaq al-Khaqani, the name of this complex, can be considered more appropriately the first Dar al-Khalifa in Samarra. It rises above the banks of the Tigris, whose waters feed its canals and fountains. The complex covers an incredible area, approximately 370 acres

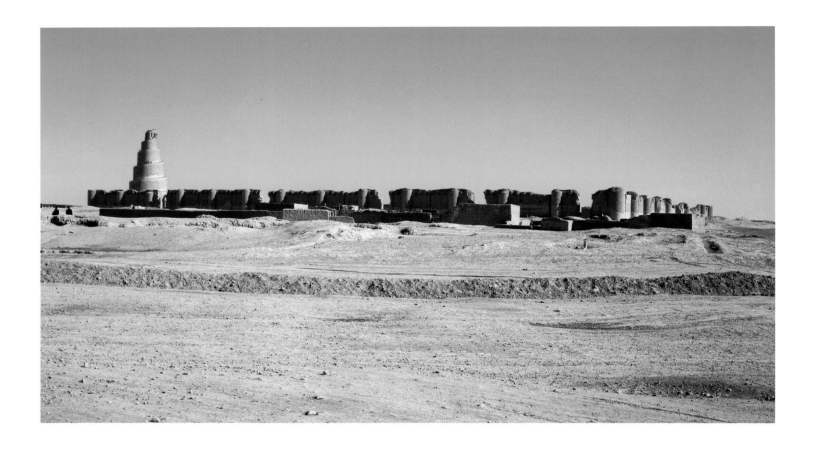

ABOVE
138. A panoramic view
of the Great Mosque of
al-Mutawakkil in Samarra.

OPPOSITE
139. A view from the
minaret of the Great
Mosque of Samarra; the
external wall encloses an
impressive area, encom-
passing the courtyard,
the side entryways, the
colonnaded room of
the mosque, and, in the
background, the *mihrab*.

(150 hectares)![22] The plan of any such space is, of course, complicated (Sam. 18). The Bab al-'Amma, the best-preserved entryway to the palace, is a tall gate with three *iwans*. The middle one is the largest and is supported by two pilasters. The two side *iwans* are smaller, and the rooms behind the archways are roofed by semidomes resting on squinches, a feature already in use during the Sasanian era. Beyond the Bab al-'Amma is the western garden, which was reached by a monumental staircase that today has disappeared. Through the garden passed one of Samarra's principal north-south arteries (Shari' al-Azam). The monumental gate is followed, internally, by a series of five transverse rooms and a smaller foyer that leads to a courtyard with a basin. To the north of these transverse rooms is a circular structure (probably another basin for water, though larger), while to the south are structures that have not been clearly identified. Facing the courtyard to the south is a bath, and to the north there is another basin, connected by a *kanat* to the one in the courtyard.[23]

Along the middle axis marked by the Bab al-'Amma, toward the eastern side, has been identified a further important structure, comprising a square room onto which four other rooms open in a cruciform shape. Each of these rooms is divided into three areas by rows of columns. The room to the east leads into a transverse room that faces onto the large, open eastern esplanade. To the north and south of the "crossroads" are two courtyards. The one to the north and its rooms have not yet been excavated. To the south, Herzfeld has identified a harem. A large tub in red Egyptian granite found in this room (known as the "Pharaoh's cup") was brought to Baghdad, to the Khan al-Mirjan and then to the so-called "Abbasid

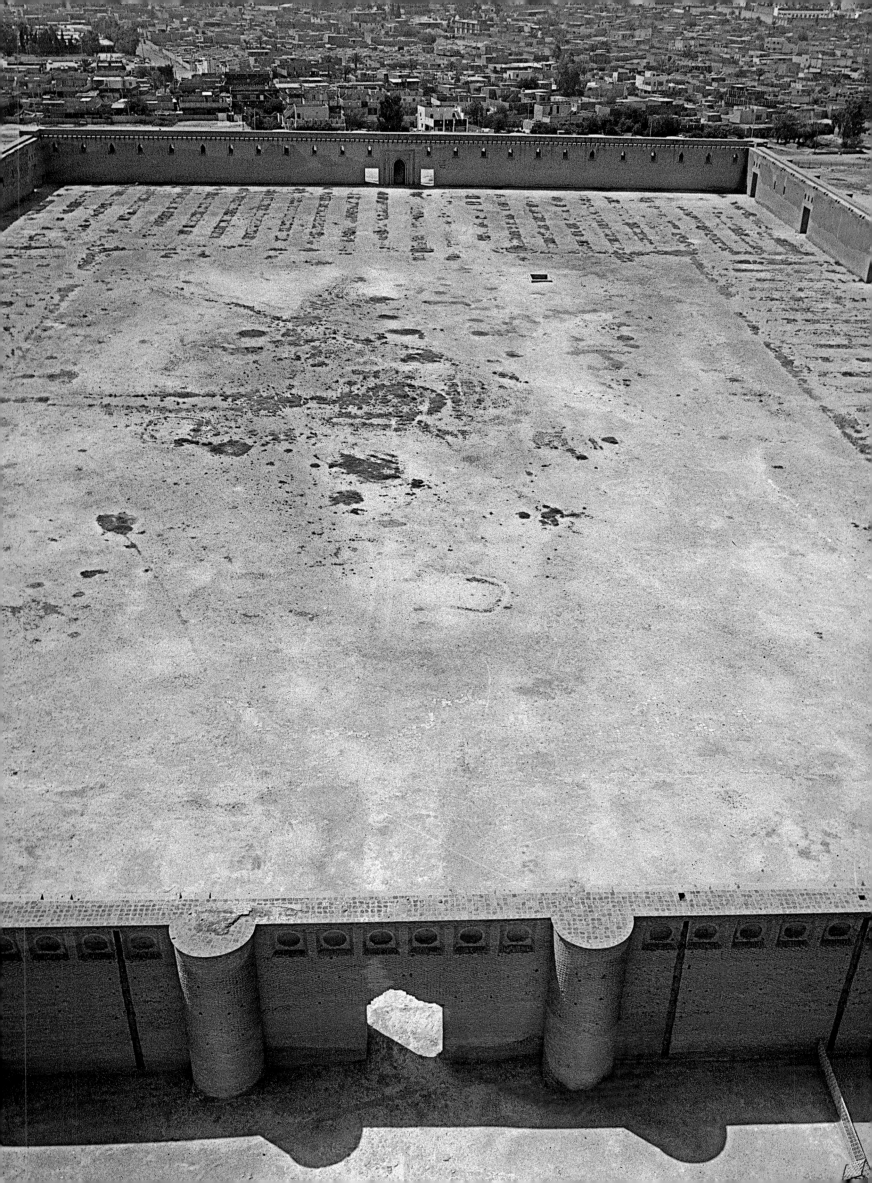

Palace," in the center of whose courtyard it still rests today (plate 162). The designation of these rooms as a harem is logically deduced from the decorations, for the most part painted, found here by German archaeologists. These decorations all align with our knowledge of Umayyad art, such as the work found in the palace of Khirbat al-Mafjar in Jericho[24] and in Qusayr 'Amra.[25] The large central courtyard measures 984 by 610 feet (300 by 186 m) and was surrounded by a wall built of unbaked bricks, with blind niches and stucco decorations. The southern part of the access area and the large esplanade, even though they are only partially excavated, have already revealed a series of structures whose interpretation is anything but easy. It may be deduced that the palace's structure underwent various modifications, at least three, and the misalignment of the walls suggests that in these spaces were arranged various rooms used for lodging and services. The situation to the north is different. Next to the northern part of the palace and along the entire side of the first courtyard is a square space with a courtyard and a circular structure, identified as a large *serdab* (a Persian term that literally means "cold water"; an underground room created to be used during the unbearable dog days of the summer months). Iraqi excavations between 1987 and 1990[26] showed that the central basin (213 feet [65 m] in diameter) was fed by two canals. The earlier work by Herzfeld shed light on rooms with very thick walls to protect against the heat and on deposits of various materials (among which were luster-painted ceramics and Chinese porcelain). As proof of the complexity of this architectural style, on the eastern side of the *serdab* there is a structure that Herzfeld calls a "Rotundabau" or "Rundsaal." It is a central round, domed pavilion preceded by a transverse space that faces onto a courtyard. A double-roomed transverse structure occupies the opposite side.

To the north of these buildings there is another palace surrounded by a protective wall measuring approximately 1,510 by 1,080 feet (460 by 330 m) with semicircular towers 36 feet (11 m) in diameter. Inside there are various buildings, generally located around courtyards of smaller proportions. Many of the walls were built of baked bricks that have been removed. The palace function is for the most part fairly evident, and even though the buildings underwent many changes that make the task of definitively identifying their uses more difficult, the majority seem to be residential in nature. To the west of this large enclosure, and still north of the principal axis (east-west), there is a series of modular buildings (again with small courtyards). Based on their characteristics, they seem to be garrison lodgings. This assumption is supported by the presence of three small mosques, each one probably assigned to a different ethnic group.

140–41. Details of the decoration of a window (above) and an entryway (below) of the Great Mosque of Samarra.

Returning to the main axis, beyond the courtyards there is a small *serdab*.[27] Along its sides there are three long galleries (348 by 36 feet [106 by 11 m]). Without a doubt these were intended as stables for the horses used on the nearby polo field. Along the sides of the stalls there are two large courtyards. Not perfectly on axis with the small *serdab* is the field used for polo (a *maydan*, or open space, measuring 1,722 by 217 feet [525 by 66 m]). The field has on its western side seats for the public (92 by 148 feet [28 by 45 m]), from which one could observe the field or, on the opposite side, the starting gate for horse races or other equestrian sports.[28] The literary sources and archaeological finds are often at one in documenting a grandiose urban and architectural conception that borders on megalomania.

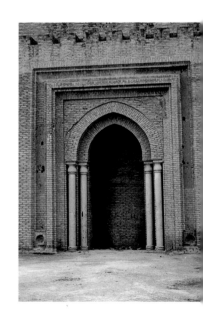

This impression of exceptional proportions is confirmed by the construction of the Great Mosque, erected by Caliph al-Mutawakkil 'Ala Allah in 847. The figure of al-Mutawakkil is especially important in the theological and doctrinal fields, as he distanced himself from the until-then prevailing Mu'tazilah school of thought and, more specifically, refuted the doctrine of the *mihna*.[29] He recalled from exile in Tarsus Ahmad ibn Hanbal (780–855), who was the founder of the Hanbali[30] legal school, and thus marked a fundamental step in the development of Sunnism. The name of al-Mutawakkil for us, though, is linked to the construction

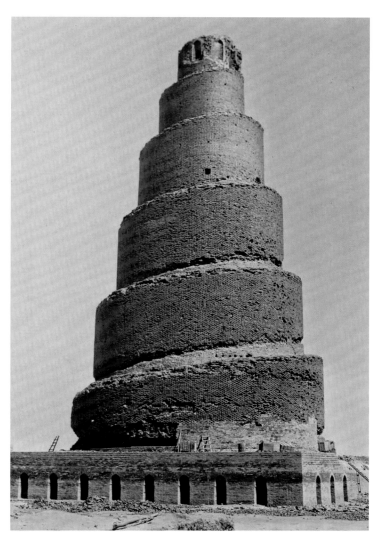
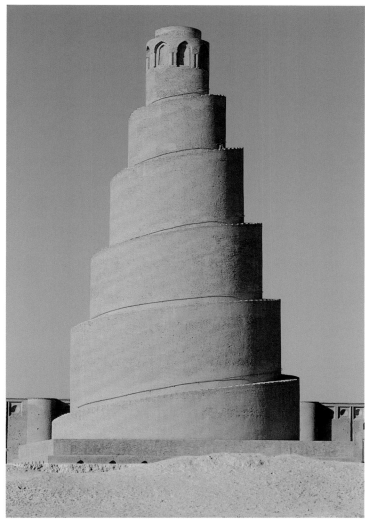

142–43. The minaret of the Great Mosque of Samarra in both a historical image and a more recent photo. Note that, in the 1930s, restorations were already underway on the top of the minaret, which was perhaps originally crowned by a wooden structure.

of one of the largest Muslim mosques ever, whose imposing remains still amaze its visitors today (Sam. 7–11). The protective wall, in baked brick, is marked with semicircular bastions (plate 139). It measures approximately 790 by 525 feet (240 by 160 m; a proportion of 3:2, a module that is very common in all of urban Samarra), with an impressive surface area of 410,000 square feet (38,000 m²). Besides the bastions, this wall was marked by sixteen gates. Only the perimeter wall has survived, but while the interior was completely despoiled, archaeological excavations have fully revealed its form: A large central courtyard was surrounded on three sides by a tripled-ordered portico, and the prayer room was divided into twenty-five aisles (each about thirteen feet [4 m] wide). Each one of these aisles added 9 piers to the grand total of 464 piers in the mosque. The piers had square bases (with stucco painted to imitate marble) surmounted by columns with hourglass-shaped capitals directly supporting the wooden roof. That no imposts of arches or domes have been found confirms that this was a hypostyle structure. The *mihrab* was rectangular in shape, presumably decorated with gilded glass mosaics, as indicated by finds from the site.

Two other features to be noted in this mosque include the enormous *ziyada* around three sides (an empty space bounded by a retaining wall that helped to keep the sounds of the city from interfering with the necessary tranquillity of prayer) and the characteristic minaret. This minaret (*manaret al-malwiya*, with *malwiya* meaning "spiral") is one of the most notable symbols of the Muslim world. It is made of baked brick and set upon a square base 108 feet (33 m) per side, with nine niches on each side. It has a twisting ramp that turns counterclockwise around the exterior and completes five full rotations, becoming gradually steeper as it rises so that the levels reached are each the same distance apart. At the top (at ninety-nine

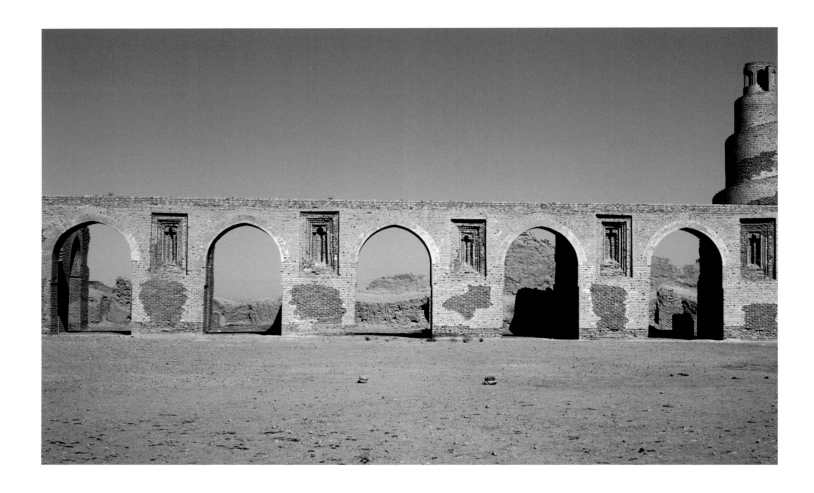

cubits, or 164 feet [50 m]) there was a pavilion in wood mounted on eight columns. The *mal-wiya* was inspired by the Babylonian ziggurats and is itself an excellent indication of an incredible architectural continuity (plates 142–43).

To Caliph al-Mutawakkil is attributed in 859/60, after a visit to Damascus the previous year, the construction of another mosque, that of Abu Dulaf, in the area to the north of the Great Mosque called Ja'fariyya, which he wanted to establish as a new, independent city. It is here that on December 11, 861, al-Mutawakkil was assassinated, and al-Muntasir named as his successor to the Caliphate, though only for a year. This was sufficient time, however, for him to abandon Ja'fariyya and return the capital to Samarra.

The plan of the Abu Dulaf mosque (Sam. 12–16) is identical to that of the earlier mosque, with a fortified wall in unbaked brick measuring 699 by 443 feet (213 by 135 m) and a court-yard of 377 by 427 feet (115 by 130 m). The *riwaq*, or portico, runs along three sides with three rows on each side. The prayer room, which is also hypostyle, is constructed with seventeen aisles perpendicular to the *qibla*, each with five rows of arches. A double transverse row of arches that rests on the last piers (which are T-shaped, like those on the opposite side that create the facade of the prayer room, but unlike the previous ones, which are square) marks off the area of the niche-shaped *mihrab*. The central aisle, corresponding to the *mihrab*, is wider than the others, and the double transverse space in front of the niche produces a T-shaped plan, as in Kairouan[31] but also in Cairo.[32]

The mosque has a *ziyada* and a twisting minaret (plate 145), though this is smaller than its predecessor in that there are only three complete counterclockwise rotations in the ramp, reaching a height of just over fifty-two feet (16 m). Curiously—though not if we consider the construction material of unbaked brick on the outside and baked brick on the inside—the perimeter wall of Abu Dulaf has almost completely disappeared (except for some of the entryways: fifteen of the original, supported by frames in baked brick), while the internal walls are well preserved (plate 144). A building excavated in the 1940s, immediately behind

ABOVE
144. An aisle of the Abu Dulaf mosque, Samarra, with elegant blind windows that lighten the massive walls.

OPPOSITE
145. The minaret of the Abu Dulaf mosque, though restored and of smaller proportions, reflects that of the Great Mosque.

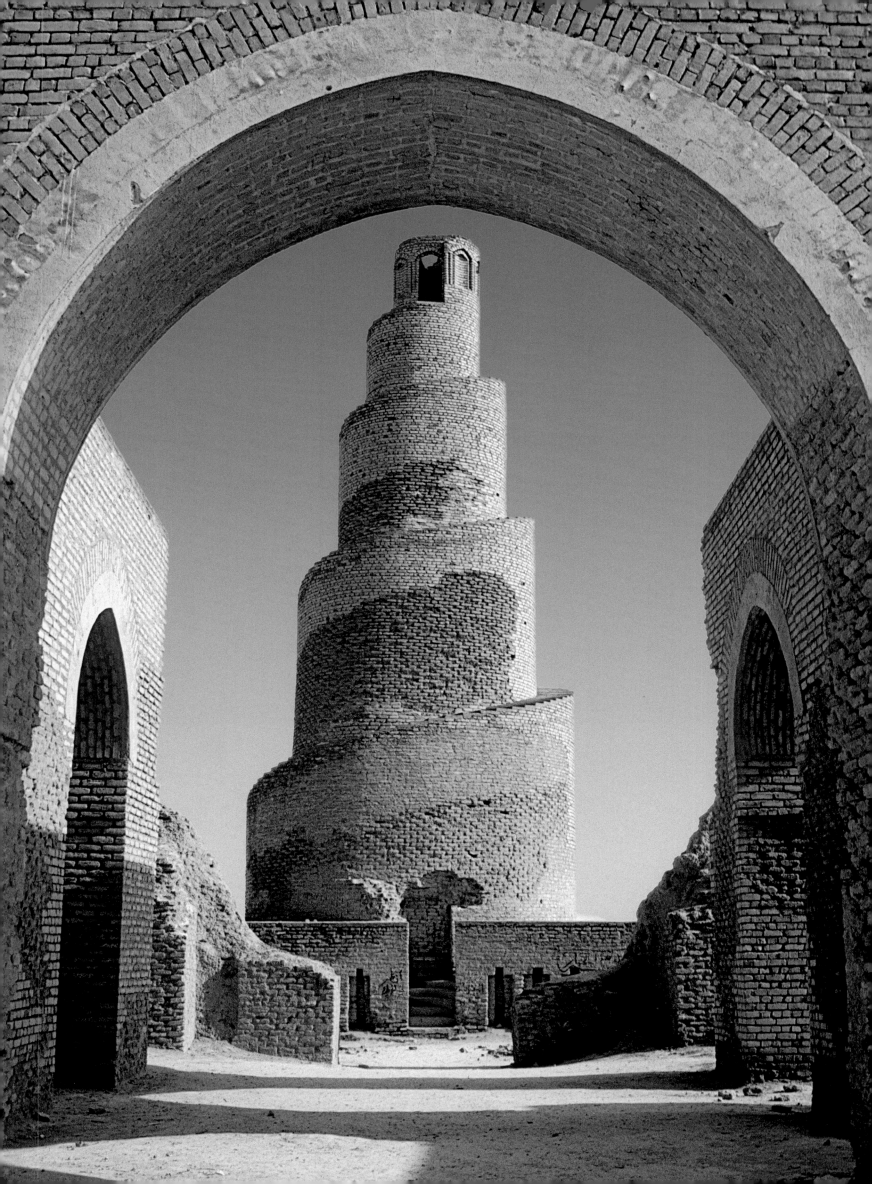

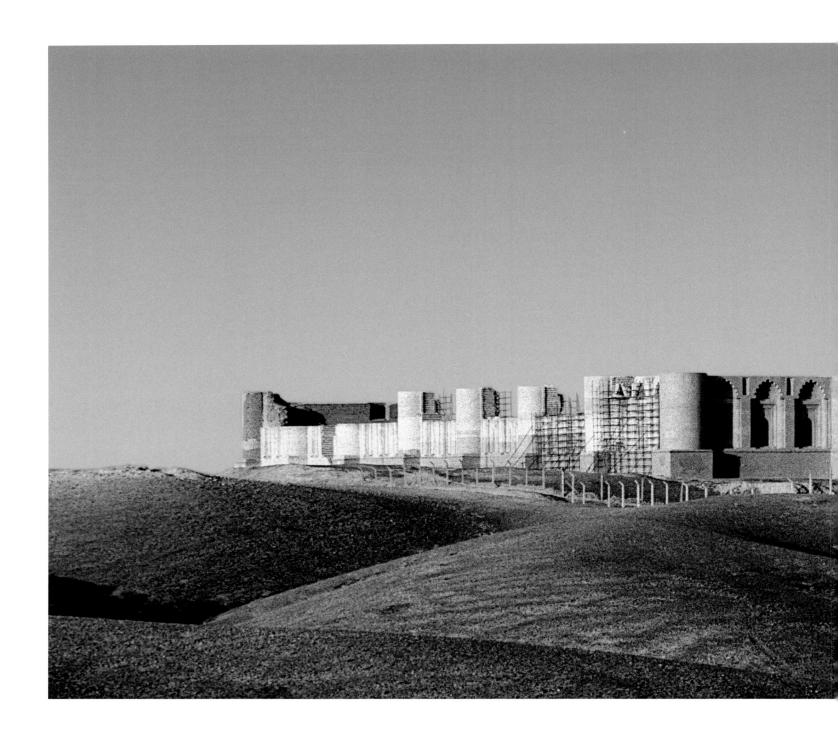

the *mihrab* of the mosque, is of great interest. Measuring 140 by 114 feet (42.7 by 34.7 m), it is laid out around two courtyards. Onto the first courtyard face four *iwans* and vestibules (one of these led to the mosque, probably through a *maqsura*). The other seems to be a *bayt*. This building seems to have functioned as a small apartment or rest and meditation area for the Caliph or for the Imam of the mosque.

Naturally, a city of the extent and importance of Samarra would be home to many other monuments worthy of attention in this context, beginning with the large irrigation canal (Nahrawan) ordered by the Sasanian king Khosrow Anushirvan, whose purpose was to join the waterways heading to Ctesiphon. In reality, the city's water supply, despite its location along the Tigris, was always one of its weaker points. Alistair Northedge claims that the wells of today, although reaching down sixty-six feet (20 m), still do not produce more than a couple of barrels of water per day.[33]

In any case, of those sites that should still be mentioned, there is the large octagonal compound of Husn al-Qadisiyya, whose sides measure from 2,008 to 2,044 feet (612 to 623 m)

146. A panoramic view of the imposing al-Ashiq palace on the banks of the Tigris. Restoration and re-creation allow us to appreciate the extraordinary size of many of the palaces that were built in Samarra.

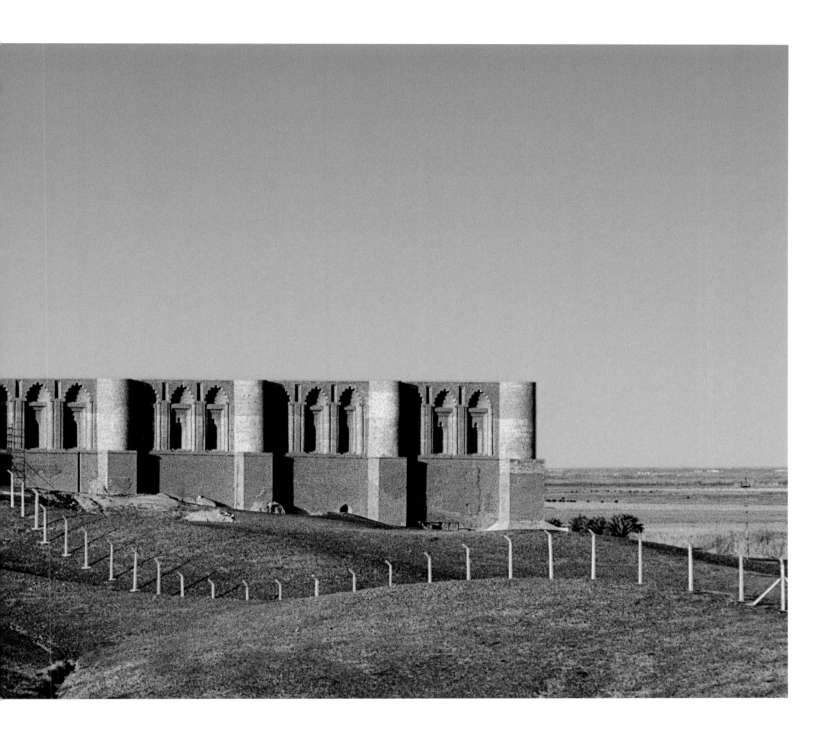

with a central portal on each wall. It appears that these unbaked brick structures were never completed (nor was the central mosque, which has a *sahn* measuring 341 by 512 feet [104 by 156 m], exactly the same proportions as the one in Abu Dulaf). Sources suggest that it could have been a palace/city ordered by Harun al-Rashid (b. 766, r. 786–809; the most famous Abbasid Caliph, celebrated and immortalized as the legendary husband in the stories of *A Thousand and One Nights*) before he transferred his court to Ar Raqqah in northern Syria. Al-Istabulat is a fortified (as usual) rectangular enclosure measuring 5,646 by 1,866 feet (1,721 by 575 m). Its interior houses an extensive network of residential spaces, all of which have rooms on two sides of a courtyard. Its primary function has not yet been verified; according to Herzfeld,[34] it could have been the palace of al-'Arus, one of the many palaces (at least seven to twenty, calculating from the sources) built at Samarra on the orders of the Caliphs. Alternatively, it could have been a sort of military encampment able to house a garrison of more than forty thousand soldiers.

Balkuwara (four miles [6 km] southeast of present-day Samarra) is a palace on the eastern banks of the Tigris, built on the orders of Caliph al-Mutawakkil in 849 for his second child

in the line of succession, al-Mu'tazz, as confirmed by an inscription found by Herzfeld, which states: *"al-amir al-Mu'tazz al-Mu'minin."* The outer wall is more or less square and measures 3,822 by 3,842 feet (1,165 by 1,171 m) with the actual palace extending between 1,522 and 1,866 feet (464 and 575 m) along the transverse axis (Sam. 17). Oriented from northeast to southwest, it displays a plan that is, in some ways, similar to Jawsaq al-Khaqani, with two large gardens divided into quarters and an internal courtyard that leads to a tripartite room that, in turn, accesses a cross-shaped room (a reception and audience hall). This room leads to another tripartite structure that opens onto a garden set directly on the river. As usual, this well-defined axis is joined on the north and south by areas for lodging (always with internal courtyards), *hammam*, and other structures, including a palace mosque made up of only a prayer room.

The Qubbat al-Sulaybiyya is found at a distance of one mile (1.5 km) to the south of Qasr al-Ashiq.[35] It is a domed building of great architectural interest, partially excavated by Herzfeld and restored in the 1970s by Iraq's Directorate General of Antiquities. Basically, it is a double octagon with each of the external sides opened by a passage that leads to a hallway. The smaller, central octagon has four closed sides (on the inside of which are niches, however) and four openings. Excavations beneath the pavement level revealed two tombs. Although there is no agreement among researchers on the identity of the bodies, Herzfeld's hypothesis, later reinforced by Creswell, is that this is the tomb or mausoleum of Caliph al-Muntasir, built in 862–63. The architectural type, probably completed by an octagonal esplanade accessed by four ramps, is strongly reminiscent of the beautiful Qubbat as-Sakhrah

147–48. Two historical photographs of the excavations in a residential area of Samarra. Some of the famous stucco panels can be seen in their original positions.

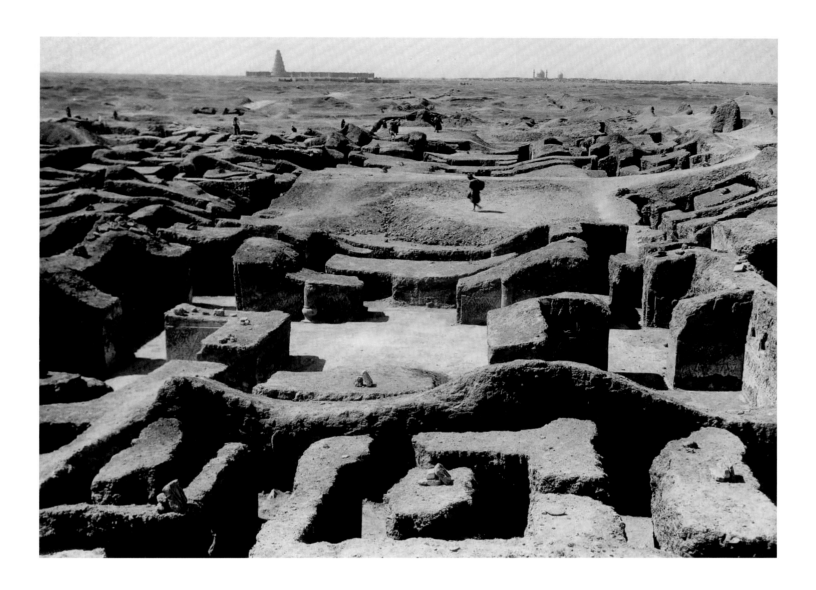

(Dome of the Rock) in Jerusalem. It is the first example known to us of a monumental Islamic tomb. In fact, the previous Muslim tradition, according to which Muhammad himself was buried, does not place any emphasis at all on the veneration of the mortal remains of Muslims. This tradition slowly eroded until enormous mausoleums were constructed.

Stuccos

The archaeological area of Samarra, as we noted, is an immense field of ruins. In an ongoing attempt to catalogue the structures, A. Northedge has recorded a total of 6,314 buildings, among which are 2,252 residential blocks.[36] This is an enormous range that makes it easy to think there will be vast amounts of work for many future generations of archaeologists to do. Samarra, naturally, was, and still is, an important treasure trove of decorative art, in addition to architecture. The construction materials that were used, unbaked and baked brick, are, as has so often been observed, suited perfectly to the large-scale use of stucco as the main decorative element (plates 147–48). Stucco in this instance means a material with a high percentage of gesso that could be easily shaped, especially into panels, with the aid of wooden or terra-cotta molds, and mounted as trim in very many rooms. Quite probably, the stucco was finished in polychrome, even if all traces of the paint have since been lost.

Herzfeld[37] classifies three main styles that are also meant as a progressive development, though many analyses have demonstrated that the first two, called A and B by Creswell

(plate 149),[38] are almost certainly coeval, since they coexist in single buildings. The motifs include plant and floral abstractions (palmettes, grape leaves, clusters, or pinecones) inserted into a geometric scheme. This allowed for an exceptional flexibility in usage. The origins of these designs undoubtedly have roots in the late-antique classical repertoire already found in the Umayyad period,[39] such as in the stone *mihrab* previously described (plate 132), though with a tendency to disassemble the forms in a completely new way. This tendency came to be fully realized in the so-called "third style" or "beveled style," in which the carving is oblique and receding, giving a completely new body to the panels (plate 150).[40] This device would be quoted in various contexts, as at Ibn Tulun in Cairo.[41]

Even beyond its wonderful monumental buildings and the excavation campaigns that have centered on it, Samarra remains our focus as a location that benefited from the development of a renewed, and fully autonomous, language of Islamic art, a language by now completely distinct from its sources. It is with the Abbasids and in Mesopotamia, in fact, that Islamic art, following a period of apprenticeship, expresses itself with its own personality: the initial ferment, with roots divided equally between the western world (Mediterranean and classical Syrian) and eastern lands (the Persian Sasanian cultural heritage and that of Iraq itself), reaches a point of self-expression based on these never-repudiated foundations but guided by its own formalized artistic concept, from which later conceptual elaborations will find it difficult to free themselves. This can also be seen in monumental paintings, even though in some ways they tend toward a more accentuated conservatism. As noted, in the Dar al-Khalifa (or Jawsaq al-Khaqani) in Samarra, some areas have been identified as harems, particularly because of the painted murals that decorate the upper part of the walls. The most famous and frequently reproduced of these images is a depiction of two dancers with long braids and flowing garments, set in mirrored positions, each with the left leg lifted and the right hand holding a goblet (the arms of the women cross) into which she pours wine (?) from a bottle with a long neck and rounded body.[42] This image shows a typical scene of

149–50. Two stucco panels from Samarra, one in the "first style" (left), and one in the "third style" (right). National Museum, Baghdad.

courtly entertainment—dancing, hunting, and drinking—with the sovereign depicted on a throne, an obvious sign that the representation of power is now accepted by the Abbasid court, although it still lacks its own ceremony—that will come from that most structured of defeated empires.

Ceramics

Among the finds from Samarra, we should make at least a brief observation concerning ceramics. For a long time during the last century, following the reports of the German mission of 1911–13[43] and the archaeological data therein, it was believed that the city had been definitively abandoned by 883 (in reality, a more accurate reconstruction advances this event to 892; an article by numismatist G. Miles[44] pushes the date to 953, during the Buyid era, but the circumstances are still controversial). It was thought, therefore, that any material found there should be dated somewhere within the short span of time in which the city was the capital of the Caliphate; in fact, this is clearly not the case, because some of the ceramic types (as well as a large group of graffiti) date, without a doubt, to the twelfth or thirteenth century. Other circumstances are also important in evaluating the collection of ceramic finds from Samarra: that the examples collected by the Germans were dispersed to various museums (in London, Paris, Istanbul, Berlin, and elsewhere), that the archaeological provenance of only half the pieces discussed by Sarre is known (some, surely, were acquired in the marketplace in Samarra, as well as in Baghdad and even Paris), and that the examples were selected for their representativeness, or simply their beauty, as is evident from the mass of fragments of "common" ceramics uncovered in later excavations.[45] All this creates a picture as complex as it is significant.

Among the most important finds are those from Qasr al-Ashiq (occupied from 878 to 883; subtle, "eggshell"-white common [that is, not glazed] ceramics with stamped decoration in

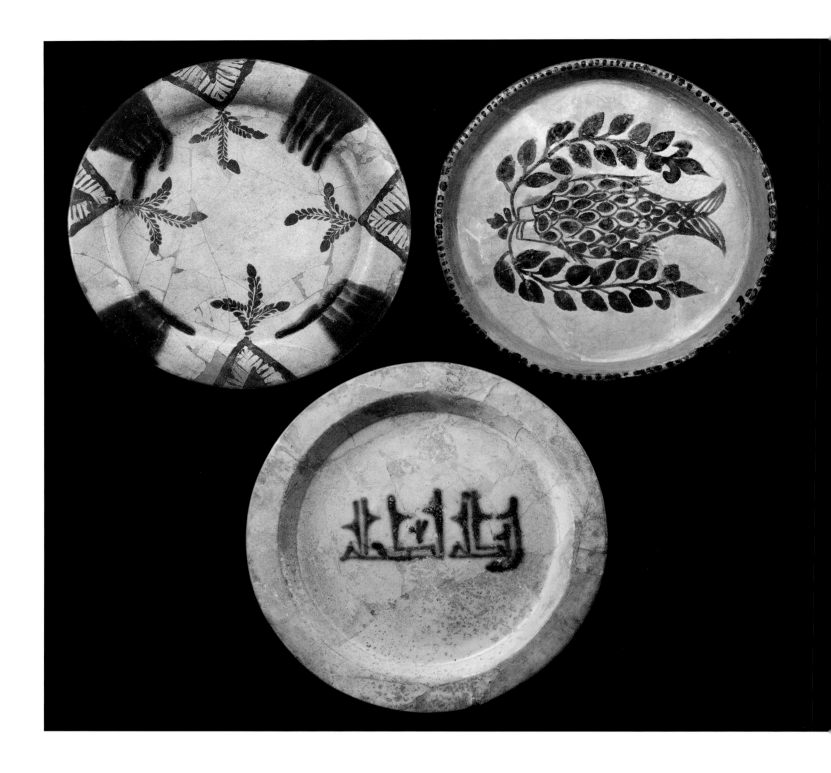

cobalt blue on white, blue and green on white, and monochrome and polychrome lusters, as well as imported ware from the Far East) and from the Dar al-Khalifa (molded oil lamps with non-glazed decoration in cobalt blue on white or blue and green on white, or with metallic luster decoration on a blue ground; tiles with monochrome and polychrome lusters; and painted, non-glazed ceramics). From the so-called harem and the other rooms of the palace complex (all constructed between 836 and the abandonment of 892–903; here, in particular, finds of Far Eastern ceramics, both porcelain and stoneware, were noteworthy) come many pieces, and likewise from the few excavated houses, while in the palace of Balkuwara (constructed between 854 and 859 and almost immediately abandoned) and in the mosques finds have been relatively scarce, as would after all be logically expected.

Among the most characteristic types is that with stamped and luster-painted decoration, exemplified by a plate in Berlin that came from Babylon.[46] The ground is a delicate cream

151–53. Three examples of ceramics of the Samarran type. Top left, a terra-cotta plate with an opaque white glaze and decorations in cobalt blue and copper green, Victoria and Albert Museum, London. Top right, a plate decorated in cobalt blue with an image of a fish with two sprigs of a marine plant, Ashmolean Museum,

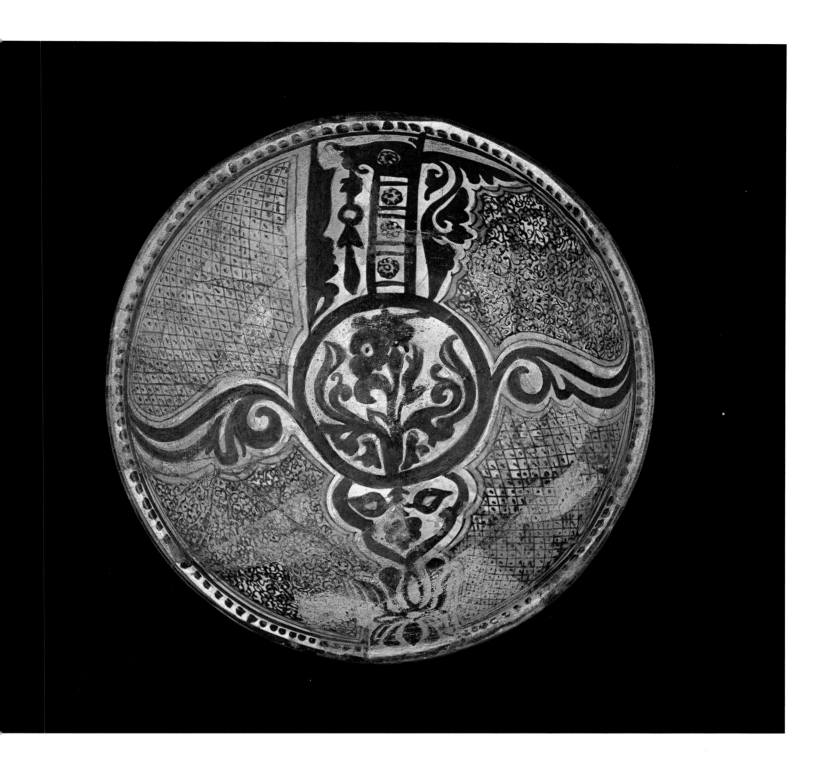

Oxford. Bottom, a plate decorated in copper green with a Kufic inscription, Museum of Fine Arts, Boston.

154. A goblet from Samarra, in terra-cotta with an opaque white glaze, decorated with an image of a large stylized bird. Museum für Islamische Kunst, Berlin.

color enlivened by touches of green. The technique recalls the tradition, first Roman and then Byzantine, of *terra sigillata,* but the decoration here shows a geometric pattern that is not incompatible with a Chinese influence (reflecting, for example, the decoration on a number of the bronze mirrors from the Tang era) and has a continuity with the Persian Sasanian style. Another type with notable impact is the open form with copper green or cobalt blue (it is very rare to find these two colors used together) on an opaque white ground. Although there are naturalistic motifs such as flowers, palms, or fish, the most common examples, and the most beautiful, are those decorated with simple Kufic epigraphs, such as the one in Boston[47] with a marvelous "rose thorn Kufic" (plate 153). The most glorious Samarran ceramics, however, are those produced in a metallic luster, an ancient technique already in use in Pharaonic Egypt (on glass) and reinvented by Muslim artisans who applied it even to decorative wall tiles.

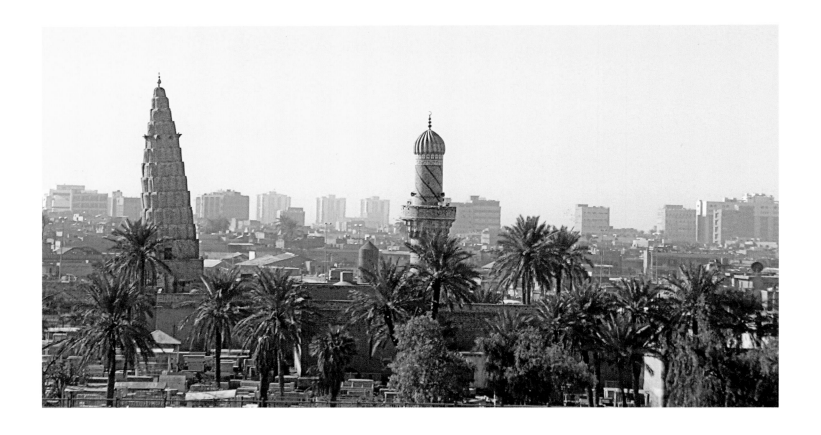

A goblet from Samarra, now in Berlin,[48] shows a highly stylized bird (maybe an eagle or peacock) that divides the painting into four sections (plate 154). At the center of the animal's body there is a circle, inside of which is a floral design (or, possibly, another stylized bird) with what appear to be wings. In reality, they are nothing more than half palmettes, and under them is yet another floral design. Above this, the bird holds a pendant in its beak (a possible Byzantine or Sasanian link), and it has a crest made of a half-palmette motif. The four sections have alternating painted backgrounds of grids of dotted rhombuses and little spirals. A heraldic animal, the eagle, if that is what it is, but executed in a fresh and imaginative style, allusive and lively, seems the perfect symbol of the artistic expression of Samarra, one of the greatest cities ever built by Muslims.

The circumstances surrounding the abandonment of Samarra, although amply documented by the historical sources, are still problematic. It is probably attributable to a series of preexisting political, strategic, and economic factors. The increasing difficulty of obtaining water for a polycentric city whose expansion was, to say the least, tumultuous, was clearly a major factor in itself. However, it was with Caliph al-Muʻtadid in 892 (or with al-Muktafi in 903) that the Muslim court returned to Baghdad and made that city the capital once again. The political situation, however, was no longer the same. Just to the north of the city, in the Mosul region, control was assumed by a local dynasty, the Uqaylids (990–1096), a Bedouin clan who originally came from central Arabia and then spread across various regions. This clan expanded its powers into central Iraq, at least as far as Tikrit, though they were ultimately defeated by the Seljuks. The latter were a Turkish dynasty from central Asia that took over from the Buyids as "protectors" of the Abbasid Caliphs, who remained nominally

ABOVE
155. In the urban landscape of modern Baghdad rises the dome of ʻUmar al-Suhrawardi's thirteenth/fourteenth century mausoleum.

OPPOSITE TOP LEFT
156. A detail of the dome of ʻUmar al-Suhrawardi's mausoleum in Baghdad.

OPPOSITE TOP RIGHT
157. A view of al-Hasan al-Basri's thirteenth-century mausoleum in Basra.

OPPOSITE BOTTOM
158. The exterior of the eleventh-century Imam Dur in Samarra.

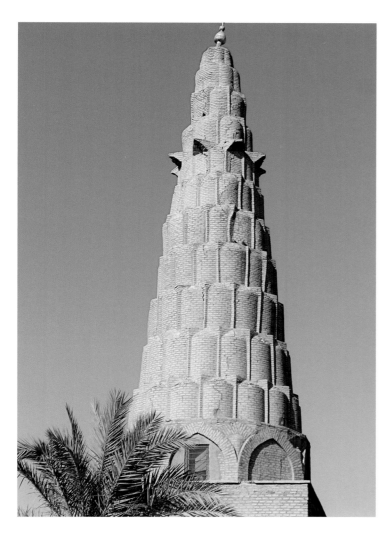

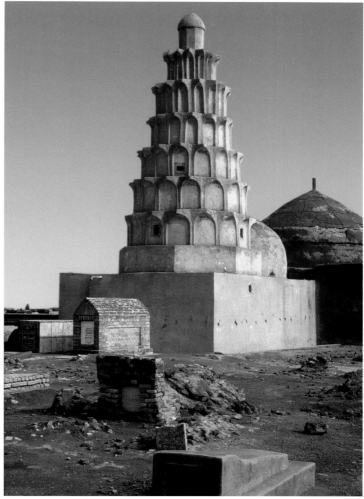

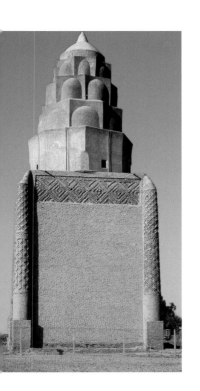

in power until 1258, though for long periods they had only very limited autonomy. The political unity of the Muslim world, if it had ever existed, was already finished.

The Seljuk rule of Iraq began in 1055 when Toghril Beg (990–1063) took over Baghdad and ended in 1194 when power returned to the Abbasid Caliphs who were, in turn, defeated by invading Mongols. In the northern region of Mosul all the way to Aleppo, power was seized by a small but potent *atabeg*[49] dynasty, the Zengids, who dominated these regions between 1127 and 1222. The Ilkhanid, or Mongol, domination of Iraq lasted until 1328, when the Jalayirid dynasty took over (until 1411).[50]

IRAQI MONUMENTS OF THE ELEVENTH TO FOURTEENTH CENTURIES

Unfortunately, little or nothing remains of the Muslim monuments built around the millennium in Iraq. This is due to a decline in construction activity caused by many factors, both political and economic. One of the oldest and most interesting monuments in Baghdad is the mausoleum of Zumurrud Khatun, mother of Caliph an-Nasir (Abu'l-'Abbas Ahmad an-Nasir li-Din Allah, b. 1158, r. 1180–1225). This edifice is dated somewhere within the reign of this enlightened sovereign who took back the reins of power from the Seljuks and returned the Abbasid Caliphate to its prestigious position. Among other things, he restored good relations with the Ayyubids in Egypt, the Zaydi Imam of Yemen, and Qatada ibn Idris, a Shiite and Sharif of Mecca. (*Sharif* is a title generally applied to descendants of the Prophet, with the same meaning as *Sayyid*, but later becoming specific to those governing Mecca and to

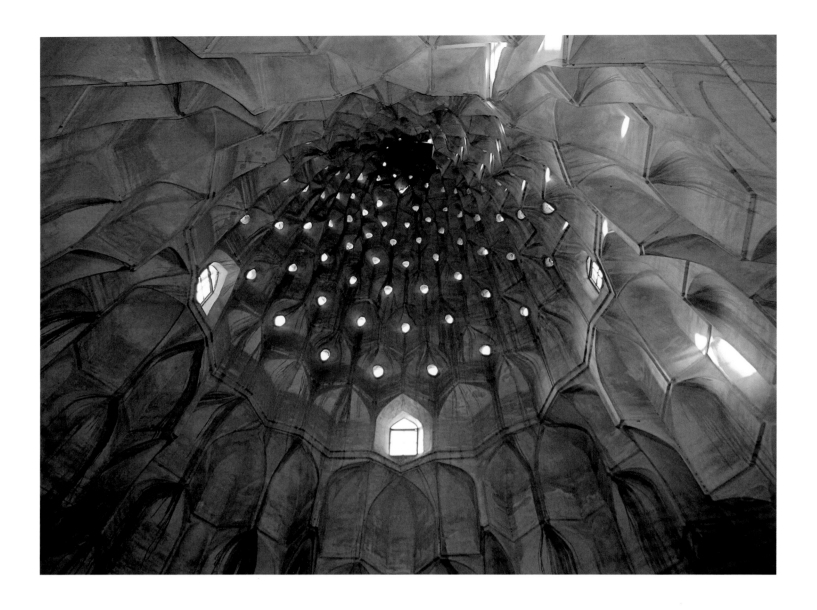

some reigning houses, such as that of Morocco.) This monument (plates 159–60)[51] is one of the most famous in Baghdad and is commonly referred to as Sitt Zubaydah, since for a time it was considered the tomb of the wife of Harun al-Rashid, the Caliph who, as has been said, is most famous around the world for his role in the wonderful stories of *A Thousand and One Nights*. Architecturally, this building is based on an octagonal plan, which is fully in line with the function it performs (considering the very ancient type of the *martyria*). It is crowned by a conical "sugar-loaf" dome, created by a series of stalactite elements known in architectural terms as *muqarnas*. The silhouette is characteristic and unmistakable; the invention of this type of structure probably took place in Iraq.

Another example of this stylistic form is the Imam Dur in Samarra (plate 158; Sam. 19),[52] which dates back to 1085 and is the tomb of Sharaf al-Dawla Muslim, an Uqaylid Emir. Its plan is square, with four semicircular corner towers. The *muqarnas* roof, the oldest known, is made with only five orders topped by a small dome and is imperfectly integrated into the proportions of the underlying "cube." A further building in Baghdad with a similar roof (though a double inner dome) is the mausoleum of 'Umar al-Suhrawardi (plates 155–56; Bagh. 6–13),[53] a mystic, expert on Islamic law, and Imam of the Shafite school, who died in 1224. This building was built, therefore, about the same time as the mausoleum of Sharaf al-Dawla Muslim, even though an inscription reads that the place in question was "restored" in 1334 by Muhammad ibn al-Rashid.

An overview of this type of *muqarnas* roof in Iraq should also include the mausoleum of Imam al-Hasan al-Basri in Basra (first half of the thirteenth century; plate 157) and a similar

ABOVE
159. The interior of the dome of the mausoleum of Zumurrud Khatun in Baghdad, decorated with *muqarnas*.

OPPOSITE
160. The exterior of the mausoleum of Zumurrud Khatun, an octagonal building surmounted by a *muqarnas* dome.

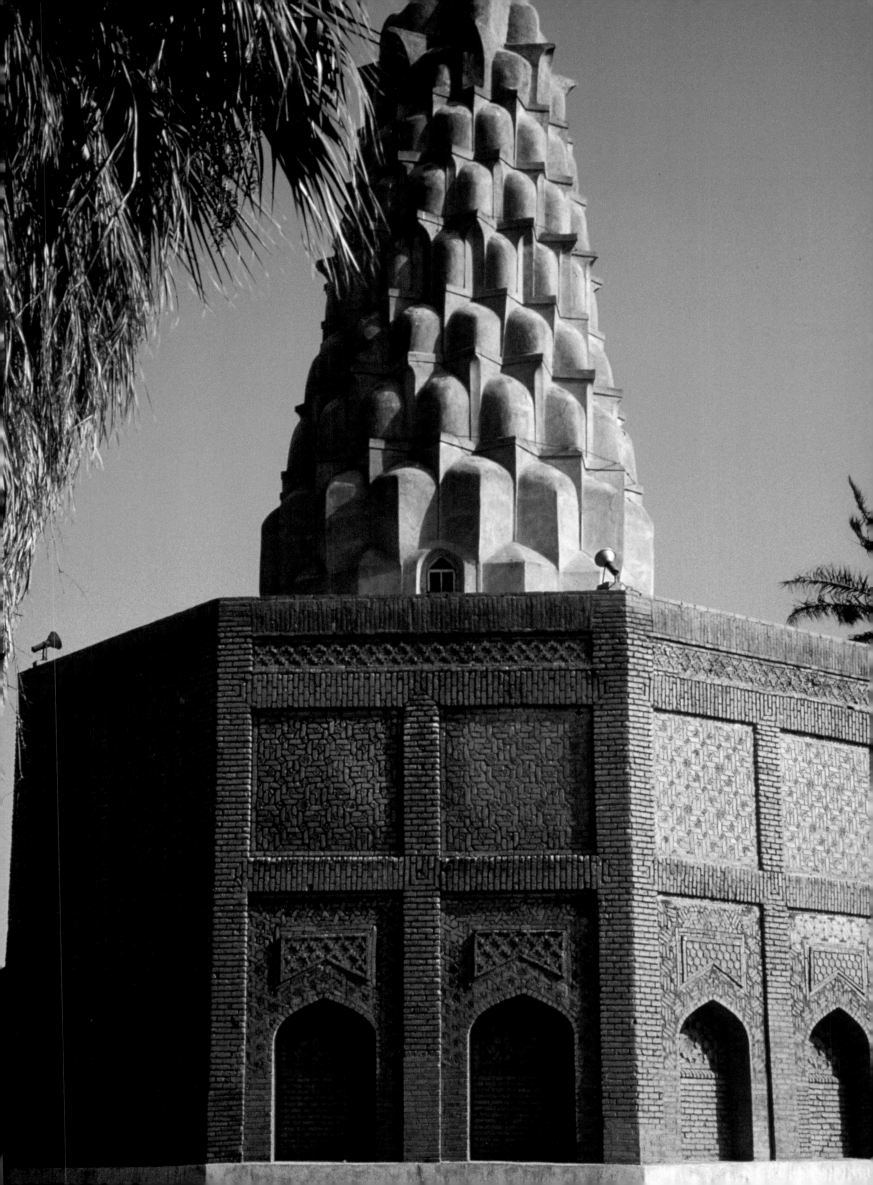

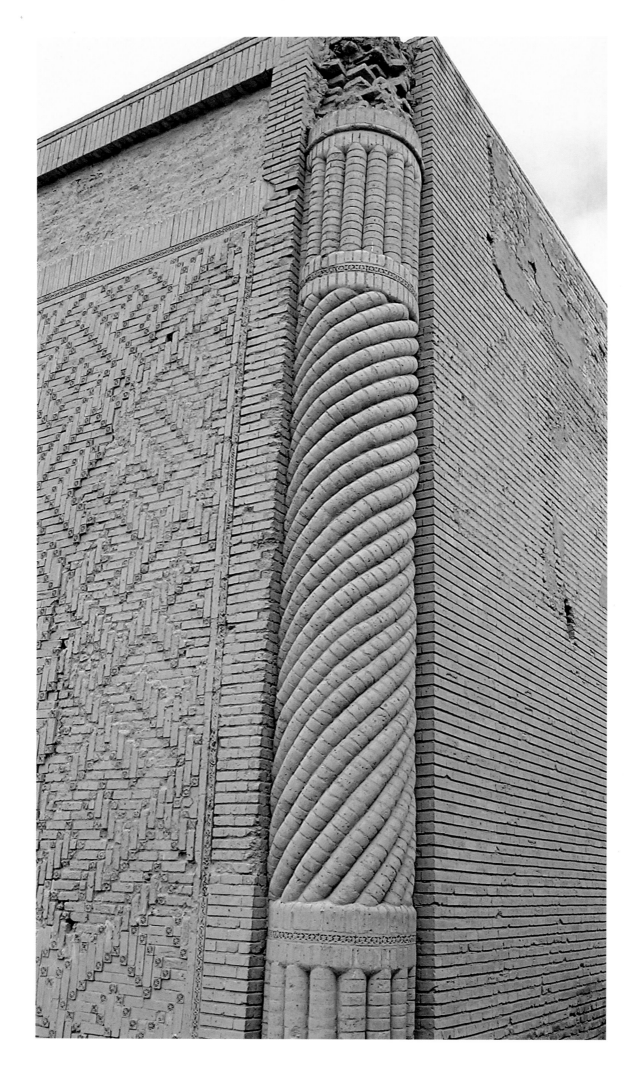

161. This twisted brick
column at an exterior
corner of the so-called
"Abbasid Palace" in
Baghdad is, along with
the brickwork patterns
in the wall to the left,
testimony to the care
with which this structure
was built in the thir-
teenth century.

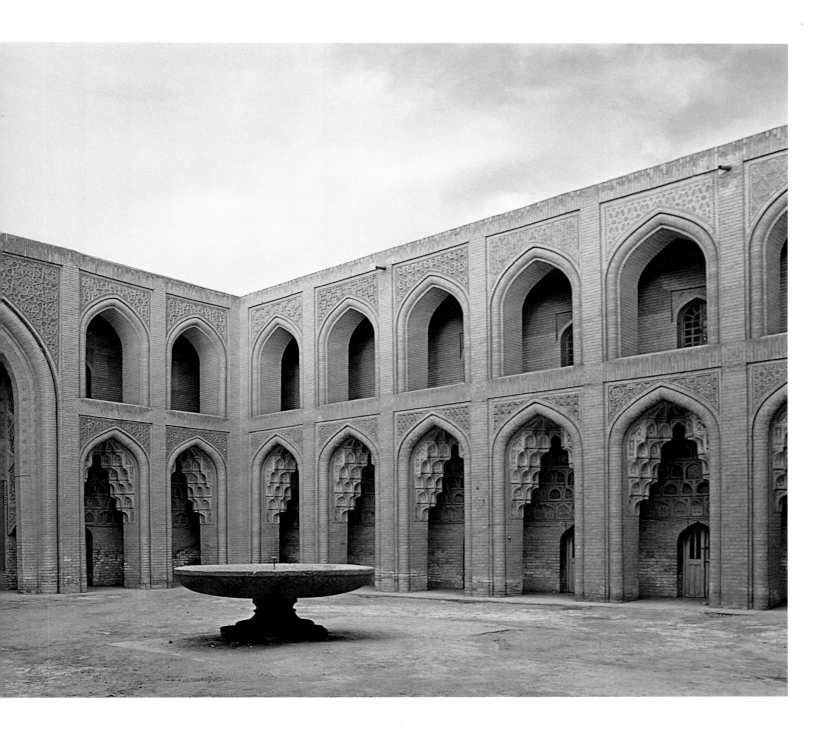

ABOVE
162. The central court-
yard of the "Abbasid
Palace" in Baghdad
(probably a *madrasa*, or
Qur'anic school), onto
which face the cells and,
on the left, the *iwan*.

monument in Dhu'l-Kifl,[54] a small town halfway between al-Hillah and Najaf, traditionally the burial place of the Prophet Ezekiel and thus a pilgrimage site especially for Jews, but also for Muslims. Dhu'l-Kifl is noted for the structural difference between its interior and exterior, and also for its incredibly beautiful cylindrical minaret (seventy-nine feet [24 m] high). Its decoration of facing bricks is unique even in the very rich Islamic repertory of that material. The most probable dating, based on historical evidence, is 1316, during the reign of Oljaitu the Mongol. A similar structure is found in Susa in Iran, at the so-called "Tomb of Daniel" (and the fact that this same style is used for yet another Biblical prophet is, I feel, noteworthy), and in Damascus, Syria, at the al-Nuri Hospital; both of these monuments date from the thirteenth to the fourteenth century.

Except for a pair of historically important minarets—though they are not so important from an artistic point of view, and have been "restored" almost to the point of re-creation[55]— the most interesting and best-preserved monument in Baghdad, though not uninjured by restoration, is the so-called "Abbasid Palace," c. 1230 (plates 161–64; Bagh. 19–22). The purpose of this building is unclear. The plan, although reconstructed from excavations and

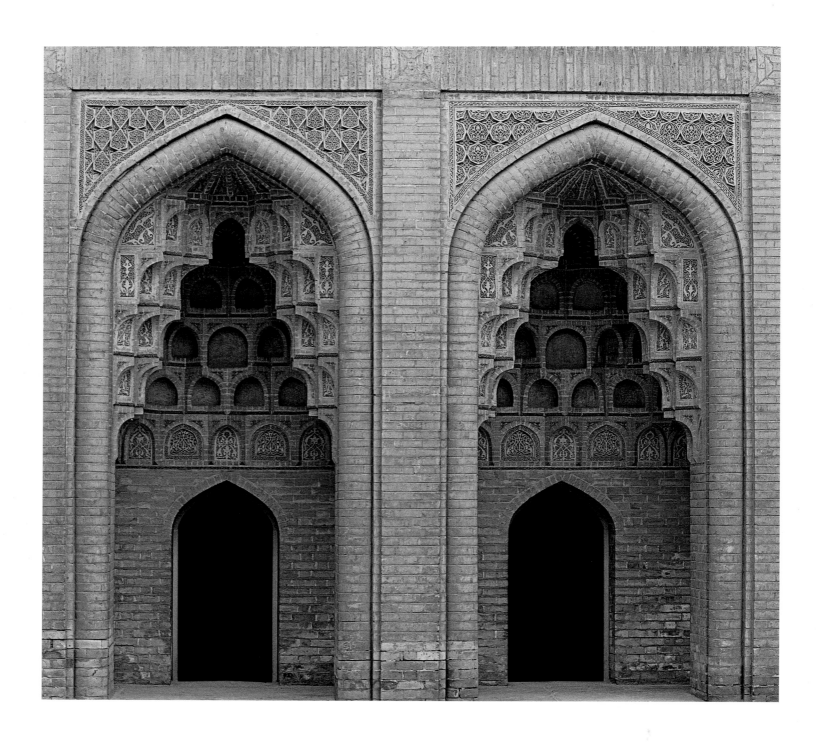

163. Detail of two arches with *muqarnas* in the "Abbasid Palace."

from restoration work done in various stages[56] by the Directorate General of Antiquities, has not yielded a precise interpretation. Onto the east side of a central courtyard, housing a basin in red Egyptian granite brought from Samarra, opens an *iwan* with two stories of rooms on either side. To the west, though not on the same axis, there is a portal that faces onto a garden located along the banks of the Tigris. The portal is characterized by a screen structure that protects the inside from being spied upon, a feature typical of large private buildings in Baghdad (though, interestingly, not just here: in China, too, palaces had similar protective devices!). In Iraq, this structure was called a *mabayn*. To the side is a large room

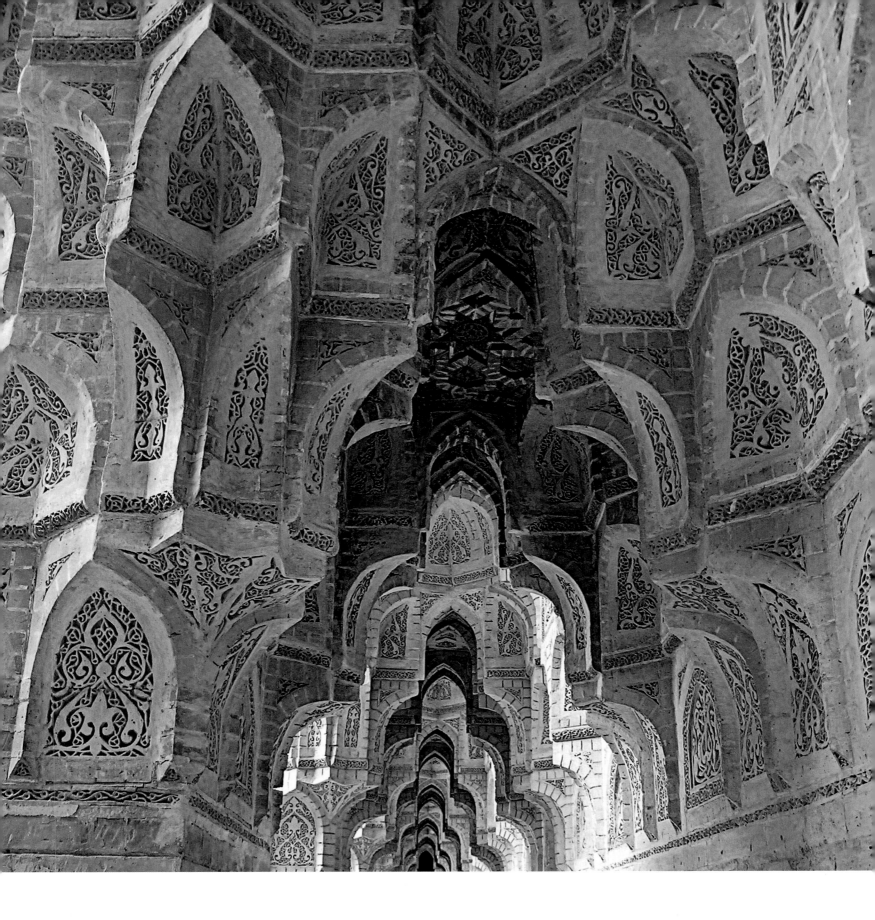

164. The arabesques
carved into the *muqarnas*
of the "Abbasid Palace"
symbolize well the deco-
rative richness and
finesse of the architec-
ture of the Caliphate.

that excavations have determined was not an *iwan*. To the north and south, a string of seven cells faced onto the courtyard. Behind the southern cells was a slim corridor that led to a series of large rooms that did not all communicate with each other.

There is little dispute over dating this building to the late Abbasid period, mainly because of its architectural and decorative elements. There remain two hypotheses, however, as to the use of the building. According to two leading Iraqi researchers,[57] this is the Dar al-Musannah of Caliph an-Nasir. N. Ma'ruf, however, feels that this is a *madrasa* and, more specifically, that it is the Shirabiyya[58] *madrasa*. This hypothesis seems more likely, and the

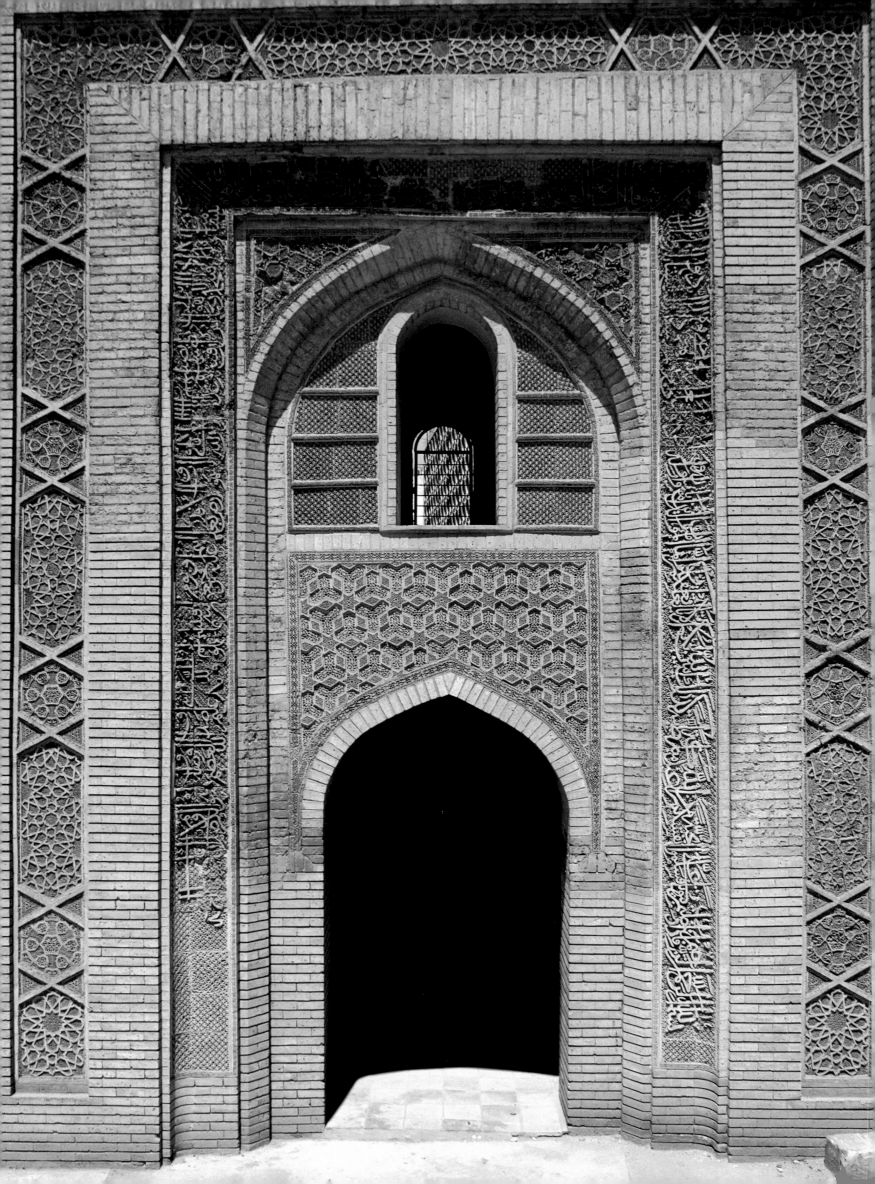

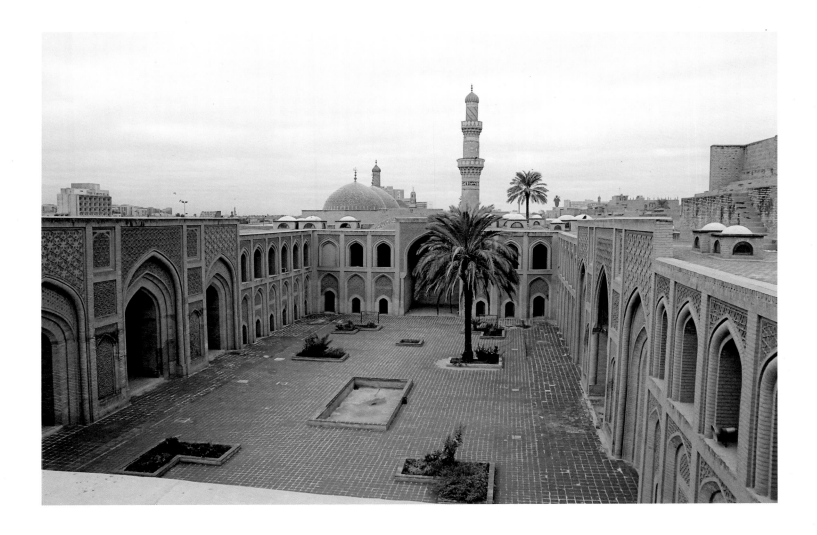

OPPOSITE
165. An entrance to the
Mustansiriyya *madrasa*
in Baghdad.

ABOVE
166. A view of the
courtyard of the Mustan-
siriyya *madrasa*, showing
the two levels of student
cells and three of the
four *iwans* facing onto
the courtyard.

question of why only a single *iwan* was found (in contrast to the only slightly later Mustan-siriyya *madrasa*) can probably be explained by the fact that there was no requirement that there be a location for all four of the canonical schools; in any case, there is no law that each one required its own *iwan*. The oldest and best-preserved part of the building is the *iwan*, with its brick and stucco decorations representing a free evolution of Samarran classicism filtered through the Seljuk experience and, in some ways, the Persian experience too. The gallery, vaulted in *muqarnas*, that surrounds the courtyard on three sides deserves its fame, and the perspective of the *iwan*, with the rhythmic progression of niches decorated with precious plays of arabesques, is unforgettable: it is a perfect synthesis of the exquisite finesse and subtlety of Iraqi Islamic art of the period.

The Mustansiriyya *madrasa* (1233)[59] rises over the most central area of Baghdad along the eastern banks of the Tigris, on a site that was at one time occupied by the Caliph's palace. Being well preserved (thanks to the remarkable restoration works begun in 1936), it must be counted among the most important Islamic monuments still in existence in the millennial Iraqi capital (plates 165–70). The plan is classic for structures of this type. There are four *iwans* on the axes, all facing onto a courtyard with two stories of student cells, along with a prayer room, kitchens, and service areas. On the exterior, along the facade facing the river, there is a beautiful frieze inscribed in cursive letters, topped by an elegant play of protruding bricks that create a geometro-epigraphic interlace. On the opposite side is the tall access portal, marked by ten lines of Naskhi (cursive) script set upon a minute arabesque floral background. The delimiting columns, the intrados, and the upper arches display a splendid and complex series of geometric motifs in shaped terra-cotta (again with floral backgrounds) in a joyful play of triangles and polygonal stars. Of the four *iwans*, the northern served as a passageway and the southern as the prayer room. As such, the use of the building for the four schools was not necessarily connected to the number of *iwans*. The structure is quite large

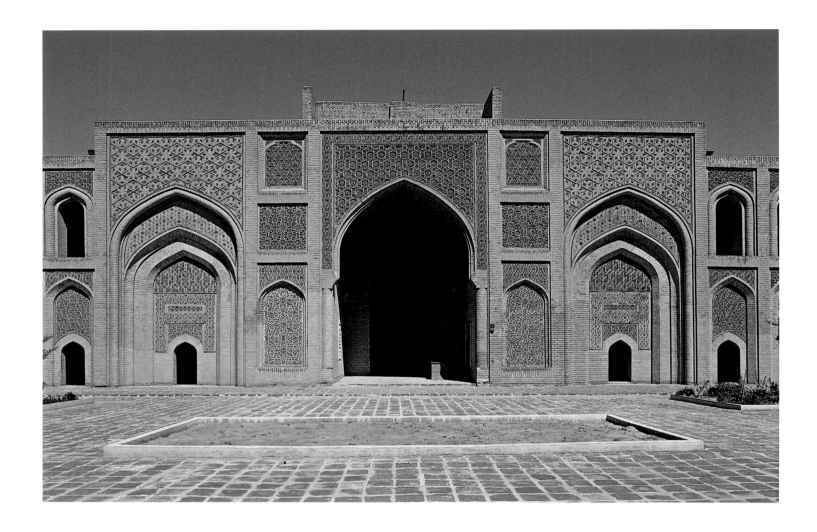

(344 feet long by 164 feet wide [105 by 50 m]), and the internal areas are also decorated with a profusion of geometric elements.

The minaret of Suq al-Ghazl (plate 171),[60] the only surviving element of the ancient Khulafa mosque, today rises alongside a modern one. It is almost suffocated by the expansion of the city with its extremely congested traffic arteries and similarly crowded markets. It has, placed beneath the current road level, a dodecagonal base with four levels of *muqarnas*, giving rise to the cylindrical shaft (with geometric meander motifs), topped by five levels of *muqarnas*. The generally accepted construction date is the late thirteenth century, during the Mongol era.

Slightly later, already under the Jalayirids, is the al-Mirjan *madrasa* (1357) and the nearby *khan* (caravansary; 1359).[61] A large part of the *madrasa* was destroyed after World War II to enlarge Rashid Street. As a result, only the monumental access portal and minaret (plate 172; Bagh. 14–18) remain of the original plan. Some decorative fragments were removed from the interior and transported to the Islamic rooms at the National Museum in Baghdad, but the loss was still enormous. The portal has two registers, with a sharp arch for the entrance and a lobed window at the upper level. Both of these are framed by cording and geometric plays, exactly as in the Mustansiriyya *madrasa*. Unfortunately, during restoration works, some of

ABOVE
167. The approach to an *iwan* from the courtyard of the Mustansiriyya *madrasa*.

OPPOSITE
168. A detail of the facade of the Mustansiriyya *madrasa* facing onto the courtyard.

PAGE 190
169. The decoration of the vaulted ceiling of one of the *iwans* of the Mustansiriyya *madrasa*.

PAGE 191
170. A detail of the decoration of the Mustansiriyya *madrasa*.

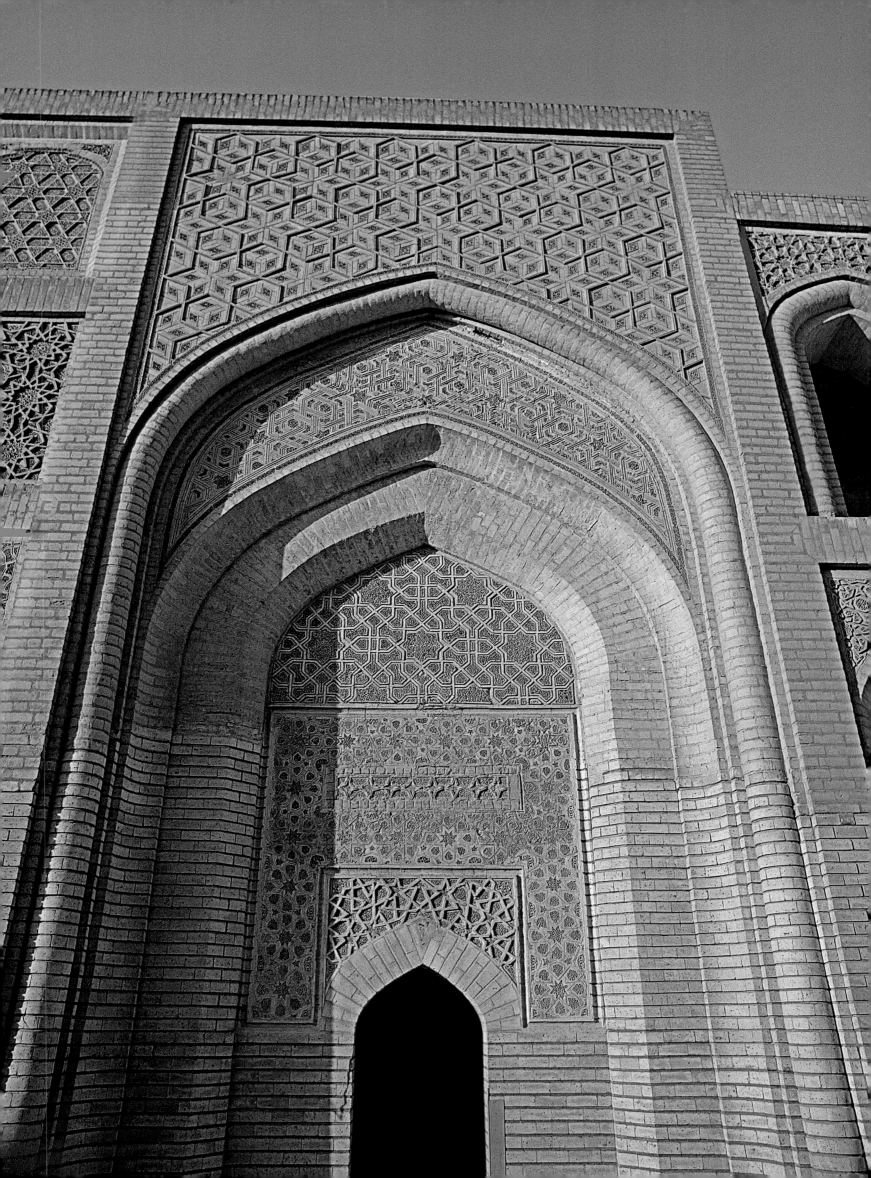

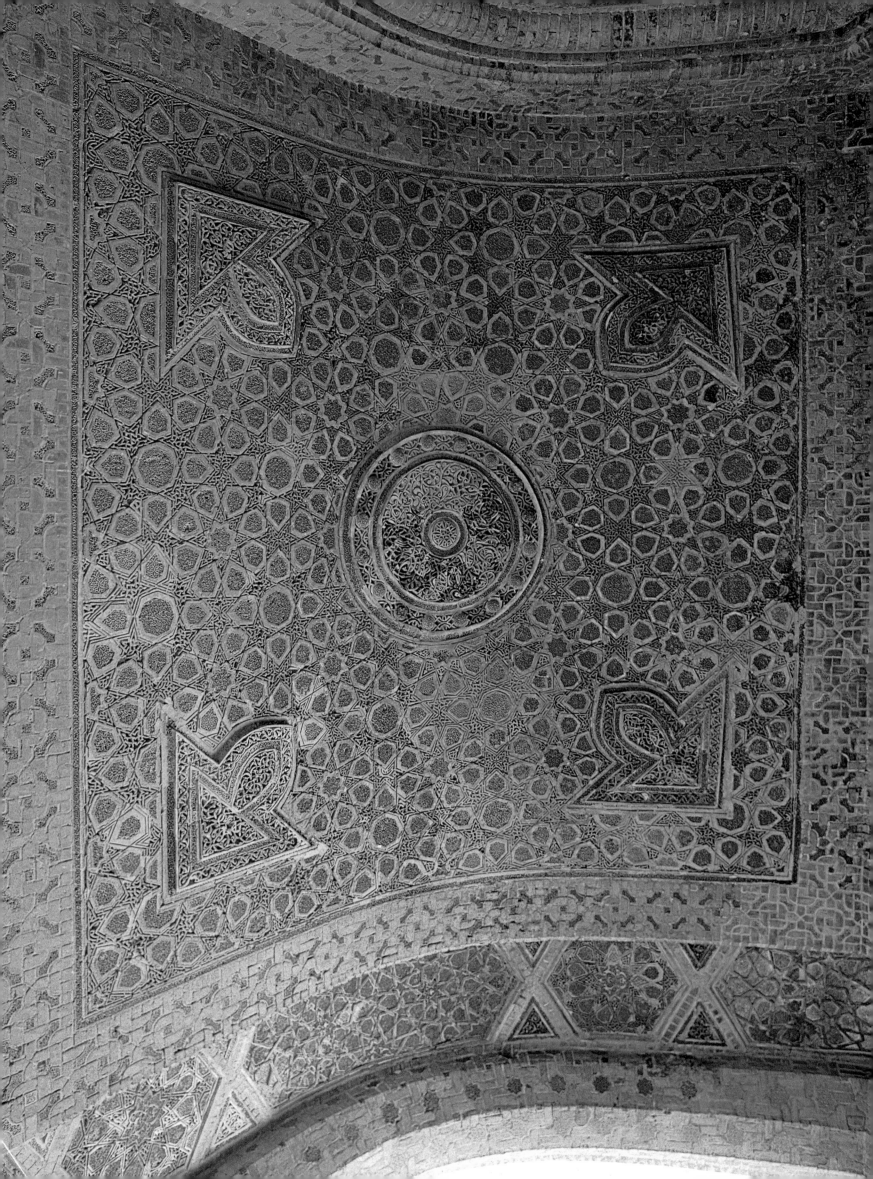

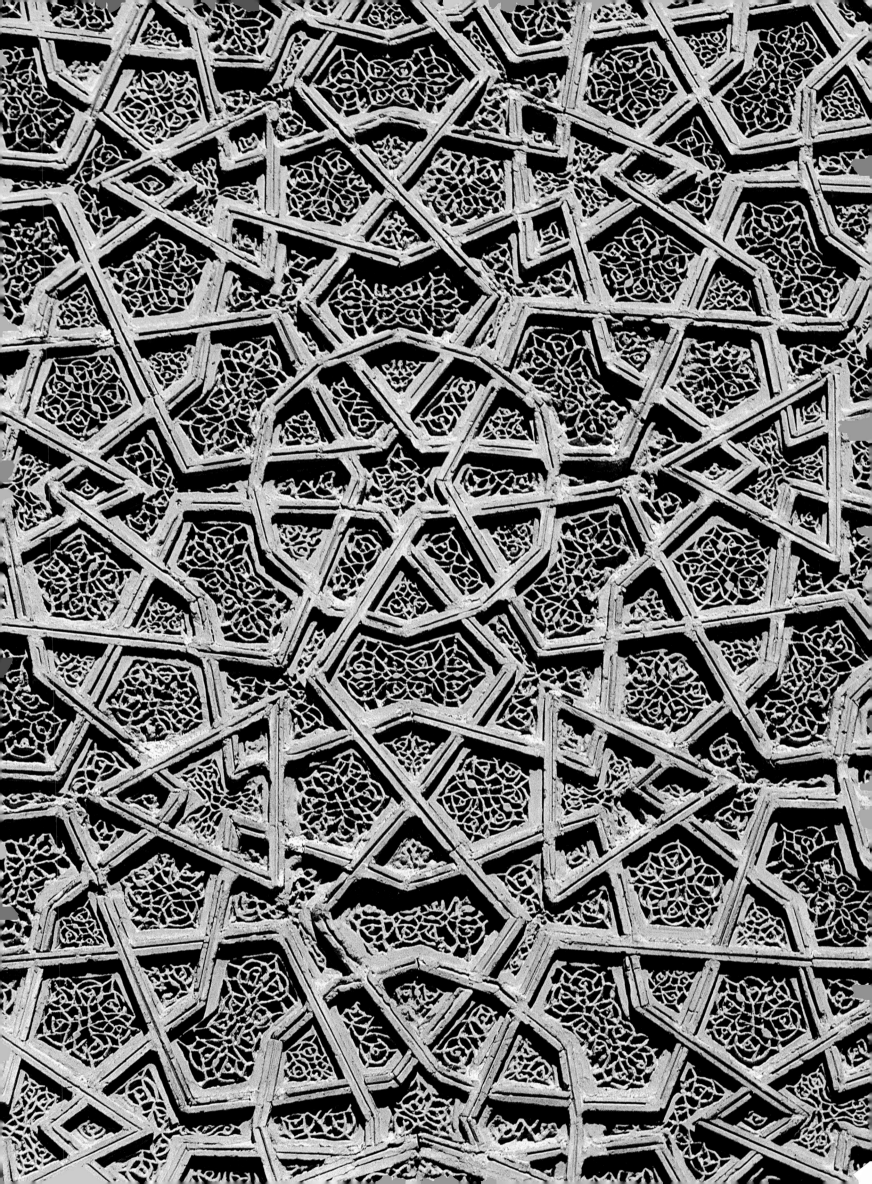

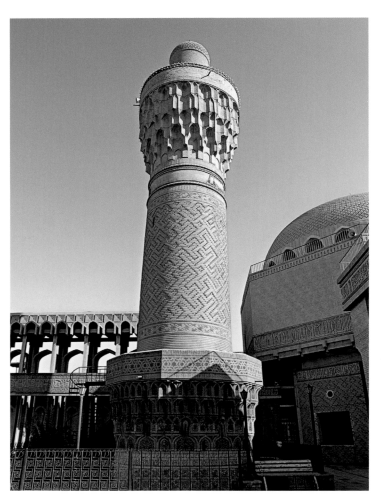

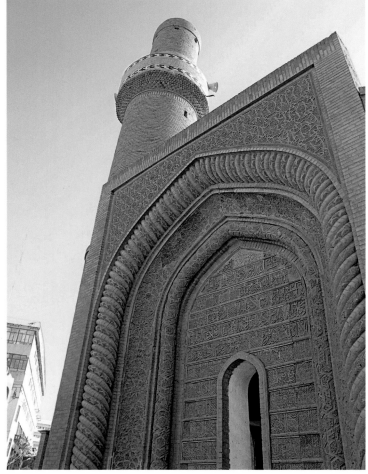

the inscriptions were altered by attempts to fill in missing words, while others were destroyed, or reversed. The decoration includes magnificent geometric interlaces (*hazar-baf*) created with baked bricks and other terra-cotta elements, appropriately placed.

The caravansary, also in brick, is found a short distance from the *madrasa,* of which it is a *waqf* (or religious endowment). Currently it has been transformed into a restaurant. It is a rectangular space (103 by 148 feet [31.5 by 45 m]) on two stories (the second is now basically just a ballroom), and it is noteworthy for its creative solution for the roof, which is made up of eight large transverse arches placed at regular intervals (the central part having a greater depth) with large windows between them (plate 173). The result of this design, unique in the entire Muslim world, is something that is serenely majestic.

Although constructed later, the al-Kazimiyah complex—the burial site of Imam Musa al-Kazim (745–799) and Muhammad Jawad, especially venerated by the Shiites[62]—is one of the most visited sanctuaries today (plates 174–75). Inside a large square outer wall measuring about 430 feet (130 m) on a side and housing a number of small cells, the sanctuary itself comprises two connected buildings. The one in front has three facades with large porticos supported by columns (in the Persian style), four minarets, and two gilded domes. Even

ABOVE LEFT
171. The minaret of Suq al-Ghazl in Baghdad.

ABOVE RIGHT
172. The monumental entryway and minaret of the al-Mirjan *madrasa* in Baghdad.

OPPOSITE
173. The interior of the al-Mirjan *khan* (caravansary), showing the upper level with its graceful, arched roof.

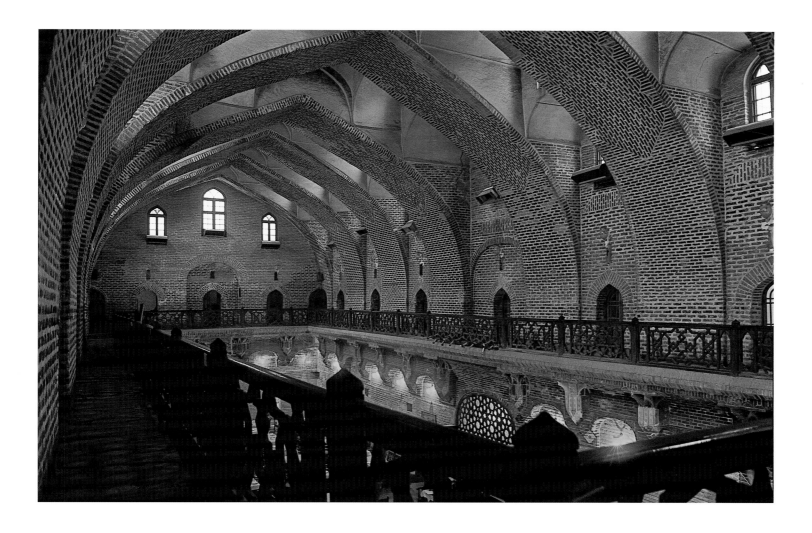

174. The facade, with its Persian-style *talar*, or portico, of the sanctuary inside the al-Kazimiyah mosque in Baghdad.

OVERLEAF BOTTOM
175. A detail of a panel with a geometric inscription, on one of the portals of the sanctuary in the al-Kazimiyah mosque.

though their layout is clearly older, going back to the period of Safavid domination, the rooms with mirrored and tiled decorations (where splendid pink, green, and yellow tones prevail) are of the Persian school of the late nineteenth century, exactly like those in the Karbala and Najaf sanctuaries (cf. Karb., Naj.).

This overview of Islamic architecture in Iraq should also highlight some buildings in the northern territories, especially in Mosul, one of the most important political and artistic centers of Iraq, where the population is, for the most part, Kurdish. In Mosul, and to the north of this city, many buildings were constructed in stone, not brick, bringing them closer, culturally, to the bordering area of Anatolia, where a long Christian tradition of stonework[63] was also to become the basis for the architecture of the Seljuk era.

The Nur al-Din mosque in Mosul was built between 1170 and 1172, during the Zaydi era, probably with modifications to a previous building built at the behest of Saif al-Din Ghazi in 1148. Unfortunately, this mosque, too, was destroyed, and there are only a few elements still remaining, such as a very beautiful *mihrab* in stucco (plate 179; Mosul 5–8). This can be linked to the sponsorship of Badr al-Din Lu'lu (r. 1233–1259), a powerful lord of the region, who was a very active patron in many areas. It was remounted in the Islamic rooms of the

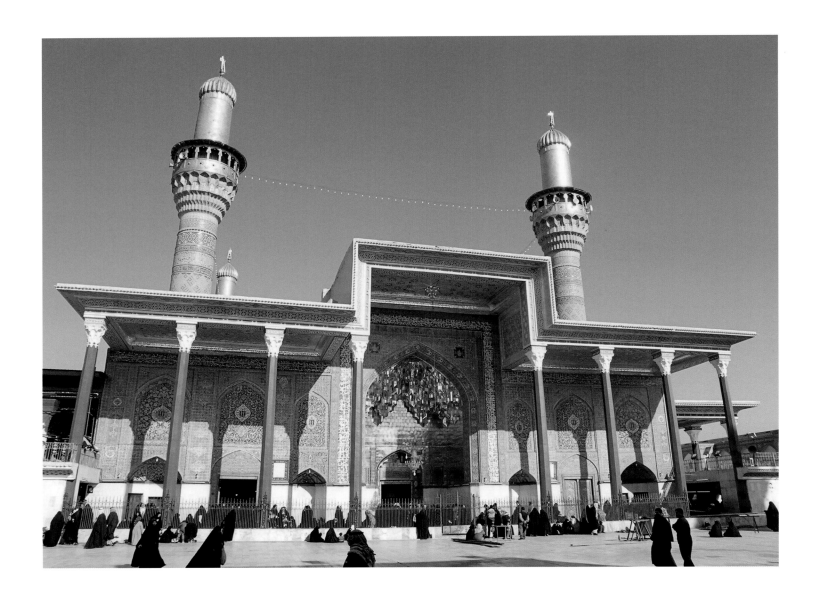

National Museum in Baghdad. The minaret of the mosque, in brick, is still *in situ* in Mosul. It is a cylindrical shaft on a cubical base, in serious danger now since it is leaning alarmingly; it is becoming the Tower of Pisa of the Near East (plate 178).

The tomb of Imam Yahya ibn al-Qasim can be dated to 1229. On a square base, with a series of added external buttresses, it has an umbrella-type dome that can be traced back, more or less, to the contemporary Anatolian *turbe*, even though in this case the decoration is far less exuberant (plate 177).

The use of stone is confirmed by numerous structures detached from important buildings and now housed in Baghdad. Of particular note are two similar contemporary *mihrabs* made of monolithic slabs of gray stone. One is from the mausoleum of Imam 'Abd al-Rahman (plate 180), and the other is from the al-Juwaishi[64] mosque (plate 181); both deserve a detailed description. The plan of each is the same: two attached semicolumns with capitals support a lobed arch, at the center of which is a decoration of arabesques that is repeated in the spaces to the sides of the arch. Above, there is a strip inscribed in Kufic. The central parts are different, however. In the first *mihrab*, from the Imam's mausoleum, there is an inscription in Kufic that acts as a cornice (*basmala* and beginning of Sura 112) along with a highly original decoration: exactly half of a design that replicates the form of the *mihrab* (that is, in this case, half of a lobed arch) with a geometric background. The other panel, by contrast, carries an ornamental frieze of palmettes on three sides, topped by a geometric background motif. At the center there is an inclined plane, clearly representing a door that is half-closed (an allusion to the fact that Allah never fully closes to man the possibility of entering into His grace).

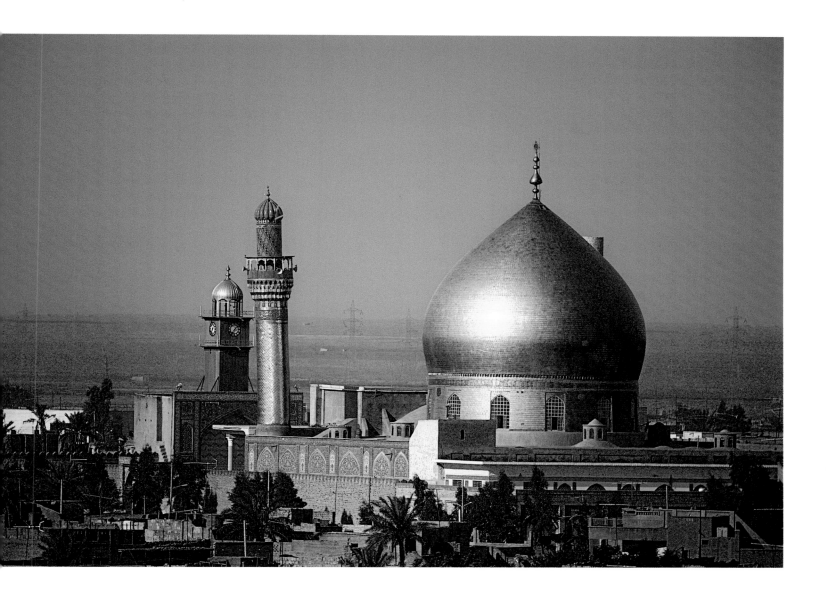

ABOVE
176. The Shiite mauso-
leum of Hasan al-Askari
in Samarra was originally
erected in the tenth
century and was rebuilt
several times, most
recently in the nine-
teenth century. The
gilded dome seen here
was destroyed in 2006.

OVERLEAF
177. A detail of the brick
decoration of the tomb
of Imam Yahya ibn
al-Qasim in Mosul.

PAGE 197
178. The minaret, in
brick, of the Nur al-Din
mosque in Mosul.

Without a doubt, these two examples, made of the same material, and with evident origi-
nality in each case, were created by a single school of artists.

A portal in the Imam Bashir mausoleum, again in thirteenth-century Mosul,[65] reaches
the highest level of quality. The exterior cornice bears the famous Throne verse (Qur'an
2.255), while the two piers carry lobed and corded panels with a geometric decoration. The
final part of the cording ends in eagle's (or perhaps phoenix's) heads. On top, above the
architrave, which is composed of an alternating pattern of hourglass-shaped panels with an
inscription of the name of Allah and arabesque elements, there is a series of small niches
with *muqarnas* with a rope frame ending in the heads of dragons whose serpentine bodies
(that is, the rope frame) intertwine to form a knot: splendid.

A large stone niche, perhaps originally a fountain or pavilion, from Mosul or Sinjar[66] but
now in Baghdad, has a series of lobed panels in which, along with the normal arabesque
motifs, it is not difficult to discern standing figures armed with bows or sabers. This decora-
tion is, in fact, incompatible with a public structure that also had a religious function.

WORKS IN WOOD AND METAL

Among the most interesting furnishings are two wooden cenotaphs. The oldest is that of
Imam Musa al-Kazim (plate 182), ordered by Caliph Abu Ja'far al-Mustansir (I) Billah (r.
1226–1242).[67] Its shape is almost square, with imposing panels characterized by bands of
epigraphs in a heavy Kufic style (with intertwined stems and foliate endings), and crowned

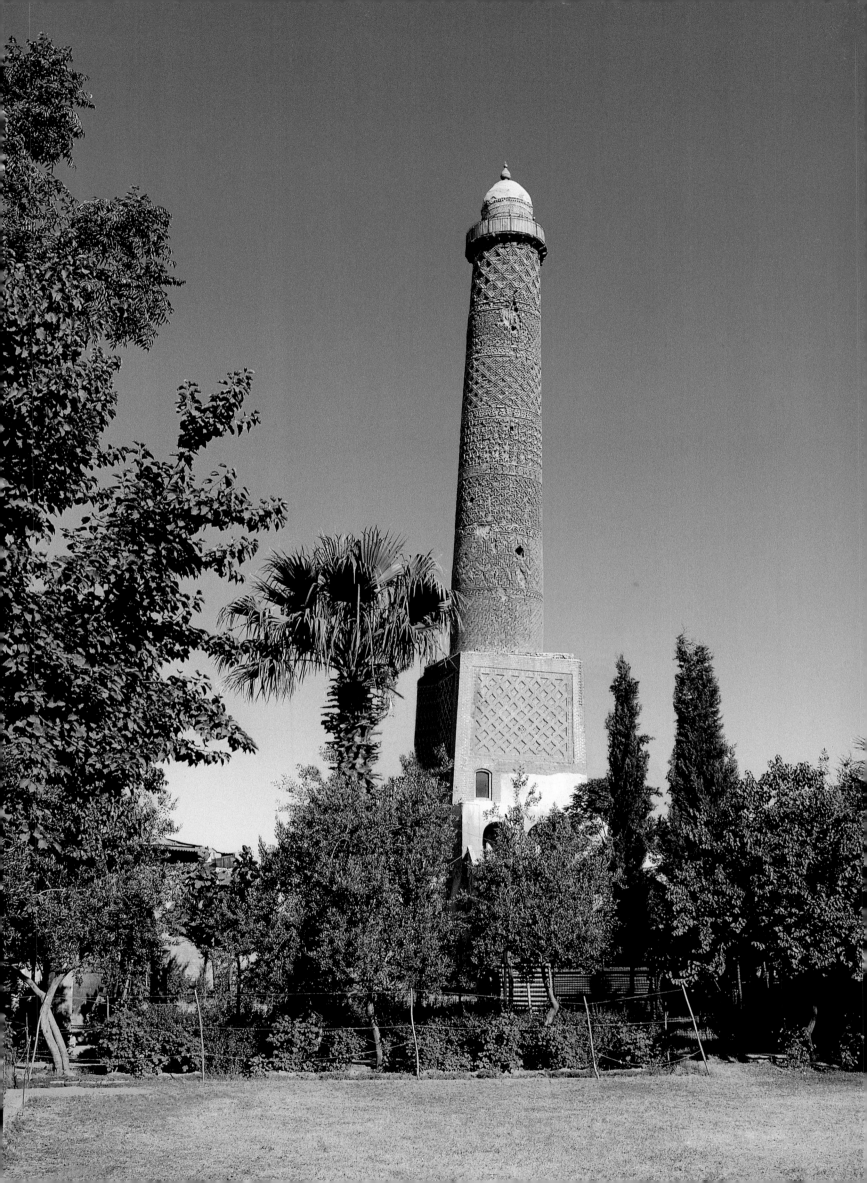

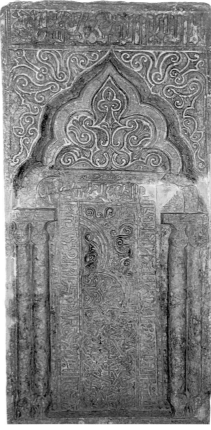
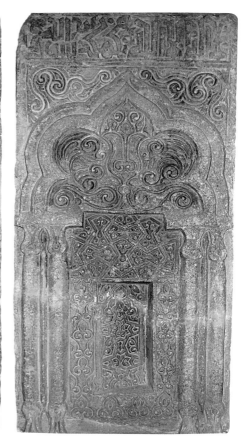

by a strip of arabesques. A small arabesque frame also marks the upper lid along its thickness. The other cenotaph,[68] from the al-'Aquliyya mosque, is probably of a slightly later date (plate 183). It is in the classic parallelepiped form and has panels with Kufic inscriptions on a ground of very airy, spiraling floral forms. A plain frame is then surrounded by spiral volutes. In the middle of the four sides of the lid, on the thickness of the wood, is a cursive inscription, again on a ground of palm volutes.

The wooden *minbar* (pulpit) in the Al-'Amadiyya congregational mosque (northwest of Mosul)[69] dates from 1153, according to one of its Kufic inscriptions. This *minbar* is made of panels decorated with arabesque motifs (the Samarran origin of these seems incontrovertible); the design is interrupted, according to a geometric pattern, by flat panels. Metal studs and nails, some original, fix and connect the various wooden elements.

Mosul was an extremely important center of toreutic art during the Middle Ages, especially during the thirteenth century. It was here, probably for the first time in the Middle East, that metal turning was used, an innovation that made the work go faster, so that artisans could better satisfy the growing demands of the market. There were about twenty artists who signed with the *nisba* of Mausili (Da Vinci, for example, is the *nisba* for Leonardo), and their works, all of extraordinary quality, are found in major museums around the world.

LEFT
179. A *mihrab* from the Nur al-Din mosque in Mosul. National Museum, Baghdad.

CENTER
180. A *mihrab* from the mausoleum of Imam 'Abd al-Rahman in Mosul. National Museum, Baghdad.

RIGHT
181. A *mihrab* from the al-Juwaishi mosque in Mosul, with a half-closed door at the center. National Museum, Baghdad.

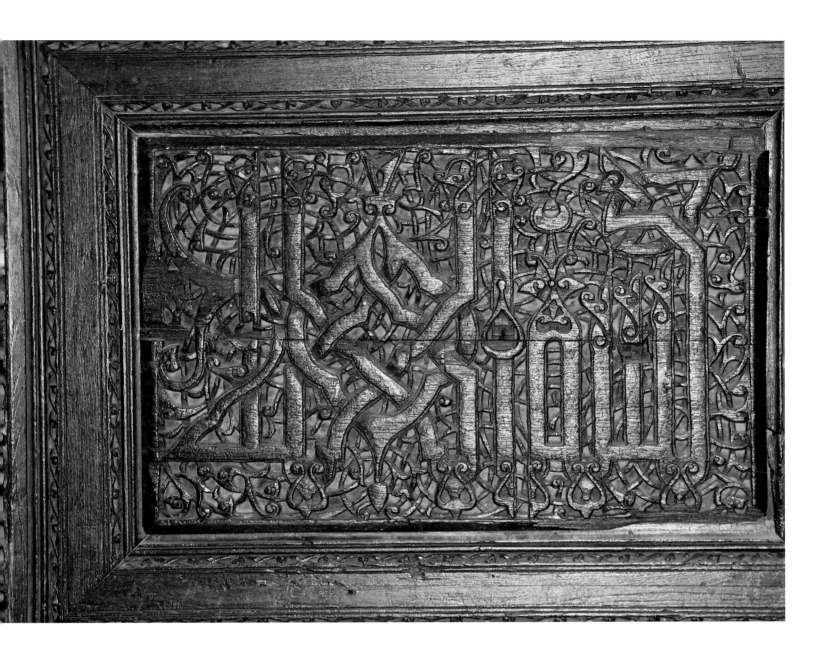

182. The wooden ceno-
taph of Imam Musa
al-Kazim, first half of
the thirteenth century.
National Museum,
Baghdad.

The material they used was normally brass or, more rarely, a bronze alloy, cast or pounded
into sheets and then carved and encrusted with silver.

The so-called Blacas Ewer in the British Museum in London[70] was created in Mosul in
April 1232 for Badr al-Din Lu'lu by an artist who signed his name Shuja' ibn Man'a al-Mausili
(plate 185). An excellent example of metalworking, and a good representation of the artistic
abilities of the artisans of the era, its surface is divided into horizontal bands in which epi-
graphic strips alternate with bands bearing medallions of figures, scrolls, and backgrounds
of original and highly decorative geometric motifs. The balance of the composition is, one
senses, almost perfect, and the entire surface, although dominated by a sense of *horror vacui*,
does not appear overburdened.

There is a further significant piece of Iraqi metalwork in the Museo Nazionale del Bargello
in Florence. This brass (or a bronze alloy?) vase encrusted in silver, signed by 'Ali ibn Hamud
an-Naqqash al-Mausili and dated 1258–59 (plate 184),[71] bears a very interesting inscription that
reveals the name of the client, a certain Haqta or Qista ibn Ruhara, who could be a Constan-
tine, son of Theodora, that is, possibly a Christian. The vase itself has a tall neck, a globular
body and a large, flared foot. In medallions—set against a very beautiful ground of inter-
twining T shapes (an extension of the swastika design), a very modern conception earlier

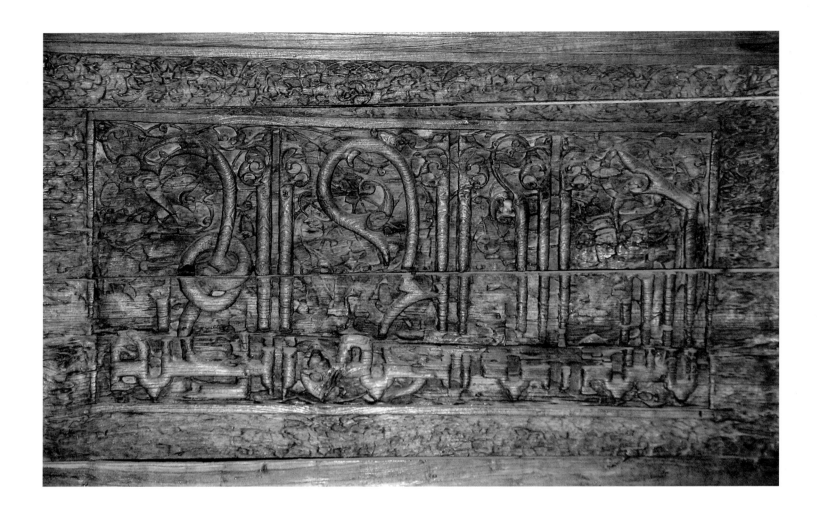

employed on the aforementioned ewer—are depictions of standing figures, banquets, and falconry, all of great artistic depth. The repertoire of shapes seems to follow a late antique tradition (by way of Byzantium), while the technique of encrusting, or agemina (from the Arabic term *'ajam*, meaning "foreigner," normally a Persian), goes back to the Persian East and was rather varied, including scenes of everyday life.

The arrival of the Mongols in 1244 and the sack of Mosul in 1261 were probably fatal to the metal workshops. All the same, their influence extended all the way into bordering regions (Syria, Egypt, and also Iran and Anatolia), and the *nisba* of Mausili became a guarantee of a high-quality product. The figures carved into the metal, which are sometimes very naturalistic, suggest some contact with the art of miniatures, which was also widespread during the Middle Ages.

MANUSCRIPTS AND MINIATURES

The centers of manuscript production were very active during these years, especially the two most important cities, Baghdad and Mosul. The Abbasid capital was the main player in a cultural blossoming that had few rivals anywhere in the world, and it is clearly no exaggeration to state that the time was, without a doubt, the golden age of Islamic civilization.

ABOVE
183. A wooden cenotaph from al-'Aquliyya mosque in Baghdad. National Museum, Baghdad.

OPPOSITE TOP
184. A silver-encrusted vase by 'Ali ibn Hamud an-Naqqash al-Mausili, dated 1258–59. Museo Nazionale del Bargello, Florence.

OPPOSITE BOTTOM
185. The Blacas Ewer by Shuja' ibn Man'a al-Mausili, dated 1232 and created for Badr al-Din Lu'lu. British Museum, London.

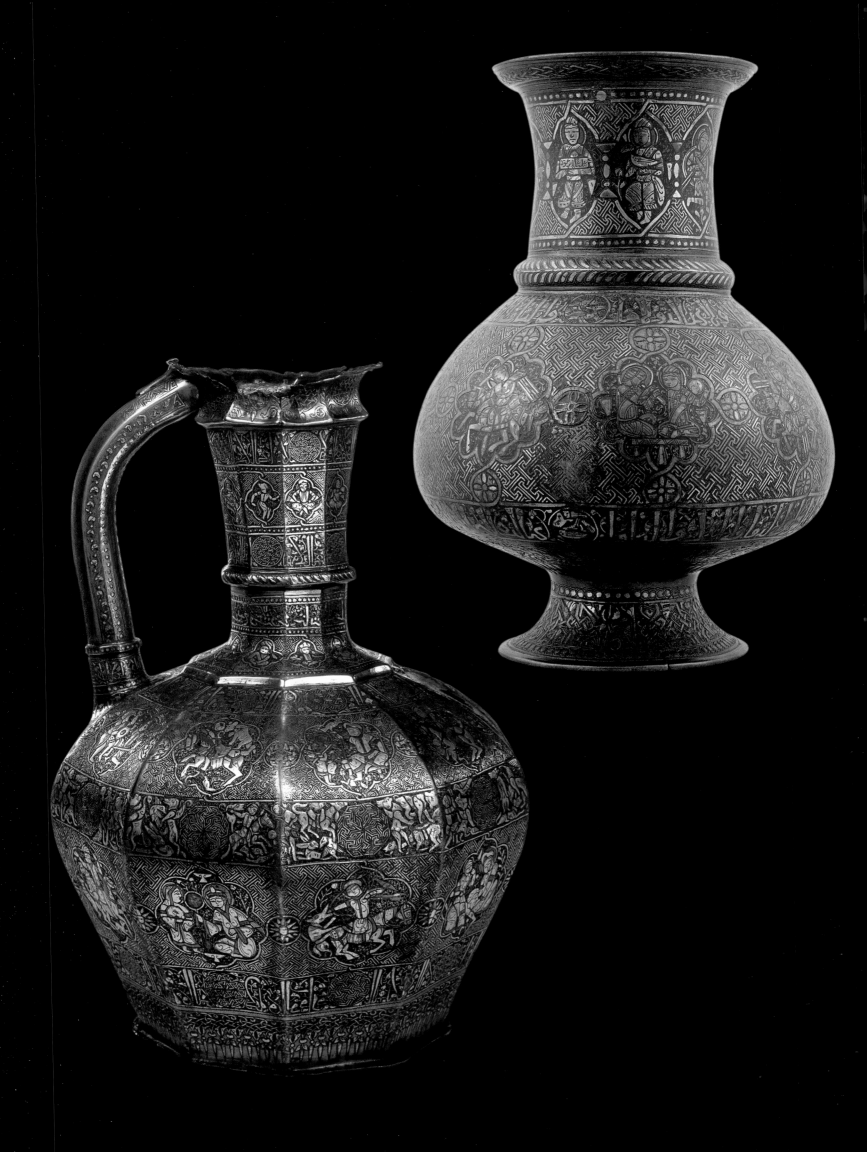

الطيور و الطاوس ثما تعرف البومة وذلك ... و ... بالليل ... خفا ... البومة و ...
و ... على ... الصياد ... للطير بالبومة ⑤

وا ... ان عمار لا ... خفيا ... الكبار و ... ان ...
... لا ... خطاف ... بعد ... لا ... إذا ... طيرانا

ABOVE AND OPPOSITE
186–87. Two pages from the manuscript of the *Kitab
al-Hayawan* (Book of Animals) by al-Jahiz in the
Biblioteca Ambrosiana, Milan: they depict a eunuch
capturing birds (left), and a brooding ostrich (right).
Ms Arabo D 140 inf., ff. 63v and 10r.

ملاحشاتك مشقضًا أوشأ أوبش من المبالة

الأونس الاعطًا وأو بش هو الذئب وقال المدابل

مانعل البومر أوبش في الغنم

وقال اميته بن أبي الصلت

وأبو اليتامى كان بحسن أوشهم ويجوطهم في كل عامر جاحد

وتقولون احمو من نعامة قالوا ذلك لا نها ندع الحضر على بيضها ساعة الحاجة الى الطعم

فإن هي في خروج ماذلك زات بيضر لعامة قدخرجت للطعم خضنت بيضها وأشبيت بيش

نفتها ولعل تلك ان تصاد ولا ترجع إن بضها حتى تملك قالوا ولذلك قال ابن

هد رمة

OVERLEAF
188. *Kitab fi Jawari 'ilm an-nujum* (Book of Elementary Notions on the Science of Heavenly Bodies) by Al-Farghani, Biblioteca Medicea Laurenziana, Florence. Ms. Or. 95, f. 29r.

PAGE 205
189. "Juniper and Sabina," from the manuscript of *De materia medica* by Dioscorides in the library of the University of Bologna. Ms. 2954, f. 39r.

وفي بعضها على مجنى نصف ساعة وأقل وأكثر وتد يطلع منكسفان
بعضها فلا يرى في بعضها لكونه تحت الارض في طلوعه في البلدان السيّة
نبل طلوعه في الغربية ويرى خسوف القمر من طرفه الشرقي اذ هو
الذاهب الى الاستقبال ثم ينحرفون نحو الشمال والجنوب وانجلاؤهم ايضا
من طرفه الشرقي واما بدء وكسوف الشمس فمن طرئها الغربي ذلك القمر
متصل بها من ناحية المغرب وكذلك لانجلاء الطرف الغربي والطول
ما يكون زمان الكسوف اربع ساعات بالتقريب ومن هذا الشكل
تتصور كيفية كسوف القمر م

شمس

فلك الشمس

الارض

فلك القمر

خارج مخروط الظل

ماهو صغير وكلاهما اينجان ويلطفان
وبدران البول واذا دخّا طرد الهوامّ
ولهما ثمر ما يوجد عظمه مثل عظم
الباقي غيرالله كله مُسند يُرطب الرائحه
حلوفيه شئ من مراره ويُقال لِارفو
بسروهر بمفتتن اينجانا يسركاقابض جيّد
للمعده واذ اشرب كان صالحا لاوجاع الصدر والسّعال والنفث والمغص وطرد
الهوامّ وبدران البول ويوافق نشرخ العضلا واوجاع الارحام

Abdallah ibn al-Muqaffaʿ, who died in 757, translated the ancient Indian fables of the *Pan-chatantra* (Stories of Bidpai) from Pahlavi (Middle Persian) into Arabic under the title *Kalilah wa Dimna*. This text enjoyed great success in both literary and artistic terms.[72] Abu ʿUthman ʿAmr bin Bahr al-Jahiz (776–869), a native of Basra and grandson of a black slave, is credited with a notable series of works. The most famous of these are the *Kitab al-Hayawan* (Book of Animals; two illustrations from the manuscript in the Biblioteca Ambrosiana in Milan are seen here in plates 186–87), the *Kitab al-Bayan wa at-Thabyin* (Book of Illustrations and Commentary), and the *Kitab al-Bukhala* (Book of Greed), a well-crafted treatise on behavioral psychology in which, for example, the scientist al-Kindi is also mentioned. One legend has it that the author died at ninety-three years of age, buried under falling books in his own study, an appropriate end for one so totally dedicated to learning and writing.

The *Kitab al-Aghani* (Book of Songs) by Abu al-Faraj al-Isfahani, who passed away in 967, is an anthology in twenty-four volumes, rich in information of all types (including accounts of poets and musicians from the court of Harun al-Rashid); it is written in a refined Arabic.

Abu ʿAli Muhammad ibn Muqlah (d. 940) was an extremely important person in Baghdad during the tenth century. He was the vizier (or prime minister) for no fewer than three Abbasid Caliphs (al-Muqtadir, r. 903–932; al-Qahir, r. 932–934; ar-Radi, r. 934–940), and he was also an extraordinary calligrapher who revolutionized the art of writing, indelibly linking his name to a graphic reform that is still today the basis of the canon of proportions for letters.[73] Founding the entire Arabic alphabet on a unit of measurement from the diagonal stroke of a reed, he made a rhombus that, multiplied by five or seven, gave the standard height of the first letter, the *alif*, and then used this element to obtain the diameter of a circle. All of the letters of the alphabet were joined by these parameters and linked together through established proportions and distances measured out according to the base unit, the small rhombus. By this means, Arabic writing was able to anchor itself to geometric and mathematical rules and thereby assume a rhythm and balanced tempo that set it apart as a particularly elegant form of calligraphy.

In considering Abbasid Baghdad, it is important to mention the role of Caliph ʿAbdallah al-Maʾmun (r. 813–833), patron of the Muʿtazilih philosophical school and an extremely gifted commentator on the Hanbali law school. He is credited with the construction of the Bayt al-Hikma, not just an incredible library but also an extremely lively center for the translation of texts from Greek and Syriac, as well as Sanskrit or Pahlavi (Middle Persian), into Arabic. It was here that a first-rate intellectual class was formed and from here that classical works, translated and also annotated, were disseminated, thus becoming the basis for knowledge across medieval Europe.

Musa bin Shakir's three sons (Muhammad, Ahmad, and al-Hasan) inherited their father's exceptional intellectual talents and were industrious students of geometry and astronomy, mechanics, and yet more geometry. They were fierce rivals of Abu Yusuf Yaʿkub al-Kindi (c. 801–873), a highly regarded court-appointed scientist and physician, who also became famous for formulating, for his students, the six traits necessary to become a philosopher: "a superior mind, uninterrupted passion, great patience, a soul free of any worry, a competent teacher, and lots and lots of time."[74] All of these were, in his words, indispensable, and missing just one of them would jeopardize the final outcome. The three Musa brothers conspired to place al-Kindi in a harsh light with the Caliph and then took advantage of the situation to appropriate the scientist's library. Later on, al-Mutawakkil wanted a canal in Jaʿfariyya (near Samarra), and the three brothers subcontracted the work to Ahmad bin Muhammad bin Kathir al-Farghani, an astronomer and mathematician who built the "Nilometer" in Cairo and also authored the *Kitab fi Jawani ʿilm an-nujum* (Book of Elementary Notions on the

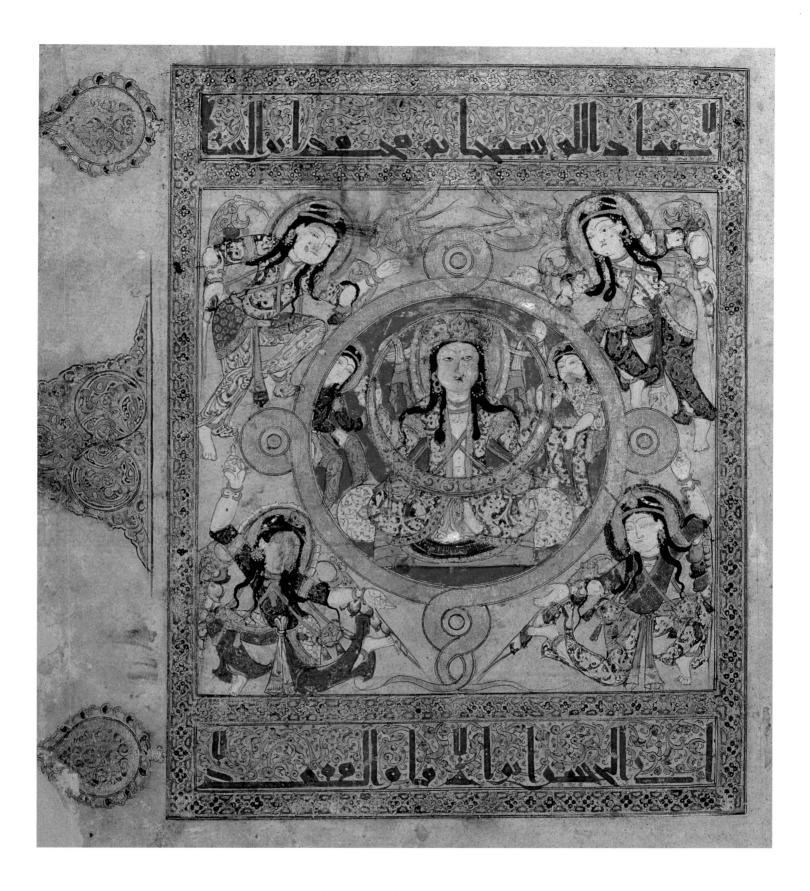

190. The title page of the manuscript of the *Kitab al-Diryaq* (Book of Antidotes) by Pseudo-Galen in the Bibliothèque Nationale, Paris. Arabe 2964, f. 37.

Science of Heavenly Bodies; a beautiful illustration from the codex dated 1310, in the Medici Laurentian Library in Florence, is seen here in plate 188). Al-Farghani was not up to the task and was replaced by an engineer by the name of Sanad ibn 'Ali, who completed the job but also demanded the return of the library to al-Kindi in order to save the three brothers from problems with the Caliph! Musa bin Shakir was teacher to the Sabian Abu al-Hasan Thabit ibn Qurra al-Sabi' al-Harrani, from Harran in northern Mesopotamia. He is credited with moving the in-depth studies of astronomy by a group of experts strongly influenced by Neo-platonism and Greek Hermetism to the Abbasid court in Baghdad. This tradition had begun in the region with the conquests of Alexander and was jealously guarded. The Sabians are

named in the Qur'an (2.62) among those who "shall have their reward from their Lord, and there is no fear for them, nor shall they grieve."

In medicine, it is important to remember Abu Zayd Hunayn bin Ishaq al-'Ibadi (809–873), son of a Christian pharmacist, from a tribe originally from al-Hirah. He translated the works of Galen (with a modern method of collecting as many examples as possible of the same manuscript and then comparing the variations in them, thus establishing an unambiguous and coherent reading). He was also the author of treatises on ophthalmology and the *al-Masa'if fi at-Tibb* (Introduction to the Art of Healing), the fundamental text used for medical exams during the Middle Ages. Another of the most celebrated physicians of antiquity, Abu Bakr Muhammad bin Zakariya al-Razi (865–925), completed his curriculum of studies in Baghdad and then practiced his craft in Rayy (in Persia, an ancient city just south of present-day Tehran).

The school of Baghdad, obviously, was also very active in the field of miniatures, though relatively few works remain of the many that must have been produced. Ibn al-Nadim, a bookseller of the tenth century, created a catalogue of works in his possession. One of these was the *Kitab Suwar al-Kawakib at-Thabita* (Treatise on Fixed Stars). There is an illuminated codex of this work dated 1009,[75] and it is not unreasonable to assume that it may well have been produced in Iraq. There is a manuscript dated 1244 of *De materia medica* by Dioscorides in the library of the University of Bologna[76] with an incredible 475 images of significant quality (for example, "Juniper and Sabina"; plate 189). There is also a splendid title page from this same work preserved in Istanbul.[77] The Byzantine artistic influence is evident both in the general placement of the figures and in some of the details, such as the drapery.

It is said that another lively center was the region of Mosul in northern Iraq during the Zaydi era. Badi' az-Zaman Isma'il ibn al-Razzaz al-Jazari (twelfth and thirteenth centuries) was an important figure, originally from, and active in, the area of Al-Jazira, which is today divided between Anatolia (the area where the Tigris and Euphrates begin), Syria, and northern Iraq. He was the author of a famous treatise, *Kitab fi Ma'rifat al-Hiyal al-Handasiyyah* (Book of Knowledge of Mechanical Devices). That fifteen manuscripts of this remarkable book survive is ample testimony to the Muslim interest in this specialized branch of scientific knowledge. Two extremely beautiful illustrations from this text (Iraqi, thirteenth century) are in the Bernard Berenson Collection at the Villa I Tatti in Settignano, Italy.[78]

To Mosul may also be attributed the title page (plate 190) of the *Kitab al-Diryaq* (Book of Antidotes) by Pseudo-Galen, now in Paris,[79] which depicts a sovereign, seated on a throne with legs crossed and holding a crescent moon, enclosed within a circle created by a central knot formed by the intertwined bodies of two facing dragons (or serpents?); this could be an image of Atabeg Badr al-Din Lu'lu (plate 190). In any case, there is clearly a Byzantine influence to be seen here.

Abu Muhammad al-Qasim bin 'Ali al-Hariri al-Basri (1054–1122) is credited with the *Maqamat* (Assemblies), an extraordinary success among illustrated texts. The work is a series of picaresque stories about Abu Zayd al-Sarugi, a foolish and incompetent knave, wherein at times he is the victim of swindles, and at other times himself the author of irresistible pranks. The collection is also extremely enjoyable because of its inexhaustible supply of humor and linguistic versatility, particularly its risqué wordplay. The manuscripts in the Bibliothèque Nationale in Paris[80] and the Academy of Sciences in Saint Petersburg are notable.[81] The images in the latter, which was originally part of the collection of French diplomat J. L. Rousseau (1780–1831), are particularly lively and so full of detail that they create a fascinating testimony to daily life in the "fabled" Iraq of the thirteenth century.

KEY SITES OF MESOPOTAMIAN ART

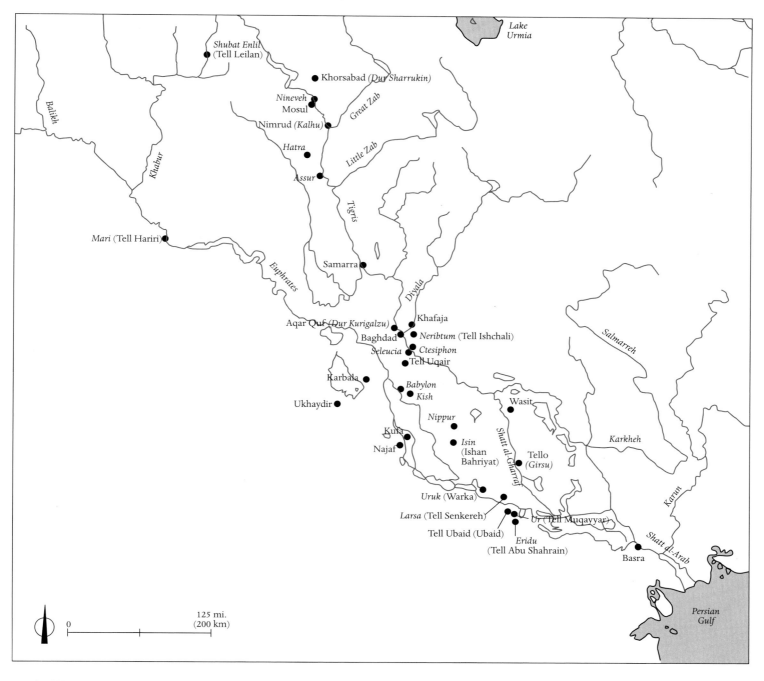

Shubat Enlil
(Tell Leilan)

Khorsabad (Dur Sharrukin)

Nineveh
Mosul

Nimrud (Kalhu)

Hatra

Assur

Balikh

Khabur

Great Zab

Little Zab

Tigris

Lake
Urmia

Mari (Tell Hariri)

Euphrates

Samarra

Diyala

Aqar Quf (Dur Kurigalzu)

Baghdad

Seleucia

Khafaja

Neribtum (Tell Ishchali)

Ctesiphon

Tell Uqair

Salmarreh

Karbala

Ukhaydir

Babylon
Kish

Wasit

Nippur

Karkheh

Kufa

Isin
(Ishan
Bahriyat)

Najaf

Shatt al-Gharraf

Tello
(Girsu)

Uruk (Warka)

Larsa (Tell Senkereh)

Tell Ubaid (Ubaid)

Ur (Tell Muqayyar)

Eridu
(Tell Abu Shahrain)

Basra

Karun

Shatt al-Arab

Persian
Gulf

125 mi.
(200 km)

0

On the following pages, scales are given in meters.

In this section, the sites are listed in alphabetical order, according to the name used most frequently. For the ease of the reader, if the ancient name of a place was different than its modern one, then both names are to be found in the following list, with the ancient one in italics.

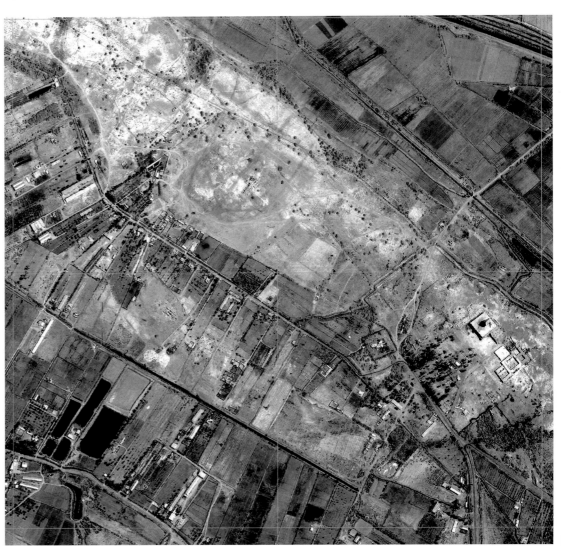

1. An aerial view of the site
2. A plan of the palace at Kurigalzu

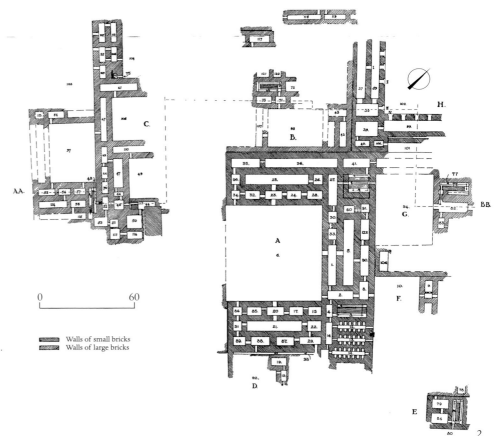

0 60

▨ Walls of small bricks
▨ Walls of large bricks

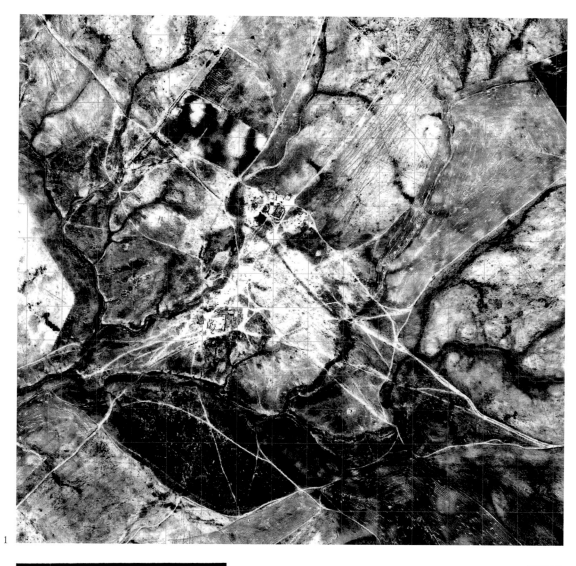

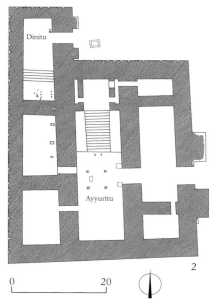

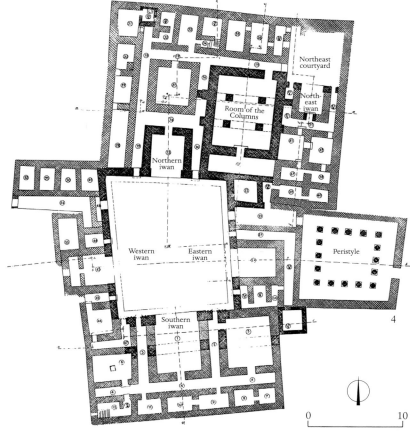

1. An aerial view of the site.

2. A plan of the temple of
Ishtar of Tukulti-Ninurta I
(r. 1244–1208 BC).

3. A plan of the temple of Nabû
and Ishtar, end of the seventh
century BC.

4. A plan of the Parthian palace.

Northeast
courtyard

North-
east
iwan

Room of the
Columns

Northern
iwan

Western
iwan

Eastern
iwan

Peristyle

Southern
iwan

Dinitu

Ayyuritu

0 20

0 10

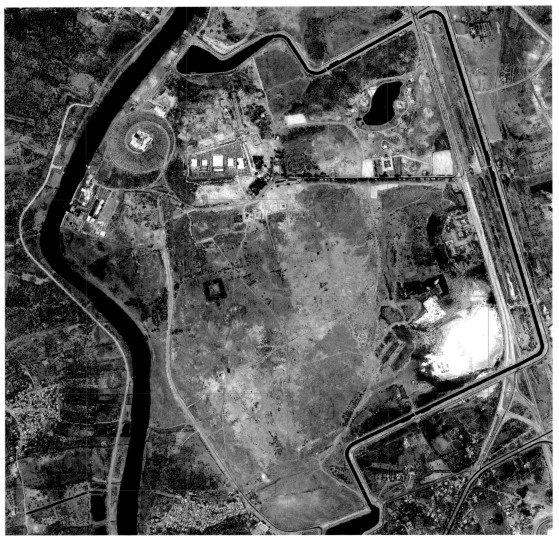

1. An aerial view of the site. All of the illustrations relate to neo-Babylonian ruins dating from 626 to 539 BC.

2. A map of the city, showing: (1) the Summer Palace; (2) the western rampart; (3) the North Palace; (4) the South Palace; (5) the processional way; (6) the Ishtar Gate; (7) the ziggurat, known as the Tower of Babel or Etemenanki; (8) the temple of Marduk, or the Esagila; (9) the temple of Ninmah.

3. A plan of the area near the ancient course of the Euphrates, where the Esagila (temple of Marduk) and the Etemenanki (ziggurat) were erected.

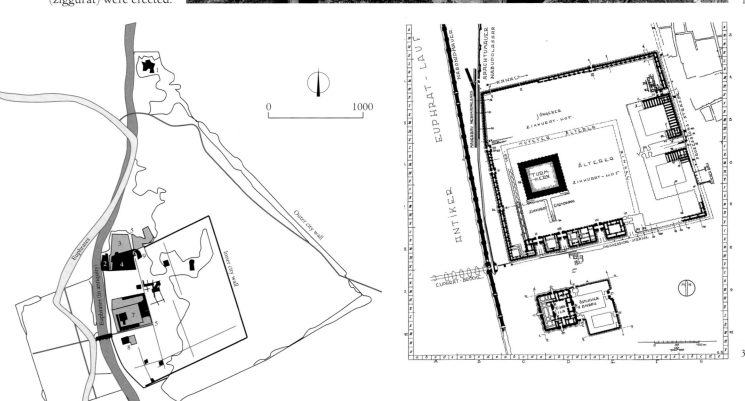

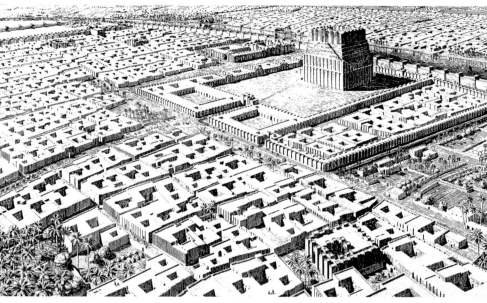

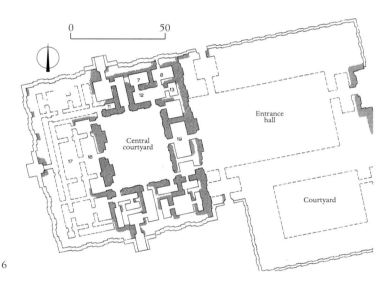

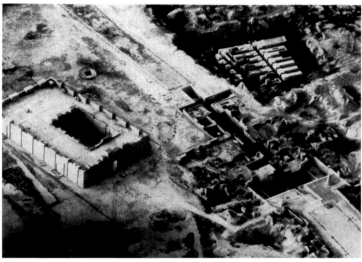

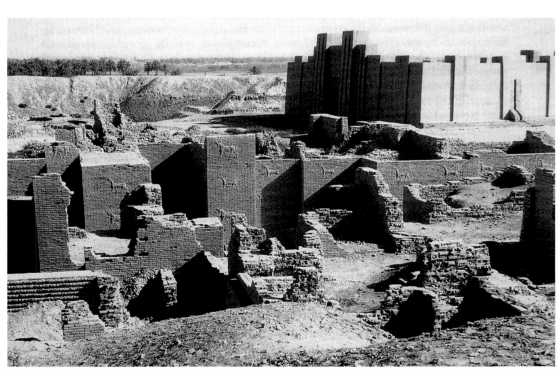

4. Two reconstructions of the Etemenanki, the ziggurat of Babylon (Tower of Babel).

5. A reconstruction of the aerial view of the urban area and the Tower of Babel.

6. A plan of the Esagila, the temple of Marduk.

7. An aerial view of the Ishtar Gate, with the "Hanging Gardens" on the right and the restored temple of Ninmah on the left.

8. The restored temple of Ninmah along the processional way.

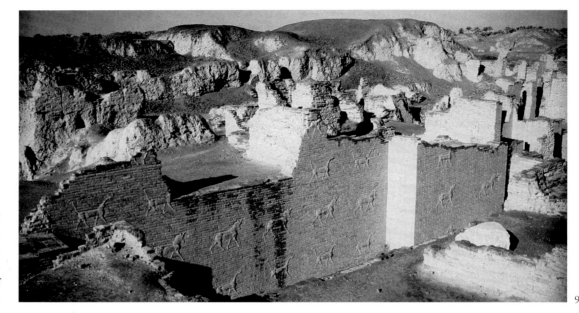

9. The processional way
at the Ishtar Gate.

10. A reconstruction of the
elevation of the Ishtar Gate.

11. A plan of the temple of
Ishtar of Akkad.

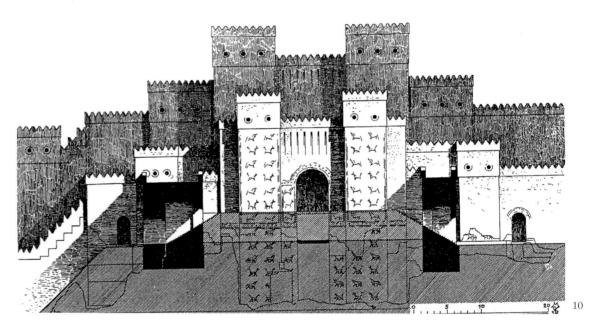

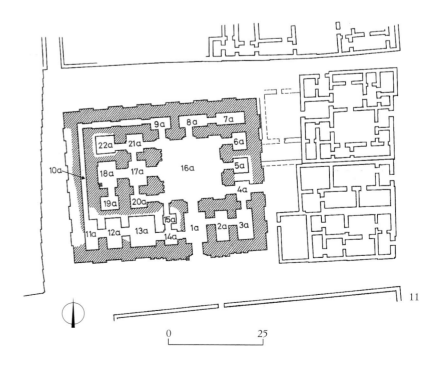

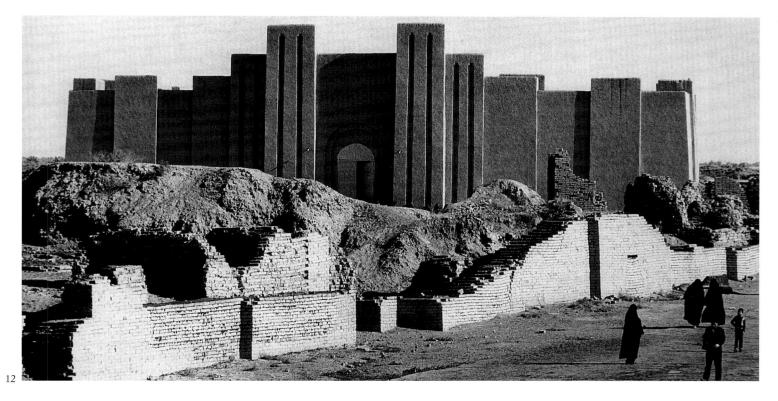

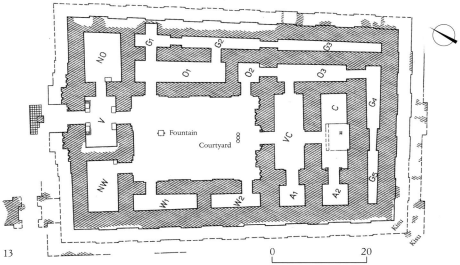

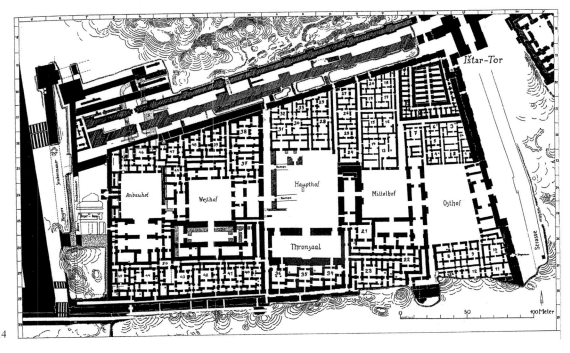

12. The temple of Ishtar of Akkad restored.

13. A plan of the temple of Ninmah.

14. A plan of the South Palace, built by Nabopolassar and enlarged by his successors.

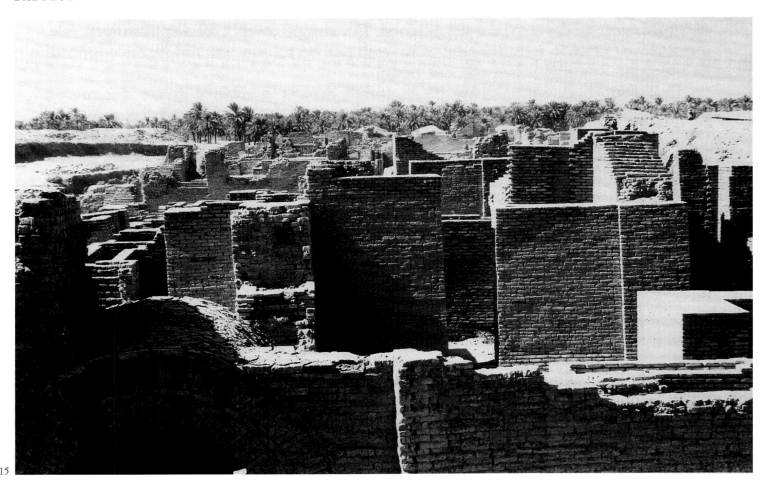

15

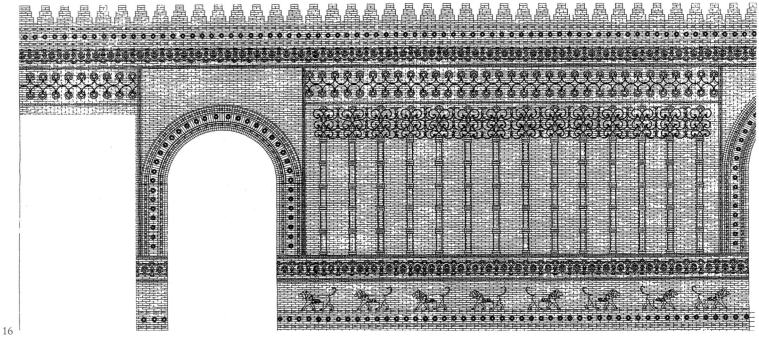

16

15. The South Palace.

16. A reconstruction of the facade of the throne room of the South Palace with its glazed-brick decoration.

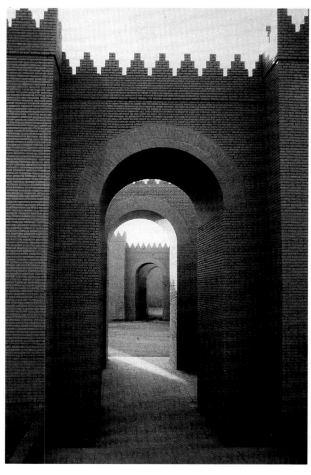

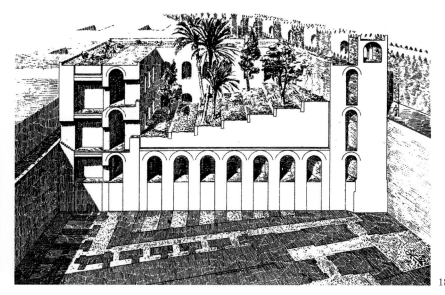

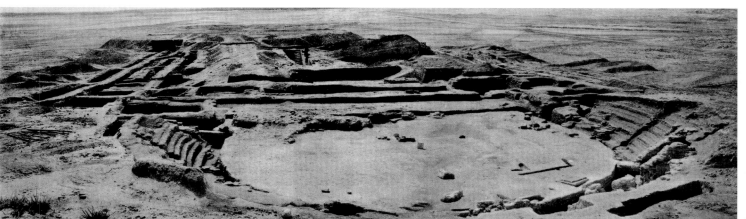

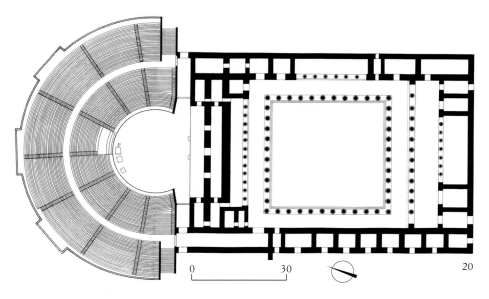

17. An entrance to one of the courtyards of the South Palace.

18. A reconstruction of the "Hanging Gardens" by Koldewey. In reality, this structure was a warehouse.

19. A view of the excavations of the Hellenistic theater, undertaken in the first half of the twentieth century.

20. A plan of the theater.

1–4. The circular plan of Baghdad, as it was under al-Mansur in 762 AD (4), has important precedents in Asia. The aerial images, for instance, are of Sasanian Firuzabad (1) and Takht-i Sulayman (2) in Iran, and Parthian Hatra (3) in Iraq.

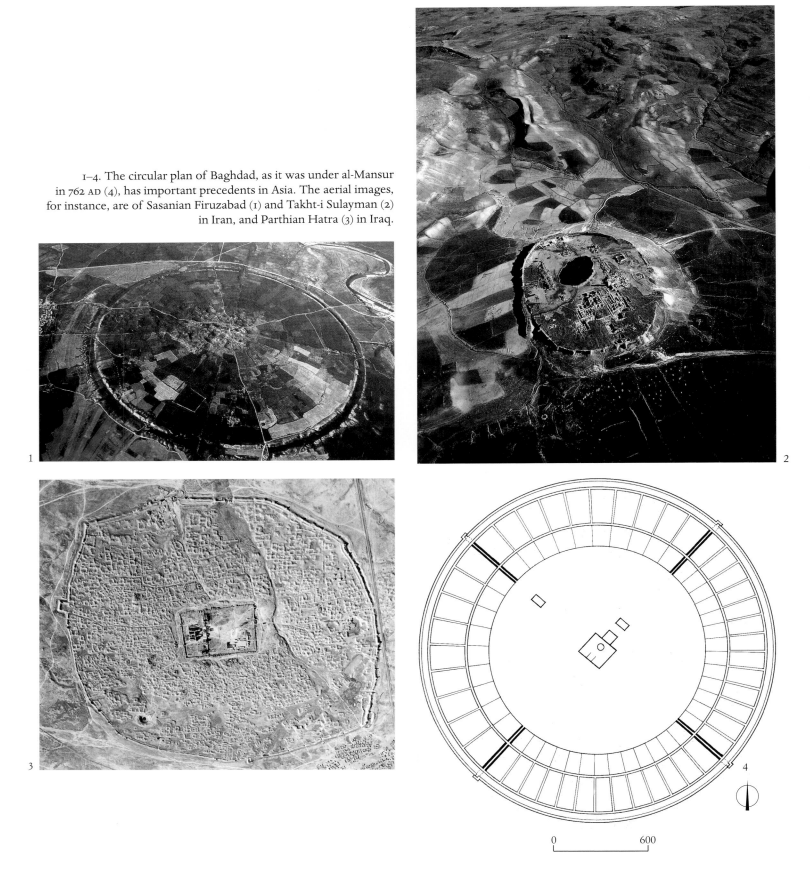

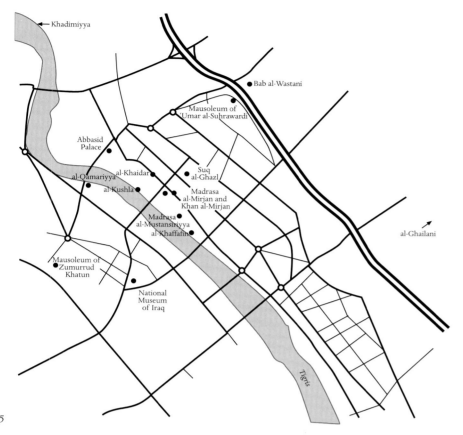

5. A map of modern Baghdad shows that all the major ancient monuments are concentrated in a very limited area.

6–13. The funerary complex of 'Umar al-Suhrawardi is based upon the mausoleum with a "sugar-loaf" *muqarnas* roof. A plan (9) outlines modifications, like the later, though pleasing, external facade (10), and the internal facade, with its inscribed gateway (13).

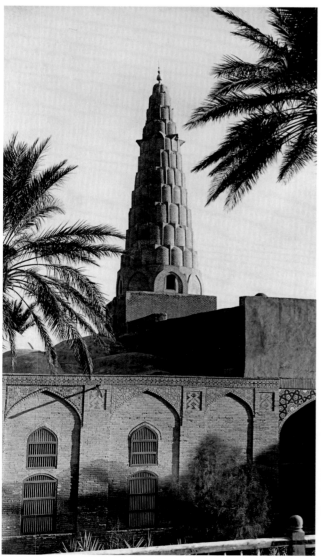

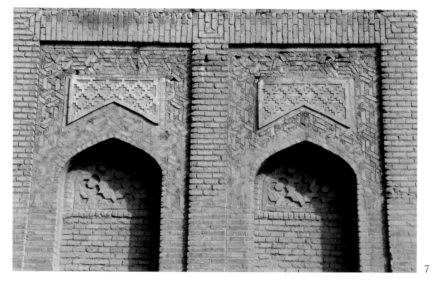

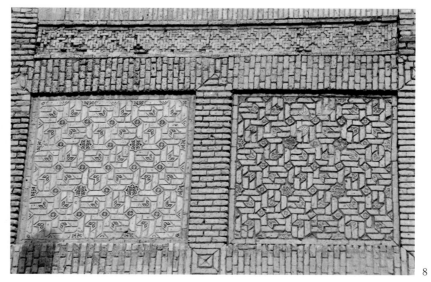

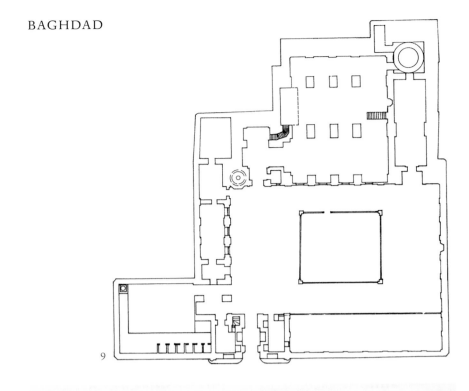

9

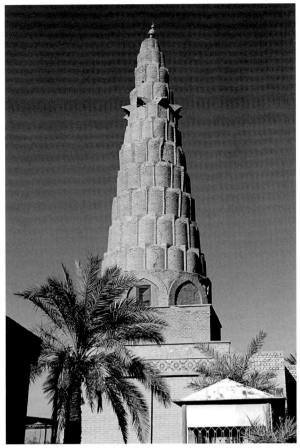

12

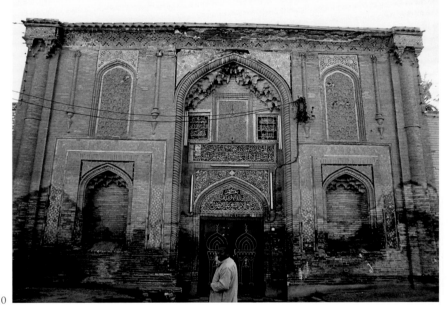

10

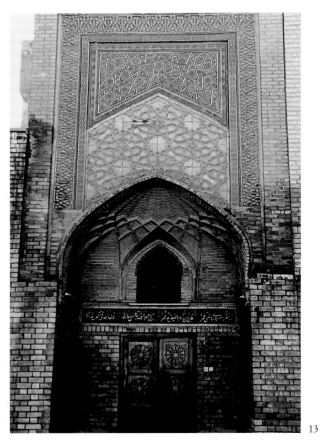

13

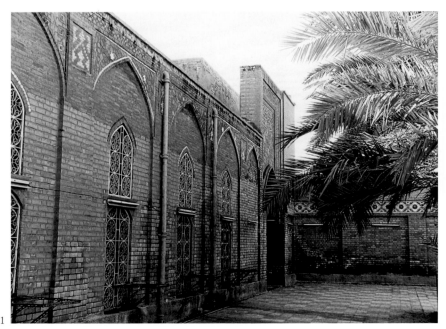

11

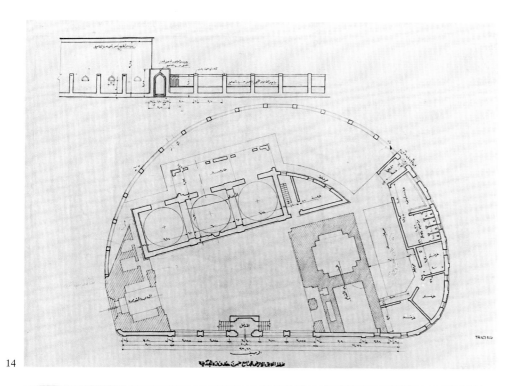

14

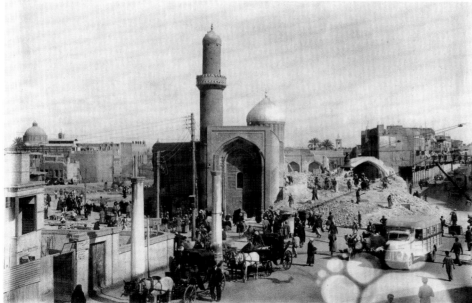

15

14–18. The al-Mirjan *madrasa* in Baghdad was partially destroyed in the mid-twentieth century, in order to enlarge a central arterial roadway. The archival photographs show these modifications, as well as the placement of the decoration *in situ* (18), prior to its transfer to the National Museum, Baghdad.

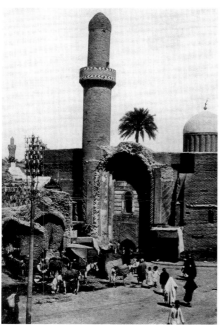

16

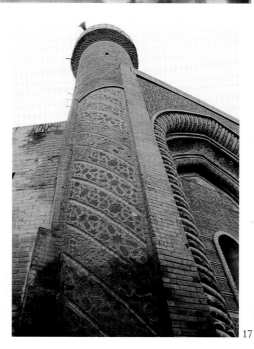

17

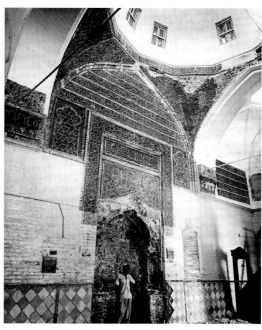

18

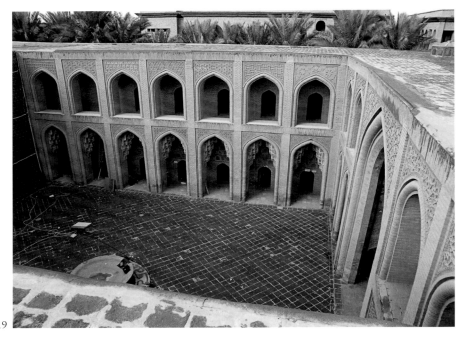

19

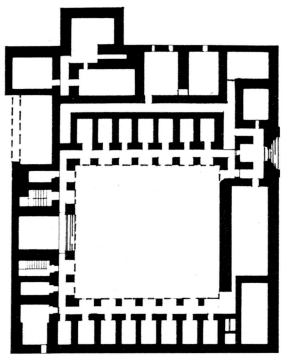

20

19–22. The so-called "Abbasid Palace" of the twelfth century, which was more probably a *madrasa*. It is perhaps one of the most celebrated monuments in Baghdad. Shown here are the courtyard (19); the plan (20); the decoration, of incredible quality, above an arch (21); and the corridor that separates two sections of the building (22).

23–28. Unfortunately, not much remains of the city walls of medieval Baghdad, other than the Middle Gate (Bab al-Wastani), which is still in fairly good condition. Unhappily, the Talisman Gate (shown here in an archival photograph [26]) was accidentally destroyed at the beginning of the twentieth century by an explosion, after it had been transformed into a munitions warehouse.

21

22

23

24

27

25

26

28

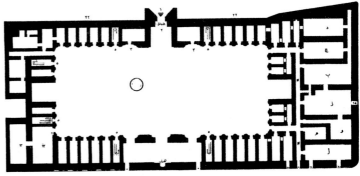

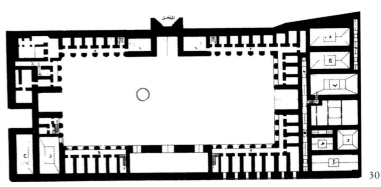

29

30

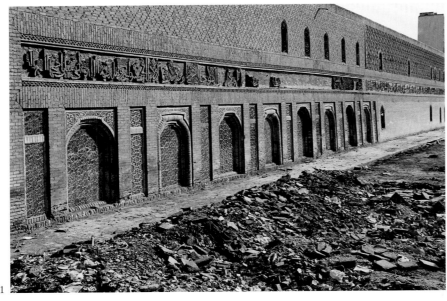

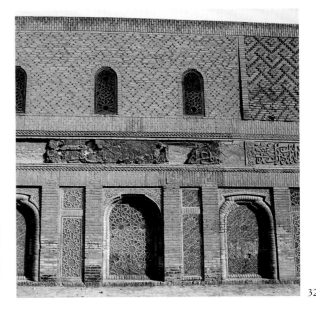

31

32

29–33. The Mustansiriyya *madrasa,* built in 1233, has been heavily restored, but in its current state still offers a good impression of an important medieval Muslim building. The plans of the two levels (30) show the logic underlying its construction. Great care was also given to decoration, as is seen in the external wall facing the river (31–32), dominated by a beautiful inscription, and in a detail of the inscribed entryway (33).

34–40. The al-Kazimiyah mosque is one of the main Shiite pilgrimage destinations in Iraq, because it is the burial site of the "two Kazim," the seventh and ninth Imams of the twelve Imams of the Shiite tradition. This immensely venerated location has been destroyed numerous times (with particular ferocity by the Mongols in 1258). The current structures, which are also shown in valuable archival images, clearly exhibit the nineteenth-century Persian architectural style, from the time when Persian leaders financed the restoration.

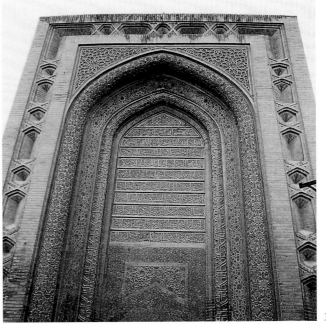

33

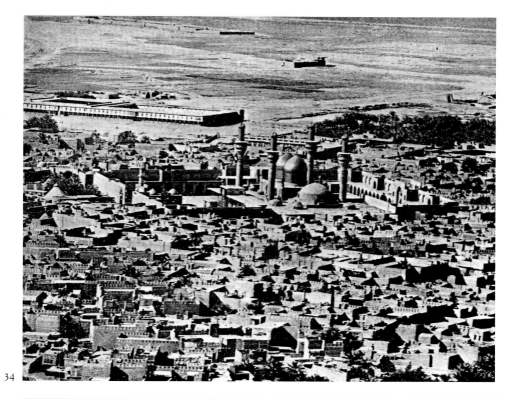

34

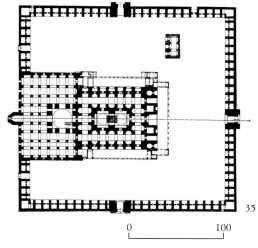

35

0 100

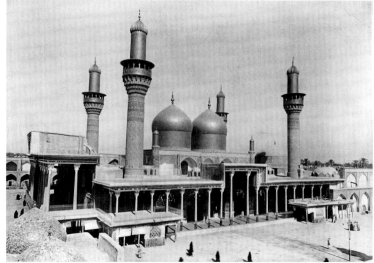

36

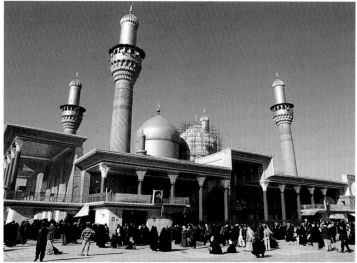

37

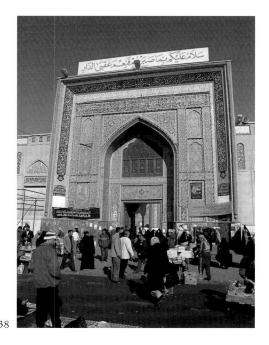

38

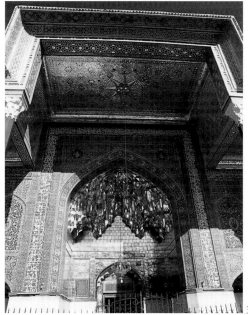

39

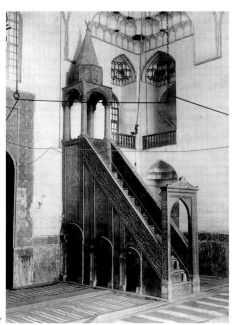

40

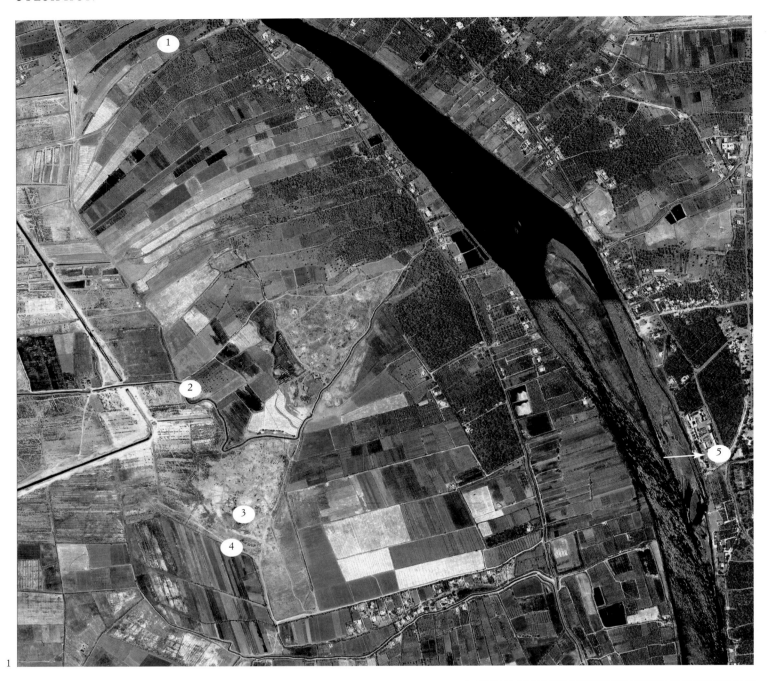

1

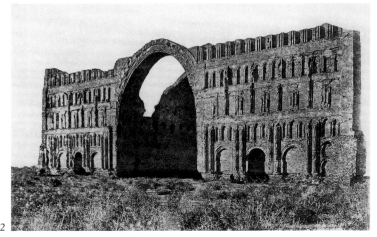

2

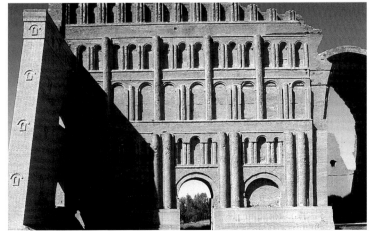

3

1. An aerial view: the area of Ctesiphon is to the east of the Tigris, while that of Veh-Ardashir is to the west. Remains of walls (1, 4); German excavations of the Qasr bint al-Qadi church (2); Italian excavations (3); toward the Taq-i Kisra and the Southern Building (5).

2. The *iwan* and the facade of the Sasanian palace, the Taq-i Kisra, prior to its partial collapse in 1888.

3. The facade of the Taq-i Kisra following its restoration.

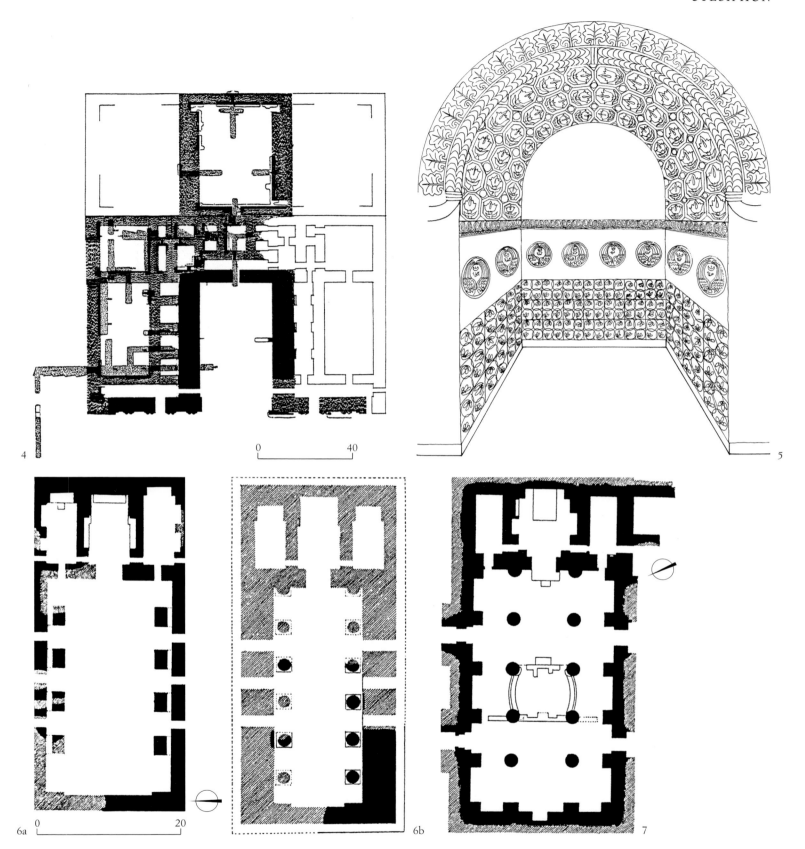

4. A plan of the *iwan* and the excavation of the Taq-i Kisra.

5. A reconstruction of the *iwan,* with stucco decoration, of a building in the area of Ctesiphon.

6a–b. The upper and lower levels of the Qasr bint al-Qadi church.

7. For comparison, the plan of another ecclesiastical building, from al-Hirah (site XI).

1

1. An aerial view of the site.

2. A plan of the palace of the
Early Dynastic Period, first half of
the third millennium BC.

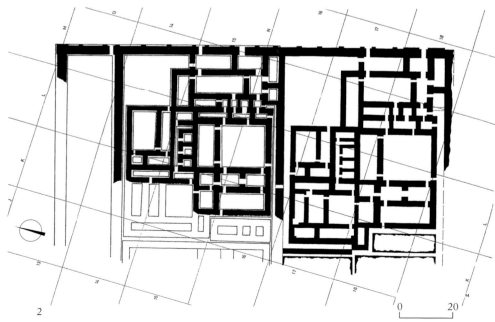

2

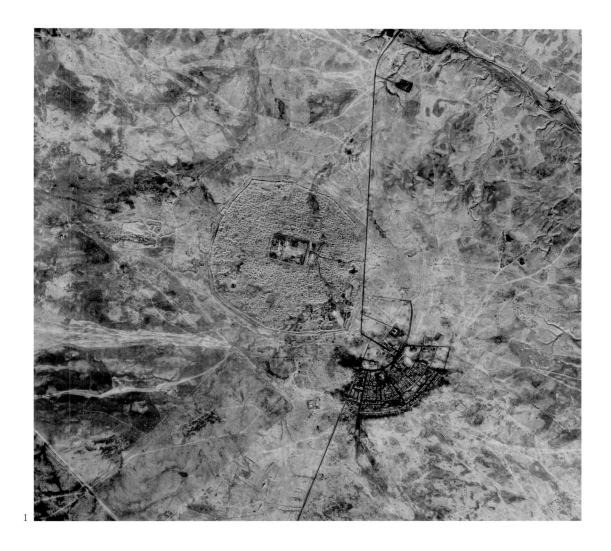

1

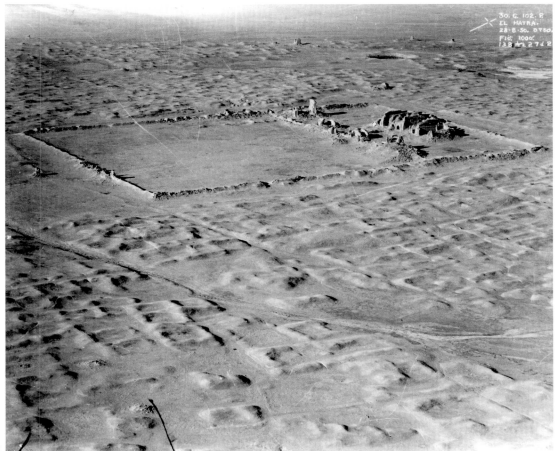

2

1. An aerial view of the site.

2. An aerial photograph of the site (1930), taken from the north, showing the *temenos* (sanctuary), with the large temples and the north-south dividing wall. In the city around it, the mounds correspond to buildings, and the sunken zones, to open areas, such as streets, plazas, or courtyards.

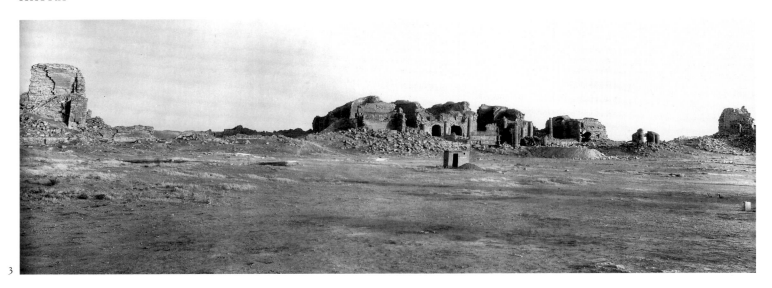

3

3. The *temenos* prior to excavations, from the east. At the center is the Great Iwans Complex.

4. The Great Iwans Complex, at the beginning of the excavations, seen from the east. To the left is the large southern *iwan,* and to the right is the northern one, still blocked by rubble.

5. A plan of the *temenos*.

6. The interior of the small southern *iwan* of the Great Iwans Complex during excavations, seen from the southeast. The large doorway gives access to the rear room. The smaller doorway to the left leads to a staircase to the upper level.

7. The antecella of one of the minor temples inside the inhabited area, during excavations. The worker on the right is standing in the entrance to the cella devoted to worship.

8. The restored archivolt of the entrance to the cella of a minor temple inside the inhabited area. It is decorated with busts of male figures, among whom Herakles and a sovereign are recognizable. They pay homage to the eagle god and a standard. The archivolt is now in the National Museum, Baghdad.

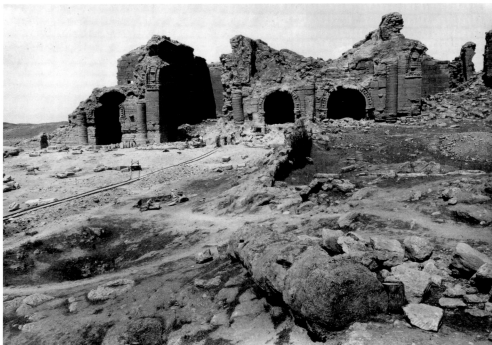

4

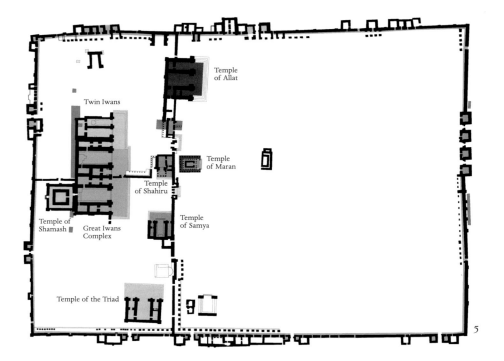

5

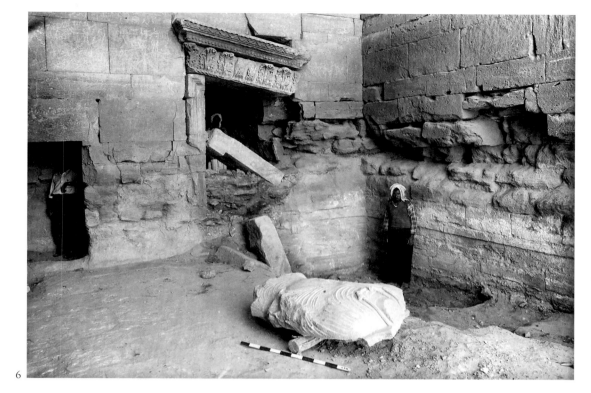

6

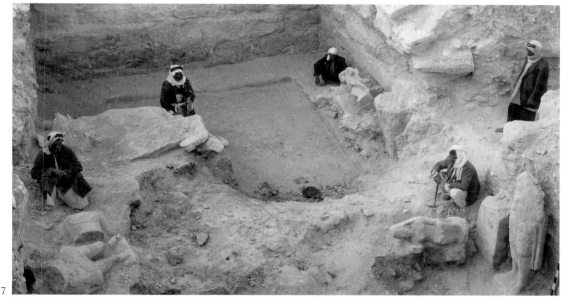

7

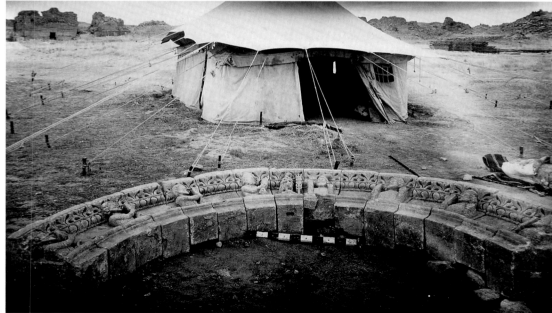

8

9. The area north of the central *temenos,* photographed from the south: "Building A" and the north-south route that connects the *temenos* with the northern city gate.

10. The central courtyard and the principal *iwan* of "Building A," from the west. To the left of the *iwan* is an altar meant for domestic worship.

11. A religious relief from a minor temple inside the inhabited area. At the center, the goddess Allat is represented as the Greek goddess Athena. To either side are two female figures, representing minor or assistant divinities devoted to the goddess. In front of the base that supports the figures stands a lion in profile. National Museum, Baghdad.

12. This unidentified male statue is probably of a noble; it was found in the antecella of a minor temple inside the inhabited area. The right hand is lifted as a sign of veneration, while the left hand holds a scroll. The tunic and pants are richly decorated with two lines of spiraling vines. Mosul Museum.

13. A relief showing a bust of the sun god Maran, the first god in the Triad, with a radiating nimbus and emerging from clouds or mountains. On his shoulders are two fibulae with an open-winged eagle, an attribute of the god. From a minor temple inside the inhabited area. Mosul Museum.

14. A relief showing a bust of the god Barmarein (son of our lord and lady), with radiating nimbus and crescent moon. The small horns emerging from his diadem are a divine attribute. From the central *temenos* of Hatra. Mosul Museum.

15. Princess Dushefri, daughter of King Sanatruq II, from the antecella of a minor temple inside the inhabited area. She is wearing a dress whose upper part is richly decorated and sumptuous jewels. On her raised hairstyle, covered by a mantle, is the figure of the sun god. The inscription on the base mentions the genealogy of the princess and the date (AD 238). National Museum, Baghdad.

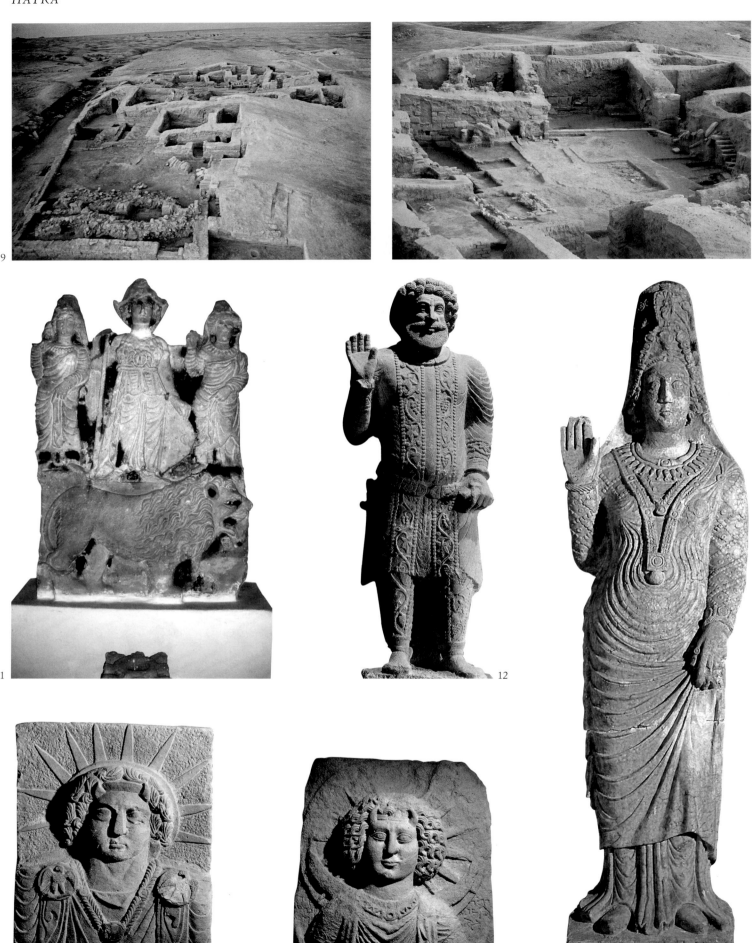

9

10

11

12

13

14

15

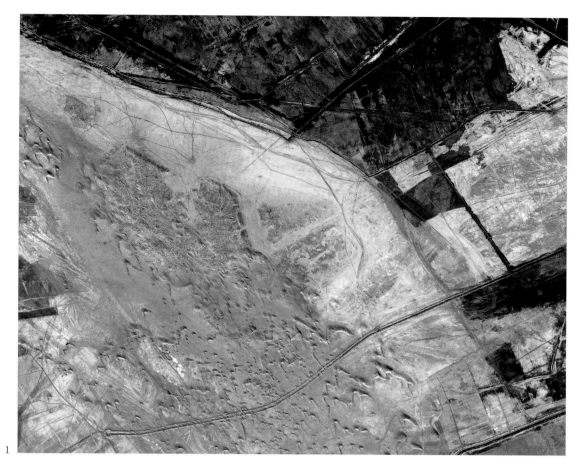

1. An aerial view of the site.

2. A plan of the temple of Gula in its final state, during the Kassite era (third quarter of the second millennium BC).

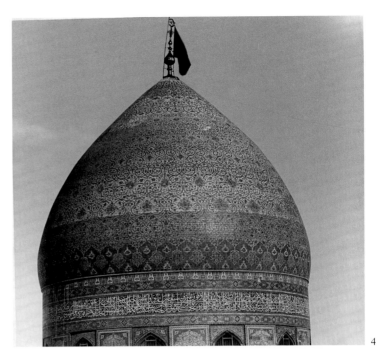

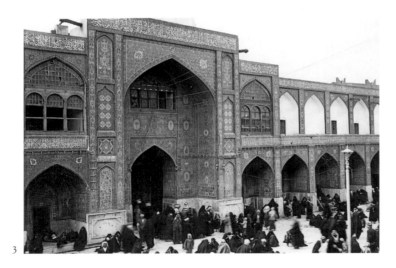

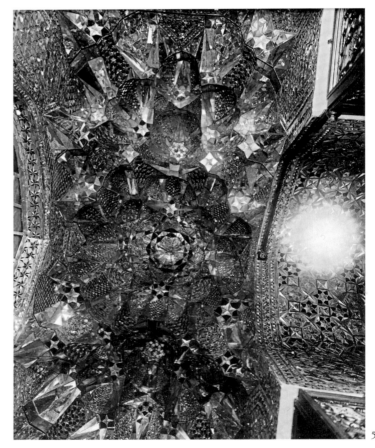

1–5. This is the site of the martyrdom of Husayn, son of 'Ali and grandson of Muhammad, as well as of his burial. Sacred to all Shiites, the city has been subject to very destructive attacks, including that of the Wahhabi sheikh Saud in 1801. During the month of Muharram (the fifth month in the Islamic calendar), the tenth day (Ashura) memorializes the martyrdom, and the city becomes a pilgrimage destination. All the images here are from historical archives.

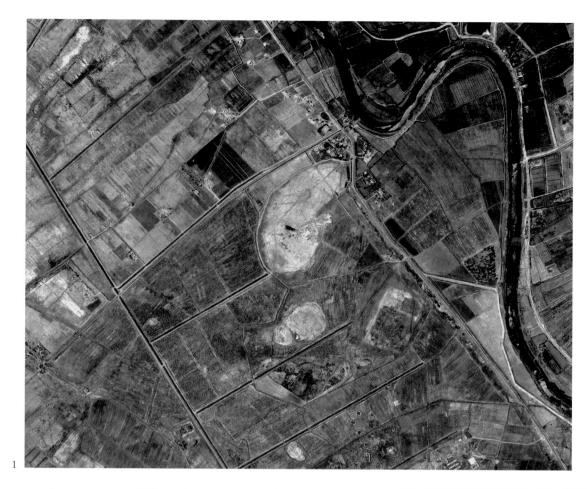

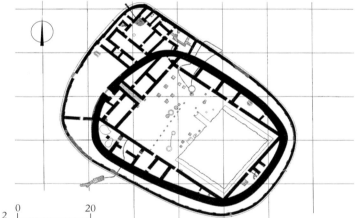

1. An aerial view of the site.

2–4. A plan of the restoration (2), a reconstruction (3), and an aerial view of the oval temple (4), Early Dynastic Period II–III, c. 2700–2400 BC.

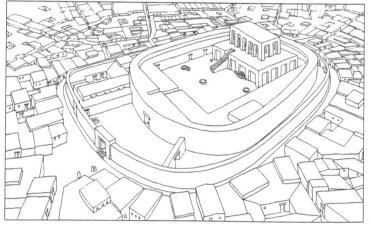

2

0 20

3

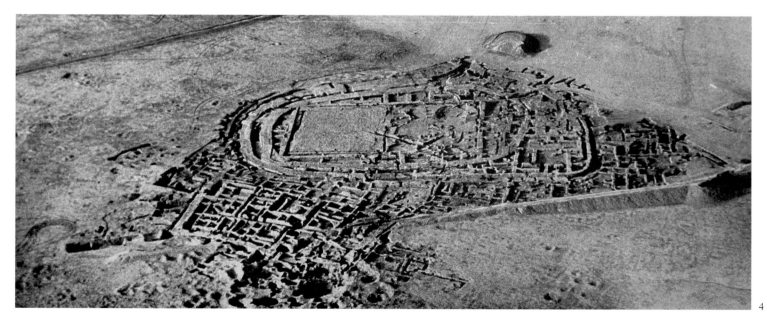

4

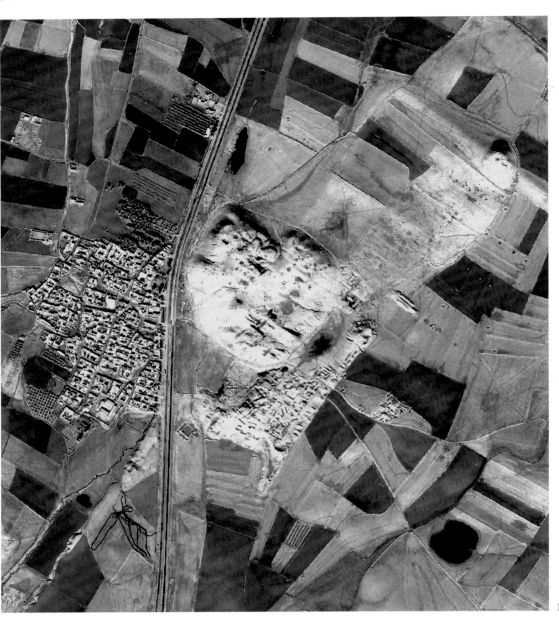

1. An aerial view of the site.

2. A plan of the citadel, with the palace of Sargon II (end of the eighth century BC) to the northwest.

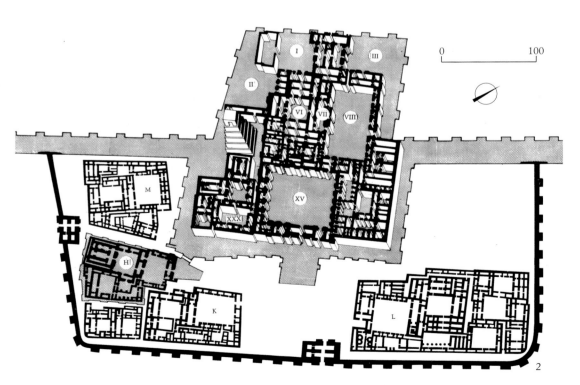

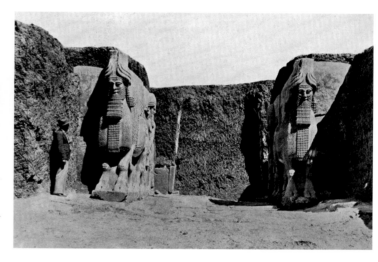

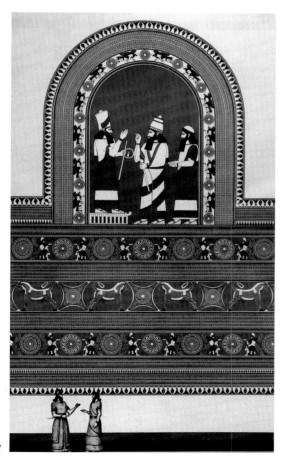

3. A reconstruction of the façade of the temple of Nabû.

4. A reconstruction of a bird's-eye view of the citadel.

5. The discovery of an androcephalous bull and a winged genie.

6. Androcephalous bulls in situ at a gateway to the citadel.

7. A watercolor rendering of a painting from "Palace K."

8. The crating and moving of one of the androcephalous bulls.

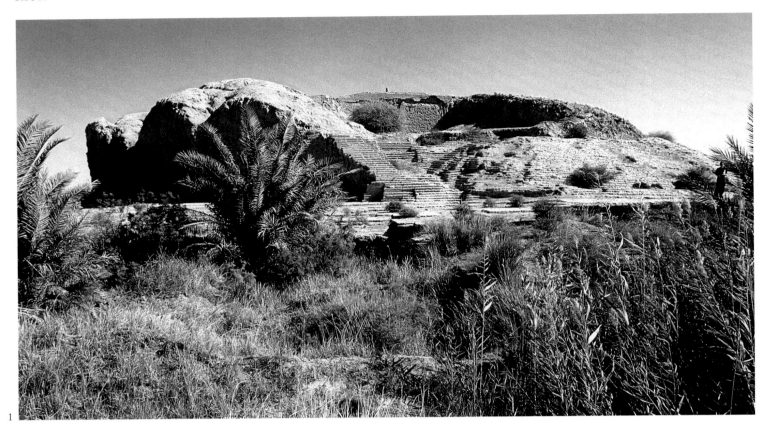

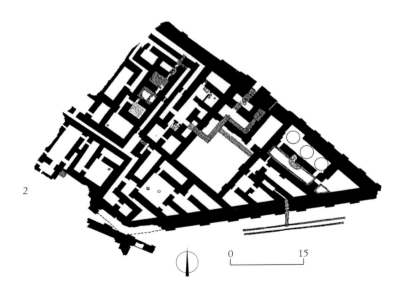

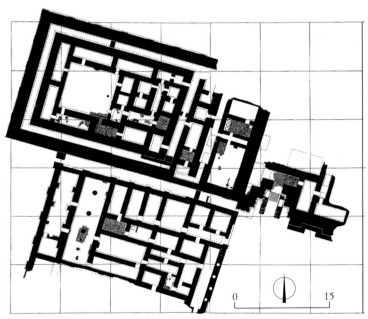

1. A view of the archaeological site.

2. A plan of "Palace P," Early Dynastic Period III, middle of the third millennium BC.

3. A plan of "Palace A," Early Dynastic Period II/III, middle of the third millennium BC.

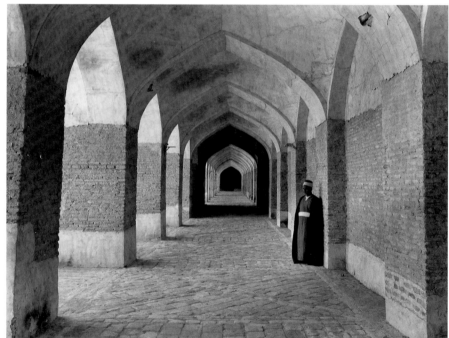

1

4

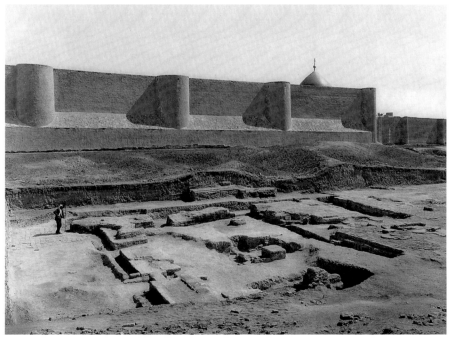

2

1–9. Kufa, founded in 638, is an extremely important Iraqi settlement. It was the center of the revolt against Caliph 'Uthman and also sided with 'Ali during the famous Battle of the Camel. 'Ali was killed here. The most elegant and monumental calligraphic style of Islam is linked to this city. These archival photographs document the twentieth-century excavations of the Governor's Palace (Dar al-Imara), undertaken in various stages by Iraqi archaeologists. Located near the mosque, this structure was fundamental to the subsequent development of Muslim civil architecture.

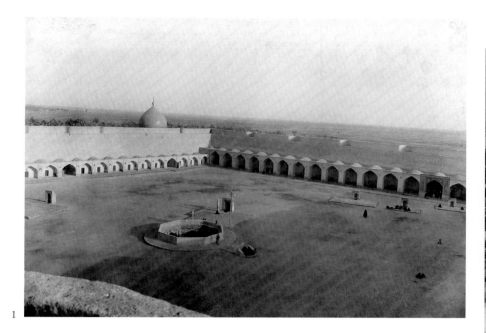

3

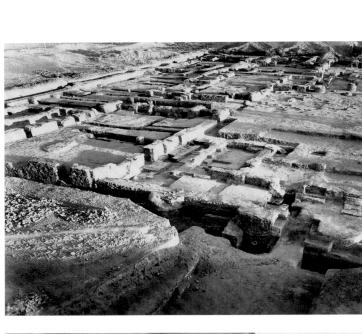

5

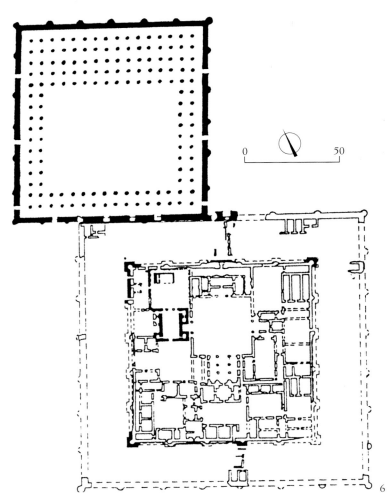

6

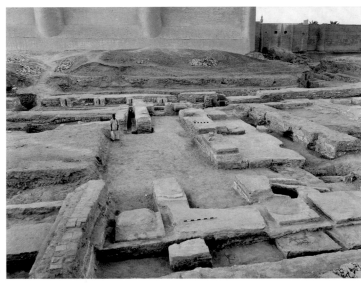

7

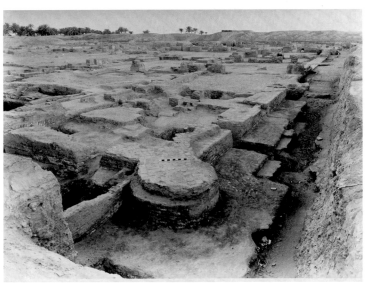

8

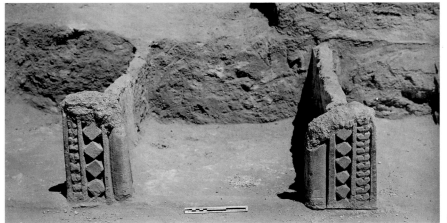

9

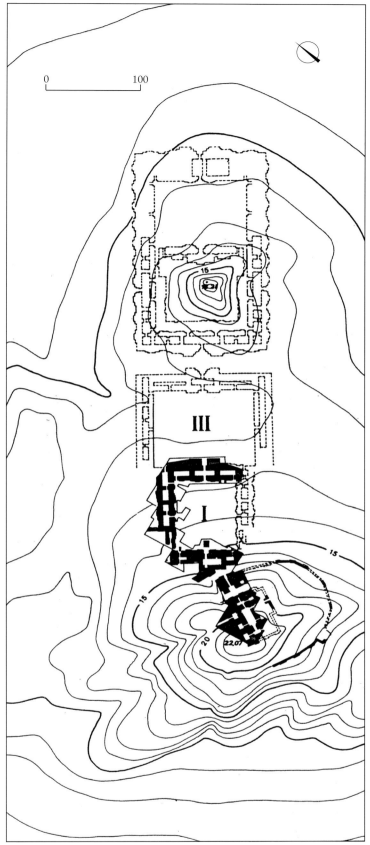

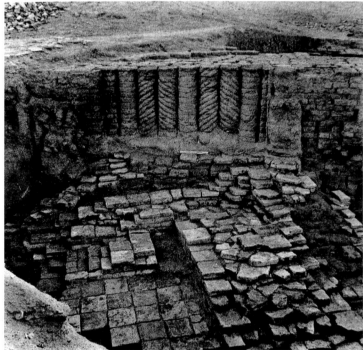

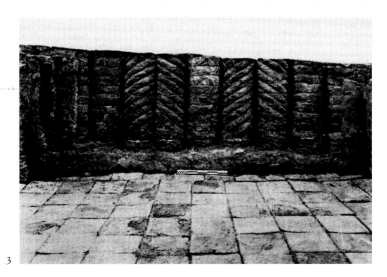

1. A plan of the palace of Nur-Adad, first half of the nineteenth century BC.

2–3. Two views of the courtyard of the E-Babbar (the temple of Shamash), with its decoration of carved twisted semicolumns.

4. A plan of the E-Babbar, with the ziggurat to the northeast, the two courtyards at the center, and the sanctuary to the southwest. The complex dates back to the eighteenth century BC, but excavations of the sanctuary have reached only the neo-Babylonian level.

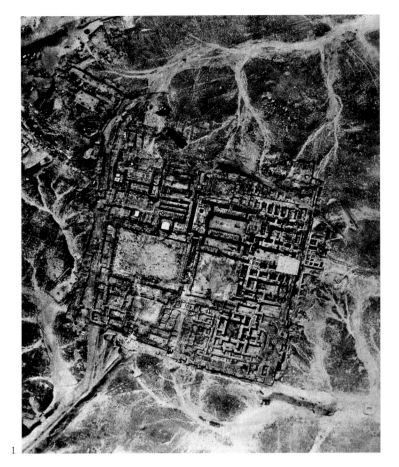

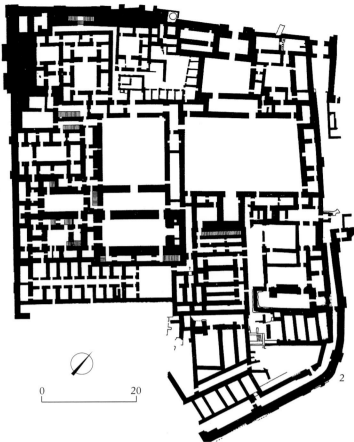

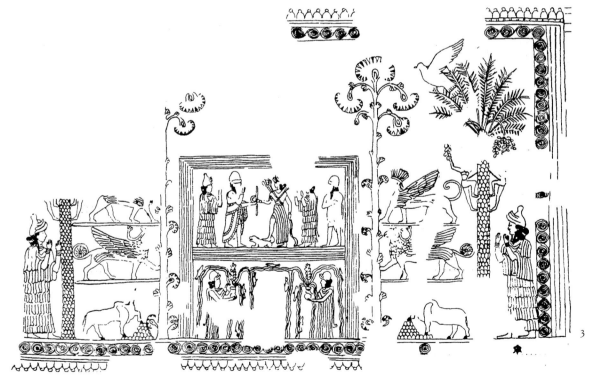

1. An aerial view of the palace of Zimrilim, eighteenth century BC.

2. A plan of the palace of Zimrilim.

3. A drawing of the Investiture Painting in the palace of Zimrilim, eighteenth century BC.

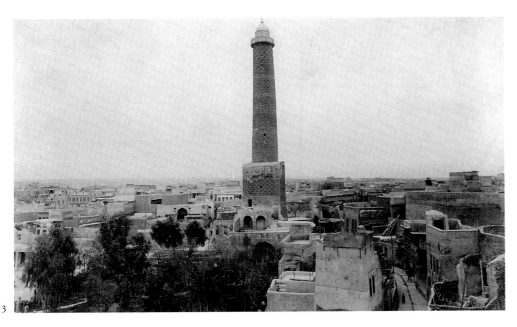

1–3. Three historical views of the famous minaret of the Nur al-Din mosque (1170–72), the symbolic monument of this city, which was an extremely important medieval artistic center.

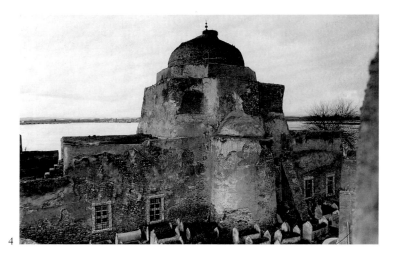

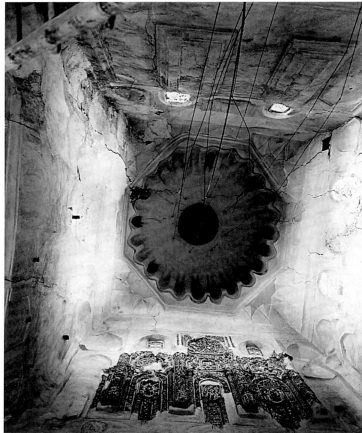

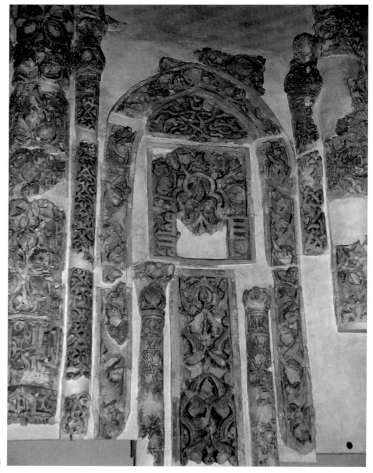

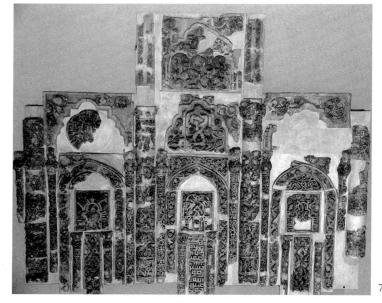

4–12. The Nur al-Din mosque prior to its destruction and before the extraordinary stucco *mihrab* (5, 6) was detached and reconstructed in Baghdad at the National Museum (7, 8). A small window (9) was similarly rebuilt in Baghdad (11). In the first of the two archival photographs (10, 12) of the wooden *minbar,* or pulpit, which dates from the thirteenth century, note the scimitar symbolically placed on the steps.

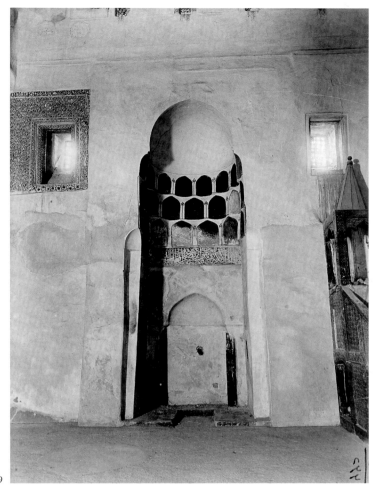

9

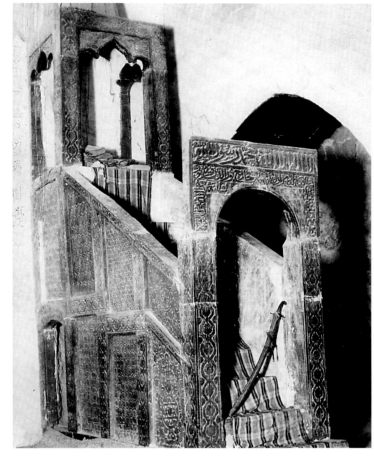

10

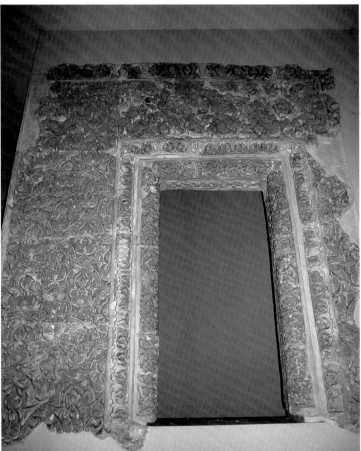

11

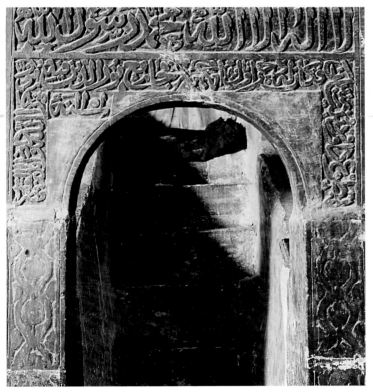

12

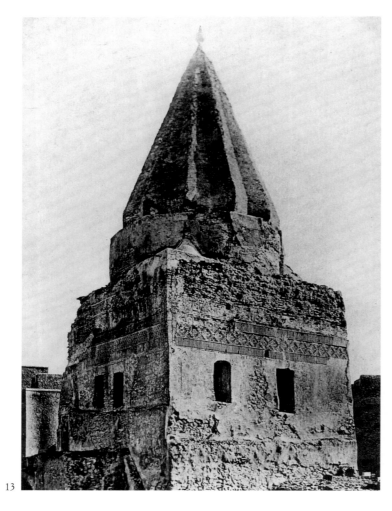

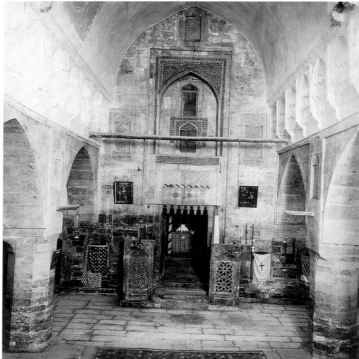

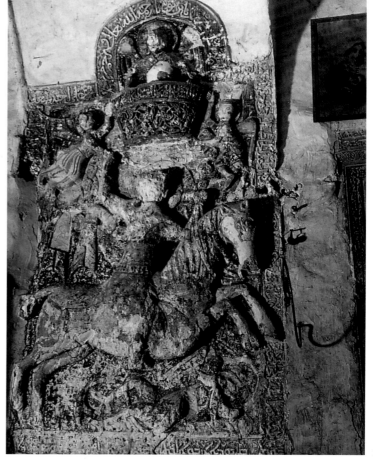

13–16. Many important monuments in Mosul have been destroyed and are documented only in historical photographs. The figure of Saint George in stucco is exceptional; the area of Jazira has always been an important Christian center.

OPPOSITE

1–4. Najaf is the main Shiite theological center of Iraq and the larger Islamic world. Najaf was the major focus of opposition to the Ottoman Turks and was later opposed to the British mandate, and then to both King Faisal I and Saddam Hussein. Here, not far from Kufa, is the supposed burial site of 'Ali. The tomb has obviously been restored many times, and its present appearance, seen in these archival photographs, is in the eastern, Iranian style.

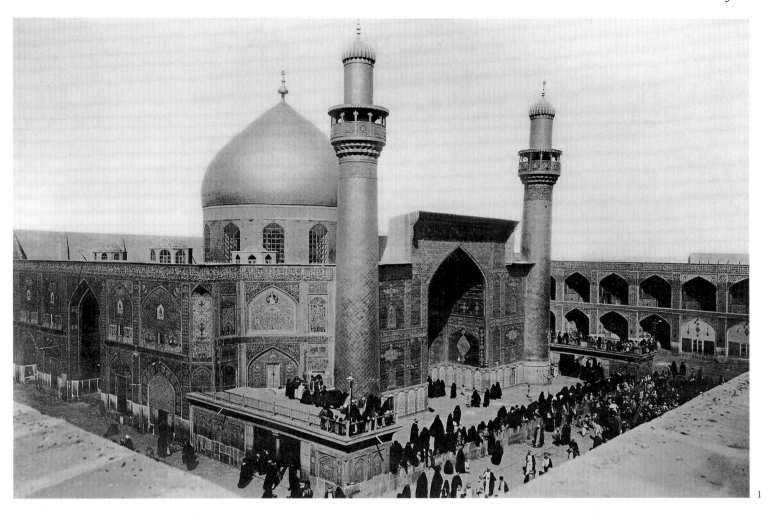

1

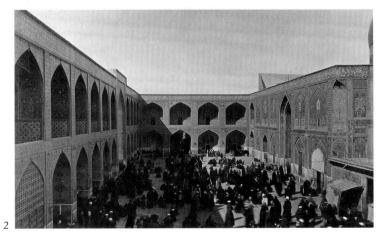

2

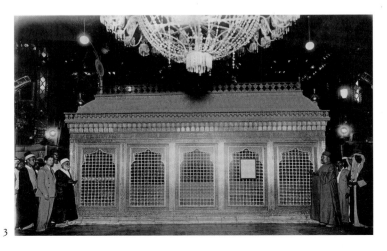

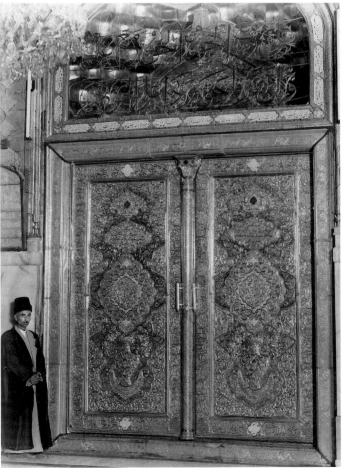

3

4

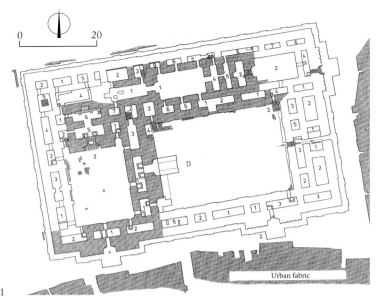

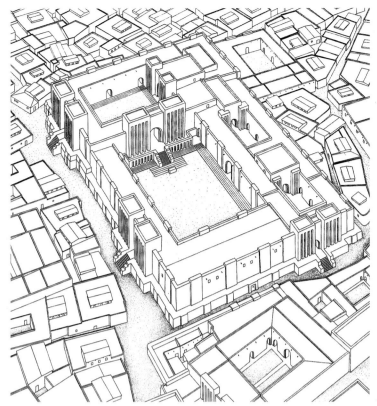

1–2. A plan and a reconstruction of the temple of Ishtar-Ktitum, built around 1850 BC.

1. An aerial view of the western part of Nimrud.

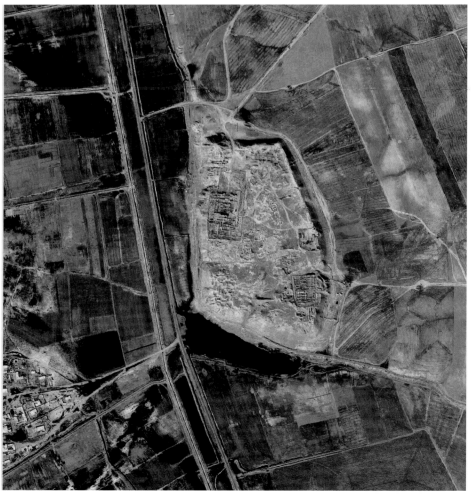

2. A drawing of a glazed-brick panel found at "Fort Shalmaneser" (height 13 ft. 4 in. [4.07 m]), ninth century BC. National Museum, Baghdad.

3. An aerial view of the eastern part of Nimrud.

4. A plan of the temple of Nabû, eighth century BC.

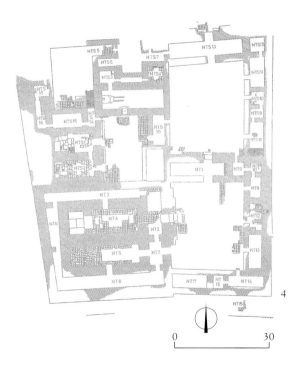

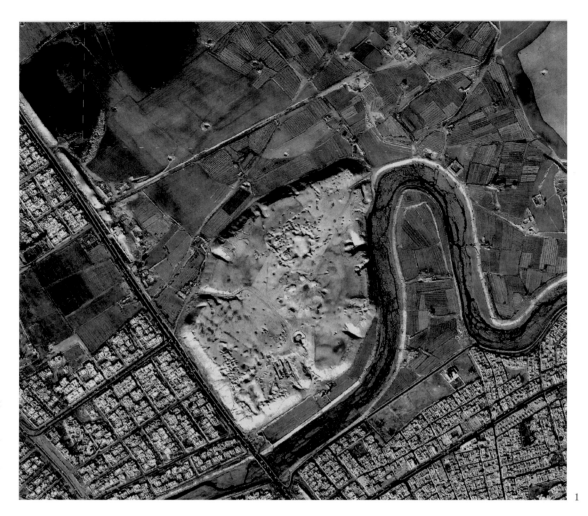

1. An aerial view of Kuyunjik, one of the tells of ancient Nineveh.

2. A plan of Tell Kuyunjik, with the palace of Sennacherib (A), the temple of Ishtar (B), the temple of Nabû (C), and the palace of Ashurbanipal (D).

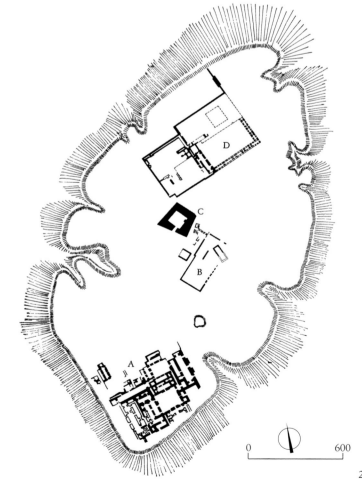

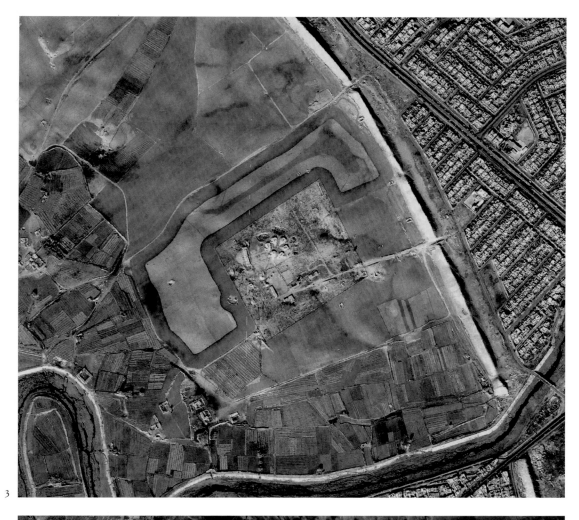

3. An aerial view of Nabi Yunus, another of the tells of ancient Nineveh.

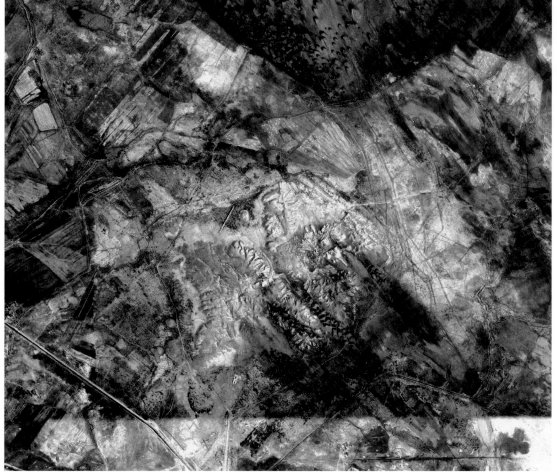

1. An aerial view of the site of Nippur.

2. A plan of the Ekur, the temple of Enlil, with its ziggurat, Ur III, twenty-first century BC.

1–3. Samarra was founded by the Abbasids in 836 and remained the capital of their empire until 889, the year in which it started to be gradually abandoned. The map of the site shows that it developed along the eastern shores of the Tigris (for the most part; some of the remains are in fact on the other side of the river), and the two aerial photographs show the extent of the archaeological area, which comprises twenty-three square miles (60 km²) of ruins.

4–6. A recent satellite view of the Great Mosque of al-Mutawakkil (4) and two older photographs (5–6) show the ruins of the Abbasid city and the development of the modern town.

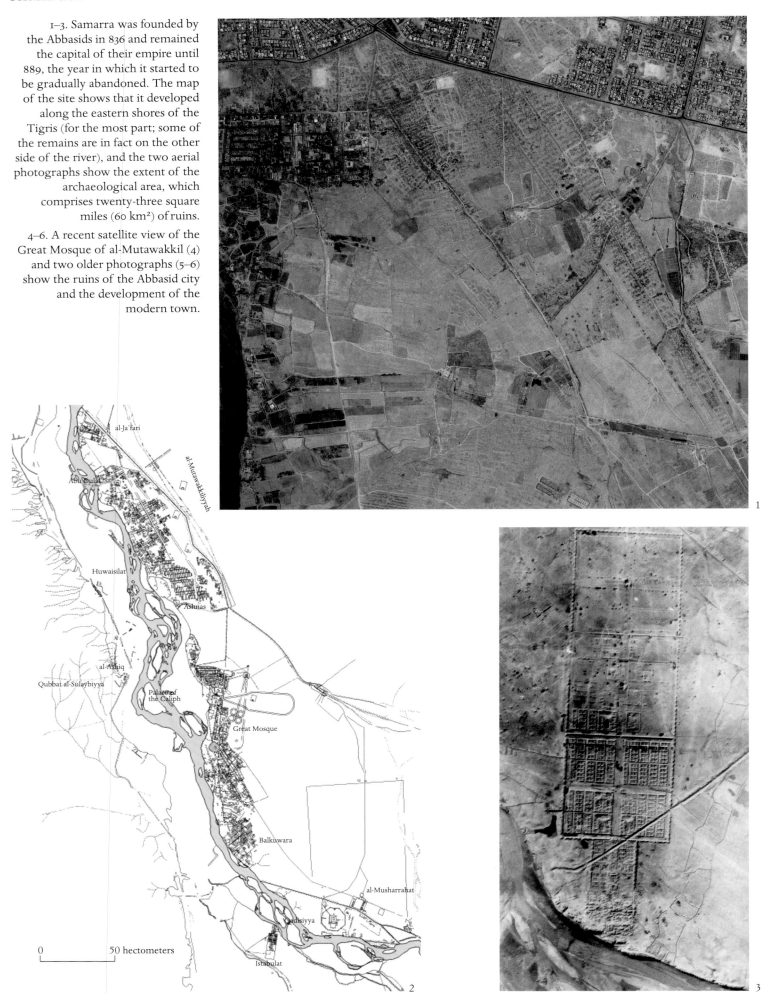

0 50 hectometers

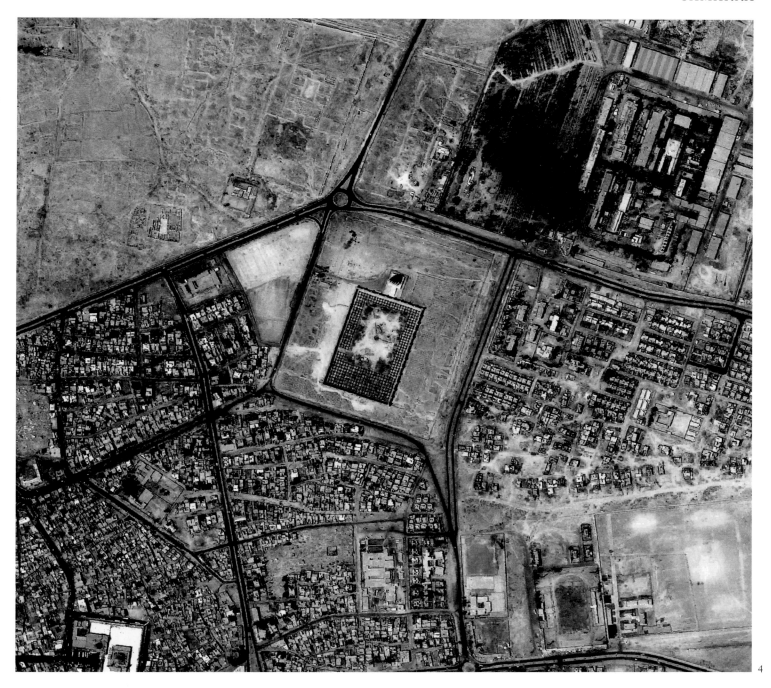

4

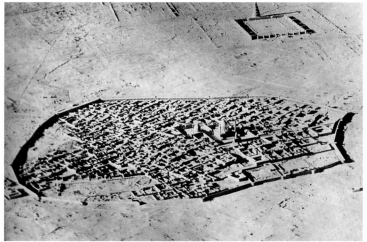

5

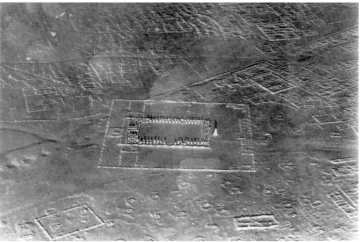

6

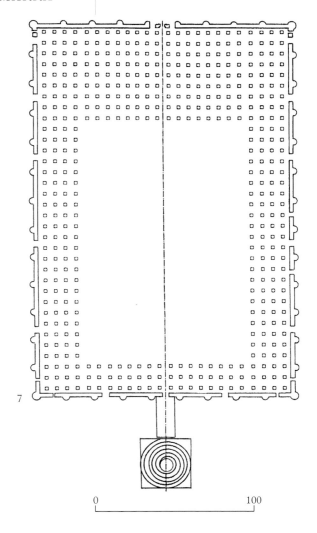

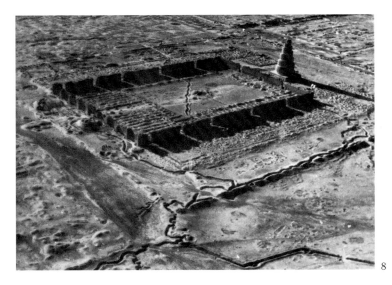

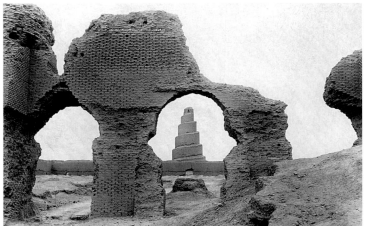

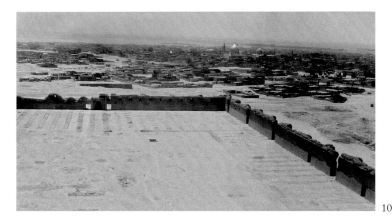

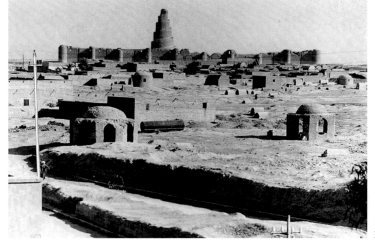

7–11. The Great Mosque of al-Mutawakkil, begun in 847, with its enormous extent and its famous spiral minaret, is the symbolic monument of Iraqi Islam.

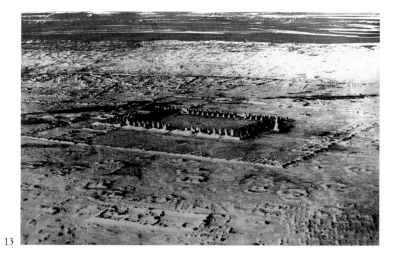

13

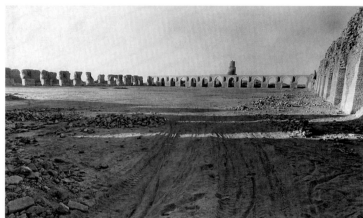

14

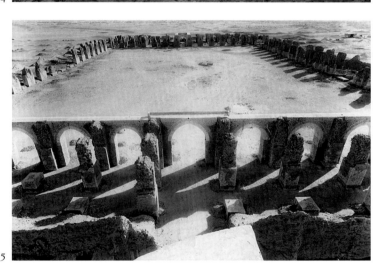

15

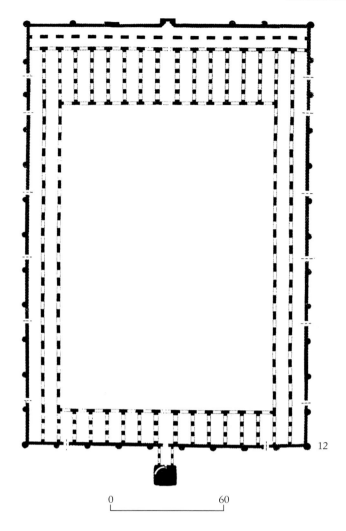

12

0 60

12–16. Abu Dulaf is a "replica" of the Great Mosque of al-Mutawakkil. With a fortified wall measuring 699 by 443 feet (213 by 135 m) and a courtyard measuring 427 by 377 feet (130 by 115 m), it is an example of how the congregational mosque was conceived to accommodate the entire *umma*, the community of the faithful.

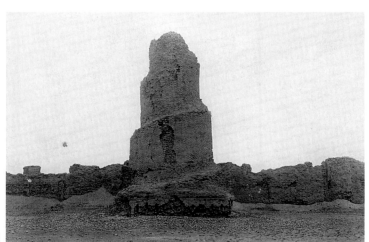

16

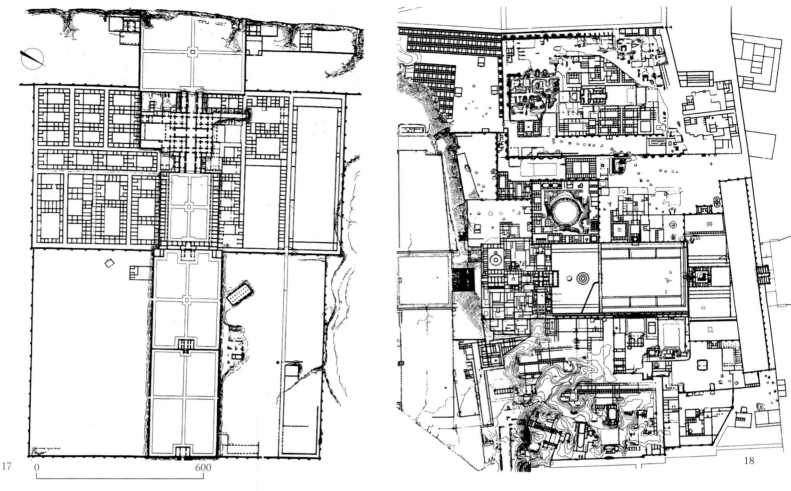

17

0 600

18

19

20

17–21. A plan of the Jawsaq al-Khaqani (18), built in 836, the first palace of the Caliph on the banks of the Tigris, with an overall area of about 370 acres (150 hectares). The palace of Balkuwara (17), built thirteen years later, is more modest, with a squared outer wall measuring 3,822 by 3,841 feet (1,165 by 1,171 m). The Imam Dur mausoleum, near Samarra, dates to 1085 and is one of the oldest Islamic funerary monuments (19).

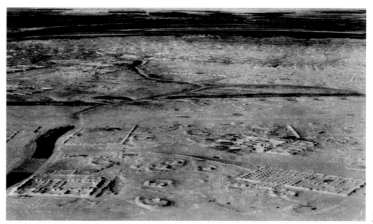

21

22

23

24

25

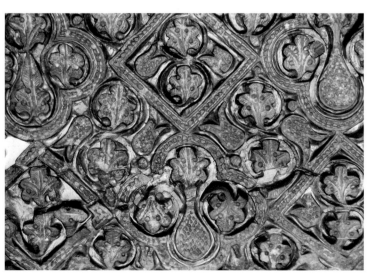

26

27

22–28. A city so extensive and so quickly built demanded decoration that could be executed rapidly. Stucco, a fast, easy-to-use, and inexpensive material that can be molded and painted in polychrome, was the main element in the decorative art of Samarra. These archival photographs show panels found in residential buildings.

28

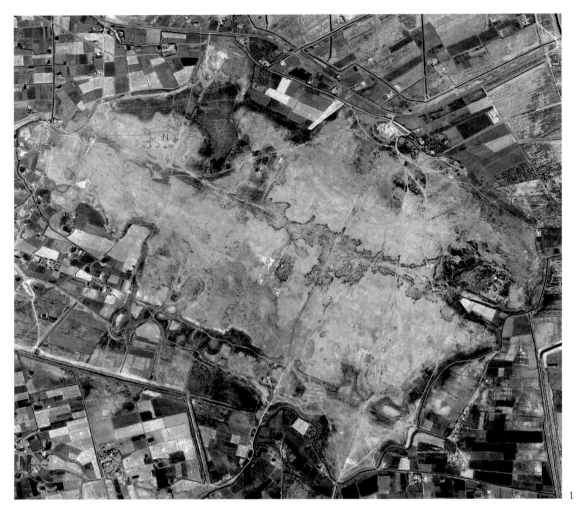

1. A satellite image of the archaeological site of Seleucia.

2. A plan of the Hellenistic city of Seleucia on the Tigris. The numerals indicate (1) Tell Umar, (2) the archives, (3) Temple A, (4) the central canal, (5) the excavated residential block, (6) the southern street, and (7) the royal canal.

3. A plan of the Plaza of the Archives and Tell Umar.

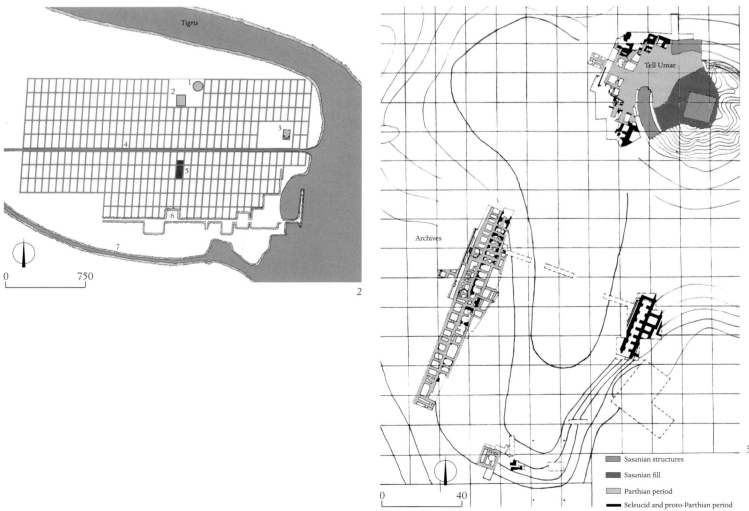

4. An image from the Spot V satellite of the region of Seleucia: the area in white at top center corresponds roughly to the ruins. In ancient times, the Tigris ran closer to the city, but it has changed course over the years, as can be seen by the large oxbow in the lower right, which corresponds to the ancient riverbed.

5–6. Two views, from the southwest, of the excavation at the Plaza of the Archives during a campaign by the Centro Scavi di Torino, 1971.

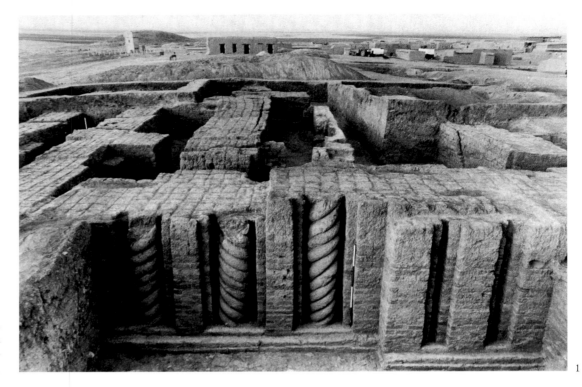

1. The temple at Shubat Enlil, with its facade decorated with twisted semicolumns, nineteenth or eighteenth century BC.

1. A reconstruction of the facade of the temple of Ninhursag at Tell Ubaid, Early Dynastic Period III, 2600–2300 BC.

2. A plan of the temple of Ninhursag with its oval outer wall and raised terrace.

3. An aerial view of the site.

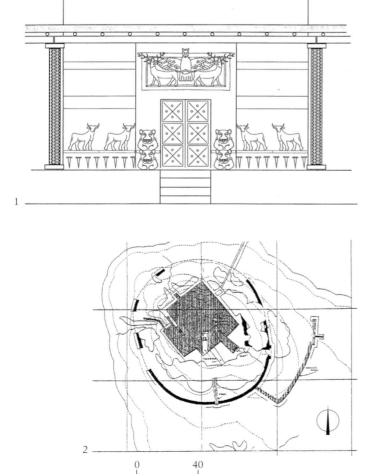

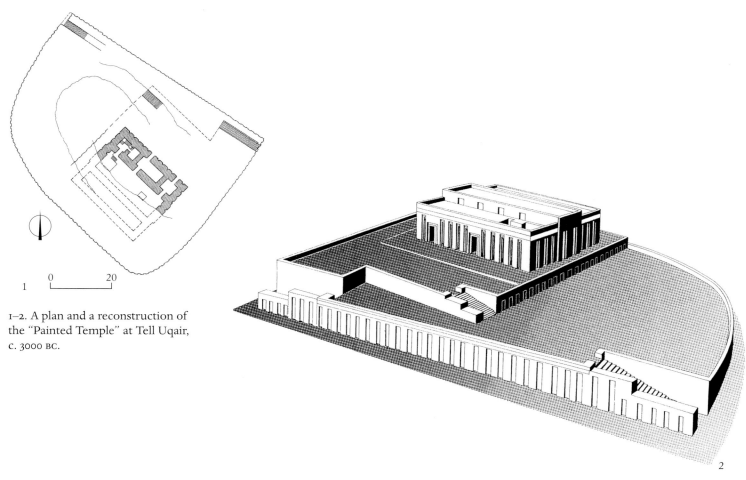

1–2. A plan and a reconstruction of the "Painted Temple" at Tell Uqair, c. 3000 BC.

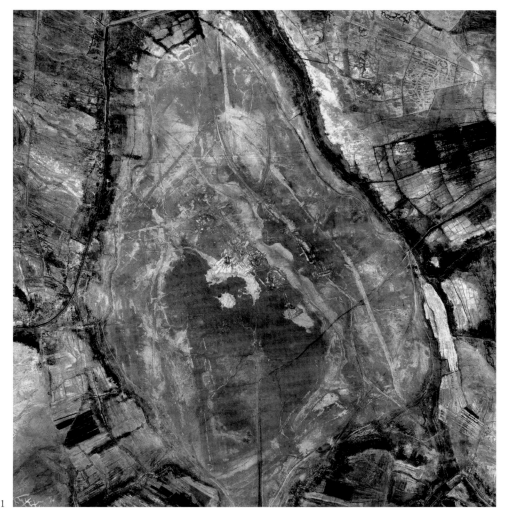

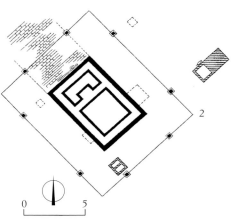

1. An aerial view of Tello.

2. A plan of the temple of Ningirsu at Tello, Early Dynastic Period III, 2600–2500 BC.

UKHAYDIR

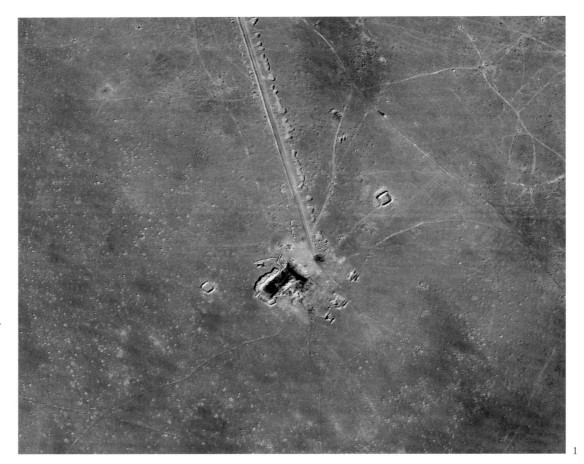

1–3. The palace and fortified outpost of the second half of the eighth century AD. This structure creates an extraordinary visual impact even today.

4–6. The walls, fortified with semicylindrical towers, have been partially restored, but the impression of strength and solidity remains unchanged.

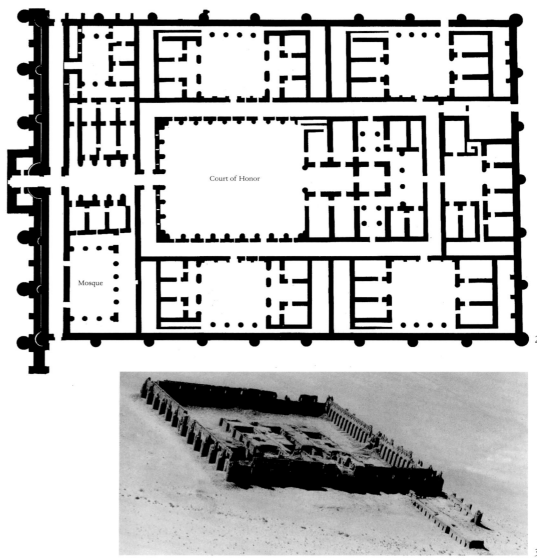

Court of Honor

Mosque

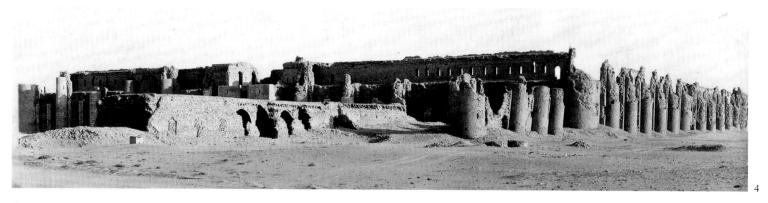

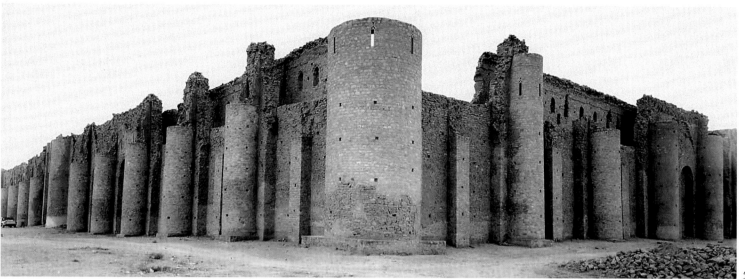

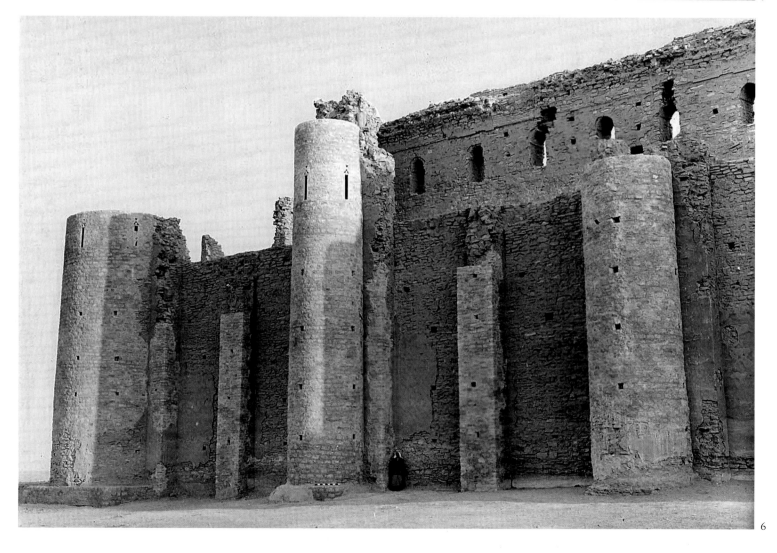

4

5

6

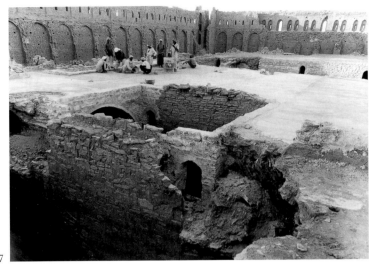

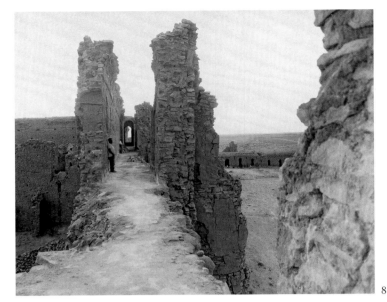

7

8

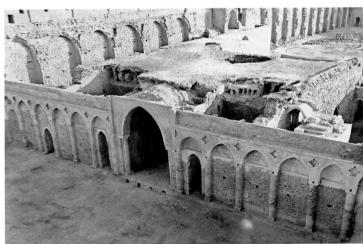

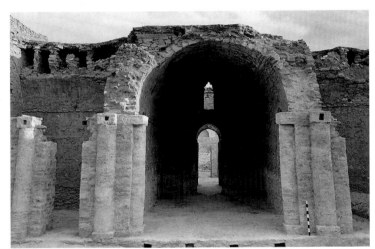

9

10

7–15. The communication
trenches on the walls tell of a
military structure, while the
blind arcades show an attention
to form on the part of the
architects. The solution for
corners, with elaborate span-
drels and transverse arches (?),
demonstrates a significant
technical awareness, in line with
the best Sasanian traditions
in construction.

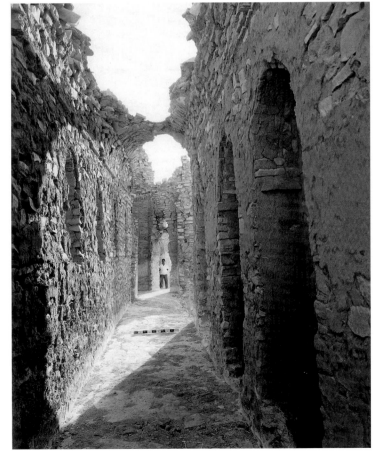

11

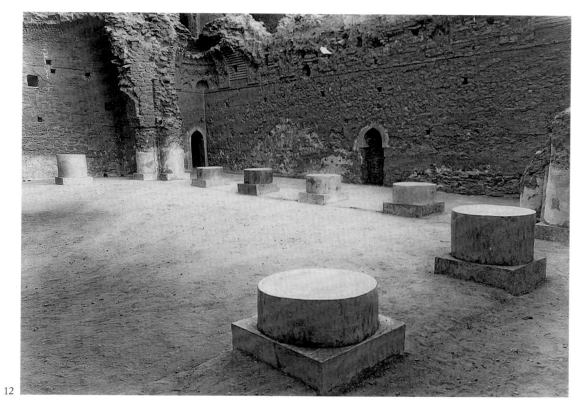

12

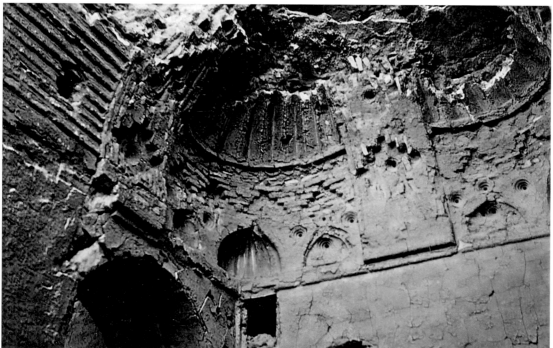

13

14

15

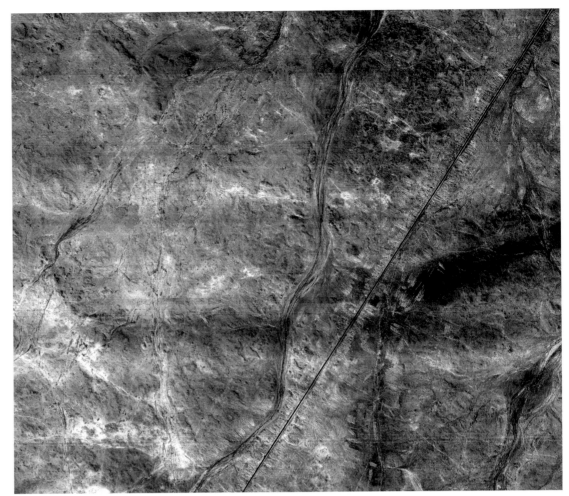

1. An aerial view of the site.

2. A plan of the sacred enclosure dedicated to Nanna, the god of the moon, with the ziggurat (1); the Giparu of Ningal, residence of the high priestess (2); the Edublalmah, or House of Tablets (3); the Enunmah (4); the Ehursag (5); and the royal mausoleums (6). Ur III, twenty-first century BC.

3. A plan of the ziggurat.

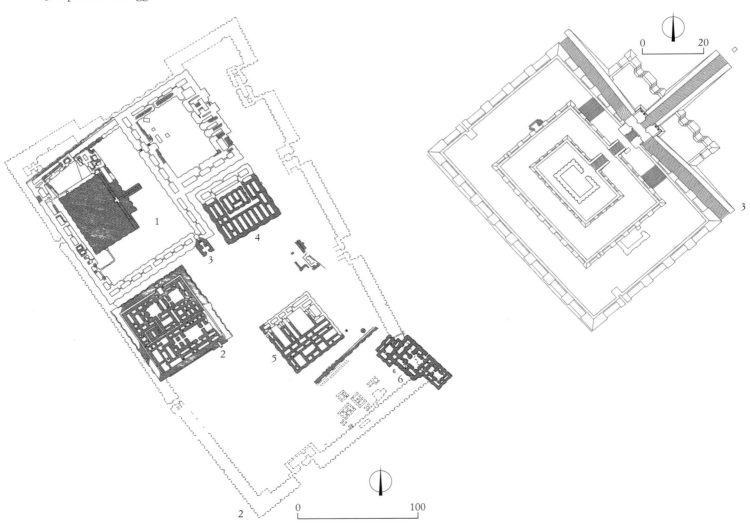

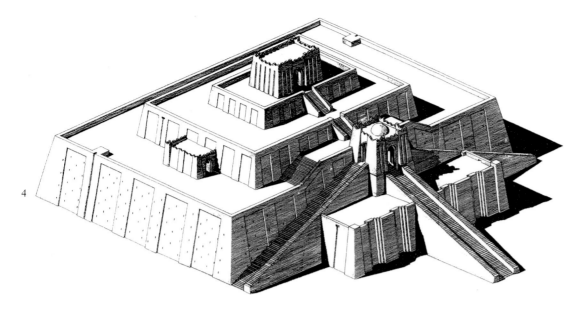

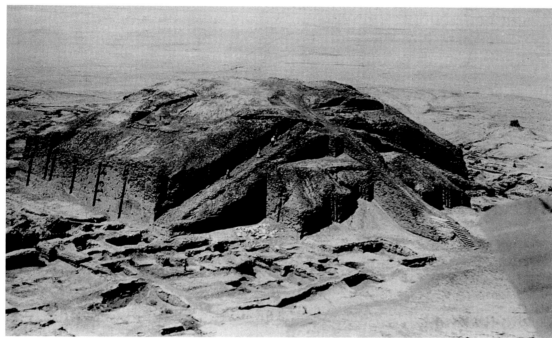

4. A reconstruction of the ziggurat.

5–6. Views of the ziggurat prior to its restoration.

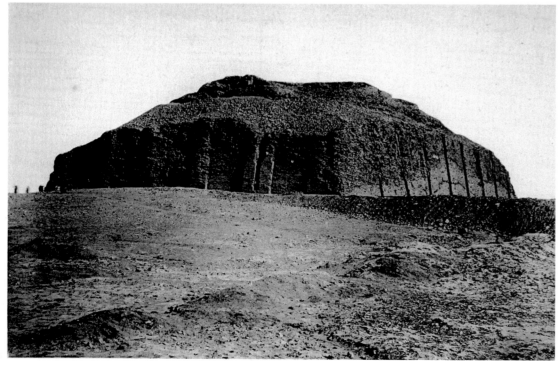

1–3. Aerial views of the site. The last one shows the *Steingebäude* and the "Anu Ziggurat." Visible in photograph 2 are (1) the Bit Resh and its temple dedicated to Anu and Antum (1a) of the Seleuco-Parthian era; (2) The "Anu Ziggurat," c. 3000 BC; (4) the Irigal, a great temple of the Seleuco-Parthian era; (7) the Eanna, a palace complex of the end of the fourth millennium BC, at the foot of the ziggurat (7a) of the end of the third millennium BC; and (10) the temple of Gareus, of the Parthian era.

4. Architectural remains decorated with cone mosaics.

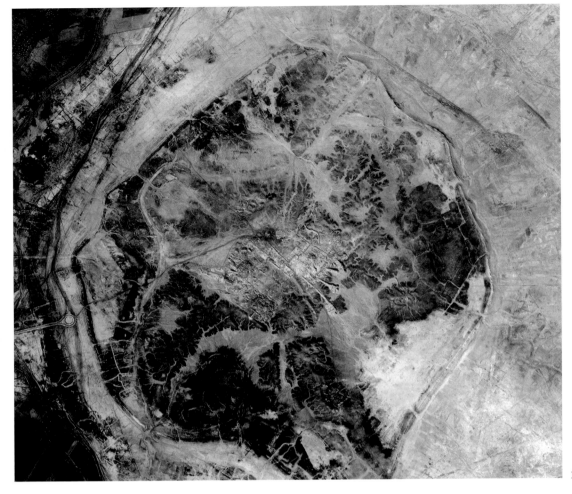

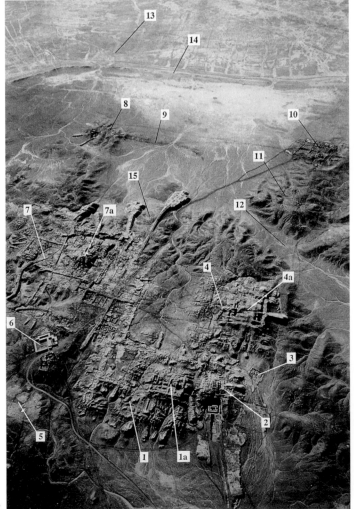

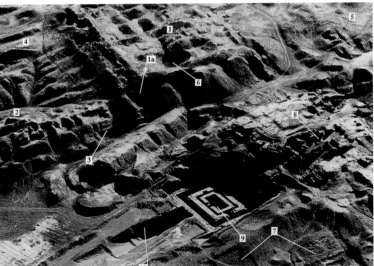

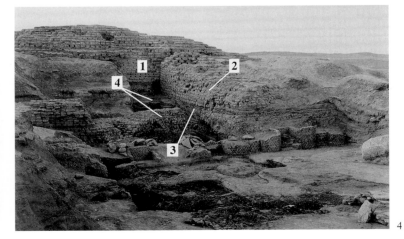

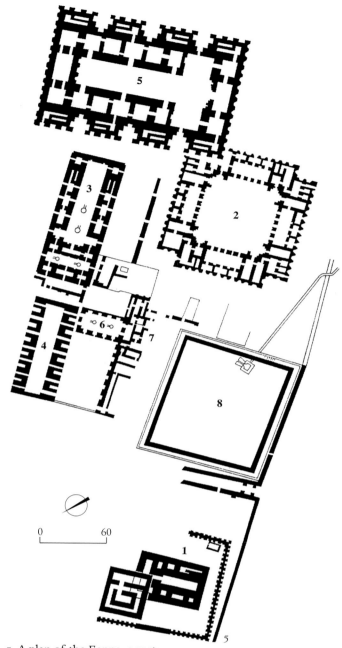

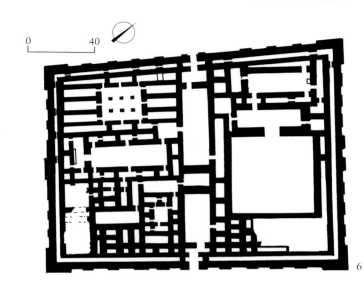

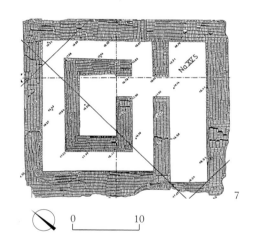

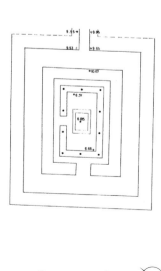

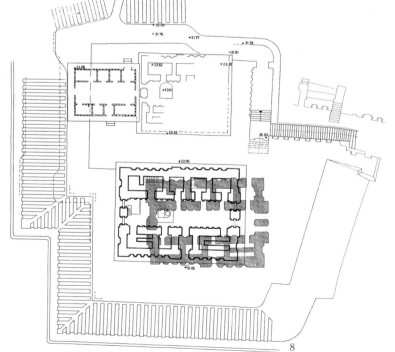

5. A plan of the Eanna, a sort of palace housing a temple that was decorated with cone mosaics. Identified here are (1) the *Steingebäude;* (2) the Square Building; (3) Temple C; (4) the Great Hall; (5) Temple D; (6) the Pillar Hall, or *Pfeilerhalle;* (7) the "Baths"; and (8) the Great Court. Uruk Period, end of the fourth millennium BC.

6. A plan of the palace of Sin-Kashid, nineteenth century BC.

7. A plan of the *Riemchengebäude,* Uruk Period, end of the fourth millennium BC.

8. A plan of the *Steingebäude* and the raised terrace of the "Anu Ziggurat," on the summit of which various buildings, including the "White Temple," succeeded each other. Uruk Period, end of the fourth millennium BC.

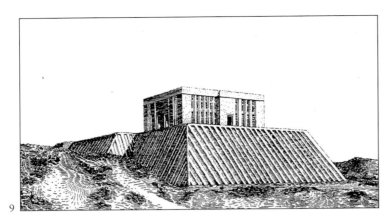

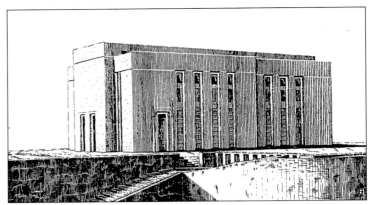

9–10. Reconstructions of the "White Temple" and the "Temple of Level E," two of the buildings that succeeded each other on the "Anu Ziggurat." Uruk Period, end of the fourth millennium BC.

11. The technique used to create the decoration on the "Temple of the Cone Mosaics": terra-cotta cramps, or fasteners, made it possible to affix the decorative cones to the walls. Uruk Period, end of the fourth millennium BC.

12. A reconstruction of one of the cone-mosaic panels inside the *Pfeilerhalle.*

13. Remains of the decoration of the "Temple of the Cone Mosaics." Uruk Period, end of the fourth millennium BC.

14. Hollow cones used to decorate the terrace of the "Anu Ziggurat." Uruk Period, end of the fourth millennium BC.

15. "Temple of the Cone Mosaics": detail of the masonry showing the (broken) terra-cotta cramps that supported the decorative facing. Uruk Period, end of the fourth millennium BC.

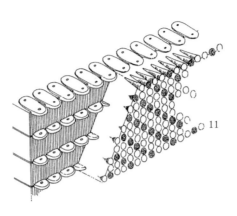

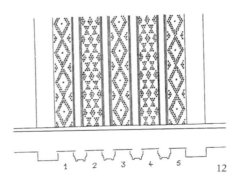

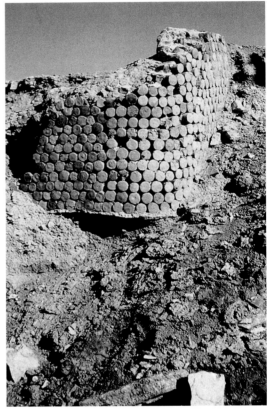

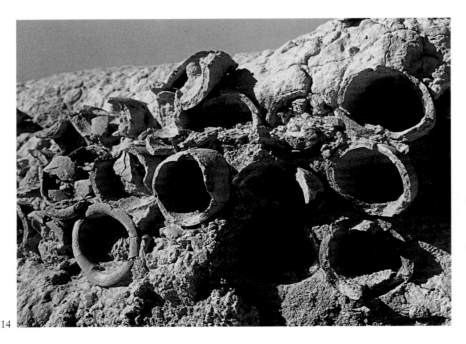

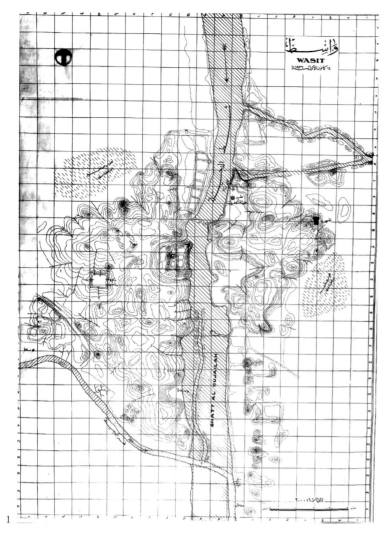

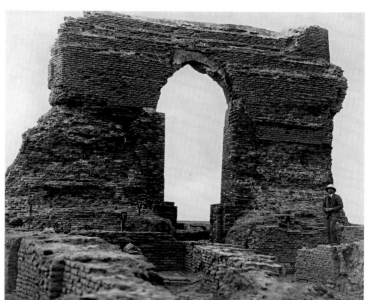

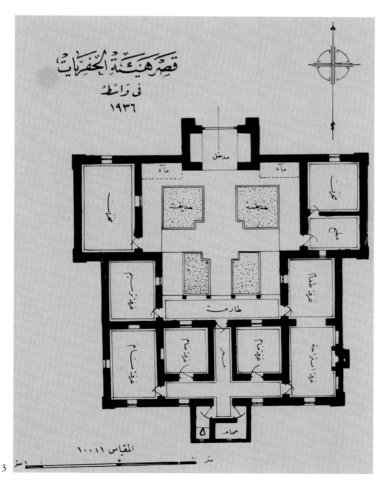

1–10. Wasit was an important city during the first Islamic period, being situated midway between Basra and Kufa. It underwent various historical and political events, including a change in the course of the Tigris. Despite its importance, the city has not been excavated, except for this monumental gateway, probably part of the Shirabiyya *madrasa* (middle of the thirteenth century), known locally as al-Manar or Manarate Wasit because of the two great minarets that flank the arch.

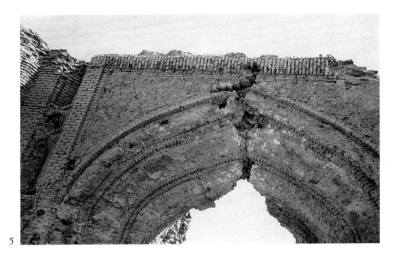

5

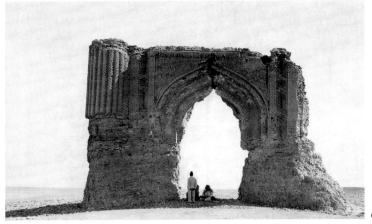

6

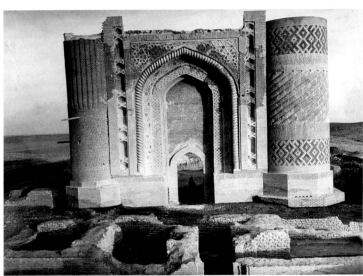

7

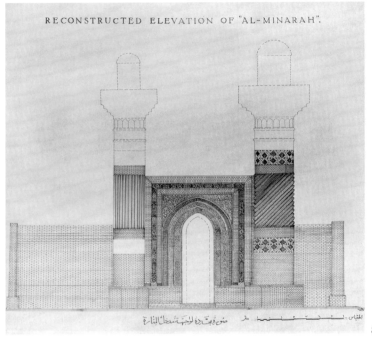

RECONSTRUCTED ELEVATION OF "AL-MINARAH".

8

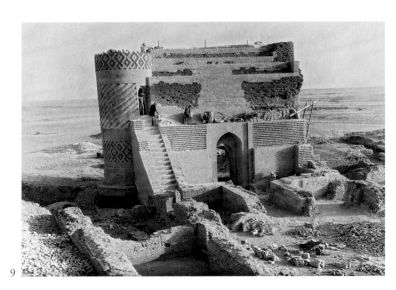

9

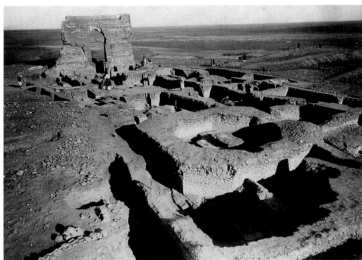

10

NOTES AND BIBLIOGRAPHIES

1–2. MESOPOTAMIAN ART

Amiet, P. *L'art antique du Proche-Orient.* Paris: Mazenod, 1977.

——. *La glyptique mésopotamienne archaïque.* 2nd revised edition. Paris: CNRS Editions, 1980.

——. *L'Antiquité orientale.* Que sais-je? Paris: PUF, 1995.

André-Salvini, B. *Babylone.* Que sais-je? Paris: PUF, 2001.

Aruz, J., ed. *Art of the First Cities.* New York: Metropolitan Museum of Art; New Haven: Yale University Press, 2003.

Benoît, A. *Art et archéologie: Les civilisations du Proche-Orient ancien.* Paris: Ecole du Louvre–RMN, 2003.

Charpin, D. *Hammu-rabi de Babylone.* Paris: PUF, 2003.

Forest, J.-D. *Mesopotamia. L'invenzione dello stato VII–III Millennio.* Milan: Jaca Book, 1996.

——. *Les premiers temples de Mésopotamie (4e et 3e millénaires).* BAR International Series 765. Oxford, 1999.

Frangipane, M. *La nascita dello stato nel vicino oriente, dai lignaggi alla burocrazia nella Grande Mesopotamia.* Bari: Laterza, 1996.

Heinrich, E. *Die Tempel und Heiligtümer im alten Mesopotamien. Typologie, Morphologie und Geschichte.* Deutsches Archäologisches Institut. Denkmäler antiker Architektur, Band 15. Berlin: W. de Gruyter, 1982.

——. *Die Paläste im alten Mesopotamien.* Deutsches Archäologisches Institut. Denkmäler antiker Architektur, Band 14. Berlin: W. de Gruyter, 1984.

Huot, J.-L. *Les Sumériens, entre le Tigre et l'Euphrate.* Paris: Armand Colin, 1984.

——. *Une archéologie des peuples du Proche-Orient.* 2 vols. Paris: Errance, 2004.

Invernizzi, A. *Dal Tigri all'Eufrate (I. Sumeri e Accadi; II. Babilonesi e Assiri).* Università degli Studi di Torino, Studi e materiali di Archeologia 6. Florence: Le Lettere, 1992.

Joannès, F., ed. *Dictionnaire de la civilisation mésopotamienne.* Paris: Robert Laffont, 2001.

——. *La Mésopotamie au I Millénaire avant J.C.* Paris: Armand Colin, 2002.

Margueron, J. C. *Recherches sur les palais mésopotamiens de l'Age du bronze.* Bibliothèque d'archéologie et d'histoire, vol. 107. Paris: Geuthner, 1982.

——. *Les Mésopotamiens.* Paris: Picard, 2003 (1991).

Reade, J. *Assyrian Sculpture.* London: British Museum Publications, 1983.

Roaf, M. *Cultural Atlas of Mesopotamia and the Ancient Near East.* New York: Checkmark Books, 1990.

Seidl, U. "Die Babylonischen Kudurru-Reliefs." *Baghdader Mitteilungen* 4 (1968): 7–220.

Spycket, A. *La statuaire du Proche-Orient ancien.* Leyden: E. J. Brill, 1981.

Tunca, O. *L'architecture religieuse protodynastique en Mésopotamie.* Akkadica Supplementum II. Louvain: Peeters, 1984.

3. HELLENISM IN MESOPOTAMIA

Notes

1. Curtius Rufus, *Histories of Alexander the Great,* 9.6.20–22.

2. Plutarch, *Parallel Lives,* 47.3.

3. Plutarch, *On the Fortune or the Virtue of Alexander the Great,* 1.5.

4. In 324 BC, the famous ecumenical wedding took place at Susa; Alexander married Roxana, and later two other noble Persian women as well. "After receiving his bride each bridegroom led her home. Alexander gave them all dowries. All other Macedonians who had married Asian women had their names registered by Alexander's orders; they proved to be more than ten thousand, and Alexander gave them too wedding gifts" (Arrian, *The Anabasis of Alexander,* 7.4.8).

5. For example, the role that Greek motifs played in the impressions from the archives of Persepolis is well known.

6. As we are told by Strabo (*Geography,* 16.1.5) and Arrian (*ibid.,* 3.16.4; 7.17.1–4). In fact, there is clear archaeological evidence of Achaemenid interventions in the palace sector: repairs, reinforcements, and the erection of the so-called "Persian Building" in the western sector of the "South Palace" confirm the cultural importance of Babylon during the Achaemenid era.

7. The last dated building intervention dates to the late second century AD and proves that this institution was still very much alive within Babylonian society (and thus that the Greek community was still strong) in the late Parthian era.

8. It is Pausanias (*Description of Greece,* 1.16.3) who tells us that part of the population of Babylon was transferred to Seleucia; according to Pliny (*Natural History,* 6.30.121), the purpose of the foundation of Seleucia was to reduce the importance of Babylon,

whereas Strabo (*ibid.*, 16.1.5) describes the greater part of the city as "deserted" (ἔρημος) after the foundation of Seleucia.

9. *Al sarruti* (royal city) in the cuneiform documents and τὸ βασίλειον (royal residence) in the Greek ones.

10. From 1927 to 1937, the expeditions by the University of Michigan took place. From 1963 to 1989, research was conducted by the Centro Ricerche Archeologiche e Scavi di Torino per il Medio Oriente e l'Asia.

11. The religious interpretation of the two buildings excavated by the American missions and described as Temple A and Temple B is not satisfactory; more recently it has been suggested that Temple A may have been a gymnasium (Invernizzi 1994).

12. This emerges from the American excavations of an entire residential block in the center of the city: the levels of the structures range from the Seleucid period (a single, little-researched level) up to the second century AD (three Parthian levels).

13. In the late Parthian period, the temple of Gareus (second century AD) is a clear example of the adoption of western forms for the decoration of a building whose structure nevertheless retains close links with the eastern tradition.

Bibliography
The bibliography on Alexander the Great and Hellenism is obviously very large; here we give a small selection of works with particular reference to the spread of Hellenism in Mesopotamia.

AUWE = Ausgrabungen in Uruk-Warka. Endberichte.

Austin, M. M. *The Hellenistic World from Alexander to the Roman Conquest: A Selection of Ancient Sources in Translation.* Cambridge, 1981.

Bollati, A., V. Messina, and P. Mollo. *Seleucia al Tigri. Le impronte di sigillo dagli Archivi.* Edited by A. Invernizzi. Vols. 1–3. Alexandria, 2004.

Bosworth, A. B. *Conquest and Empire: The Reign of Alexander.* Cambridge, 1988.

Briant, P. *De la Grèce à l'Orient, Alexandre le Grand.* Paris, 1987.

Downey, S. B. *Mesopotamian Religious Architecture: Alexander through the Parthians.* Princeton, 1988.

Funck, B. *Uruk zur Seleukidenzeit. Eine Untersuchung zu den spätbabylonischen Pfründentexten als Quelle für die Erforschung der sozialökonomischen Entwicklung der*

hellenistichen Stadt. Schriften zur Geschichte und Kultur des Alten Orients, 16. Berlin, 1984.

———, ed. *Hellenismus. Beiträge zur Erforschung von Akkulturation und politischer Ordnung in den Staaten des hellenistischen Zeitalters.* Akten des Internationaler Hellenismus-Kolloquiums, Berlin (1994). Tübingen, 1996.

Gullini, G. "Un contributo alla storia dell'urbanistica ellenistica: Seleucia sul Tigri." *Mesopotamia* 2 (1967): 135ff.

Hannestad, L. "Danish Archaeological Excavations on Failaka." In *Arabie Orientale, Mésopotamie et Iran Méridional,* edited by R. Boucharlat and J.-F. Salles. Paris, 1984.

Hopkins, C., ed. *Topography and Architecture of Seleucia on the Tigris.* Ann Arbor, 1972.

Invernizzi, A. "Hellenism in Mesopotamia: A View from Seleucia on the Tigris." *al-Rafidan* 15 (1994): 1ff.

Invernizzi, A., M. Negro Ponzi, and E. Valtz. "Seleucia sul Tigri." In *La terra tra i due fiumi* (exh. cat.), 87ff. Turin, 1985.

Karvonen-Kannas, K. *The Seleucid and Parthian Terracotta Figurines from Babylon.* Florence, 1995.

Kose, A. *Uruk: Architektur IV.* AUWE 17. Mainz am Rhein, 1988.

Kuhrt, A., and S. Sherwin-White, eds. *Hellenism in the East: The Interaction of Greek and Non-Greek Civilizations from Syria to Central Asia after Alexander.* Berkeley, 1987.

———. *From Samarkand to Sardis: A New Approach to the Seleucid Empire.* Berkeley, 1993.

Le Rider, G. *Séleucie du Tigre, Les monnaies séleucides et parthes.* Florence, 1998.

Oates, J., and D. Nimrud. *An Assyrian Imperial City Revealed.* London 2001. 257–71.

Pedde, F. "Frehat en-Nufegi: Zwei seleukidenzeitliche Tumuli bei Uruk." *Baghdader Mitteilungen* 22 (1991): 521ff.

Schlumberger, D. *L'Orient hellénisé.* Baden-Baden, 1969 (Paris, 1970).

Settis, S., ed. *I Greci. Storia, cultura, arte, società.* 2.3. Turin, 1998.

Tarn, W. W. *Alexander the Great.* Cambridge, 1948.

Van Ess, M., and F. Pedde. *Uruk. Kleinfunde II.* AUWE 7. Mainz am Rhein, 1992.

Van Ingen, W. *Figurines from Seleucia on the Tigris.* Ann Arbor, 1939.

Wetzel, F., E. Schmidt, and A. Mallwitz. *Das Babylon der Spätzeit.* Berlin, 1957.

Ziegler, C. *Die Terrakotten von Warka.* Berlin, 1962.

4. THE PARTHIAN AND SASANIAN PERIODS

WVDOG = Wissenschaftliche Veröffentlichung der deutschen Orient-Gesellschaft

Aggoula, B. *Inventaire des inscriptions hatréennes.* Paris, 1991.

Andrae, W. *Hatra. Nach Aufnahmen von Mitgliedern der Assur-Expedition der Deutschen Orient-Gesellschaft, I. Teil.* WVDOG 9. Leipzig, 1908.

———. *Hatra. Nach Aufnahmen von Mitgliedern der Assur-Expedition der Deutschen Orient-Gesellschaft, II. Teil.* WVDOG 21. Leipzig, 1912.

Andrae, W., and H. Lenzen. *Die Partherstadt Assur.* WVDOG 57. Leipzig, 1933.

Bartl, K., and S. R. Hauser, eds. *Continuity and Change in Northern Mesopotamia from the Hellenistic to the Early Islamic Period.* Berlin, 1996.

Bosworth, C. E. *The History of al-Tabari, vol. V: The Sasanids, the Byzantines, the Lakhmids, and Yemen.* Albany, NY, 1999.

Bruno, A. "The Preservation and Restoration of Taq-i Kisra." *Mesopotamia* 1 (1966): 89–108.

Christensen, A. *L'Iran sous les Sassanides.* Copenhagen, 1944.

Colledge, M. A. R. *Parthian Art.* London, 1977.

———. *The Parthian Empire.* London, 1979.

Debevoise, N. C. *A Political History of Parthia.* New York, 1968.

Downey, S. *Mesopotamian Religious Architecture.* Princeton, 1988.

Franco, F. "Five Aramaic Incantation Bowls from Tell Baruda (Choche)." *Mesopotamia* 13–14 (1978–79): 233–49.

Frye, R. N. *History of Ancient Iran.* Munich, 1983.

Gasche, H., and N. Pons. "Abu Qubur 1990. II. Chantier F. Le bâtiment parthe." *Northern Akkad Project Reports* 7 (1991): 11–33.

Ghirshman, R. *Iran. Parti e Sasanidi.* Milan, 1962.

Gyselen, R. *La géographie administrative de l'empire sassanide. Les témoignages sigillographiques.* Res Orientales I. Paris, 1989.

Harper, P. O., and P. Meyers. *Silver Vessels of the Sasanian Period: Royal Imagery.* New York, 1981.

Hopkins, C., ed. *The Topography and Architecture of Seleucia on the Tigris.* Ann Arbor, 1972.

Ibrahim, J. Kh. *Pre-Islamic Settlement in Jazirah.* Baghdad, 1986.

Invernizzi, A. "Problemi di coroplastica tardo-mesopotamica." 1–2. *Mesopotamia* 3–4 (1968–69): 227–92.

———. "Problemi di coroplastica tardo-mesopotamica." 3. *Mesopotamia* 5–6 (1970–71): 326–89.

Karvonen-Kannas, K. *The Seleucid and Parthian Terracotta Figurines from Babylon.* Mon. Mesopotamia 4. Florence, 1995.

Keall, E. *The Significance of Late Parthian Nippur.* (Ph.D. diss.) Chicago, 1970.

Kröger, J. *Sasanidischer Stuckdekor.* Baghdader Forschungen 5. Mainz am Rhein, 1982.

Lecomte, O. "Les Lakhmides de Al-Hira." In *Études Mésopotamiennes,* edited by C. Breniquet and C. Kepinski, 315–32. Paris, 2001.

Mathiesen, H. E. *Sculpture in the Parthian Empire.* Aarhus, 1992.

Monneret de Villard, U. *Le chiese della Mesopotamia.* Rome, 1940.

Moorey, P. R. S. *Kish Excavations 1923–1933.* Oxford, 1978. 122–47.

Moriggi, M. *La lingua delle coppe magiche siriache.* Florence, 2004.

Negro Ponzi, M. "Al-Mada'in: problemi di topografia." *Mesopotamia* 40 (2005): 145–69.

Okada, Y. "Early Christian Churches in the Iraqi South-Western Desert." *Al-Rafidan* 12 (1991): 71–83.

Perkins, A. L. *The Art of Dura-Europos.* Oxford, 1973.

Reuther, O. "Parthian Architecture, History." In *Survey of Persian Art I,* edited by A. U. Pope, 411–44. London/New York, 1938.

———. "Sasanian Architecture, History." In *Survey of Persian Art I,* edited by A. U. Pope, 493–592. London/New York, 1938.

Rice, D. T. "The Oxford Excavations at Hira, 1931." *Antiquity* 6 (1932): 276–91.

Rostovtzeff, M. "Dura and the Problem of Parthian Art." *Yale Classical Studies* 5 (New Haven, 1935): 157–304.

———. *Dura-Europos and its Art.* Oxford, 1938.

Safar, F., and M.A. Mustafa. *Hatra, the City of the Sun God.* Baghdad, 1974 (in Arabic).

Schippmann, K. *Grundzüge der partischen Geschichte.* Darmstadt, 1980.

———. *Grundzüge der Geschichte des sasanidischen Reiches.* Darmstadt, 1990.

Schlumberger, D. *L'orient hellénisé.* Paris, 1970.

Simpson, St. J. "Mesopotamia in the Sasanian Period: Settlement Patterns, Arts and Crafts." In *Mesopotamia and Iran in the Parthian and Sasanian Periods,* edited by J. Curtis, 57–66. London, 2000.

Sommer, M. *Hatra.* Mainz am Rhein, 2003.

Splendeur des Sassanides. Exh. cat. Brussels, 1993.

La terra tra i due fiumi. Vent'anni di Archeologia Italiana. La Mesopotamia dei tesori. Exh. cat. Turin, 1985.

Venco Ricciardi, R., ed. Proceedings of the Symposium "Common Ground and Regional Features of the Parthian and Sasanian World." *Mesopotamia* 22 (1987).

———, ed. "Dossier Hatra." *Topoi* 10/1 (2000): 87–265.

Wiesehöfer, J. *Ancient Persia.* London/New York, 1996.

———, ed. *Das Partherreich und seine Zeugnisse.* Historia, Einzelschriften 122. Stuttgart, 1998.

Wolski, J. *L'empire des Arsacides.* Acta Iranica 32. Louvain, 1993.

Yarshater, E., ed. *The Cambridge History of Iran, vol 3. The Seleucid, Parthian and Sasanian Periods.* Cambridge, 1983.

5. THE ISLAMIC ERA

Notes

1. Reuther 1933; Basmachi 1964.

2. Rice 1934: 51–73.

3. The Khawarij may be considered the first sect to arise in the Muslim world. Its members refused either a choice or a mediation, and "separated" themselves after the battle of Siffin (657) between 'Ali and Mu'awiyah, which, in fact, the latter won. They also played an important part in the rise of the Abbasid dynasty and were often the protagonists in revolts that led to the conquest, always temporary, of whole regions. From a doctrinal point of view, they were simply intransigent and posed various questions about the legitimacy of the Caliphate. On this historical period see Cahen 1969. An excellent manual of the study of Islam is Pareja 1951.

4. The term *Shi'a* literally means "party," with "of 'Ali" understood (*shi'at 'Ali*), and originates in the claim that Muhammad was succeeded by his cousin and son-in-law, whose name was 'Ali. The Shiites have successively split into many groups, among which the Imamites (Twelve-Imam Shiites) and the Ismailites (Seven-Imam Shiites) are the best known. For a doctrinal overview of Shiite issues, see Scarcia Amoretti, 1994.

5. In Islam, the word *Imam* has a double meaning. The Imam is the one who leads the community in prayer (*salat*), but for Shiites, the Imam is the manifestation of the divine in man, that is, he is the one willed by God to be the bearer of the divine essence and leader to salvation. With the occultation of the twelfth Imam, Muhammad al-Mahdi, which took place in Samarra in 874, there also developed the doctrine of the *Mahdi,* "he who is just and led by divinity." The wait for his return has messianic aspects.

6. *Qibla* in Arabic is the direction of the Kaaba in Mecca, toward which Muslims must turn during prayer; the prayer is otherwise invalidated.

7. Creswell 1966: 21–23.

8. "At Qasvin, the first Friday mosque, built by Muhammad, son of Hajjaj, who died in 760, was known as the 'mosque of the Bull.' Once again, this supports the existence of ancient Persian columns, and even a possible adaptation of an *apadana*"; Creswell 1966: 18.

9. For example, the Friday mosque of Isfahan during the Abbasid period; Curatola 2004: 140.

10. Mustafa 1963: 36–65.

11. Safar 1945.

12. Sousa and Jawad 1958.

13. Creswell 1966: 187.

14. Creswell 1966: 184–205.

15. Scarcia Amoretti 1994: 22.

16. Strika and Khalil 1987: 49–50.

17. National Museum, Baghdad.

18. Kuhnel 1933.

19. Bell 1914.

20. Creswell 1966: 226–29.

21. Herzfeld and Sarre 1911–20; Northedge 2005.

22. Northedge 1993: 143–70.

23. Goblot 1979.

24. Hamilton and Grabar 1959.

25. Musil 1907; Grabar 1954; Almagro 1975.

26. Northedge 1993: 148.

27. Small at least given the extraordinary extent of Samarra: in fact, the structure measures 197 by 177 feet (60 by 54 m).

28. This track is not the only one at Samarra. Two others have been identified, the most original of which is a four-leaf circuit, still easily visible from the tall minaret of the Great Mosque. This route, which starts from the palace, opens into a V at whose vertices is a variant of an S to give two long, parallel stretches (7,220 feet [2,200 m]) before the great curve at the end. The path was 260 feet (80 m) wide, and its total length was 34,190 feet (10,420 m); Northedge 1990: 31–56.

29. The *mihna* ("inquisition") proposes that the Qur'an was created, and that consequently the Caliph has an active role in the spread of

Islam, whereas abandoning this idea leads to entrusting theological interpretation to the *'ulama,* the experts in or scholars of religious matters.

30. One of the four canonical Islamic schools, the others being the Hanafi (founded by Abu Hanifa an-Nu'man, 699–767), the Maliki (followers of Malik ibn Anas, 710–796), and the Shafi'i (inspired by the works of Abu Abdullah Muhammad al-Shafi'i, 767–820).

31. Marçais 1955.

32. A very clear example in al-Hakim (990–1003); Behrens-Abouseif 1989: 63–65.

33. Northedge 1991: 74–93, n. 8.

34. Herzfeld 1948: 133.

35. This is an important site on the left bank of the Tigris, characterized by a palace built at the top of a hill. The excavations—conducted by Iraqi archaeologists in the 1970s and again at the beginning of the 1980s (Hamid 1974: 183–94)—have shown various phases of occupation, over a much longer term than that envisaged in the initial hypotheses (which dated the site's construction to 878/82 and its abandonment a few years later), with finds that go on up to the Ottoman era.

36. Northedge 1991: n. 3.

37. Herzfeld 1923.

38. Creswell 1966: 319–21.

39. Hamilton and Grabar 1959.

40. Herzfeld 1923; Ettinghausen 1952: 72–83; Hamid 1966: 83–99.

41. Behrens-Abouseif 1989: 51–57; in particular, 56–57.

42. Fontana 2002: 28, tab. V.

43. Sarre 1925.

44. Miles 1954: 187–91.

45. See DGA 1940; the recent Falkner testifies to the complexity of the situation.

46. Formerly Museum für Islamische Kunst, n. Bab. 2969.

47. Museum of Fine Arts, n. 35.858.

48. Formerly Museum für Islamische Kunst, n. Sam. 1102.

49. *Atabeg* literally means "father of the prince" and is used in the sense of "tutor" or "governor." In fact, they were originally attendants to the Seljuk princes who rapidly became autonomous and founded a hereditary government that was effectively dynastic.

50. The successive historical phases saw the predominance of the dynasties of the Turkmen tribal confederations of the Qara Qoyunlu, the "Black Sheep Turkmen,"

1411–68, and of the Aq Qoyunlu, the "White Sheep Turkmen," until 1508. After this phase, power alternated between the Persian Safavids and the Ottoman Turks with constantly varying fortunes: Shah 'Abbas the Great also ruled over Baghdad between 1622 and 1638, and power was then held in various forms by the Ottomans until 1917. On the history of Iraq, including recent times, see Carretto *et al.* 2003.

51. Strika and Khalil 1987: 18–22.

52. Herzfeld 1942: 11.

53. Strika and Khalil 1987: 51–53.

54. Hadithi 1972: 121–27; Janabi 1982: 96–105.

55. Minaret of the al-Khaffafin mosque, before 1202 (Janabi 1982: 61–65); minaret of the Qumriyya mosque, 1228 (Janabi 1982: 65–68).

56. DGA 1935; Herzfeld 1942: 27–29; DGA 1943.

57. Sarkis 1930: 563–71; Jawad 1945: 61–104.

58. Ma'ruf 1961: 23–30.

59. Janabi 1982: 73–76.

60. Janabi 1982: 91–96.

61. Janabi 1982: 113–40, 140–46.

62. Strika and Khalil 1987: 3–13.

63. Curatola 1986: 15–26.

64. Janabi 1982: 249–50.

65. Janabi 1982: 251.

66. Janabi 1982: 251–54.

67. National Museum, Baghdad; inv. n. A623.

68. National Museum, Baghdad.

69. National Museum, Baghdad; inv. n. A7209.

70. Inv. n. OA 1866.12–29.61. Cf. Ward 1993: 80, figs. 59–60.

71. Curatola 2002: 121.

72. Grube 1991.

73. Safadi 1978: 17.

74. Martin 1983: 68–69.

75. Bodleian Library, Oxford, ms. Marsh 144; Wellesz 1959.

76. Arabic Ms. 2954.

77. Topkapi Sarayi Library, ms. Ahmet III, 2127, fols. 2r–1v, Mosul 1228; Fontana 1998: 48, figs. 8–9.

78. Curatola 1993: 34.

79. Bibliothèque Nationale, Arabic ms. 2964, p. 37; Faris 1953.

80. Arabic Ms. 6094.

81. Inv. C-23.

Bibliography

Adams, R. M. *Land behind Baghdad.* Chicago, 1965.

Almagro, M., ed. *Qusayr 'Amra.* Madrid, 1975.

Basmachi, F. *A Historical Note on Ctesiphon.* Baghdad, 1964.

Behrens-Abouseif, D. *Islamic Architecture in Cairo: An Introduction.* Leiden, 1989.

Bell, G. L. *Palace and Mosque at Ukhaidir.* Oxford, 1914.

Cahen, C. *L'Islamismo I. Dalle origini all'inizio dell'Impero Ottomano.* Milan, 1969.

Carretto, G., G. Corm, G. Crespi, J.-D. Forest, C. Forest, and J. Ries. *Iraq. Dalle antiche civiltà alla barbarie del mercato petrolifero.* 2nd edition. Milan, 2003.

Creswell, K. A. C. *L'architettura islamica delle origini.* Milan, 1966.

Curatola, G. "Architettura armena e selgiuchide: tentativo di analisi." In *K'asakhi Vank'er,* 15–26. Documenti di Architettura Armena, 15. Milan, 1986.

———, ed. *Eredità dell'Islam. Arte Islamica in Italia.* Milan, 1993.

———. Entry 95. In *Islam Specchio d'Oriente,* edited by G. Damiani and M. Scalini, 121. Livorno, 2002.

Curatola, G., and G. Scarcia. *Iran. L'arte persiana.* Milan, 2004.

DGA (Directorate General of Antiquities). *Baqaya al-Qasr al-'Abbasi fi Qalat Baghdad.* Baghdad, 1935.

———. *Hafriyyat Samarra 1936–1939.* 2 vol. Baghdad, 1940.

———. *Binayat al-mathaf al-Islami aw al-Qasr al-'Abbasi.* Baghdad, 1943.

Ettinghausen, R., "The Bevelled Style in the Post-Samarra Period." In *Archaeologica Orientalia in Memoriam Ernst Herzfeld,* edited by G. C. Miles, 72–83. Locust Valley, NY, 1952.

Falkner, R. K. *Pottery from Samarra: The Surface Survey and the Excavations at Qadisiyya 1983–89,* Samarra Studies, vol. 1.

Faris, B. *Le livre de la Thériaque: manuscript arabe à peintures de la fin du XIIe siècle conservé à la Bibliothèque Nationale de Paris.* Cairo: Institut Français d'Archéologie Orientale, 1953.

Fontana, M. V. *La miniatura islamica.* Rome, 1998.

———. *La pittura islamica dalle origini alla fine del Trecento.* Naples, 2002.

Goblot, H. *Les qanats: une technique d'acquisition de l'eau.* Paris/New York, 1979.

Grabar, O. "The Six Kings at Qusayr Amrah." *Ars Orientalis* 1 (1954): 185–87.

Grube, E. J., ed. *A Mirror for Princes from India.* Bombay, 1991.

Hadithi, A. "Ma'dhanat al-Kifl." *Sumer* 28 (1972): 121–27.

Hamid, A. A. "The Origin and Characteristics of Samarra's Bevelled Style." *Sumer* 22 (1966): 83–99.

———. "New Lights on the 'Ashiq Palace of Samarra." *Sumer* 30 (1974): 183–94.

Hamilton, R. W., and O. Grabar. *Khirbat al-Mafjar: An Arabian Mansion in the Jordan Valley.* Oxford, 1959.

Herzfeld, E. *Erster vorlaufiger Bericht über die Ausgrabungen von Samarra.* Berlin, 1912.

———. "Die Deutschen Ausgrabungen von Samarra." *Illustrierte Zeitung* n. 3608 (1912): 335–91.

———. "Mitteilung uber die Arbeiten der zweiten Kampagne von Samarra." *Der Islam* 5 (1914): 196–204.

———. *Die Ausgrabungen von Samarra,* vol. I. *Der Wandschmuck der Bauten von Samarra und seine Ornamentik.* Berlin, 1923.

———. "Damascus: Studies in Architecture I." *Ars Islamica* 9 (1942).

———. *Die Ausgrabungen von Samarra,* vol. VI. *Geschichte der Stadt Samarra.* Hamburg, 1948.

Herzfeld, E., and F. Sarre. *Archäologische Reise im Euphrat- und Tigris-Gebiet.* 4 vol. Berlin, 1911–20.

Janabi, T. J. *Studies in Mediaeval Iraqi Architecture.* Baghdad, 1982.

Jannabi, T. A. "al-tanqib wal-siyana fi Samarra 1978–1981." *Sumer* 37 (1981): 188–211.

———. "Islamic Archaeology in Iraq: Recent Excavations at Samarra." *World Archaeology* 14 (1982): 305–27.

Jawad, M. "al-Qasr al-'Abbasi fi'l-Qal'a bi Baghdad wa Huwa Dar al-Musannat al-'Atiqa min Athar al-Nasir li Din Allah al-'Abbasi." *Sumer* 1 (1945): 61–104.

Kuhnel, E. "Mschatta." *Bilderhefte der Islamischen Kunstabteilung* 2 (1933).

Lassner, J. *The Topography of Baghdad in the Early Middle Ages.* Detroit, 1970.

Le Strange, G. *Baghdad during the Abbasid Caliphate from Contemporary Arabic and Persian Sources.* London, 1900.

Marçais, G. *L'architecture musulmane d'Occident: Tunisie, Algerie, Maroc, Espagne et Sicile.* Paris, 1955.

Martin, M. A. "Al-Kindi." *The Genius of Arab Civilization: Source of Renaissance,* edited by J.R. Hayes, 68–69. Cambridge, MA, 1983.

Ma'ruf, N. *al-Madrasah as-Shirabiyya aw al-Qasr al-'Abbasi fi Qal'at Baghdad.* Baghdad, 1961.

Massignon, M. L. *Mission en Mésopotamie: 1907–1908.* 2 vols. Cairo, 1912.

Miles, G. "The Samarran Mint." *Ars Orientalis* 1 (1954): 187–91.

Monneret de Villard, U. *Introduzione allo studio dell'archeologia islamica.* Venice/Rome, 1966.

Musil, A. *Kusejr 'Amra.* 2 vol. Vienna, 1907.

Mustafa, M. A. "Preliminary Report on the Excavation in Kufa during the Third Season." *Sumer* 19 (1963): 36–65.

Northedge, A. "The Racecourses at Samarra." *Bulletin of the School of Oriental and African Studies* 53 (1990): 31–56.

———. "Creswell, Herzfeld, and Samarra." *Muqarnas* 8 (1991): 74–93.

———. "An Interpretation of the Palace of the Caliph at Samarra (Dar al-Khilafa or Jawsaq al-Khaqani)." *Ars Orientalis* 23 (1993): 143–70.

———. *Historical Topography of Samarra.* London, 2005.

Pareja Casanas, F. M., with A. Bausani and L. Hertling. *Islamologia.* Rome, 1951.

Reuther, O. *Die Ausgrabungen der Deutschen Ktesiphon Expedition im Winter 1928–1929.* Berlin, 1933.

Rice, D. T. "The Oxford Excavations at Hira." *Ars Islamica* 1 (1934): 51–73.

Safadi, Y. H. *Islamic Calligraphy.* London, 1978.

Safar, F. *Wasit, the Sixth Season's Excavations.* Cairo, 1945.

Sarkis, Y. "Dar al-musannah: baqayaha aliwan 'lladhi bil-Qal'ah." In *Lughat al-'arab.* Baghdad, 1930.

Sarre, F. *Ausgrabungen von Samarra II: Die Keramik von Samarra.* Berlin, 1925.

Scarcia Amoretti, B. *Sciiti nel mondo.* Rome, 1994.

Sousa, A., and M. Jawad. *Dalil Kharitah Baghdad, qadiman wa hadithan.* Baghdad, 1958.

Strika, V., and J. Khalil. *The Islamic Architecture of Baghdad.* Naples, 1987.

Ward, R. *Islamic Metalwork.* London, 1993.

Wellesz, E. "An Early Al-Sufi Manuscript in the Bodleian Library in Oxford: A Study in Islamic Constellation Images." *Ars Orientalis* 3 (1959): 1–26.

INDEX OF PLACES AND MONUMENTS

PHOTOGRAPHIC CREDITS

Color photographs

akg-images/Gerard Degeorge: 118; Alistair Northedge, Paris: 139, 140, 141, 144, 145, 146; Angelo Stabin, Milan: 79; Archivio Centro Scavi, Turin: 83, 85, 86–88, 89, 90, 92, 93, 95, 110; Biblioteca Medicea Laurenziana, Florence, with permission of the Ministry of Cultural Assets: 188; Biblioteca Universitaria, Bologna, with permission: 189; Bildarchiv Preussischer Kulturbesitz, Berlin 12a, 59, 62, 73, 75, 78, 81, 94, 122; Carabinieri, Nucleo del Patrimonio Artistico: 16, 25, 27, 44, 50, 51; Corbis/© Michael S. Yamashita: 45; Foto Ciol, Casarsa: 133, 135, 136, 137; Giovanni Curatola, Venice: 132, 149, 150, 155, 156, 159, 161, 164, 166, 171, 172, 174, 175, 180, 181, 182, 183; Archive of Giovanni Curatola, with the collaboration of the National Museum of Iraq, Baghdad: 113, 114, 129, 130, 131, 142, 147, 148; Isber Melhem, Beirut: 117; Jaca Book/Sartec: 9, 10, 11, 13, 17, 19, 21, 22, 32, 33, 36, 40d, 40g, 48, 58, 74, 143, 162, 163, 165, 168, 169, 176, 178; Jean-Daniel Forest, Paris: 6, 8; Max Mandel, Milan: 7, 18, 34, 35, 47, 63, 64, 65, 66, 103, 106, 107, 111, 112, 119, 134, 167, 170, 173; French Archaeological Mission to Dura, archive of P. Leriche: 97; Nicolò Orsi Battaglini, Florence: 184; RMN: 24; RMN/Arnaudet, J. Scho: 60; RMN/Jean-Gilles Berizzi: 67; RMN/P. Bernard: 30; RMN/Chuzeville: 52, 68; RMN/C. Jean: 31a; RMN/Ch. Larrieu: 56; RMN/H. Lewandowski: 39, 53, 54, 70, 71; RMN/© Franck Raux: 40a, 55; Roberta Venco Ricciardi, Turin: 99, 100, 102, 104, 105, 108, 109, 127, 128; Scala, Florence: 14, 37, 138; Scala, Florence/© National Museum of Iraq: 80, 96, 115, 116; © The Trustees of the British Museum: 20, 28, 29, 69, 72, 76, 185; Werner Forman Archives/Scala, Florence: 77; Yale University Babylonian Collection, New Haven: 12b, 12d; Yale University Art Gallery: 98; Yasser Tabbaa: 157, 158, 160, 177, 179; Wetzel, F., E. Schmidt, and A. Mallwitz, *Das Babylon der Spätzeit*, Wissenschaftliche Veröffentlichung der Deutschen Orient-Gesellschaft, 62.8 (Berlin, 1957), t. 22a: 84.

Black-and-white photographs

The period photos of excavations, sites and monuments belong to the archive of Giovanni Curatola, with the collaboration of the National Museum of Iraq, Baghdad, with the exception of p. 229, 2; 230, 4; and 231, 7, provided by Roberta Venco Ricciardi; p. 260, 1, and 267, 5 and 6, provided by Jean-Daniel Forest; and p. 241, 2–4, provided by Jean-Louis Huot. The following images have also been used: Archivio Centro Scavi, Turin, p. 259, 5 and 6; Giovanni Curatola, p. 219, 6–8; 220, 10–13; 222, 19, 21–23; 223, 24, 25, 27, 28; 224, 29, 31–33; 225, 37–39; Max Mandel, Milan, p. 226, 3; 238, 1; Roberta Venco Ricciardi, Turin, p. 226, 4; 232, 9 and 10; 232, 15; Suire, p. 217, 17.

Plans, drawings, and reconstructions were provided by the several authors. The plan on p. 217 (20) is based on a drawing by C. Fossati.

The maps on pp. 15, 99, and 209 were created by Linotipia Jo.type, Pero (Milan).